To Lesley

Love
PJ x

" Hope it inspires You "

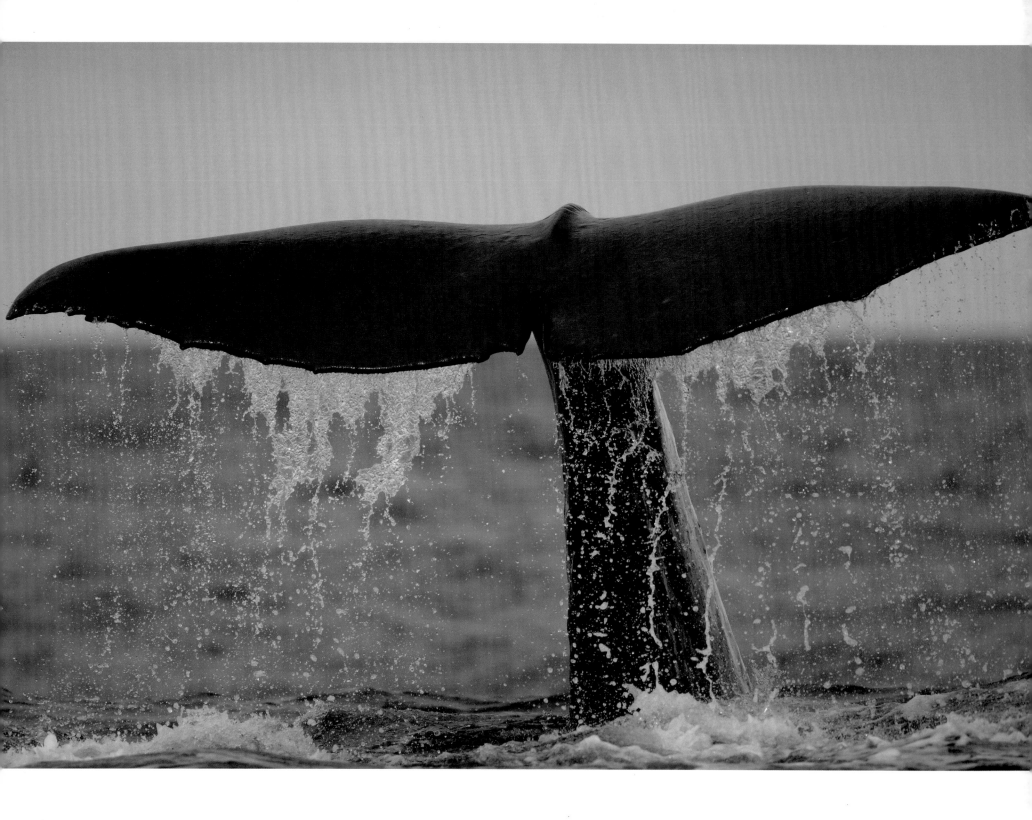

365
PHOTOGRAPHY DAYS

BY AWARD WINNING PHOTOGRAPHER **PHIL GOULD**

Book Guild Publishing
Sussex, England

First published in Great Britain in 2010 by

The Book Guild Ltd

Pavilion View

19 New Road

Brighton, BN1 1UF

Design by Simon Goggin

Printed in China by PWGS / MRM Graphics Ltd.

A catalogue record for this book is available from
The British Library.

ISBN 978 1 84624 459 9

CONTENTS

FOREWORD

INTRODUCTION
Behind the Lens – The Phil Gould Story

EAST AFRICA
Days 1-12 Tanzania

SOUTH AMERICA
Days 15-32 Brazil
Days 33-36 Argentina
Days 37-47 Bolivia
Days 48-67 Peru
Days 68-80 Ecuador

UNITED STATES OF AMERICA
Days 82-91 California
Days 92-106 Oklahoma
Days 108-109 New Mexico
Days 110-116 Arizona
Days 117-118 Nevada
Days 119-127 Utah and Arizona
Days 128-129 Wyoming
Days 130-158 Montana
Days 159-162 South Dakota
Days 163-166 Wyoming
Days 167-169 Montana
Days 172-230 Texas and Oklahoma

AUSTRALASIA
Days 231-236 Fiji
Days 237-261 New Zealand
Days 262-274 Australia

SOUTH AFRICA
Days 275-276 Benoni
Days 277-288 Mufasa River Camp
 (Phalaborwa)
Days 289-290 Benoni
Days 291-304 Johannesburg
Days 305-319 Pilanesberg
Days 320-321 Vaal Dam
Days 322-323 Johannesburg and Benoni
Days 324-339 Mpumalanga Region
Days 340-341 Benoni
Days 342-365 Kruger National Park

Useful Information
Dedication to Sarah Weston
Phil Gould on Tour
Glossary
Acknowledgements

ROUTES TAKEN BY THE AUTHOR

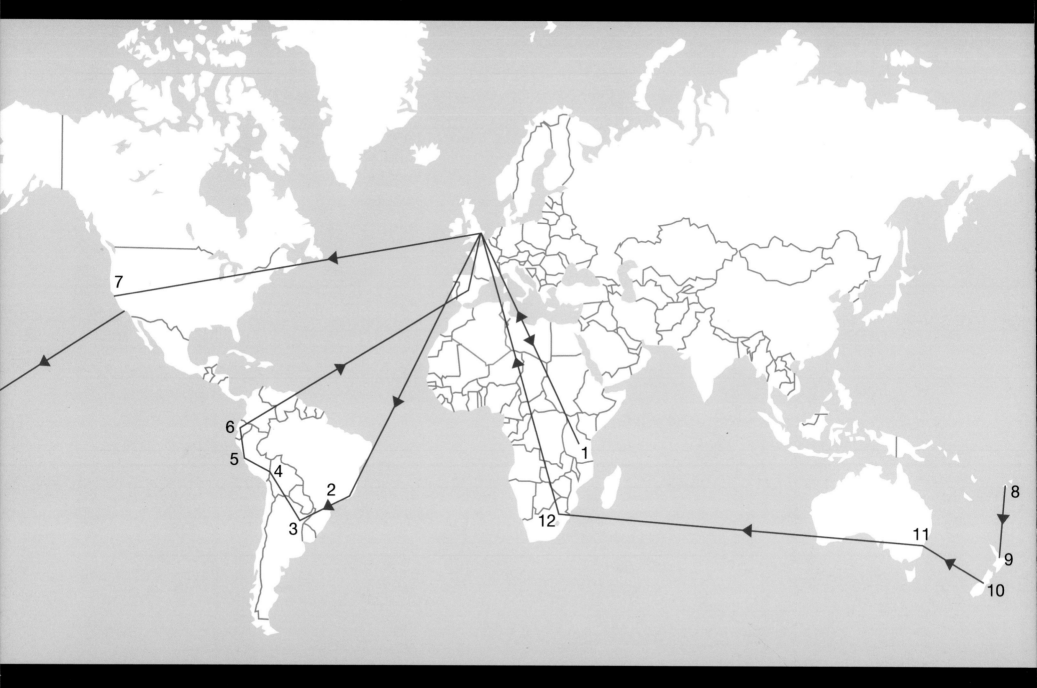

KEY **1** Tanzania **2** Brazil **3** Argentina **4** Bolivia **5** Peru **6** Ecuador **7** USA **8** Fiji **9** North Island New Zealand **10** South Island New Zealand **11** Australia **12** South Africa

DEDICATION TO HAZEL

A special thank you to Hazel without whose support this
book would never have been published

FOREWORD

So many people take photos that we think that the process is easy: we get out our camera, maybe even our mobile phone, wave it about and press a button. The results are 99.9 per cent disposable, the image having relevance for seconds or maybe a month or two. These are snaps and they have a value – but they are not valuable. They are entirely personal and communicate little or nothing to anyone else. When we try a little harder, either technically or artistically (hopefully both), then the snaps become photographs, which in turn are those that we choose to keep, maybe for years. But while they decorate mantelpieces and bedside tables they remain personal and only interest those who can give them exterior context. However, when we produce, through rare skill and creativity, something that can communicate effectively with a much wider audience, then we have a picture, something truly valuable, durable, intrinsically if not aesthetically beautiful. There's just one problem . . . making pictures is almost impossibly difficult.

To make a picture the photographer has to respond to their subject, take something from it or that response and emphatically personalise it. Then they need to capture it in an entirely unique way to produce a never-been-seen-before image. If this still doesn't sound difficult enough then consider this last thought: when anyone, even the snapper, squeezes the button they are making an almost infinite number of choices and the closer they come to making that exposure the more critical those decisions become. Thus photography is not easy at all; it is very, very hard.

And having to take a picture every day is not easy either. It's a forced rather than a creative agenda; as soon as creativity is forced it becomes stressed and this merely adds to the degree of difficulty. Phil's quest, a picture a day in a myriad of unknown locations with no time to recce, plan or research, is an inordinately tough one, a tremendously brave challenge. I think there are pictures amongst these 365 that stand in isolation; there are many that unify to tell stories, portray journeys and ideas. Equally there are some that are comparatively weak, some poor. But for me that is still a valuable part of the whole: it highlights the fallibility of the concept, the peril of ambition of this kind, and the honesty of the individual who will bare his endeavour for all to see.

I think this collection represents a challenge to many, those who at leisure pull their cameras from pouches on any given Sunday and loose off a few frames, occasionally scoring a hit if the world collides with their ambitions of the moment. If you don't like everything you see then charge your batteries, clear your cards and pack your gear on New Year's Eve, and give it a go.

Chris Packham 2009
TV Presenter

BEHIND THE LENS - THE PHIL GOULD STORY

I was born in Southampton, UK and lived in Awbridge until I was 16 years old. Here I learned the field craft of wildlife photography, watching the many birds and mammals in their natural habitat. Using these skills, and years of experience of watching and photographing wildlife, I hope to bring my pictures to life and give others the pleasure of my journal.

Four years ago I was in a plane that crashed into the sea just off Hallo Bay in Alaska. The passengers all survived but having a near-death experience changes your view on life. Inspired by the movie of the same name, I put together a 'bucket list' of things to do and places to see before I die. I had dreamed for many years of travelling and seeing the wonders of the world, so when I was made redundant I decided to go around the world in 365 days! 365 Photography Days is therefore the story of my adventures and, as a photographer, I set myself the challenge of taking a definitive image every day. Come and join me on my travels as, together, we explore the places I visited. Naturally I hope you enjoy the book as much as I enjoyed taking the photographs.

Phil

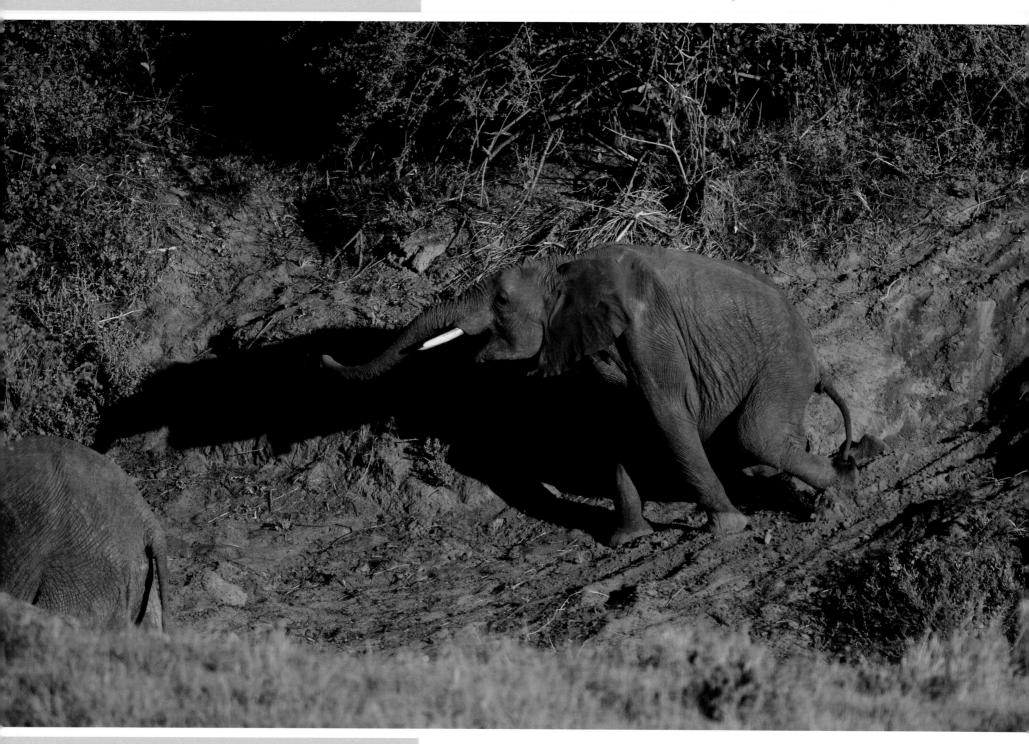

This was a special start to my trip around the world as it was my good friend, Chris Wallace's sixtieth birthday. All but one of us from the plane crash went on this trip to celebrate with him. Tanzania is one of Chris's favourite places and I have always wanted to go there to visit the famous Ngorongoro Crater and Serengeti.

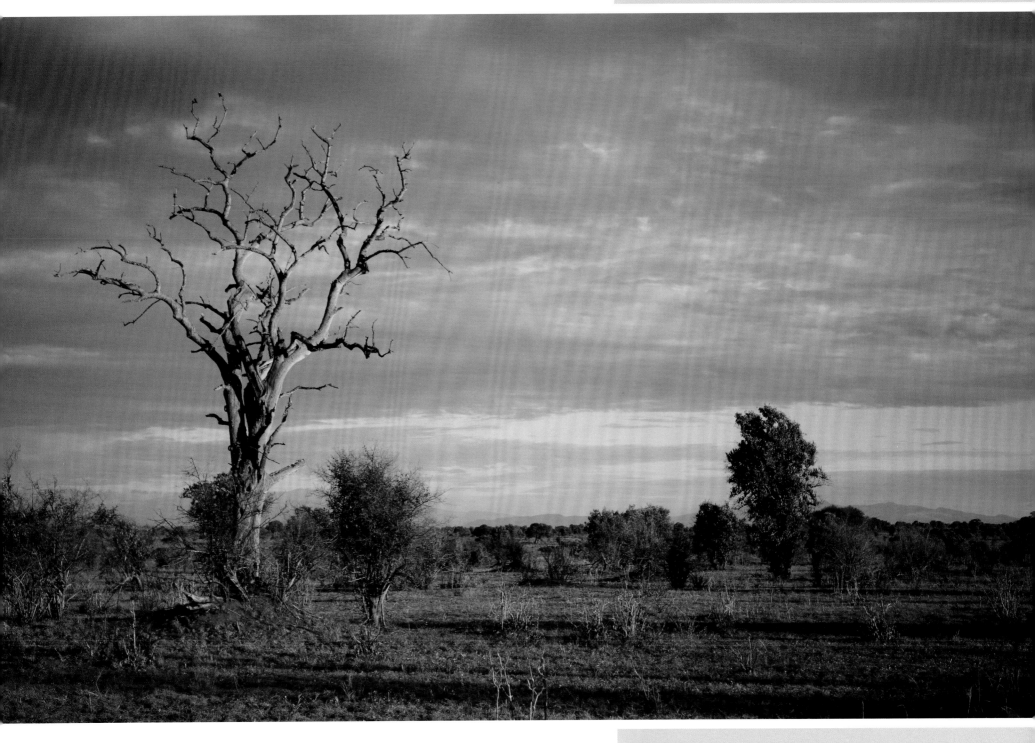

Once you have been to Africa it gets in your blood and you always want to return to this amazing place. I love this early morning soft light and would spend a year in Africa if I didn't have other things that I wanted to see.

☐ TIP
Look out for stormy and dark skies with rays of light that illuminate the landscape in unusual ways. They create powerful images.

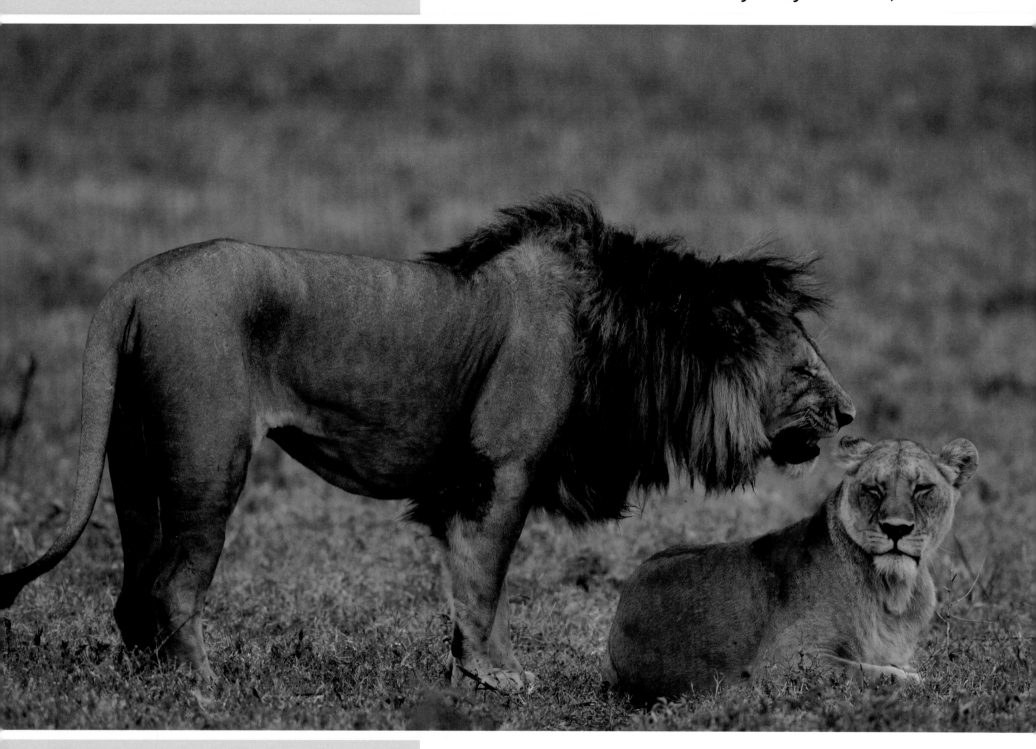

TIP

A long lens for wildlife photography is essential, so that you don't disturb wildlife in their natural habitat, especially with mating lions. I wouldn't want to upset the king of beasts in his courtship!

Ngorongoro Crater is somewhere that I have always wanted to visit and photograph. It is a wildlife haven, being the world's largest unbroken and unflooded volcanic caldera. The crater formed when the volcano exploded and collapsed on itself some two to three million years ago. Today you can see the magnificent 'Big Five' here. The first wildlife TV programmes were filmed here with David Attenborough.

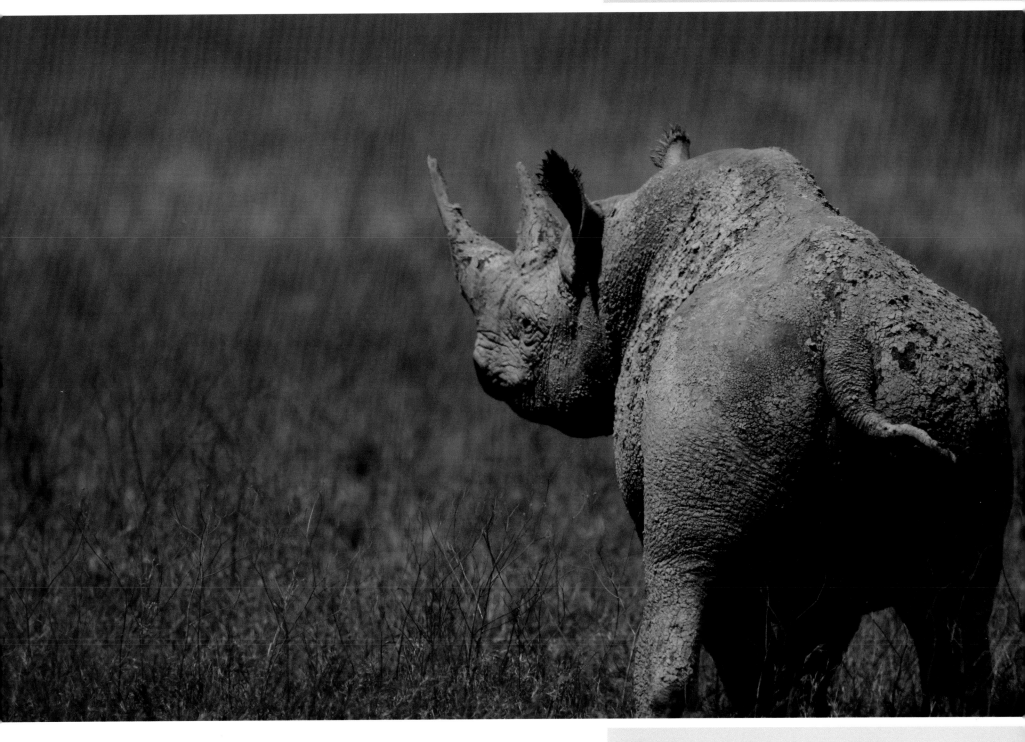

The crater has a population of approximately 25,000 large animals. Due to its steep sides the animals have more protection from poachers and it is one of the best places to see black rhinoceros in Africa. I stayed at the Ngorongoro Crater Lodge which is closest to the Park. It only takes 30 minutes to get down the steep slopes from here, whereas other lodges are over an hour away.

📷 TIP

When using long lenses, the camera and lens needs to be steady to avoid camera shake and blurred images. There are a number of ways to support your camera and lens, the most common being a tripod. It is difficult to use a tripod in a vehicle so a bean bag resting on the window provides excellent support. If you don't have a bean bag, borrow a cushion or pillow from your hotel!

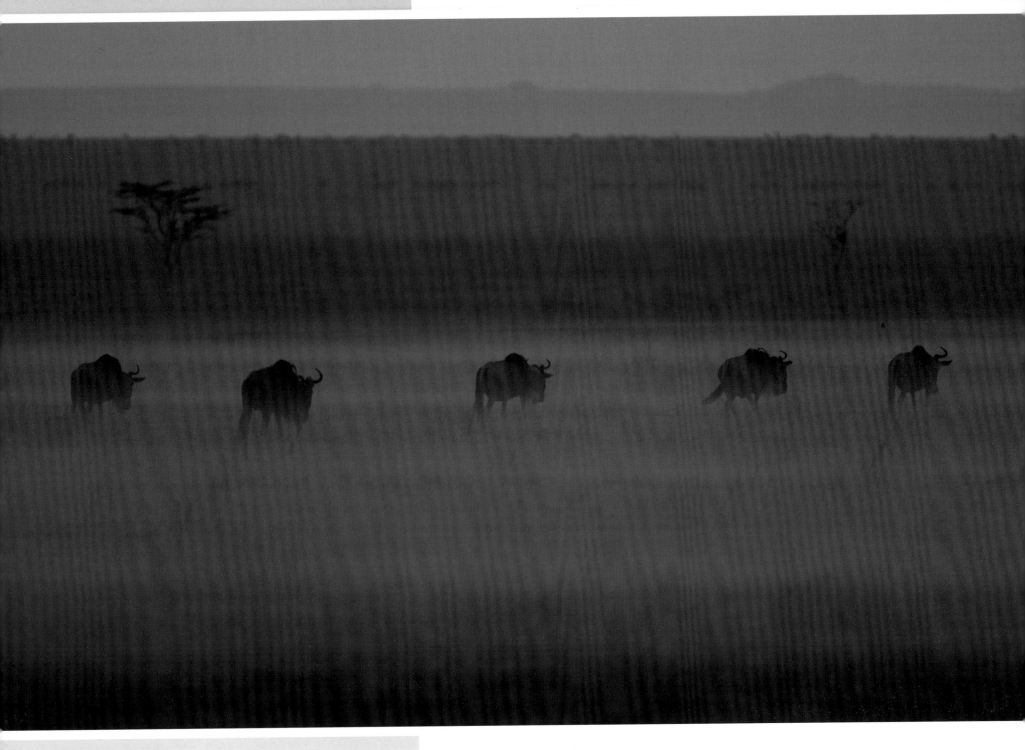

📷 TIP

Using my longer lens brought these wildebeest in this atmospheric early mist closer in the frame. If I had used a wide-angle lens it would have made it more of a landscape image and the animals would have become just dots in the frame. Deciding what image you want is one of the hardest things in photography as sometimes you only get one chance.

Ndutu is a very special place in the Ngorongoro Conservation Area, and a wildlife photographer's dream. Wildebeest live on the Plains and give birth to their calves in February. This attracts predators to the area, creating more opportunity to photograph the big cats. The Plains are often covered with early morning mist, which makes for very atmospheric photographs.

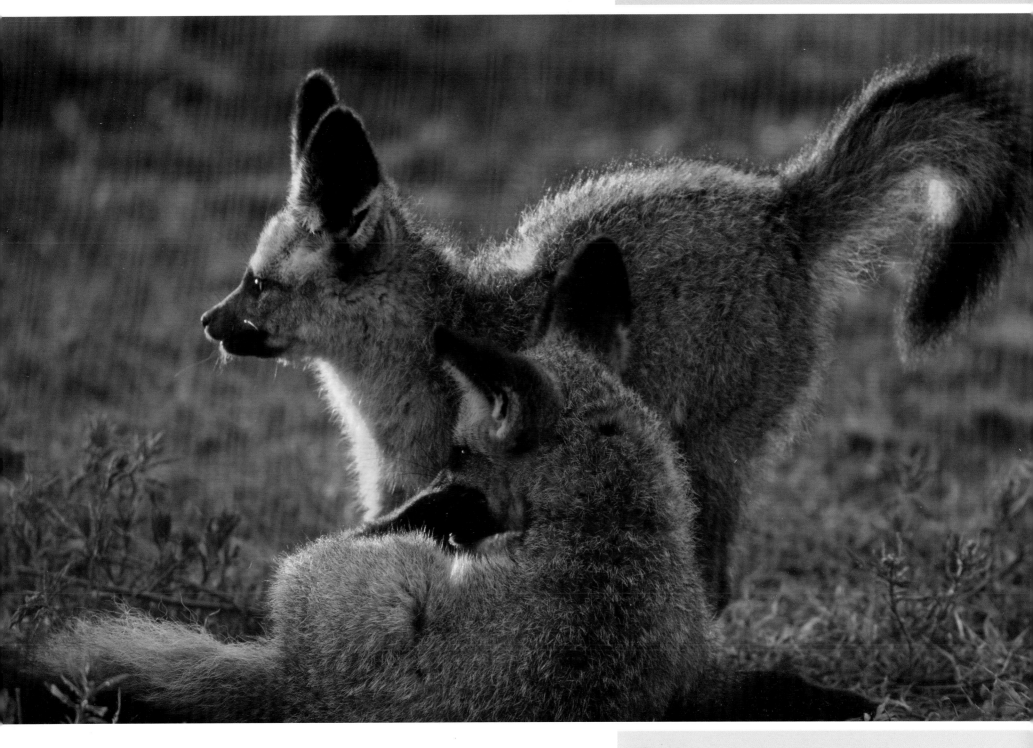

Bat-eared foxes are nocturnal and can be found on the Savannah in the early morning sunlight or just before sunset. The bat-eared fox's diet consists mainly of insects, and they live in small family groups. This group was photographed against the light, giving the fur an almost haloed effect. These animals can be found near herds of zebra and antelope as they feed on the insects landing on their excrement!

📷 TIP

Back lighting can be achieved by photographing into the sun giving a halo effect. When doing this be very careful that you don't look directly through the lens at the sun as you could damage your eyes.

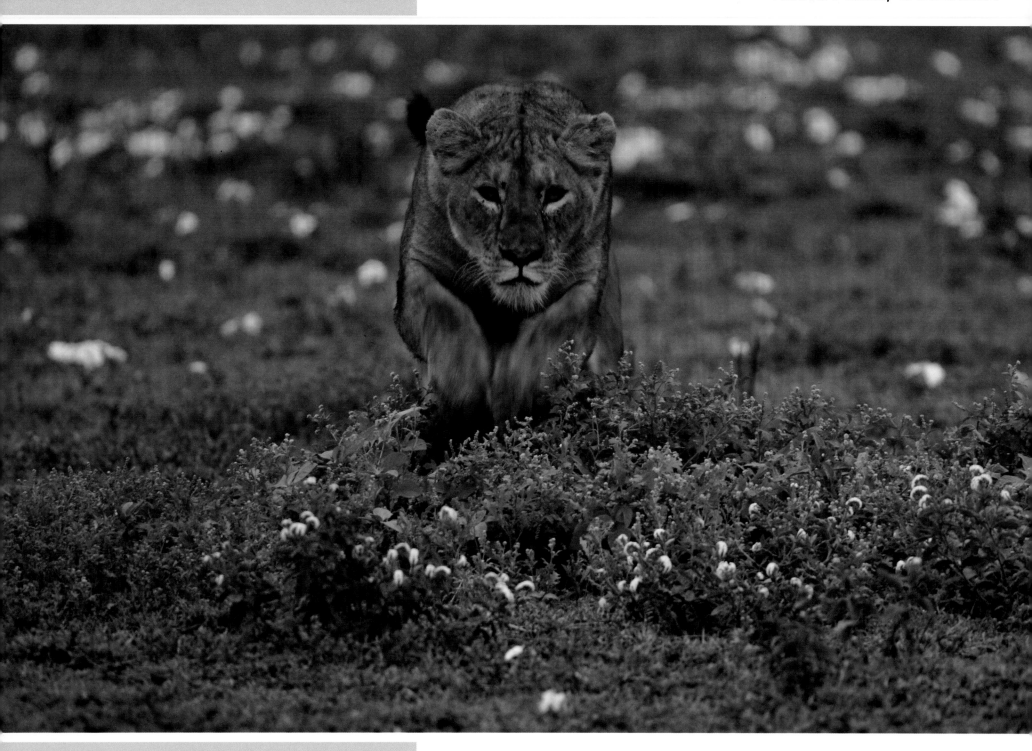

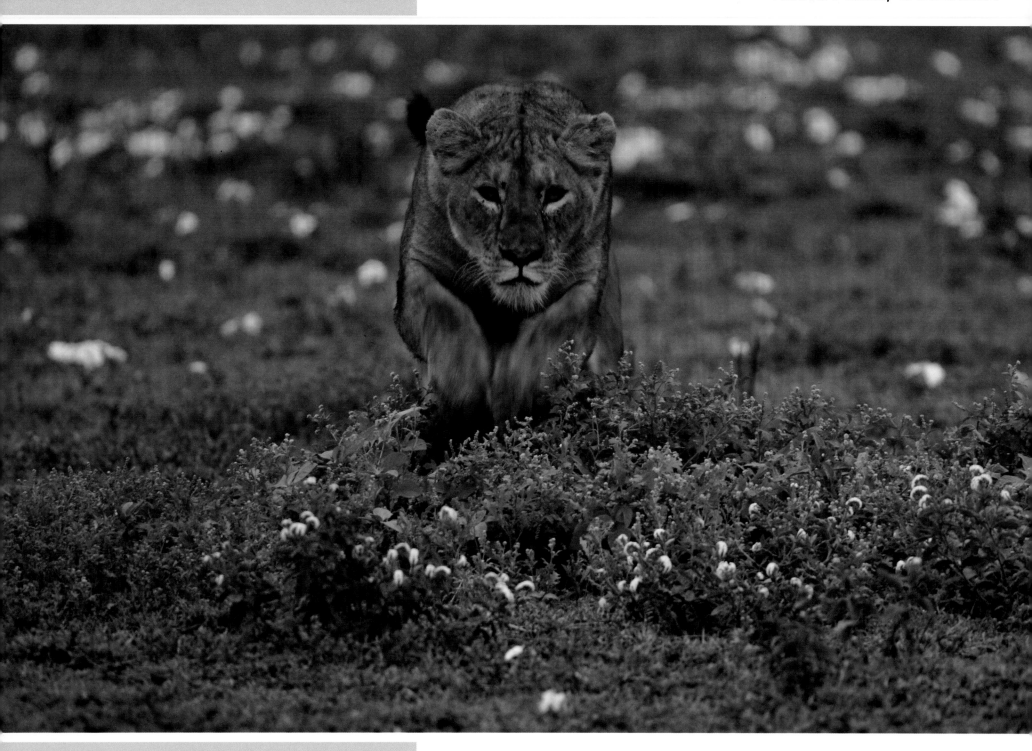**TIP**
Although in a 4x4 vehicle, I used a beanbag on the lower window to capture this eye-level shot of a fast moving cat, rather than shooting downwards. Being in the right position at the right time helps you to get shots like this.

Charging lioness springing from the vegetation directly towards us, as she stalks her prey. Her eyes were transfixed on her next meal - thankfully not me.

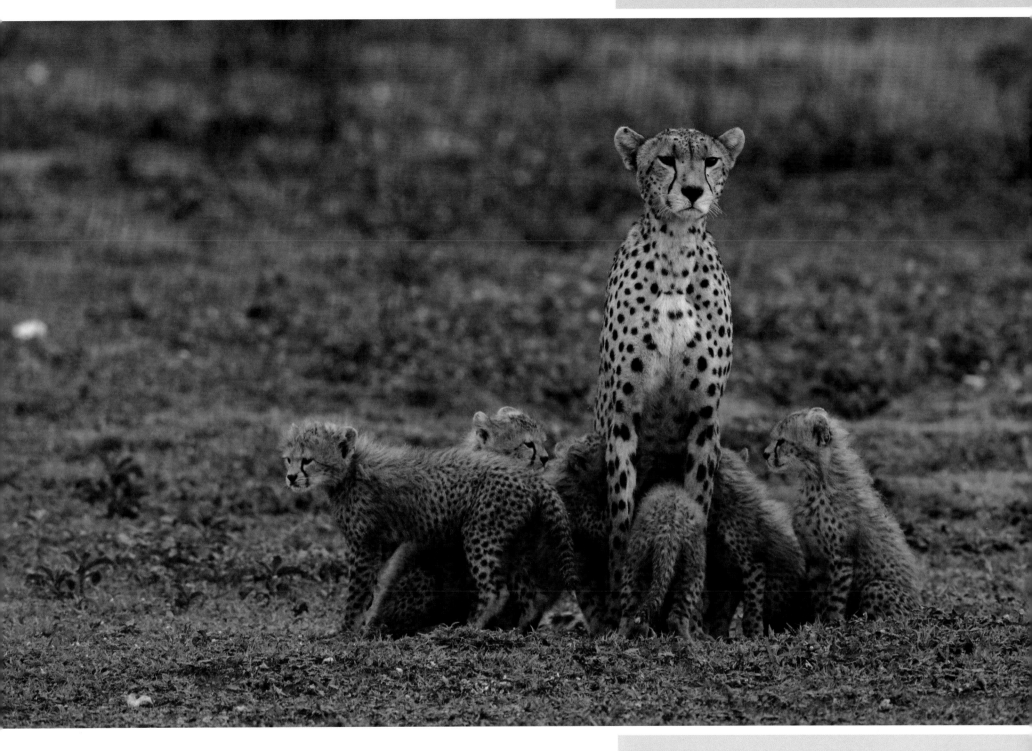

HAPPY BIRTHDAY PHIL! What a birthday present from Ndutu: a female cheetah with six young cubs. This cheetah uses the safari vehicles as cover for hunting antelope leaving us to babysit the cubs while she tries to make a kill. Don't be greedy - enjoy marvellous moments like this and don't complain if the light is not perfect. That's what makes a special shot and why I enjoy photography.

TIP

Once you have your image but if the light is not perfect, sit back and enjoy wildlife at its best rather than through the view finder. You never know what else you might see.

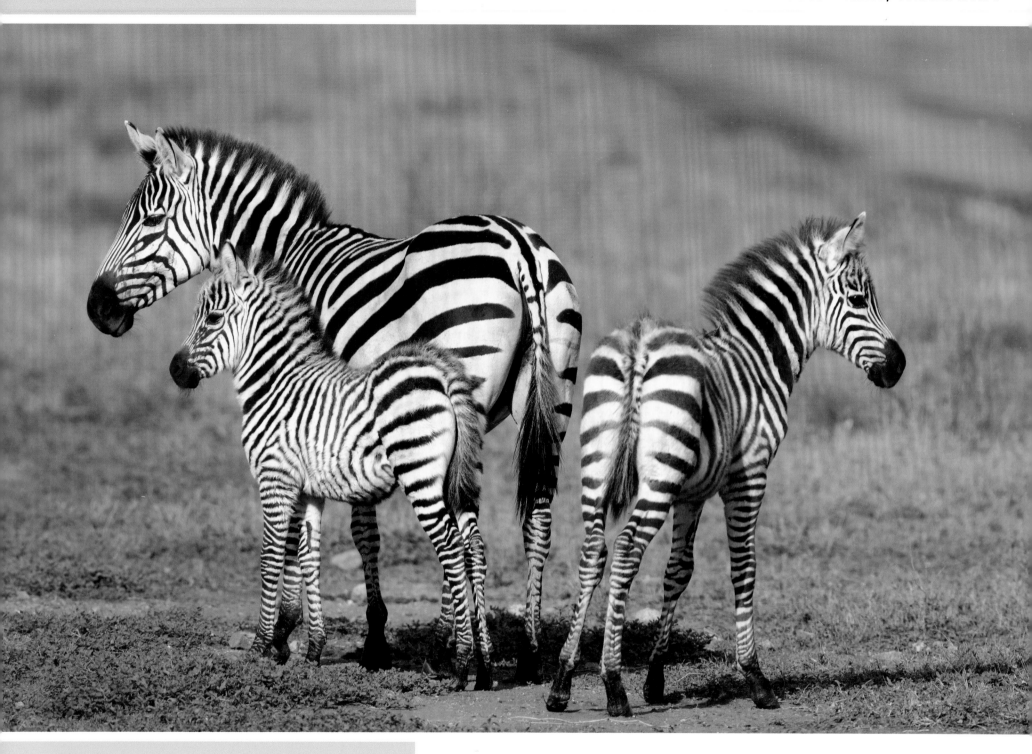

◉ TIP
Threes are always good in images, giving a balanced composition to
photographs. Regardless of the size of the group, odd numbers always
work better than even.

Ndutu's Plains have good vegetation, allowing zebra and antelope more opportunity to support
their young. This zebra has two foals of different ages.

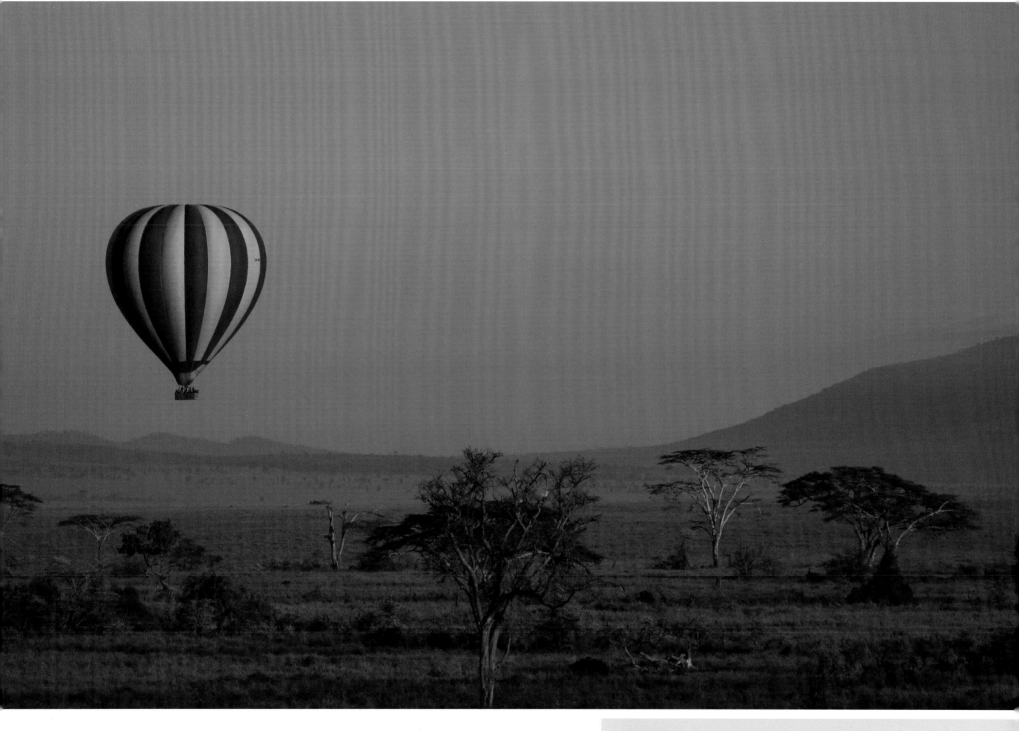

This was a special day for my mate Chris, as his wife 'Pol' had arranged a balloon flight for his birthday across the Serengeti. What he didn't know was that I was going too! A very emotional day for all of us, and something to tick off my bucket list. A two-hour balloon flight with amazing views and a champagne breakfast in the middle of the Serengeti.

📷 TIP

Try something different. Balloon travel gave a different perspective to my photography.

📷 TIP

The smaller the aperture the greater depth of field, i.e. the area of sharpness is greater at f16 than at f2.8. If you want your subject and background sharp, use a small aperture, f16. If you want the background out of focus, use a large aperture, f2.8. If in doubt use the golden rule, photograph at f8, giving a mixture of blurred and sharp photography. This image was taken at f4.

All creatures great and small - this willow warbler posed for me on the canopy of a thornbush.

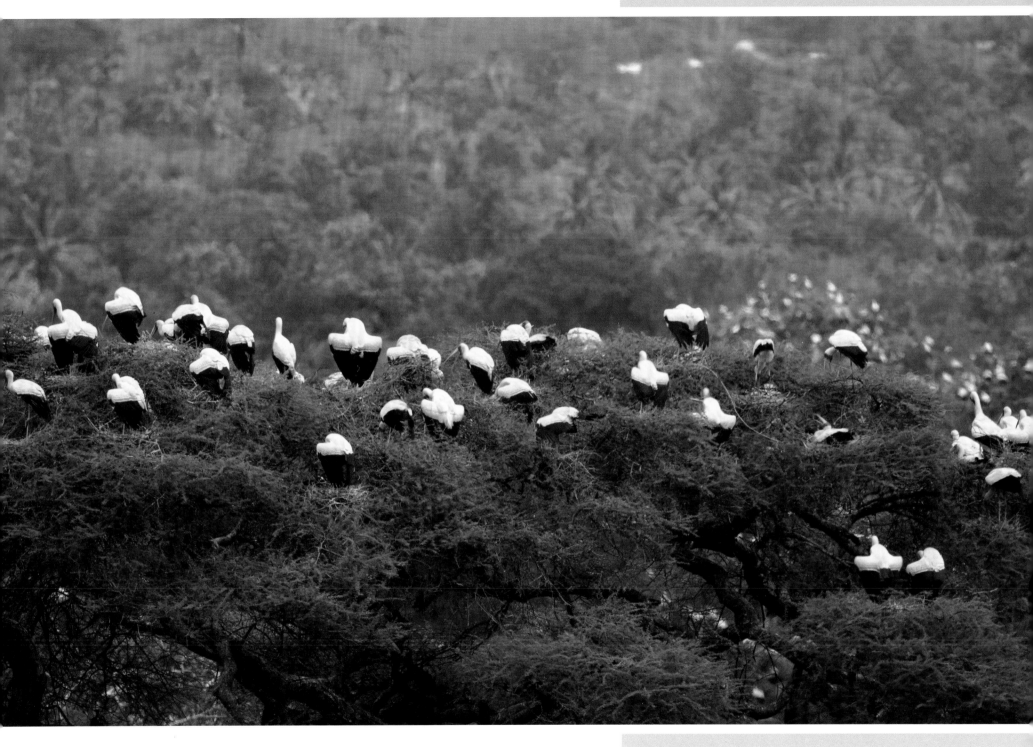

Yellow billed storks nesting in trees on the way back to the airport. Had a 12-hour delay at the airport before returning to the UK – but at least it gave me more time with friends I won't see for another year.

📷 **TIP**

Unlike the previous photo I used a high f stop giving an overall sharp image. The mist in the background slightly blurs the landscape behind.

📷 TIP

When travelling find out the weight limit that you can carry onto the plane. You can buy photographic vests that will hold some of your smaller photographic items i.e. batteries, chargers, filters, memory cards/film and storage devices. Lens pouches can also be attached to your belt, but, as I know from experience, don't get too big a pouch as it might pull your trousers down!

After the delay at Kilimanjaro Airport and a nine-hour flight home, I was glad that I had pre-booked a room before my trip to Madrid and then on to Brazil. Make sure you leave enough time for connecting flights. Allow at least 24 hours for delays and recovery time. If I hadn't allowed this time I would have missed my connection and the Rio Carnival.

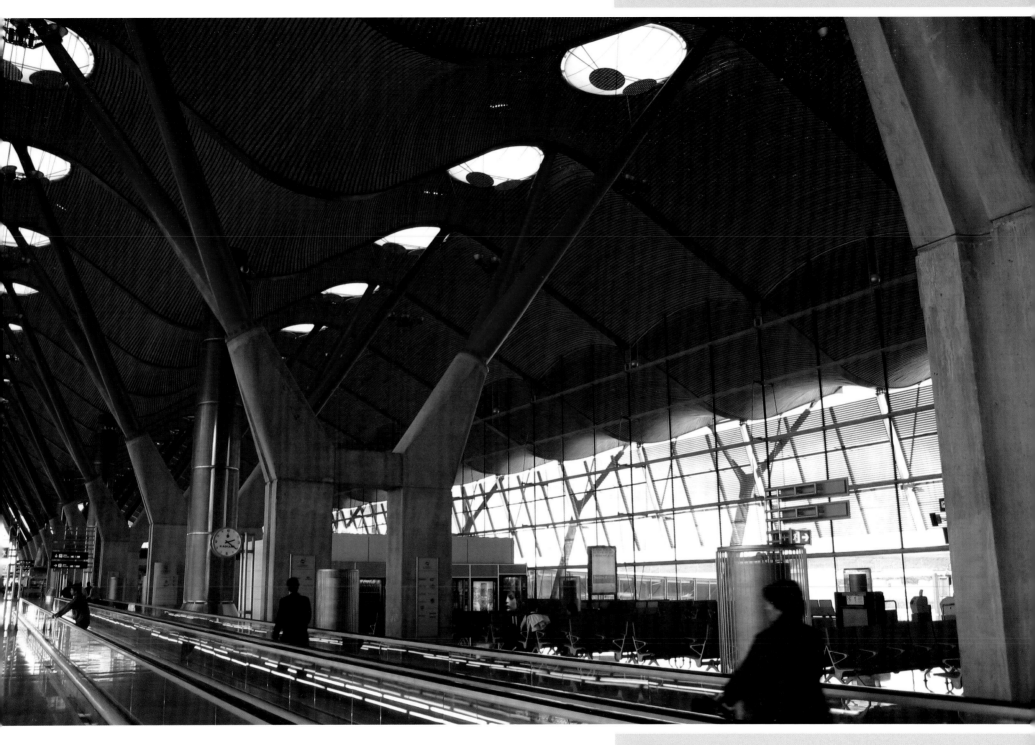

Madrid Airport is famous for its curvy ceiling. I only had a short time to look around before my connecting flight to Rio.

 TIP

Be careful where you take your camera as photography in airports is not advised!

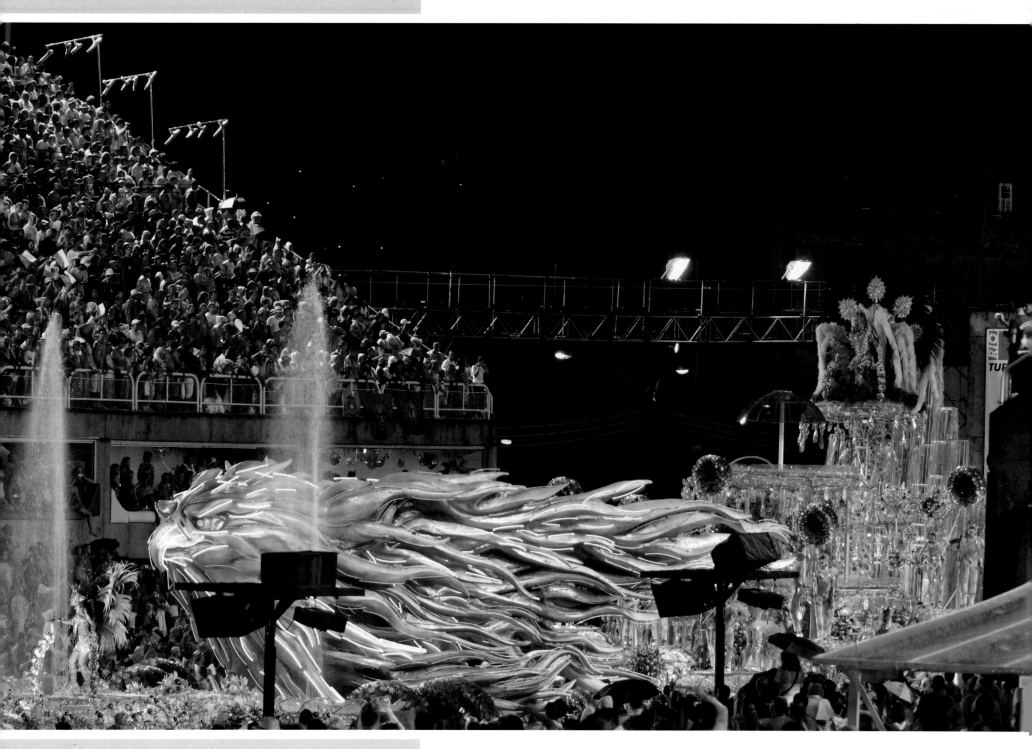

📷 TIP

Night photography can be very rewarding but has its own special rules.
Due to the lack of light your images can often be blurred or out of focus.
Use a support to steady your camera, tripod, bean bag or monopod.

Everything stops in Rio at this time of year due to the 500,000 visitors for the Carnival. It's not like any other carnival and the main event is the famous Samba Parade. This is held in the Sambadrome and not on the city's streets. The stadium has open ends through which the dancers and floats of each different samba school pass for approximately an hour. It starts at 9 pm and ends early in the morning - another tick off my bucket list.

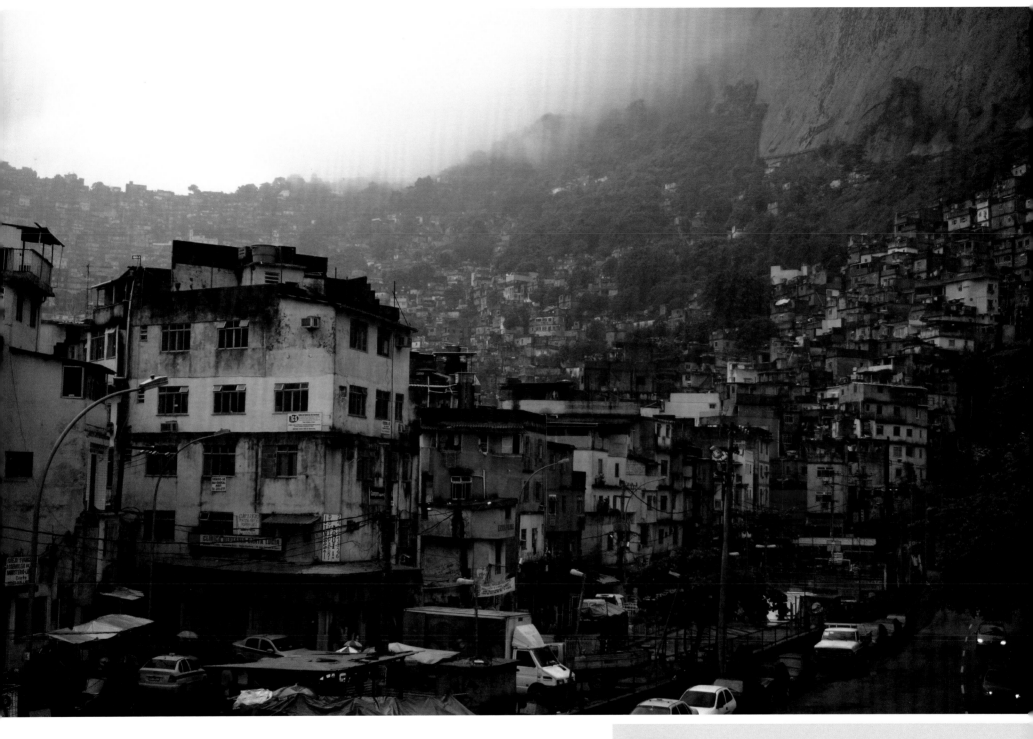

Favelas is a Portuguese word for 'shanty town', of which many of the most infamous are in Rio de Janeiro. In Rio, one in four people lives in a Favelas. They were formed by refugees and former soldiers involved in the Canudos Civil War in Bahia. The most famous town is on Morro da Providencia - Providence Hill.

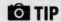 **TIP**
Be wary of where you are taking your camera, and go on organised tours.

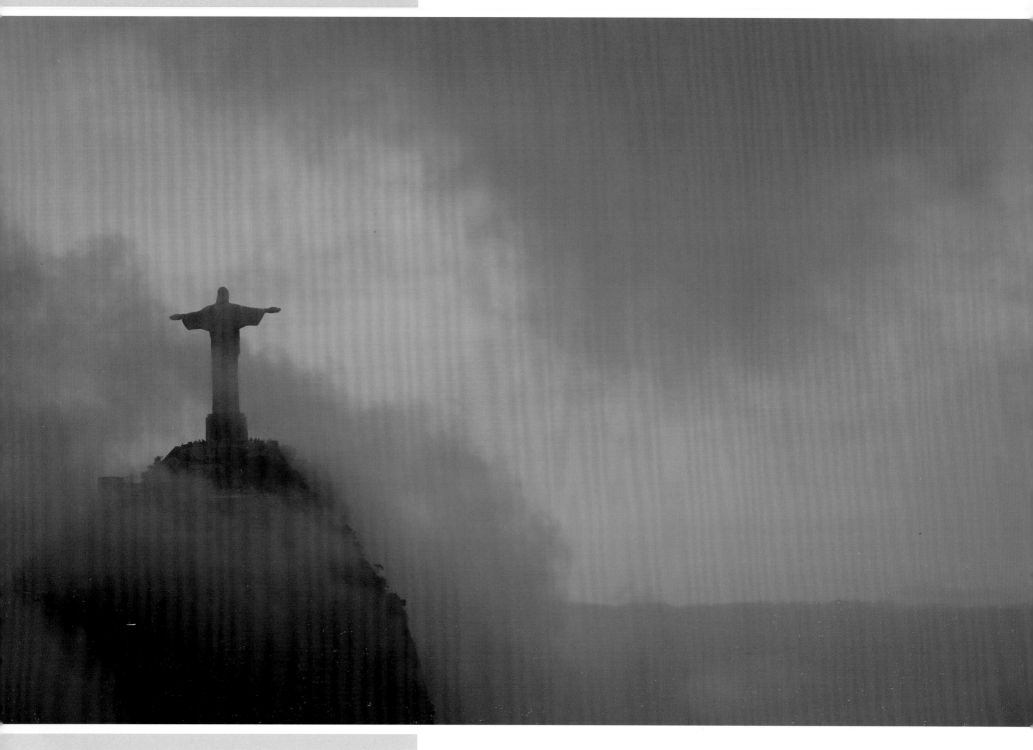

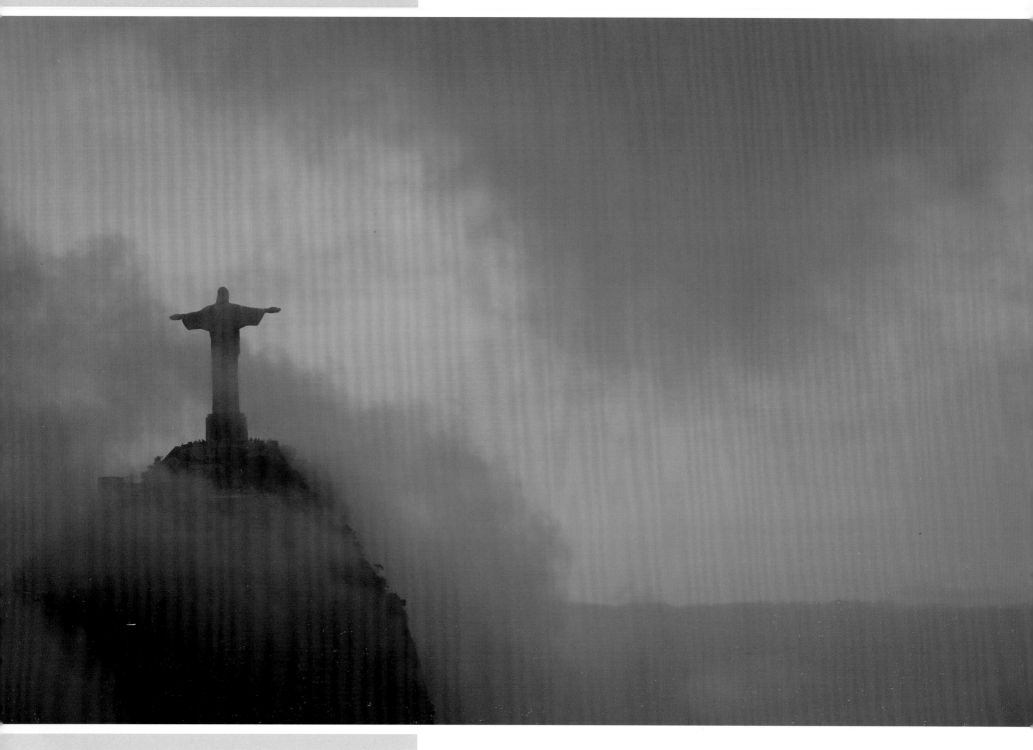 **TIP**

The secret of photographing a famous landmark is to capture the image from a unique perspective. This photo was taken with a telephoto lens from an adjacent hillside in low cloud.

Christ the Redeemer is the famous statue overlooking Rio de Janeiro - a Christian icon, the statue has become a symbol of Rio and Brazil. So familiar is this sight, that one shot of it in a film is sufficient to establish the setting as Rio.

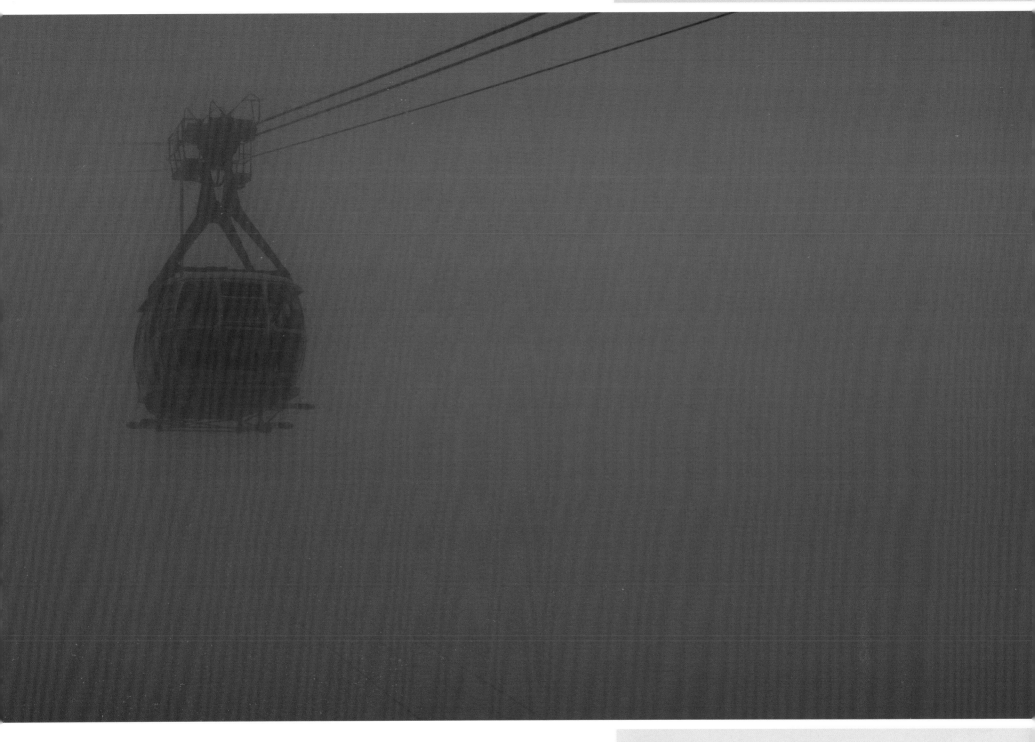

The Sugar Loaf Mountain is a large granite and quartz rock that rises from the water's edge, giving spectacular views of the city of Rio. To get to the top you use the famous cable cars.

 TIP

Keep an open mind. Though I couldn't get the photograph I wanted of the city, the image of a cable car coming out of the fog inspired me, 'a land that time forgot'.

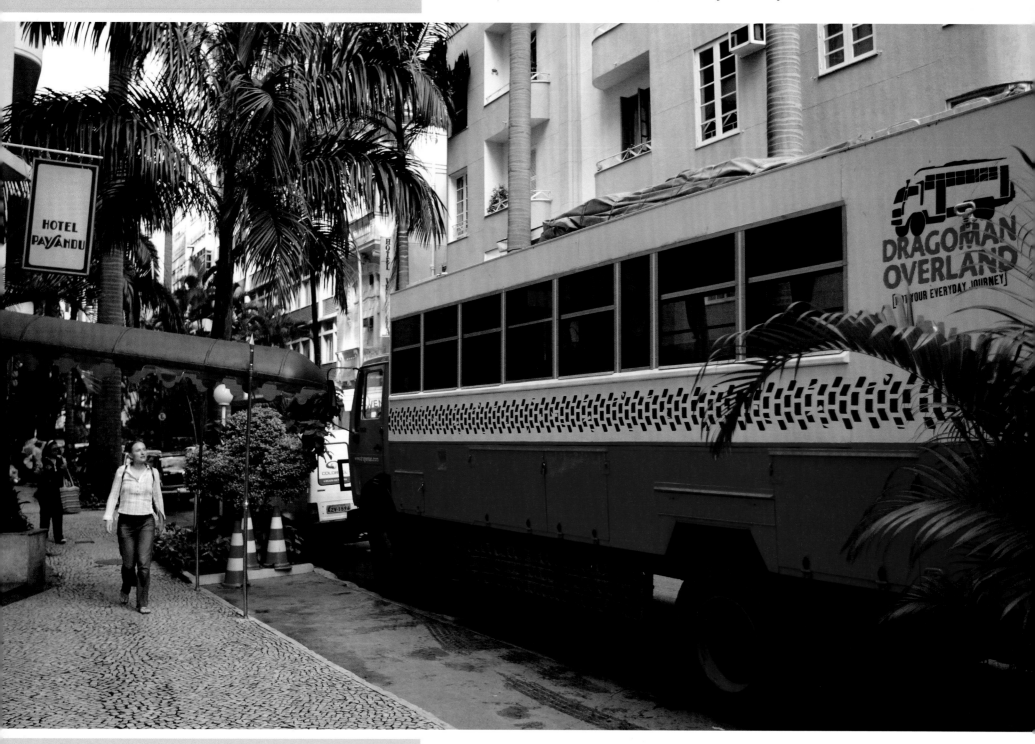

📷 **TIP**

Record every aspect of your trip, you don't get to repeat it.

My home for the next 57 days, along with 27 other people, this was an adventure itself. So come aboard the overland truck and join me as I journey through five countries, travelling thousands of miles and seeing some of the wonders of South America.

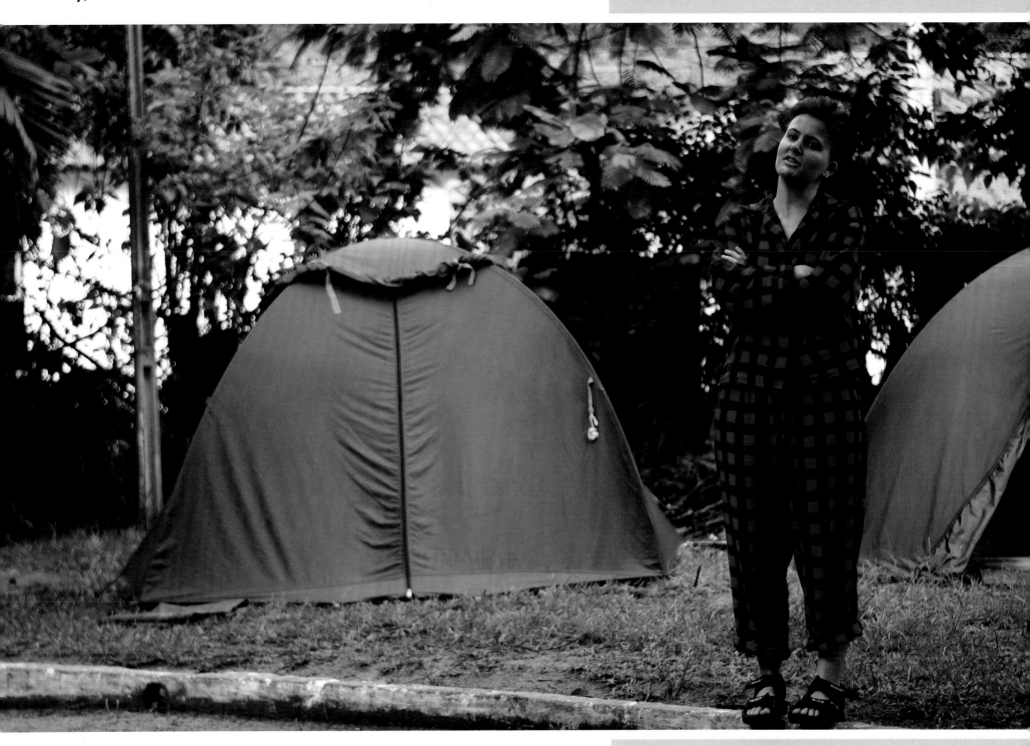

We arrived in Paraty and managed to set up the tents before it started raining. Sleeping in a tent with no home comforts, heavy rain all night, snoring neighbours (I'm sorry) and very few amenities was a new experience for many. Some people wondered what they had got themselves into. 'Phil put the camera down and cook the group's breakfast!'- a lesson in how to get along with others.

📷 TIP

When photographing people please ask for their permission. Expressions on a person's face will establish the mood of the photograph - as you could see Tara was not happy.

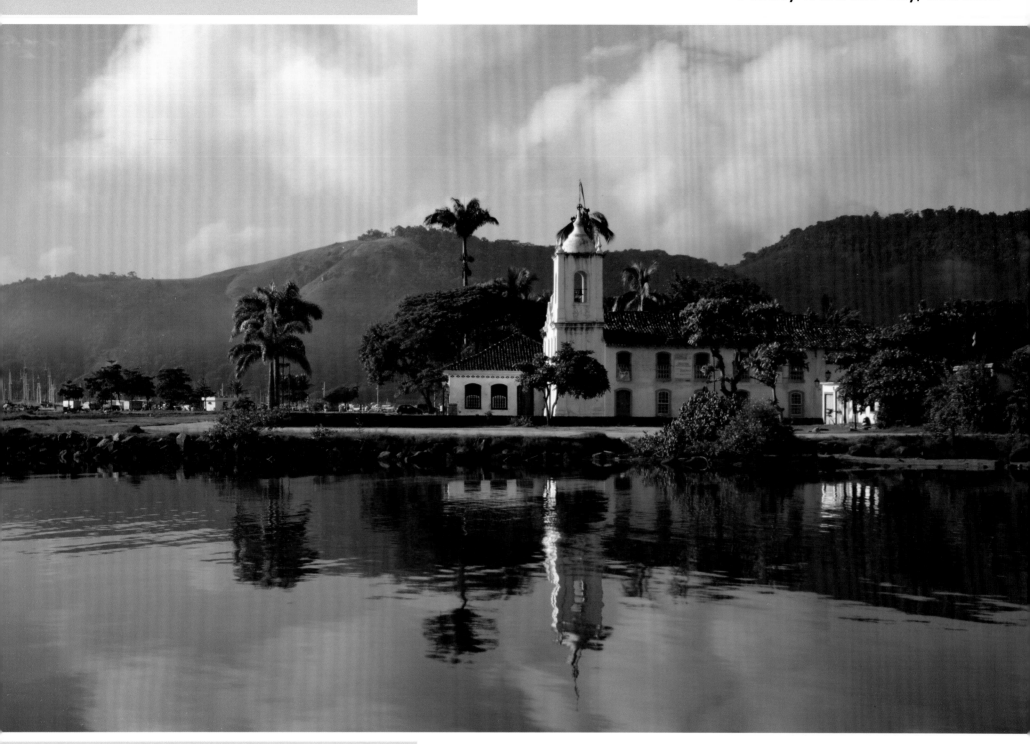

📷 TIP

Get up and about early and capture reflections before they are disturbed by the hustle and bustle of life.

Paraty is located on the Costa Verde and is surrounded by mountains and tropical forests. It is full of charm, with cobblestoned streets, whitewashed buildings and horses and carts as no cars are allowed in the city (apart from on Wednesdays for deliveries). At high tide the sea comes in and washes the streets clean.

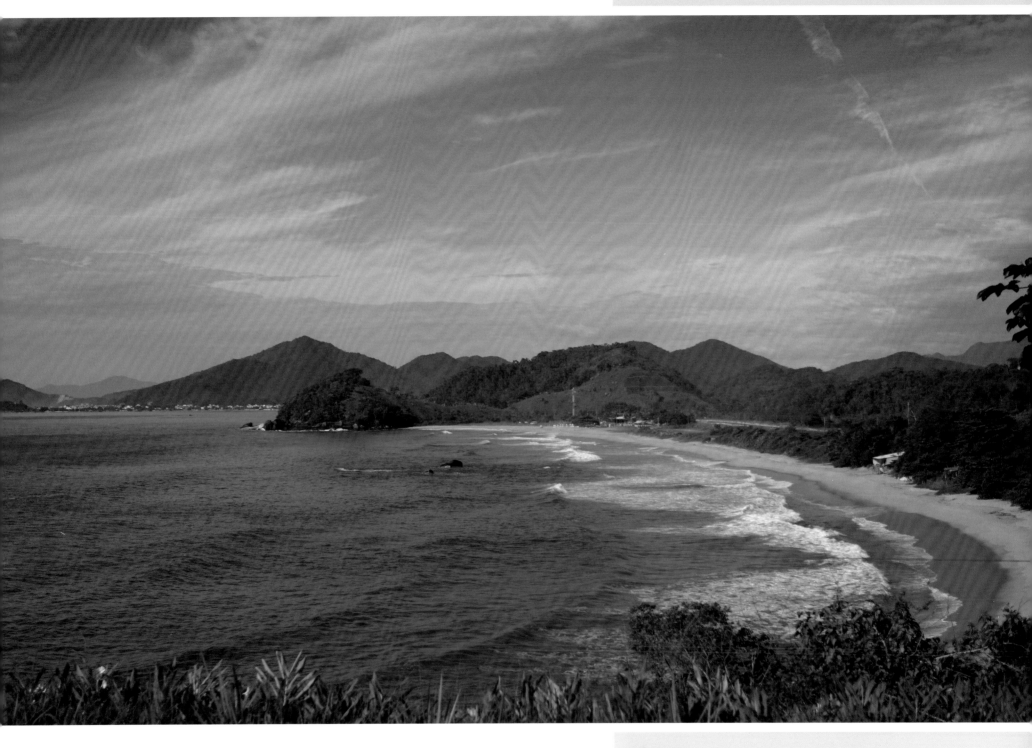

The Gold Coast of Brazil with its sandy beaches and high waves is a surfer's paradise. Trindade, with its seven fantastic beaches, is a very popular destination. This image of Trindade beach was captured as we travelled through. No time for a swim or a surf!

 TIP

Images with no dramatic lighting need to be balanced by movement and shape to create a better picture.

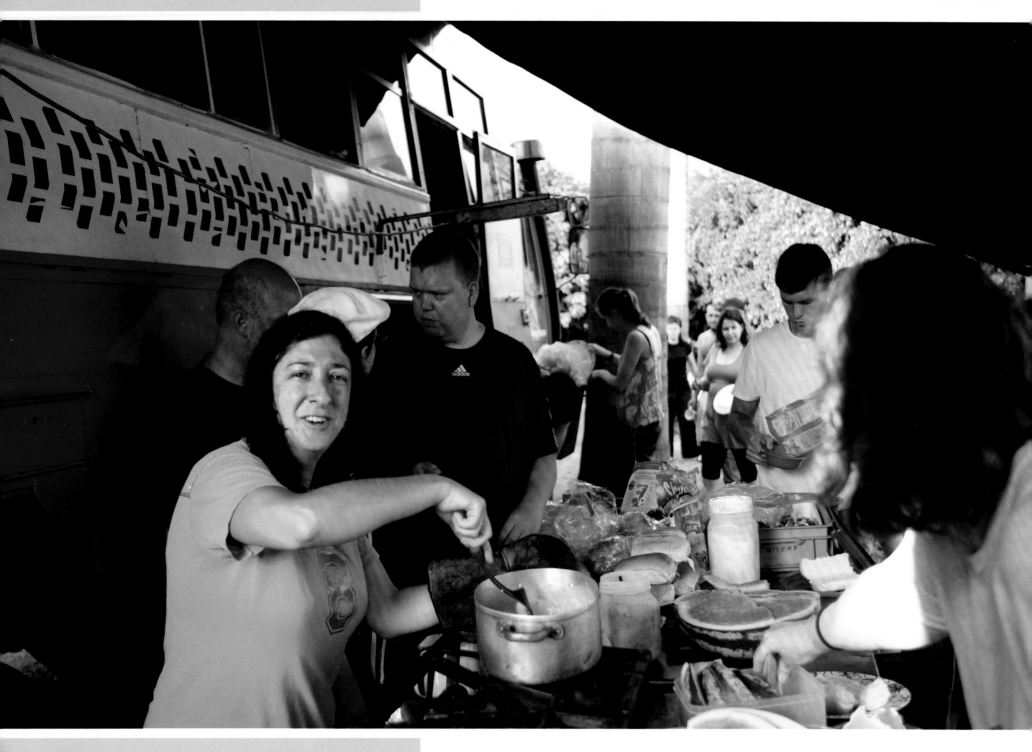

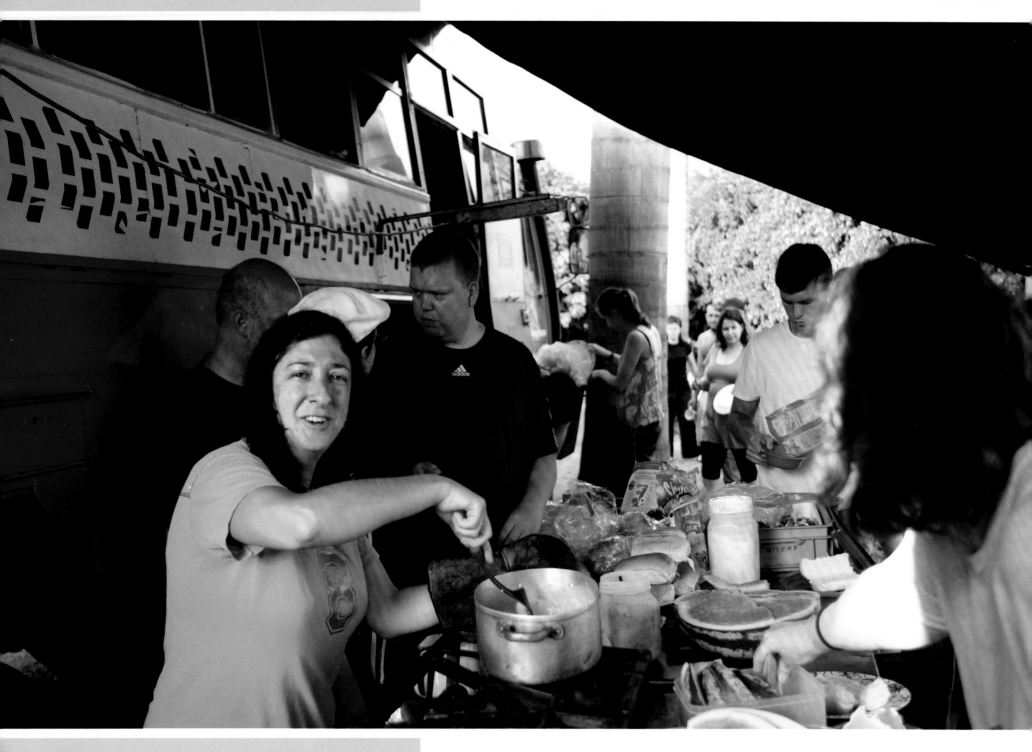 TIP

Catch their attention. It is important to get the person you are photographing to look at the camera in a natural way – this can be done by whistling or calling. If Clara was looking away, do you think the photograph would work?

Stayed at Brotas as our overnight stop before travelling to the Pantanal, the largest freshwater wetland in the world. Overlanding is all about teamwork, meeting new friends from all over the world and travelling together. We were split into groups and had a daily budget for the meals we cooked.

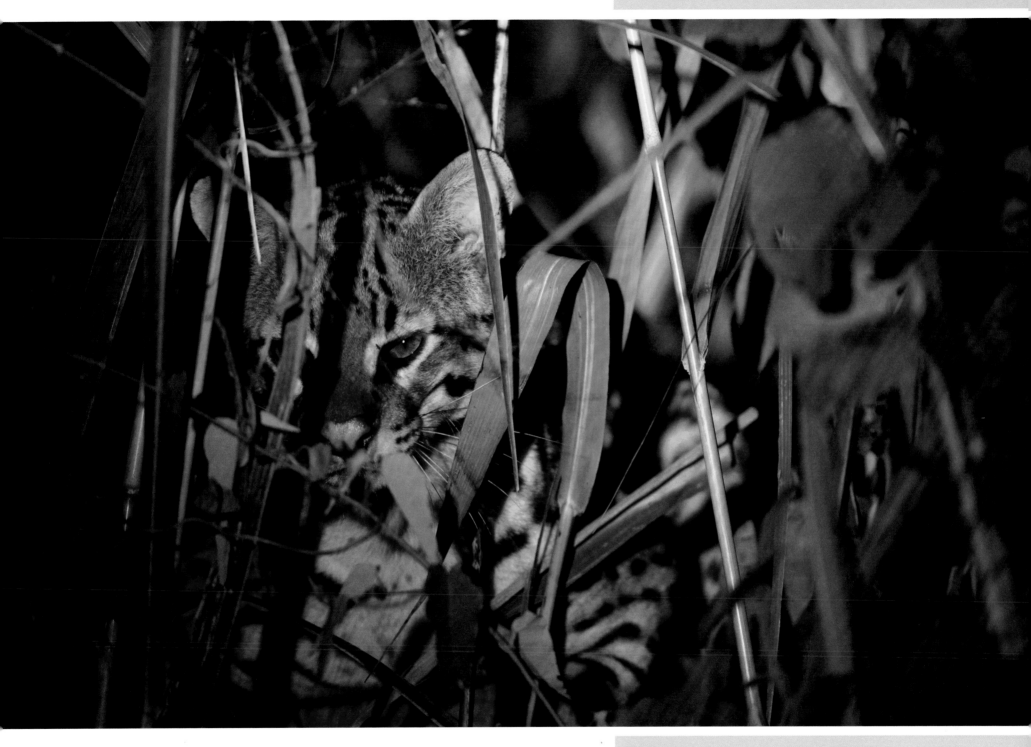

At Pantanal we stayed at the San Francisco Ranch.This is home to the first jaguar project in Brazil. We arrived in the afternoon and had time to relax and eat a lovely meal before our night drive to spot a jaguar. We didn't see a jaguar – but an ocelot sighting made it very special for me.

📷 TIP

The vehicle on this night drive had a spotlight for us to see the local wildlife. This obviously gave better light than a camera flash, but can cause distress to wildlife if focussed on them for a long time. I used a beanbag to support my long lens, reducing camera shake, and a high ISO gave me the exposure I needed to capture this image.

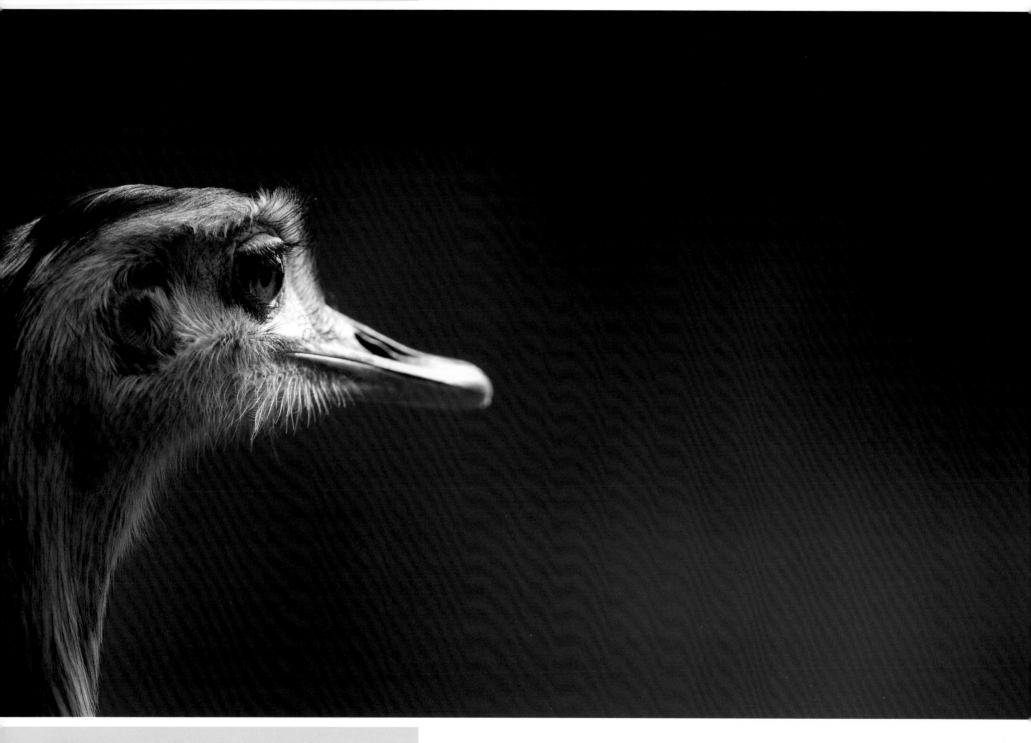

📷 TIP

Make sure you have the correct depth of field for your subject. The image here shows the depth of field was one or two stops out as the rhea's beak is not sharp compared to the eye. By increasing the f stop everything would be in focus including the background. You have to make decisions on what is important in the photograph. The eye should always be in focus.

The Pantanal is a seasonally flooded plain fed by the tributaries of the Paraguay River. At 68,000 sq miles it is almost ten times the size of the Florida Everglades. Over 650 bird species live here, the majority of which are native to the Pantanal. The icing on the cake for me was seeing three other mammals I had never seen in the wild before: an ocelot, a giant anteater and a giant river otter.

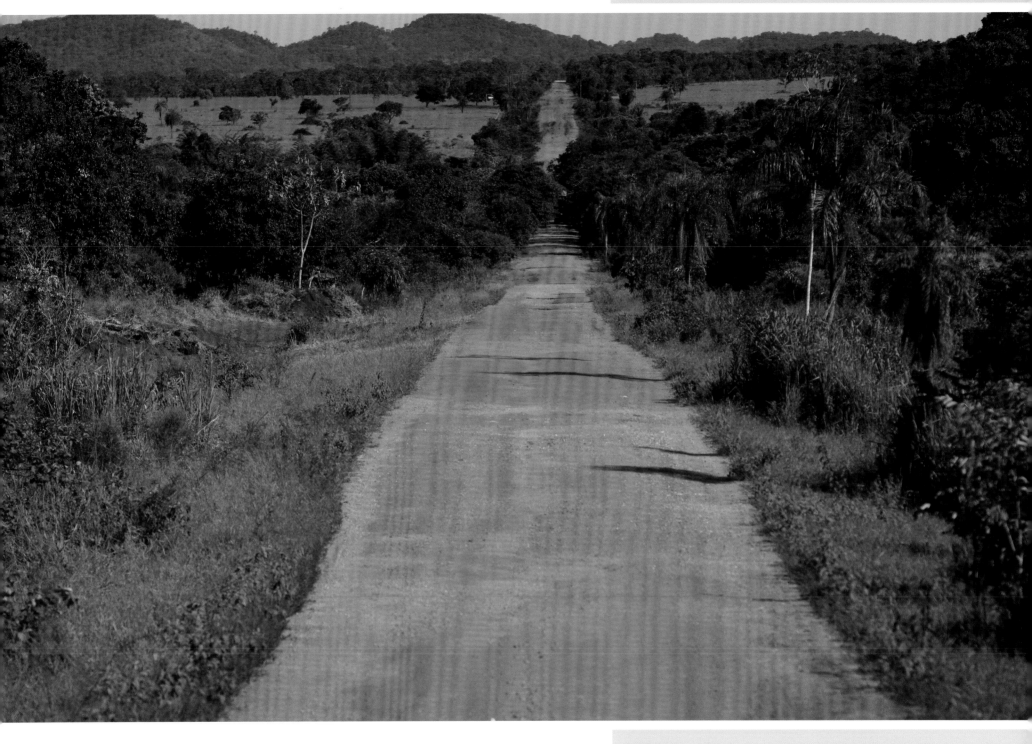

The long dusty road to Bonito forms a copper line between the rich farmland on either side. This was the only time that we could sit on the top of the truck - which was called 'Carmen' by the way.

📷 **TIP**
Strong leading lines draw the eye into this image. Being taken from a higher focal point (the top of the truck) has also given the photograph a deeper perspective.

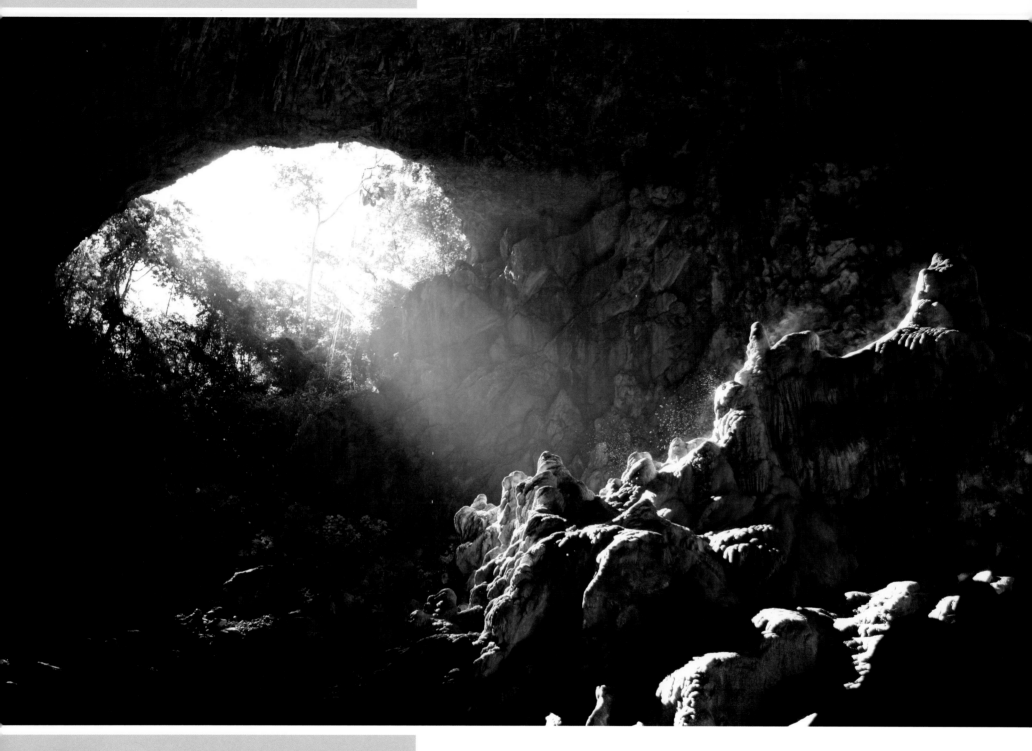

📷 TIP
Always look around to see if there is a better image. I couldn't get the Blue Lake itself but looking up I saw water bouncing off the stalagmites and light shining into the cave.

The Gruta do Lago Azul - the Blue Lake Cave - is one of the most beautiful and best known caves in Brazil. You walk down into the cave between stalagmites and stalactites until you arrive at the spectacular and mysterious blue lake.

Bonito surprises everyone with its rivers of crystalline waters which attract tourists from all over the world. You can float down rivers looking at the fish, dive in deep lagoons and go to the waterfall park. It is also a hive for backpackers travelling through to Iguazú Falls and Argentina. I'm not the person in the photograph, but he knows who he is.

📷 **TIP**

Clarify where you are going - I thought I was being taken to see waterfalls to photograph and ended up at the waterfall park!

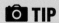 **TIP**
Never hurry a sunset, sometimes better images are achieved once the sun has set.

One of the drawbacks of overlanding is that sometimes you have to travel great distances between places. We left Bonito and travelled solidly for 48 hours to get to Foz do Iguaçu on the Brazilian Border. The highlight of the long day was the colourful sunset which 'brightened' up the day.

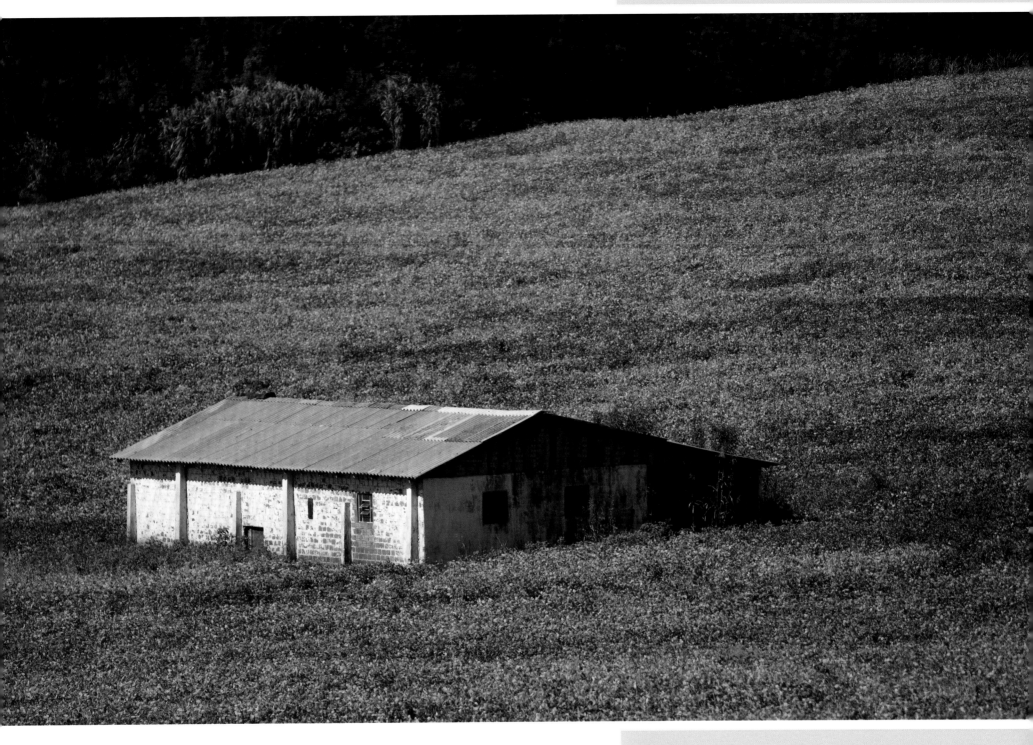

Travelling through the heart of Brazil's farmland was a huge contrast to the dusty streets and shanty towns of Rio. This image of the farm building surrounded by rapeseed is typical of the long road to Foz.

📷 TIP

Use your time wisely. Use travelling time to check your camera, clean your lenses, charge your batteries and keep up-to-date with your travel and photography notes.

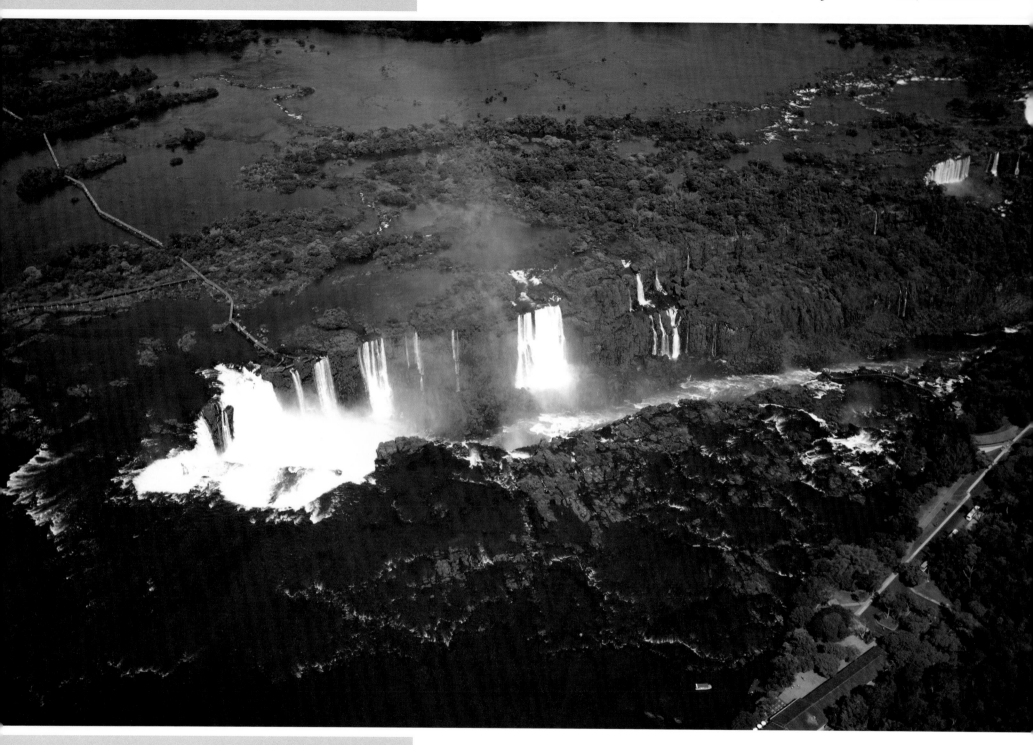

📷 TIP

Use different vantage points to achieve your 'once in a lifetime' image. To get this spectacular view, which helps to convey the size of the falls, I took a helicopter.

The Iguazú Falls, are one of the world's greatest waterfalls and one of the least known. They are more impressive than the Victoria and Niagara Falls. The waterfall system consists of 275 falls along 1.5 miles of the Iguazú River on the border of Brazil and Argentina.

In the morning we crossed the Border to approach the falls from the Argentine side. From here we could cross the falls on walkways and take a boat trip into the most famous of them, which is The Devil's Throat. The bonus at the end of the day was the lunar eclipse.

📷 **TIP**

To capture the moon use a long lens, a long exposure, cable release and a tripod. A cable release helps prevent movement when pressing the shutter button, creating or avoiding camera shake. This can also be helpful when photographing landscapes and whenever using long exposures.

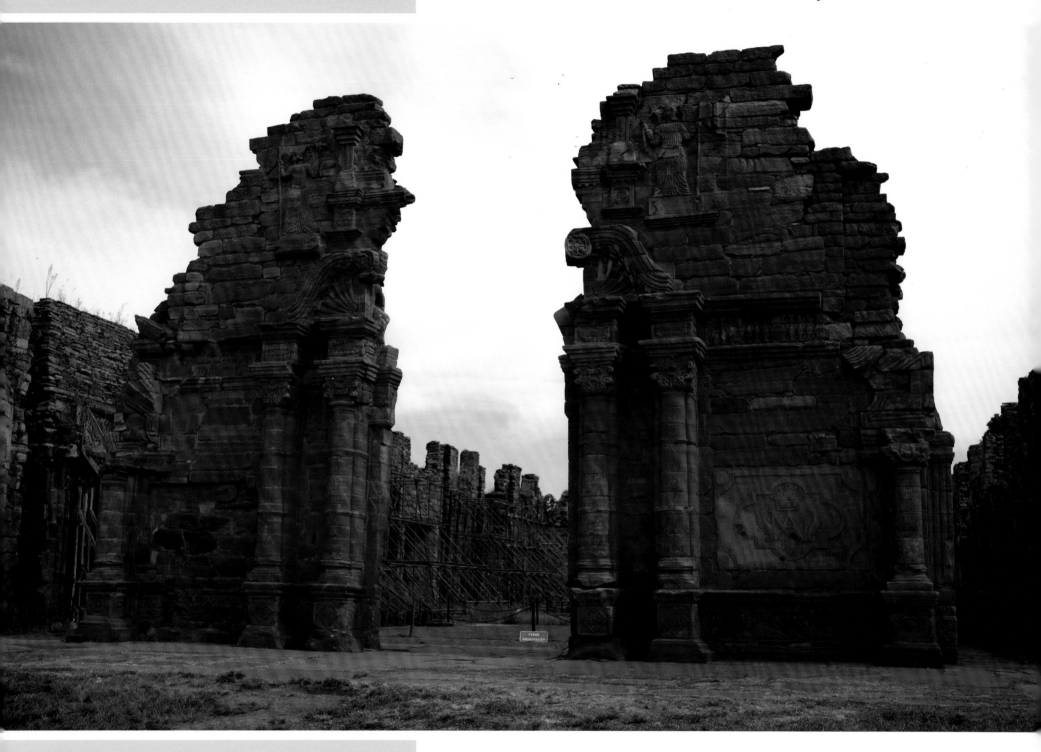

📷 **TIP**

Find the best angles. Try to make something more impressive than it looks. Good weather and blue skies would have helped. Scaffolding to support the structure should be avoided in your images if possible!

On the overland tour, we did our culture bit and went to the Ruinas de San-Ignacio – part of the legacy of the great empire built by the Companions of Jesus (Jesuits).

What a wet and horrible day - the first. The difference in wealth between Brazil and Argentina was very noticeable - everything from petrol stations to the way of life. I feel sure Argentina has a lot more to offer but the itinerary didn't give me the opportunity to experience it.

📷 **TIP**
Grey, gloomy days with poor subjects can sometimes be improved by using black and white, rather than coloured, images.

📷 TIP

Before photographing someone determine how you want the image to look. This image could have been taken in a portrait mode with just Nick's head in a shaft of light but it wouldn't have shown life on a truck or suited the style of the book! Even on a boring day a shaft of light can make a picture interesting.

Another long drive - to be honest that is all I can remember about this day! Most of us slept, played cards, or listened to music. Finally arrived at Salta.

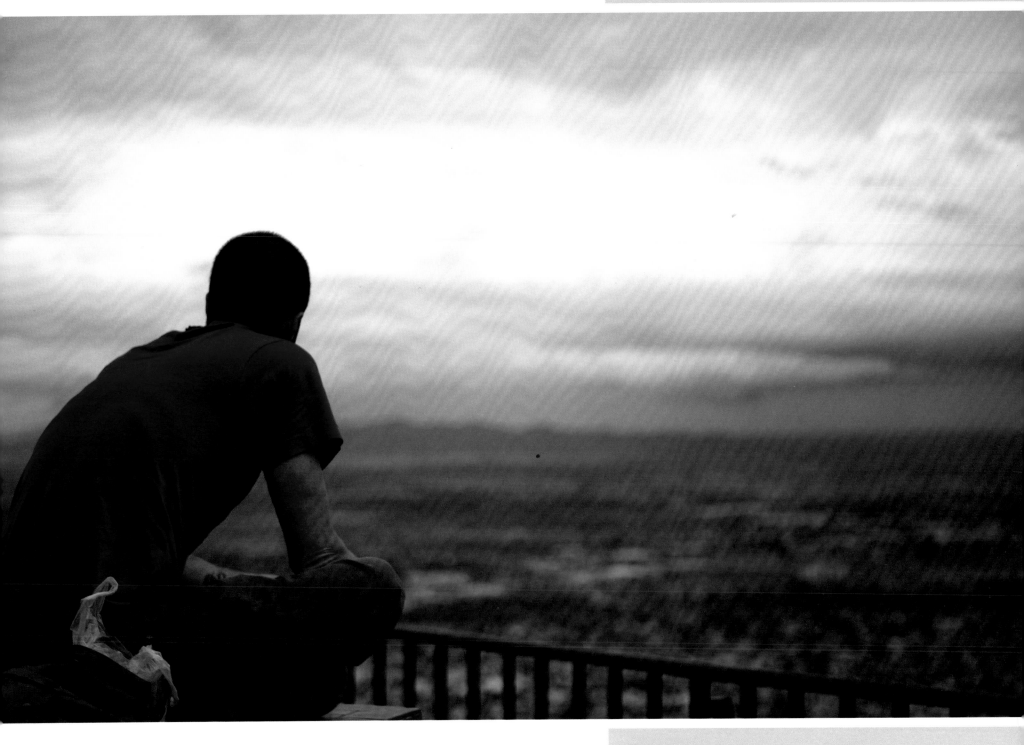

Salta is Argentina's eighth largest city. It has a wonderful cathedral, which unfortunately was closed when we arrived - this just about summed up my trip across Argentina. Took the cable car to San Bernardo Hill where I photographed this traveller deep in thought as he overlooked the city.

📷 **TIP**
You don't need a face to make a picture or to tell a story. How the person is dressed and what he is doing will often do this - look for images that give your photography a different aspect.

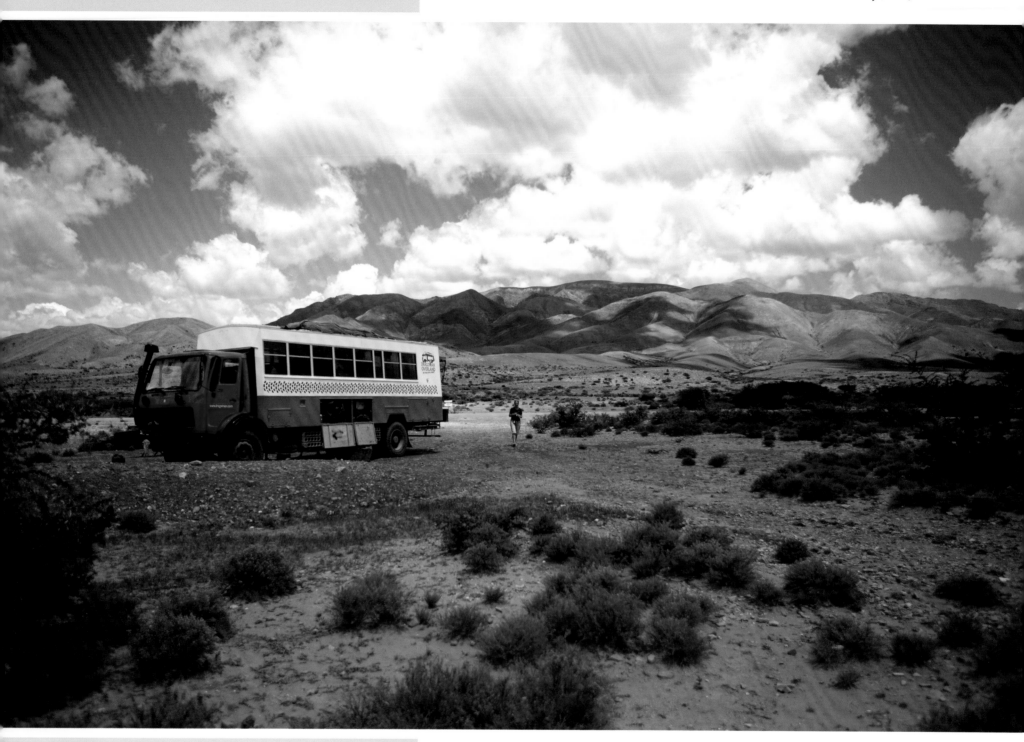

📷 TIP

Record images – shots of everyday events can be used for slide shows, talks and presentations.

We crossed another border into Bolivia and travelled along with the Andes Mountains as a backdrop. When we arrived at Tupiza the sun was setting on the red escarpments, but due to the road conditions we could not stop for photography.

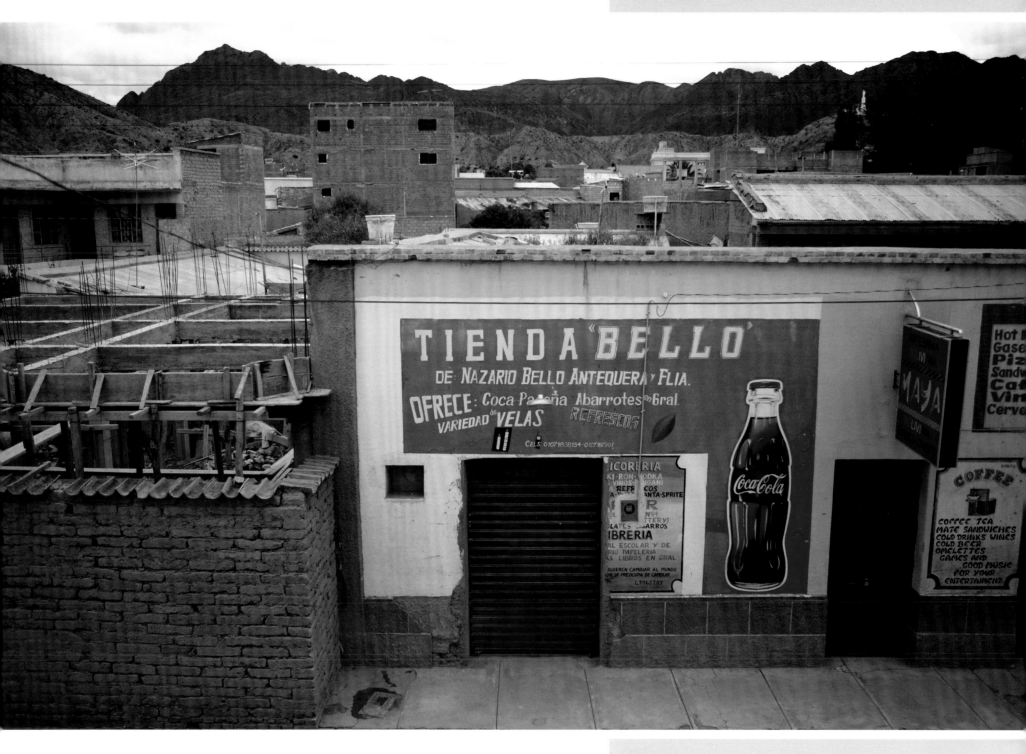

We arrived in Tupiza to find the locals having a strike over bad road conditions and the government. Blockades prevented anyone from leaving the town, so we could not go on any of the planned tours. Tupiza is famous for the death of Butch Cassidy and the Sundance Kid at the hands of the Bolivian Army. Again, I could not capture images of the red escarpments which soar ruggedly skyward.

📷 **TIP**

Look for the unexpected i.e. this Coca-Cola advertisement, taken on a disappointing day for photography, due to conditions beyond my control. If this is the case don't get 'blue' like I did.

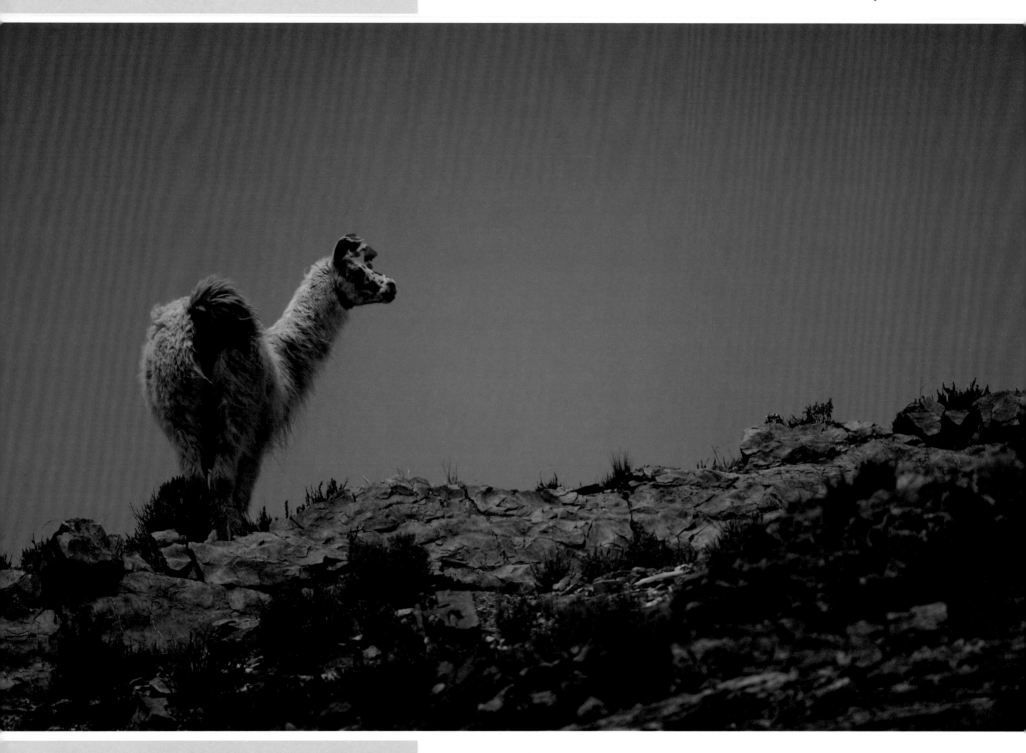

📷 TIP

Clear backgrounds offset wildlife in their natural environment to best advantage. Due to the lama looking into the picture and being on a third, this image has more impact than it would have had placed centrally. These images are also very saleable as they can be used for a number of purposes.

Managed to leave Tupiza on time despite the local strike and continued on our journey to Uyuni through the Andes Mountains. Captured an image that I had always had in my head of a South American llama. Arrived in Uyuni in the late afternoon.

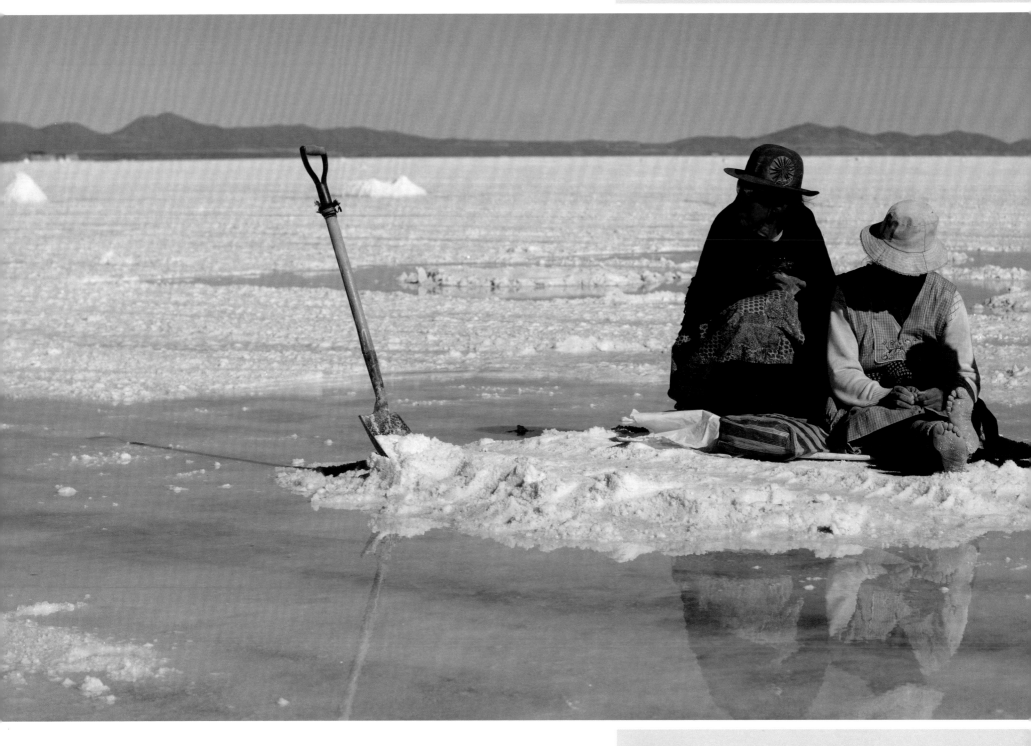

Uyuni, in the south of Bolivia, is famous for the world's largest salt flats. The workers get paid very little for collecting salt, and we provided them with sunglasses to help prevent the blindness caused by the sun reflecting off the salt. The other interesting attraction in Uyuni is the train cemetery, which is filled with old rusty steam locomotives. Give generously to the local workers, when asking to take their photographs.

⊙ TIP

Under expose the whites by bracketing. This makes sure that one of your images will be exposed correctly without losing detail.

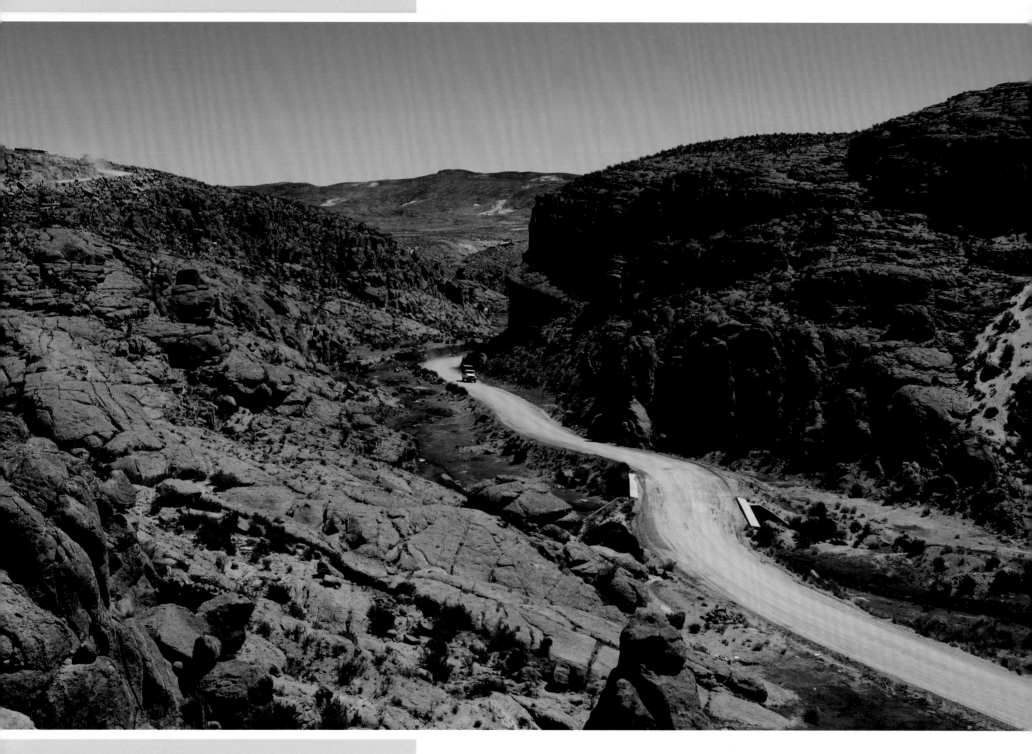

📷 TIP

A single leading line draws you into the centre of the image, whereas other leading lines take you through an image.

Potosi, the capital of Bolivia, is claimed to be the highest city in the world at 13,420 ft. It lies beneath the Cerro de Potosi – a mountain popularly believed to be made of silver ore, making this one of the richest cities in the sixteenth century. Travelling through the Andes Mountains by truck is hard going.

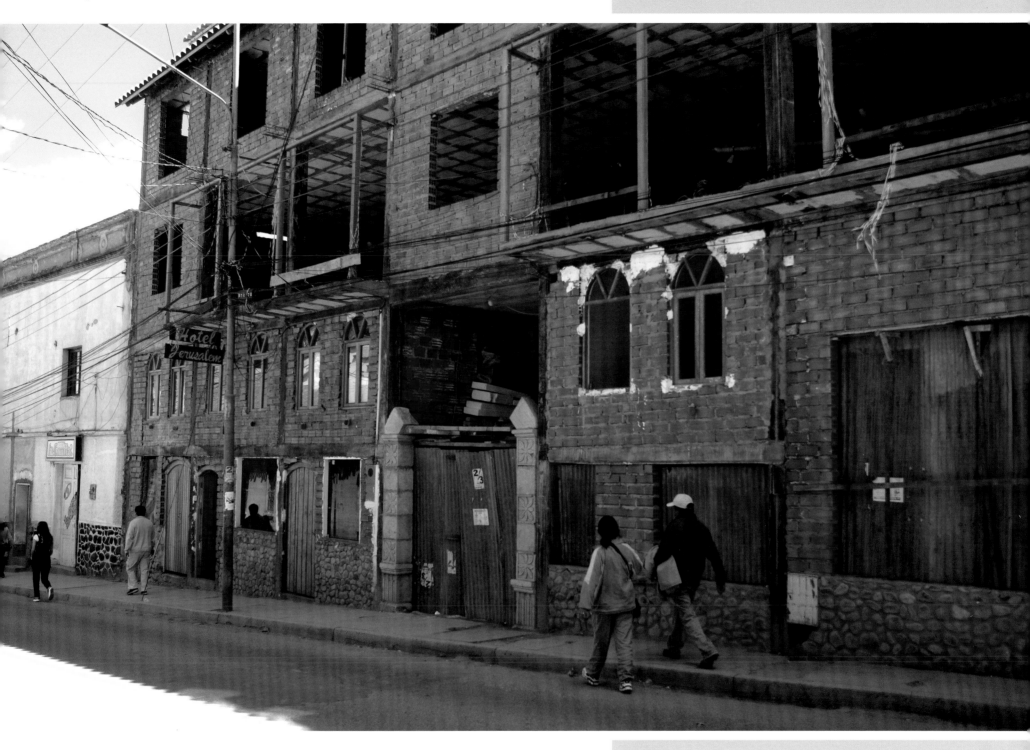

Potosi is not as rich a city as it was in the sixteenth century as you can tell by our hotel. We were only meant to be staying here for two nights – famous last words. Not every image tells an accurate story – though the hotel looks derelict from the outside, the rooms were actually clean and pleasant.

📷 TIP

This photograph is a record shot. When taking images of buildings it is best to wait for suitable light and weather – you may have to visit the building several times at different hours of the day to achieve best results.

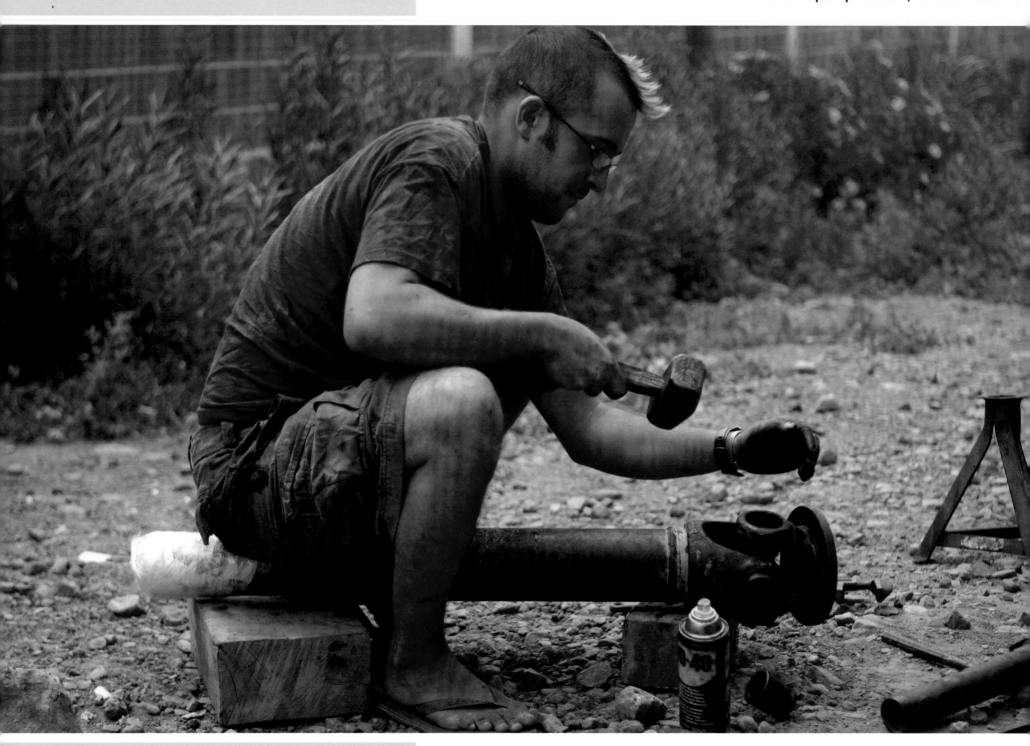

📷 TIP
Look for humour in your photography. A serious photograph can be changed by having unexpected elements within the frame.

Leaving Potosi the prop shaft went on our truck – Dave in the photograph is trying to fix it but without much luck. We get a taxi back to Potosi and stay another night – other members of the group make their own way to La Paz to do the most dangerous bike ride in the world – 'The Ride of Death'. Use the correct tools for the job. 'Dave … you can't mend a prop shaft with a hammer and WD40!'

The next day we leave Potosi to catch up with the rest of our group, assuming they have survived the bike ride. We stop in a local service station for refreshments including ice cream, and again pay the local inhabitants for allowing us to take photographs of them.

📷 TIP

Use flash to highlight facial features when photographing people, especially when in shadow. Do as I say and not as I do...

 TIP

Wherever you are you can still take an image that tells a story.

Expensive ice cream and the only time I was ill on the whole trip. If buying local foods, ensure you know their origins. I spent the next day recovering from my ordeal and missed out on a night show in La Paz on the 3rd and the city tour on the 4th. Not to be repeated.

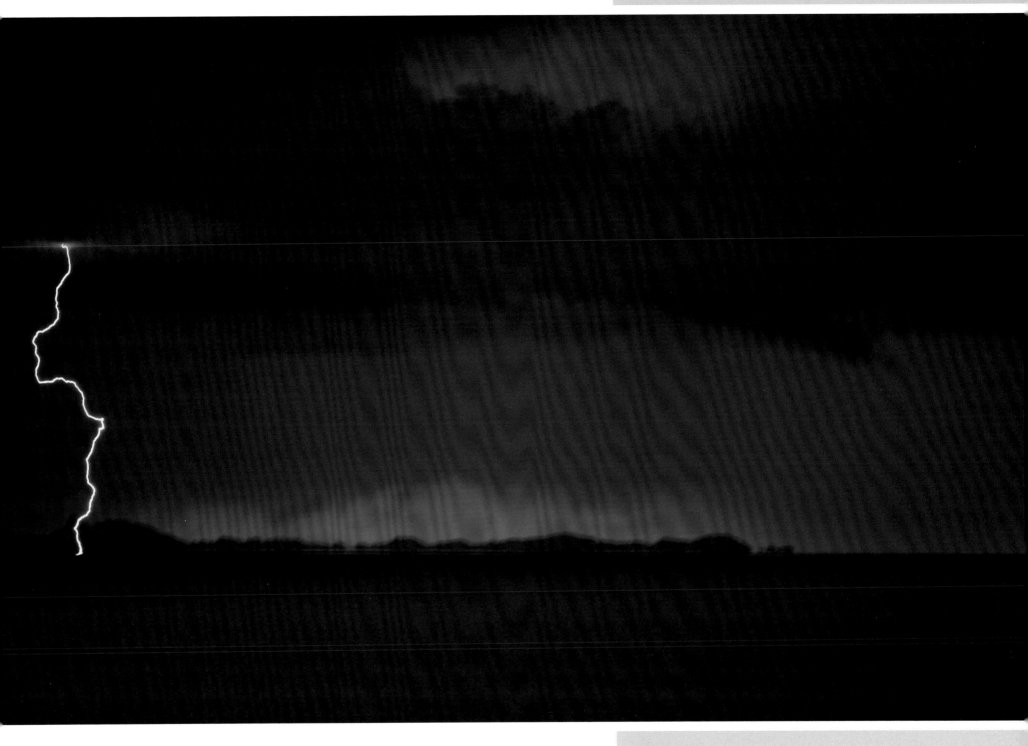

Lake Titicaca is on the border of Bolivia and Peru. It is 12,500 ft above sea level and is the largest lake in South America. There are several islands on the lake. From Copacabana you can go to the Isla del Sol (the Island of the Sun). The Incas believed that the Sun God was born here.

 TIP

A fast speed and continuous shooting ensured that I got the lightening strike over Lake Titicaca.

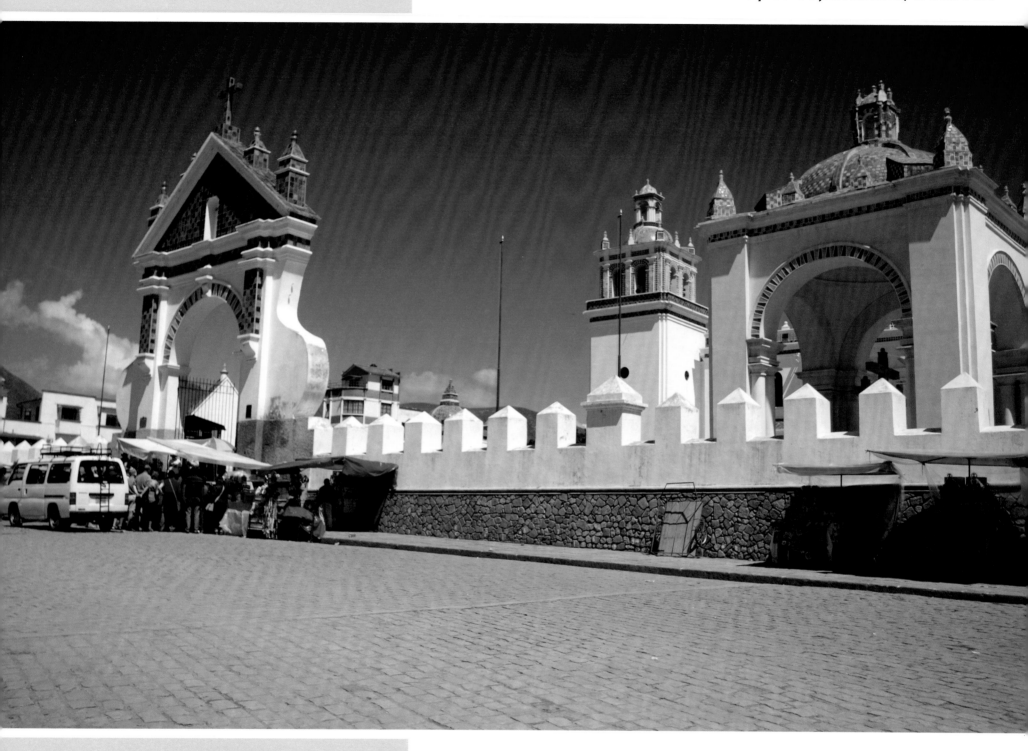

📷 TIP
For white buildings and bright sunlight underexpose your images by a third of an f stop ensuring you retain all detail.

Copacabana is the main tourist attraction for Bolivians as boats leave here for the Isla de Sol and its basilica, which is a sixteenth-century shrine to The Lady of Copacabana who is the patron saint of Bolivia. It is a pity I wasn't allowed to take photographs inside the basilica but it is important to respect the local customs.

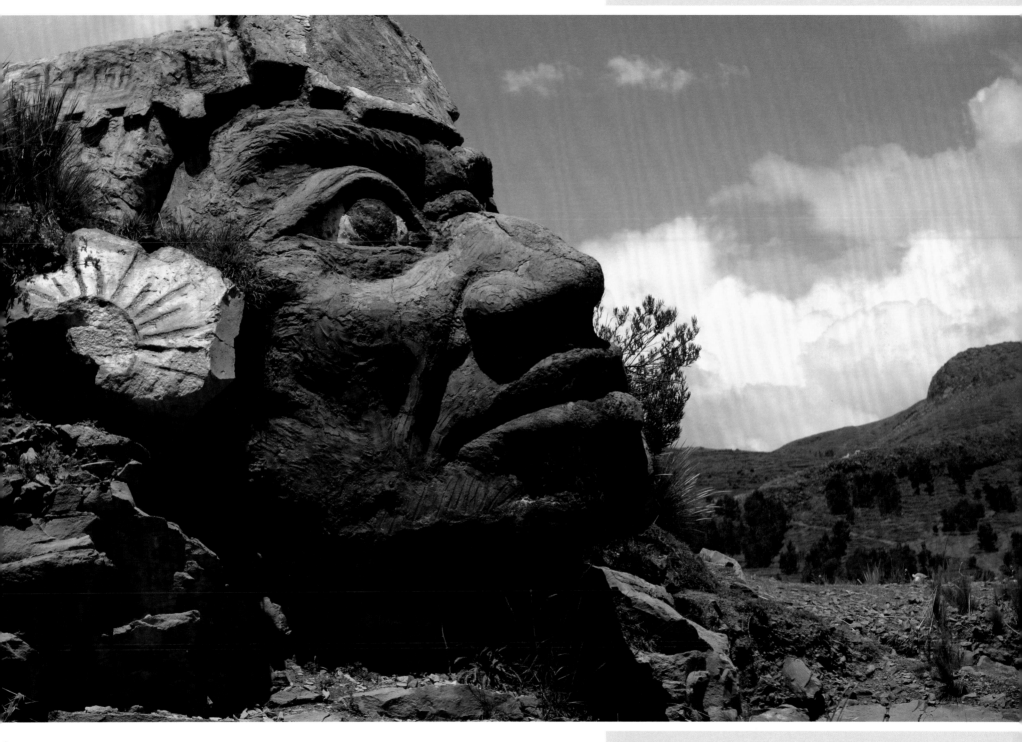

Peru, full of mystery and home of the Inca Empire from the fifteenth century – lots of 'ticks' for my 'bucket list', which includes: Machu Picchu, the Inca trail, the Nazca lines, Lake Titicaca and Colca Canyon.

◼ TIP

Local postcards used as a point of reference can be very helpful when it comes to finding landmarks to photograph, like this Inca statue on the way to Peru.

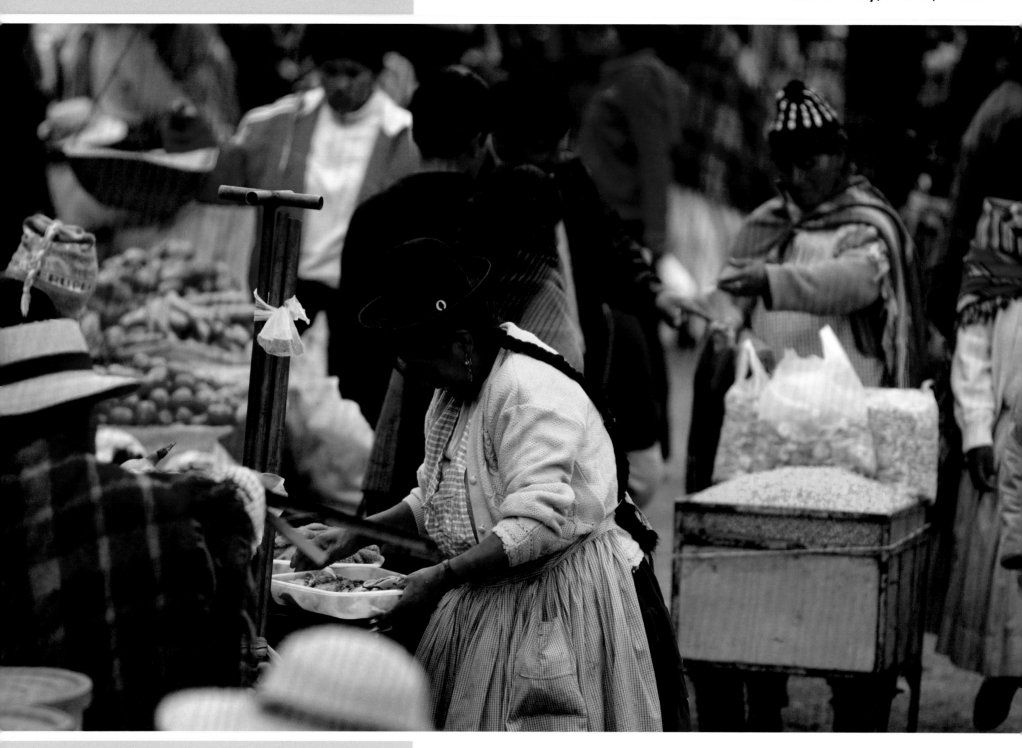

📷 **TIP**
Go to a market to see the local culture and customs – a good colourful photographic opportunity.

Puno, our first stop in Peru and home of the floating islands on Lake Titicaca. The Uros people live on these man-made islands and depend on the lake for survival and on the tourists who come to see how they live and buy their crafts. Their children however want to live a more modern lifestyle, so who knows if the Uros will still be here in 20 years time?

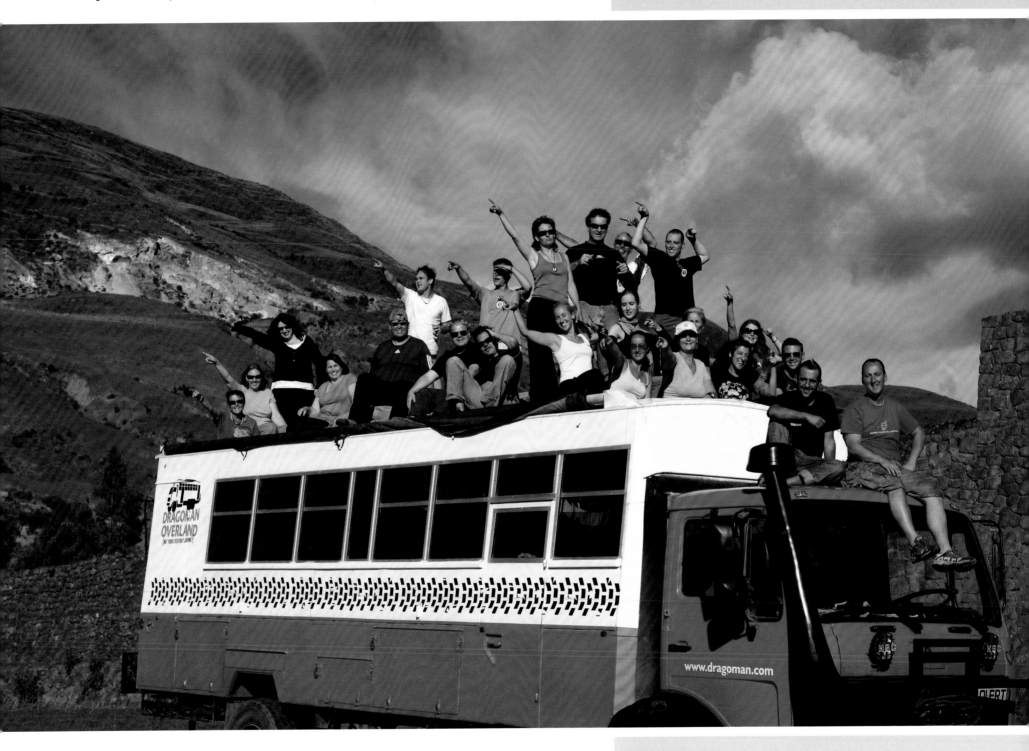

Cusco was the capital of the Incan people. We stopped at the old city gates and took group photos as some of our party were leaving after Machu Picchu. Being the only photographer meant I took this image 29 times!

📷 TIP

Photography is all about memories and a good depth of field. Good images are all about expressions and telling a story.

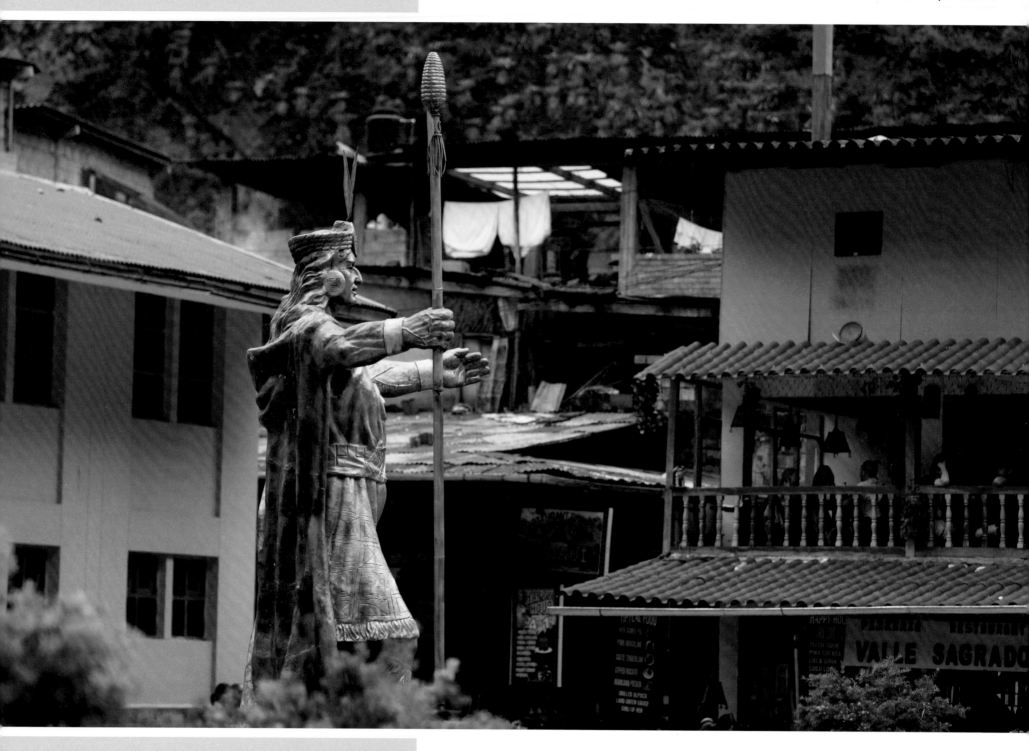

📷 TIP

Although this famous statue has been photographed many times, there is always a different way of looking at it. In my research I have always seen this statue with the blue sky and mountains behind it – I have taken it from the side view with the town's buildings surrounding it.

After arriving in Cusco and having our pre-talk about the Inca Trail I made the major decision not to walk the length of the Trail as it would only leave me half a day at Machu Picchu for photography. As this was one of the highlights of my trip, I arranged to go up on the train from Cusco to the town below Machu Picchu and meet the group when they arrived on the 14th.

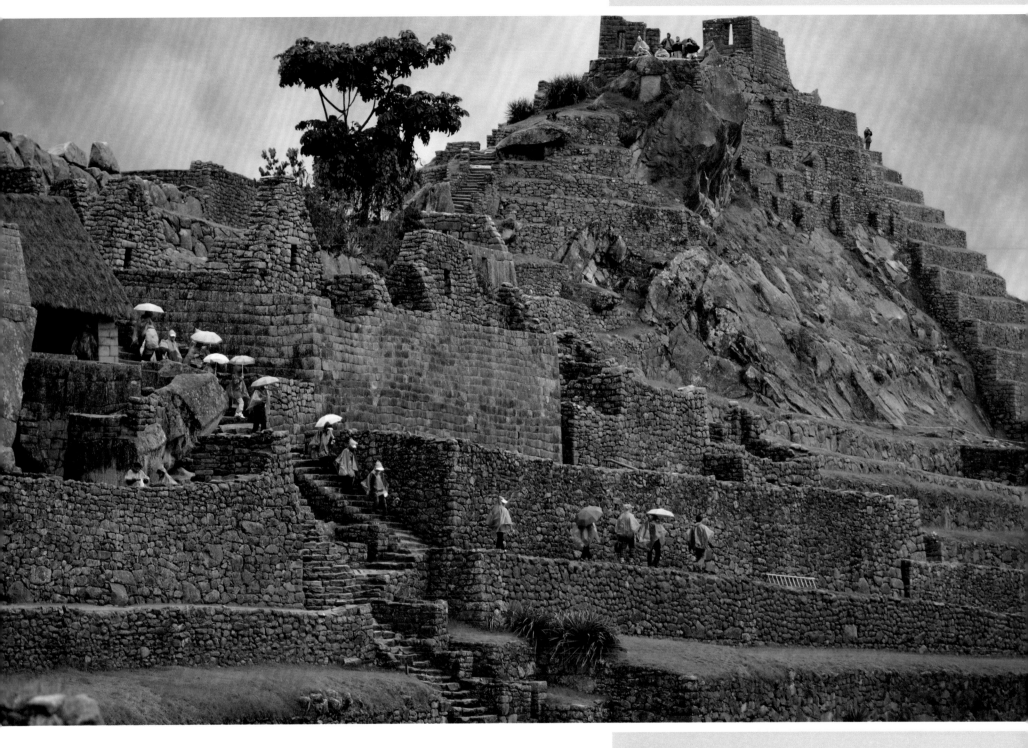

You can catch a coach up from the town at 5.30 am to Machu Picchu. By arriving early when the gates open at 6 am it means that the ruins are not covered by the thousands of tourists that come every day to view this magnificent sight.

📷 TIP

Arrive early to capture Machu Picchu both with and without people in your images. The light and shadows are stronger earlier in the day too for better definition.

📷 TIP

Check seasonal weather.

I wouldn't have chosen to come to this amazing place in the rainy season but I wanted to see the Rio Carnival and you can't always have everything! Staying in the Town is less expensive than at the hotel that has been built outside the ruins. You cannot see the ruins from the hotel or get into Machu Picchu any earlier - so there's no real advantage to staying there.

It rained and rained yesterday and today, and with the admission into Machu Picchu being expensive, going up and taking images in the wet is not worthwhile! One of the purposes of staying here was to take advantage of breaks in the weather to achieve my goals.

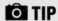 **TIP**

If you want that special image don't chance anything to the weather and the short time you might have on an organised tour.

📷 TIP

For group images, place people on a curve to ensure exact distances from the camera lens. Not possible here, on a mountain edge!

I was amazed to find my group at Machu Picchu in the early hours of the morning, having not expected to see them until lunchtime as they were hiking the Trail, some 7,500 ft above sea level. Their walk was washed out after a day and a half, making my decision to arrive early a good one.

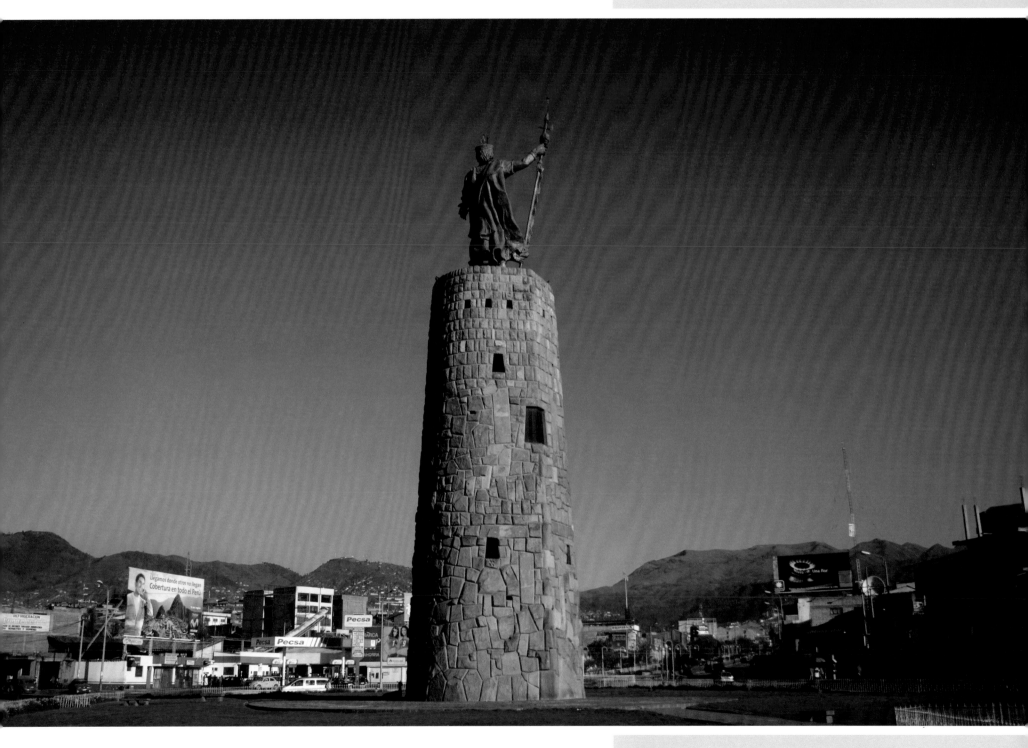

Cusco is not just the gateway to the Inca Trail and Machu Picchu. It is a World Heritage Site, capital of the Inca Empire and has over a million visitors a year. It has many splendid buildings, and you can try over 100 different varieties of potato in the restaurants!

 TIP

There are statues, monuments and architecture always available in every town. Have you photographed yours?

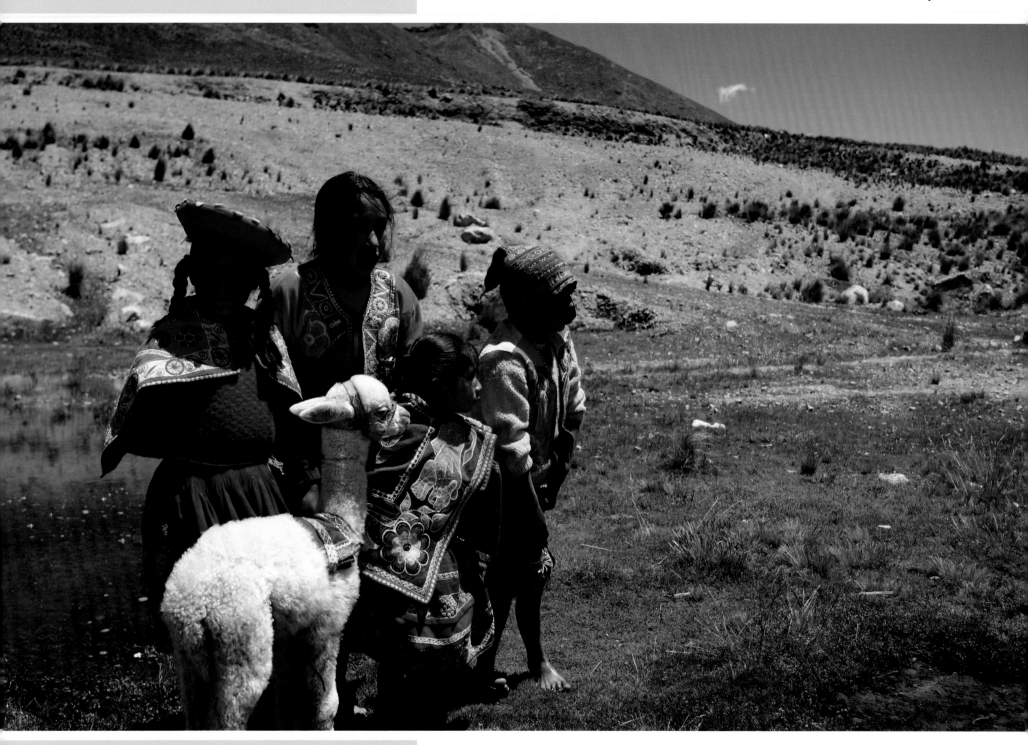

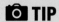 **TIP**
Small change or notes in the local currency is always handy to use as tips.

We leave in the morning to travel to the Colca Canyon near Chivay, having said our goodbyes to members of the group who are heading home. On the way we stop at many beauty spots and often find locals in national dress wanting tourists to take their picture for a small fee.

The Colca Canyon is more than twice as deep as the Grand Canyon, however its walls are not as vertical. Both can be seen easily from satellite images of the region. The Colca Canyon is home to the Andean condor. The best place to see the condors is at Cruz del Condor, especially in the early morning.

📷 **TIP**

Wildlife in its natural habitat offers a different perspective than a close up image where the landscape cannot be seen.

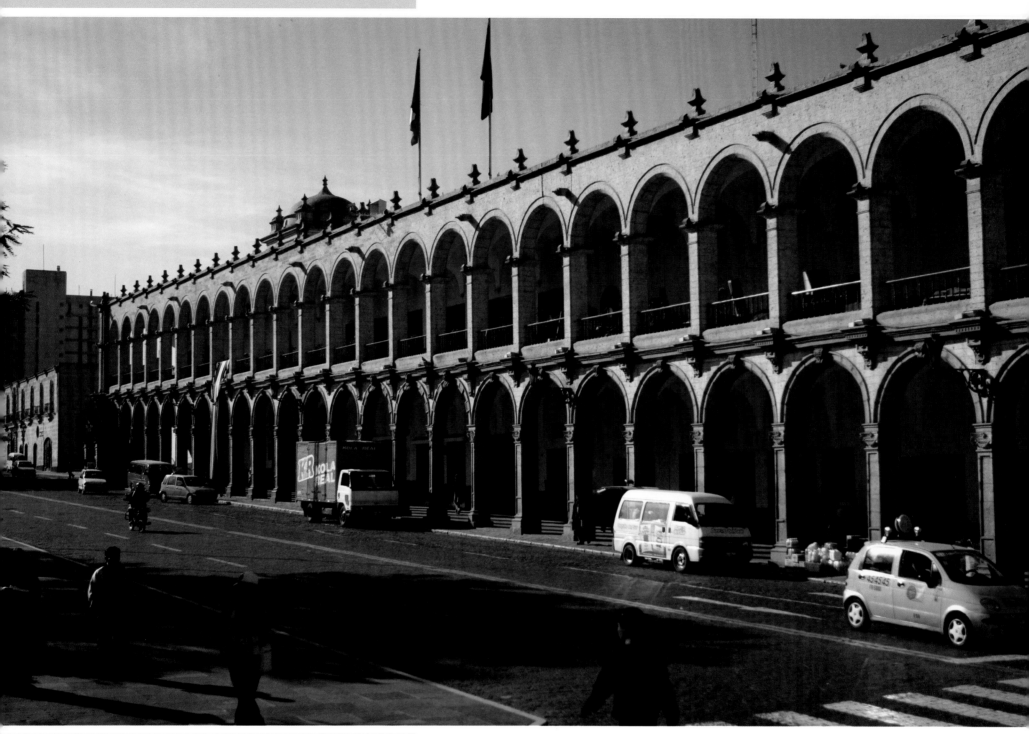

📷 TIP

Architectural images need to have strong verticals and a vanishing point – take care wide-angle lenses can distort verticals.

Arequipa lies in the Andes mountains, 7,800 ft above sea level. The city has been hit by earthquakes several times and became a World Heritage Site in 2000 in recognition of its architecture and history. Here guinea pigs can be found on the local menu served complete with head and feet.

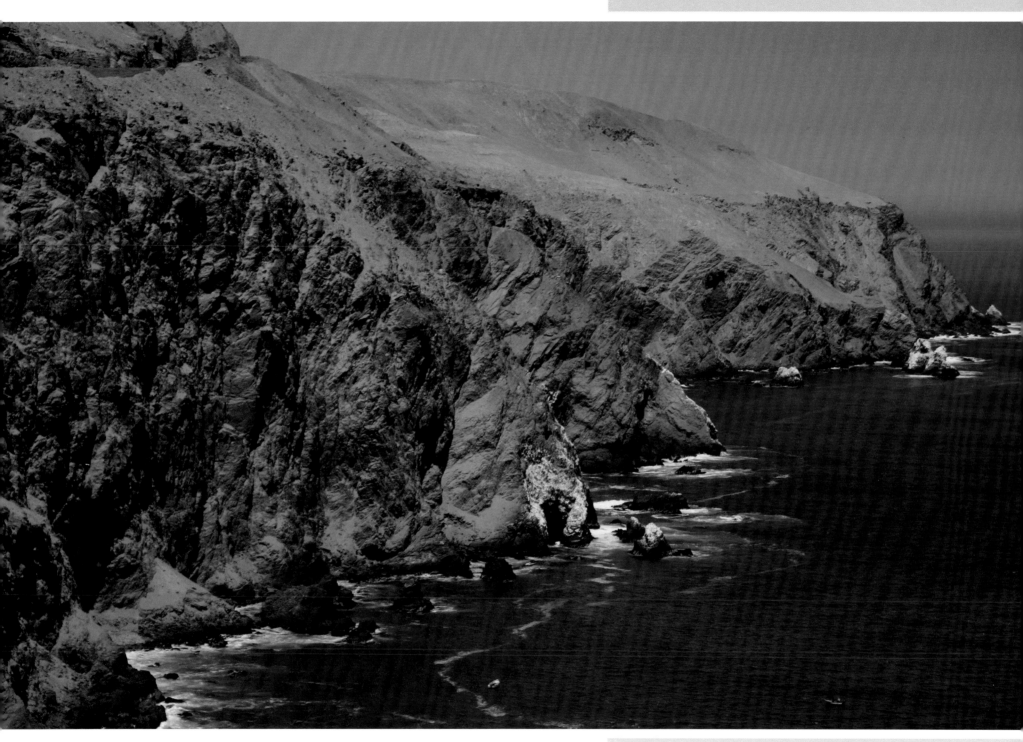

Travelling along the Peruvian coastline to the town of Nazca to see the Nazca Lines, another tick for my 'bucket list'. The Peruvian coastline is rather rugged, just like the roads that follow it. We saw at least two vehicles go off the road and down the cliff.

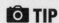 **TIP**
Choose a clear subject, simplify the image, fill the frame and you have an image with impact.

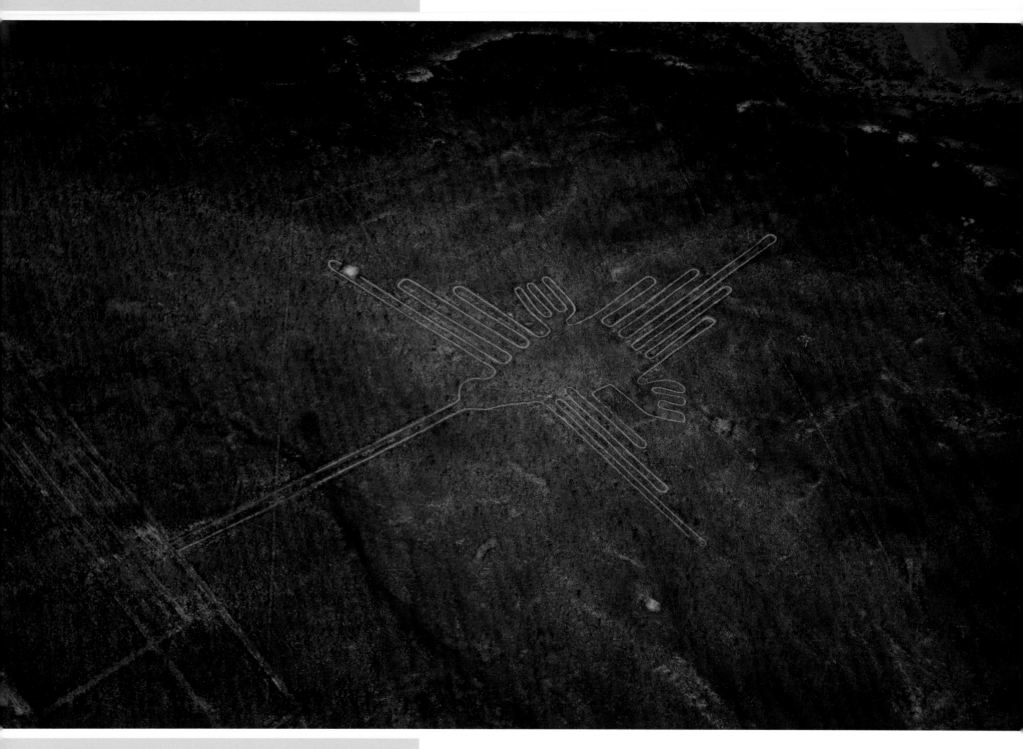

📷 **TIP**

Photography is all about confidence and knowing how to take difficult images under difficult circumstances. Sometimes there is only one opportunity – know your camera.

The Nazca Lines are a series of geoglyphs located in the Nazca Desert, which have intrigued me for years. You can only really see them from the air and a big thank you to Debs and Becky on the trip who held my hands as we took off. Right up until the last minute I didn't know if I could get into a small aircraft again after my plane crash in 2004.

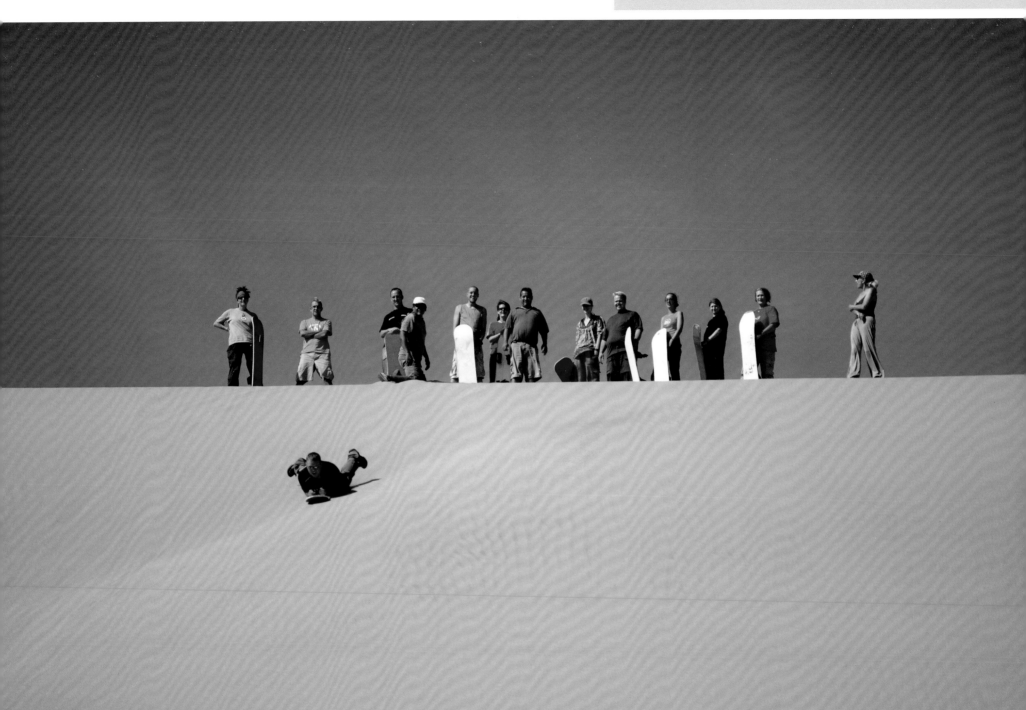

After travelling great distances over several days, it was good to have time out. Today we went sandboarding and dune buggying. This was great fun and certainly had a thrill factor with speed, mountain high dunes and an adrenalin rush.

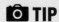 **TIP**
Make sure you have the correct lens on the camera body as 'dust and sand' are a major hazard to photographers.

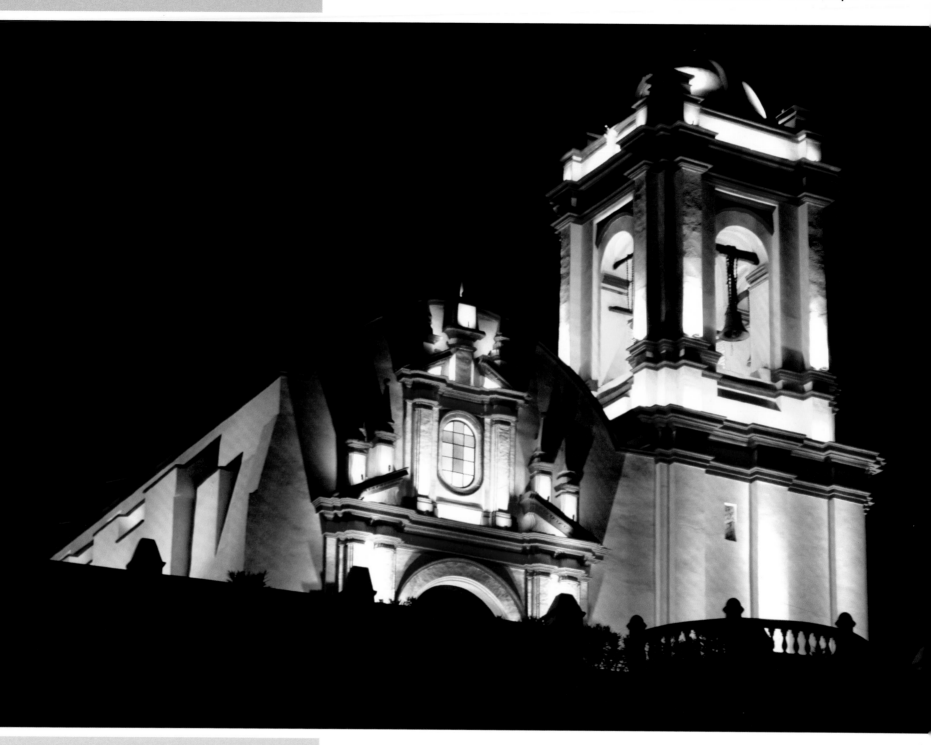

📷 **TIP**
Night photography needs a tripod, and a long slow shutter speed to achieve detail in the image.

Huanchaco is an ancient fishing village where the men go out to fish on their exquisitely crafted *caballitos de totora* – reed crafts with curved bows. The Huanchaco church was one of the first Christian churches in Peru and the bell tower has been a beacon for sailors for centuries.

Having visited the church at night I saw the cemetery next door with many crosses in its grounds. I decided to get up early for the morning light and went to see if I could capture a subtle image of peace and tranquillity in the early morning sunshine.

📷 TIP

Always look around you to see if there is another subject that you could photograph another day.

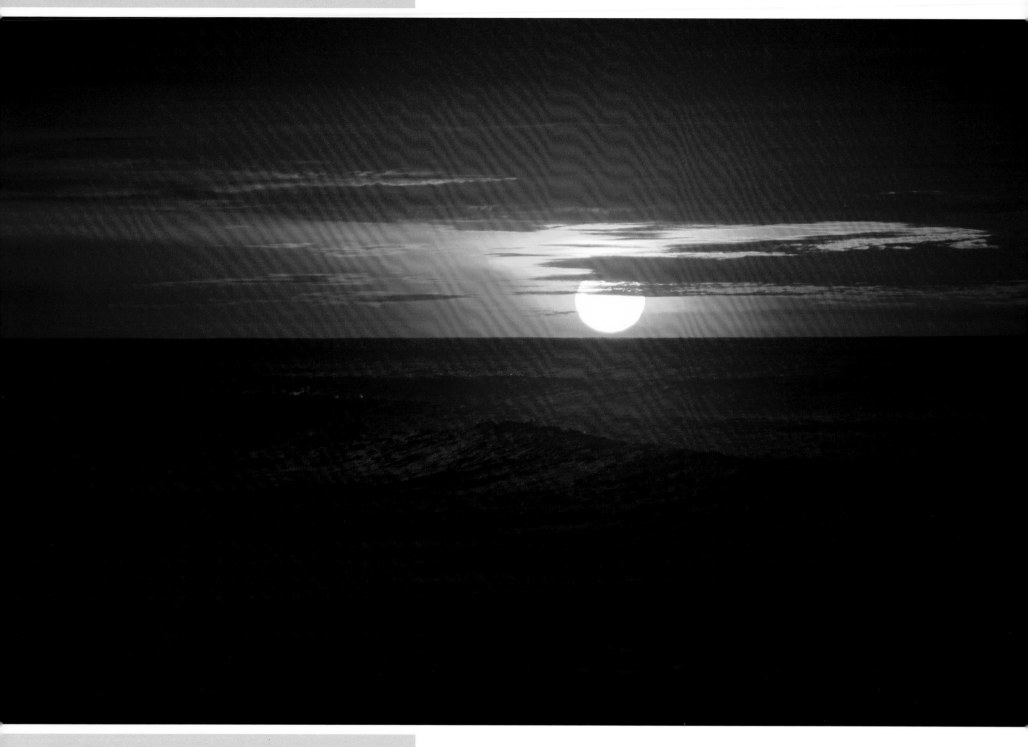

📷 TIP

Sunset images – the sky is what it is all about and you must not try to overexpose it. The sun is just part of the image – keep on shooting until the light fades – you can get some fantastic images.

Punta Sal is a perfect example of the beach life of Peru, with golden sand and waves to surf on. We arrived mid afternoon and camped on the beach – a very relaxing day with a beach BBQ in the evening watching the sun go down.

Free day relaxing on the beach. After all the travelling it is nice to feel the sand between your toes and hear the waves crashing on the shore. Tomorrow is another day and we continue travelling into Ecuador.

📷 **TIP**
Simple images can create photographs, like catching the light on the palm fronds as I look upwards. An alternative image would have been to isolate the palm fronds and fill the frame creating an abstract.

📷 TIP

While at border crossings and airports keep your photographic gear tucked under your jacket or in a camera bag – don't flaunt expensive equipment as it can be a conspicuous target for thieves. Even if you are insured, the loss of the camera equipment can be very inconvenient and ruin your trip.

A short journey to the border and the final leg of my overland experience. I am now very familiar with border crossings. We cross into Ecuador, one of only two countries in South America that does not have a border with Brazil. Ecuador is probably most famous for the Galapagos Islands, which lie 1000 kms off its coast.

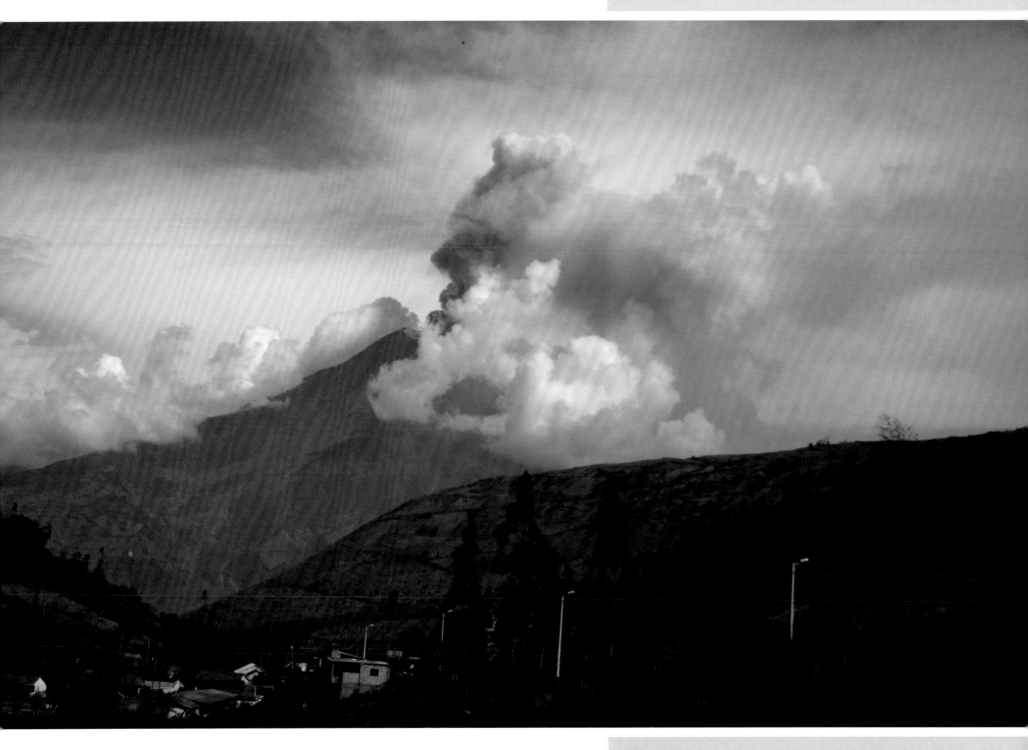

The province of Tungurahua takes its name from the volcano. This is a very active volcano and smoke and ash can often be seen spewing down the mountain side. We didn't know if we would be able to get to Banos due to the volcanic eruptions that day.

📷 **TIP**
Reportage photography is recording an event in time and a snapshot in history.

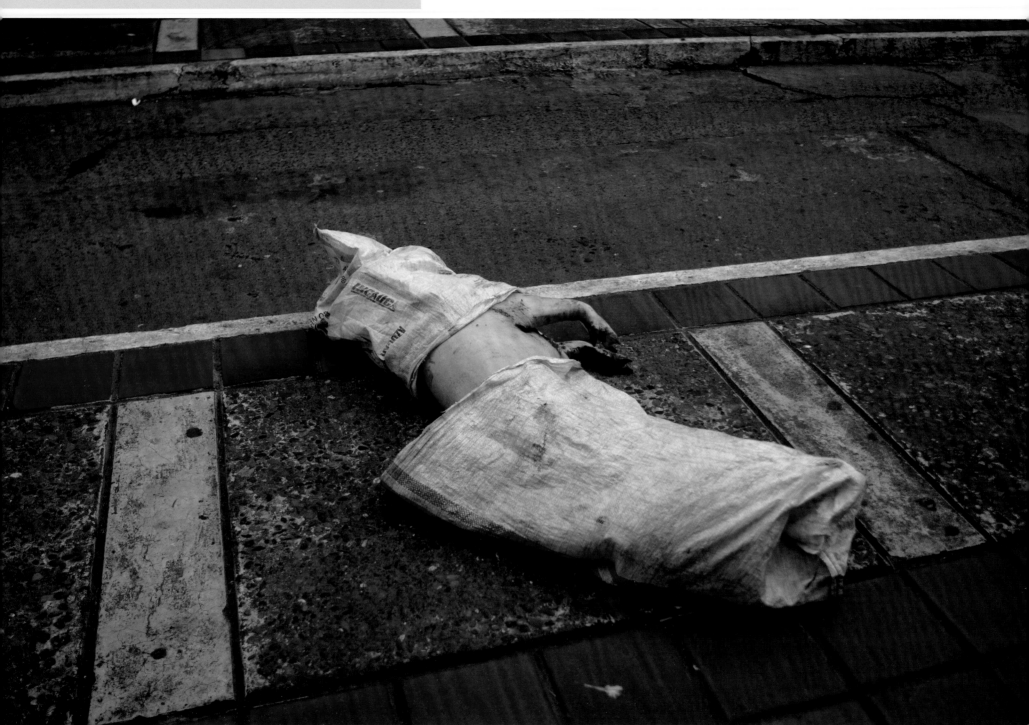

TIP

Always expect the unexpected and carry a camera with you at all times.

Banos is a Roman Catholic religious centre, as some believers say that the Virgin Mary appeared nearby. Strange visions and sightings are often seen here. We came across this pig lying on the street with its head and feet covered.

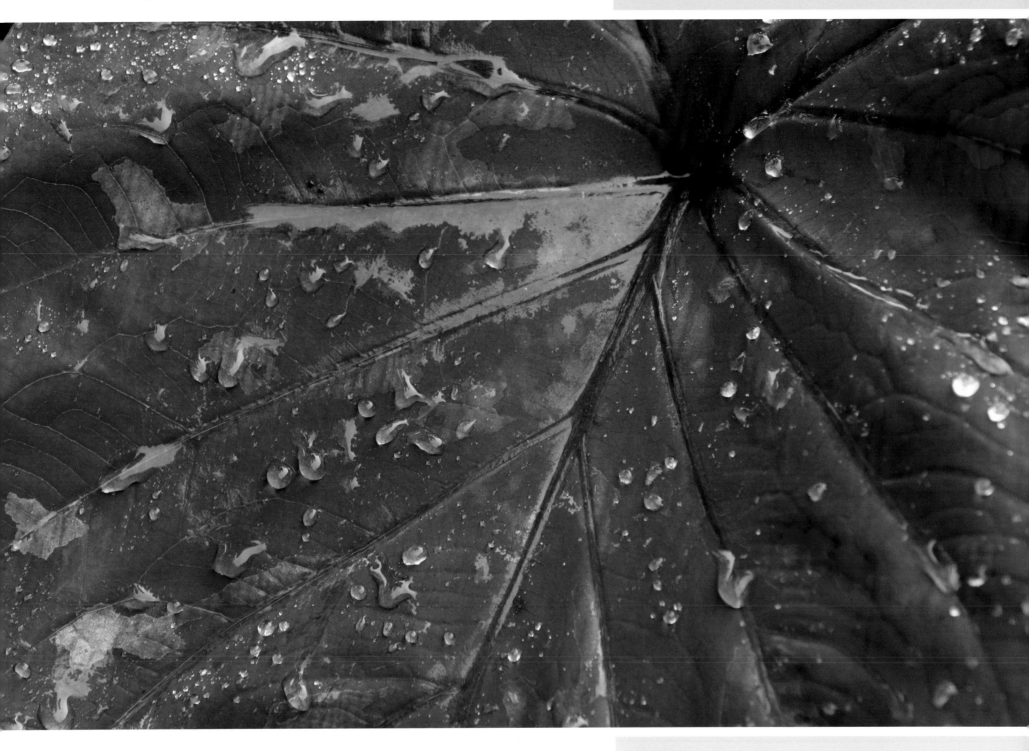

Spent three days in the Amazon jungle staying in a lodge on the Napo River. Our first day was a jungle walk with an experienced nature guide showing us the flora and fauna living in the jungle. Humid, hot and sweaty, and if you don't like spiders the tarantula that climbed on my shoulder would have freaked most people out!

 TIP

Nature is full of patterns like the raindrops on this leaf.

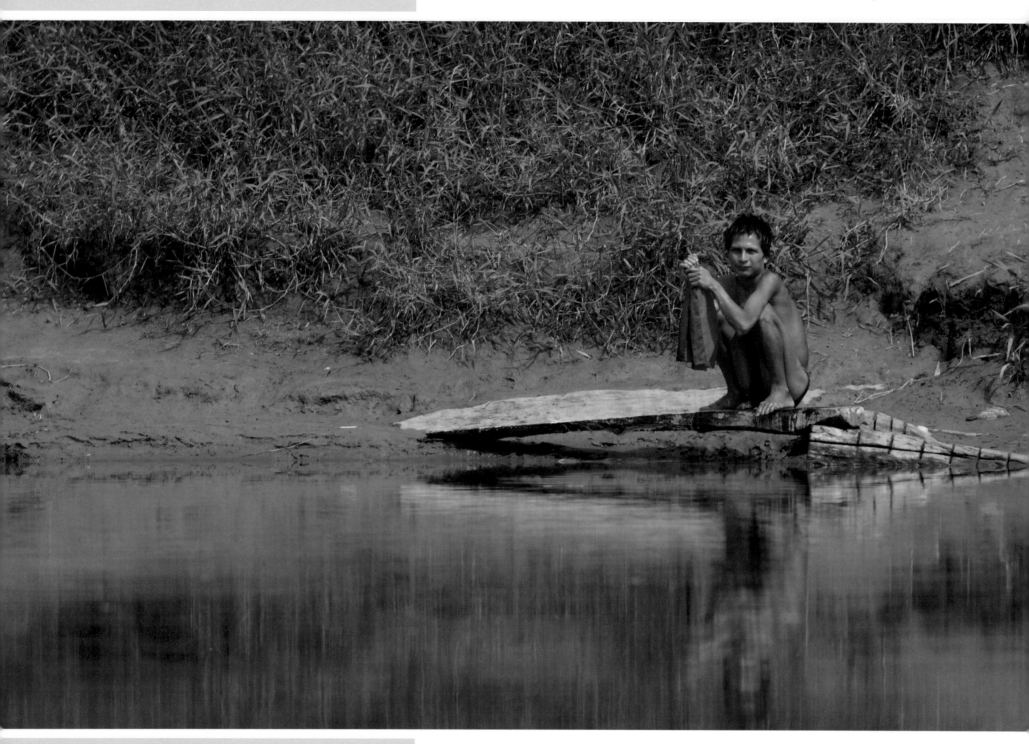

📷 **TIP**

Longer lenses can be useful for photographing people from a distance so
that they are not self- conscious and camera shy.

Today we went down the Napo River in a long wooden canoe looking for wildlife. With so many
local villages around I thought most of the wildlife would have been killed for food or scared off.
We visited a local conservation centre with woolly monkeys and other jungle mammals and birds.

Last day in the jungle and we visited a local family to see how they lived, then went up to the village to buy locally made crafts. In the afternoon we visited a butterfly farm which sells their butterflies all over the world. This is an owl-eyed butterfly with its wings up.

📷 **TIP**

Close-up or macro images. I used an f stop of f8, creating a reasonably shallow depth of field to blur out the distractions in the background and highlight the subject itself.

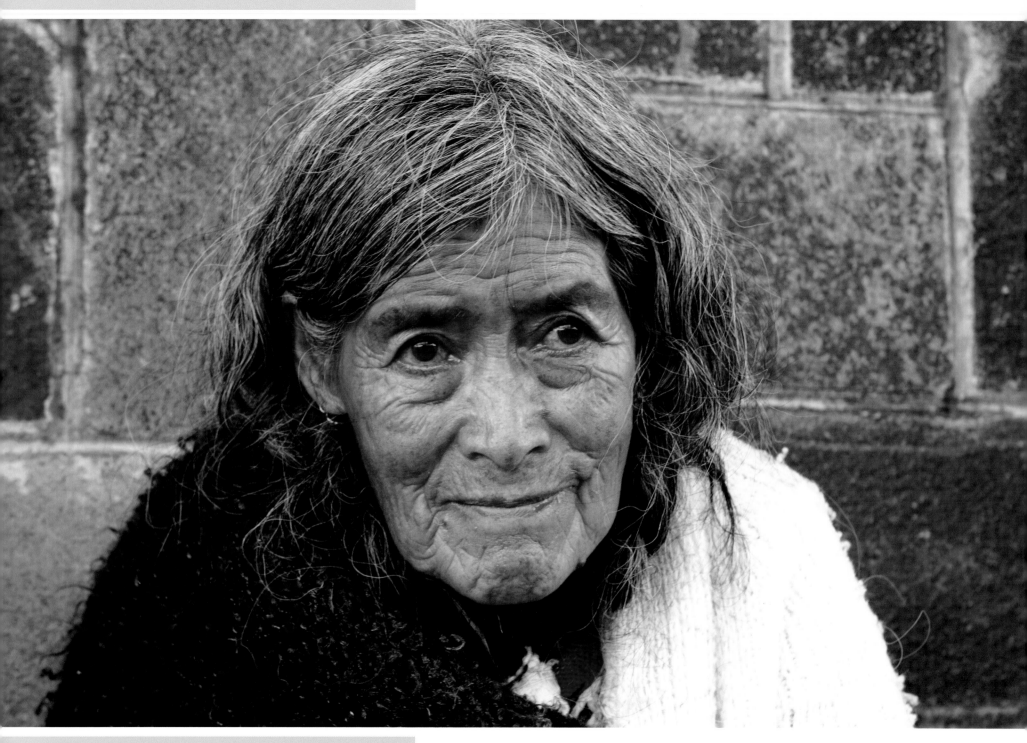

TIP
Portrait photography – features of a face, young or old, can inspire strong emotions.

An image to wrestle your soul with! This elderly lady was begging on the streets of Quito – she had such a hard and weathered face, so full of wrinkles – her eyes lost in a distant world it seemed. I took her photograph and gave her some money. But am I encouraging begging, which can be a real problem?

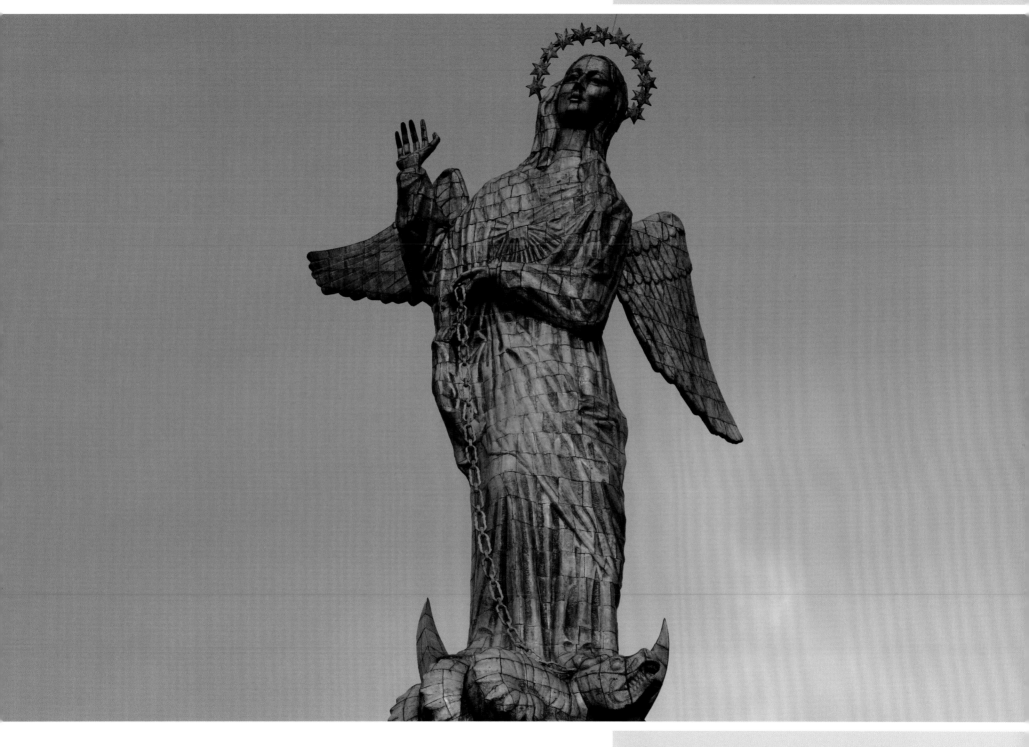

Our last day on the overland trip – and a free day for packing, souvenir shopping and saying goodbye to friends from the trip. I visited the statue of Madonna which is 45 metres high and made of 7,000 pieces of aluminium. The virgin stands on top of a globe and is stepping on a snake, which is classic Madonna iconography. What is not traditional is that she has wings. Quito claims she is the only Madonna in the world with wings, but I'm not sure.

◻ TIP

Pick up free street maps and explore the city.

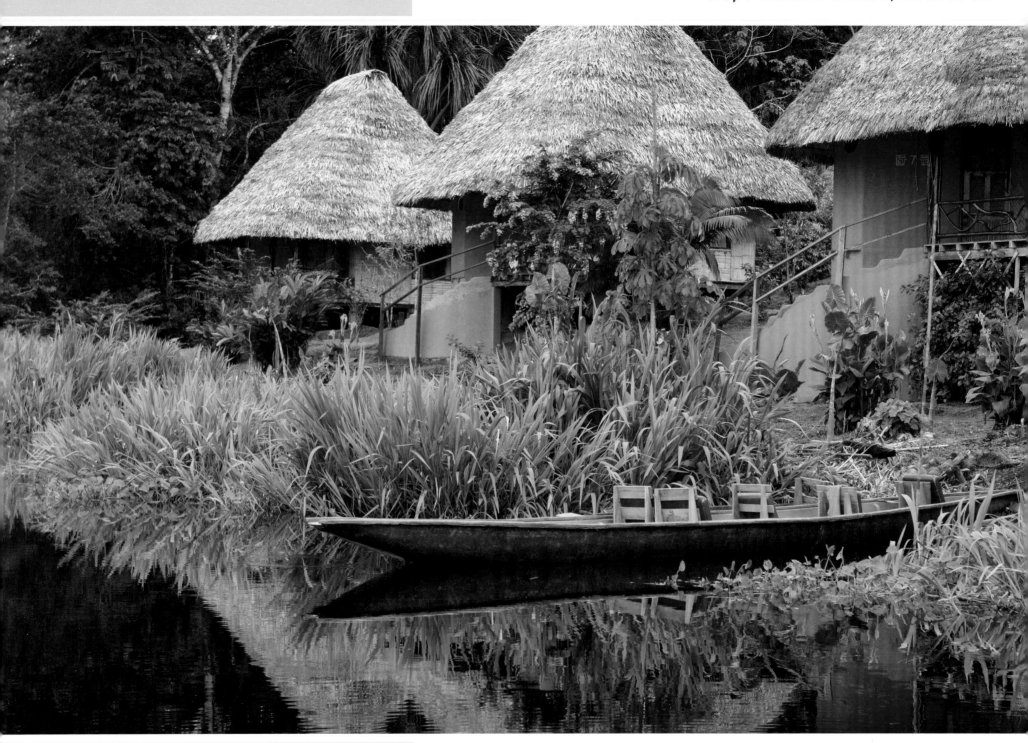

📷 **TIP**

Making choices – do you go back to somewhere you've already been or try somewhere new?

With our trip over some people flew home, others continued their tour to the Galapagos Islands or further afield to other countries in South America. I decided that I wanted to go back into the Amazon to try and take images of something very special to me. The Napo Wildlife Centre is home of the giant river otter.

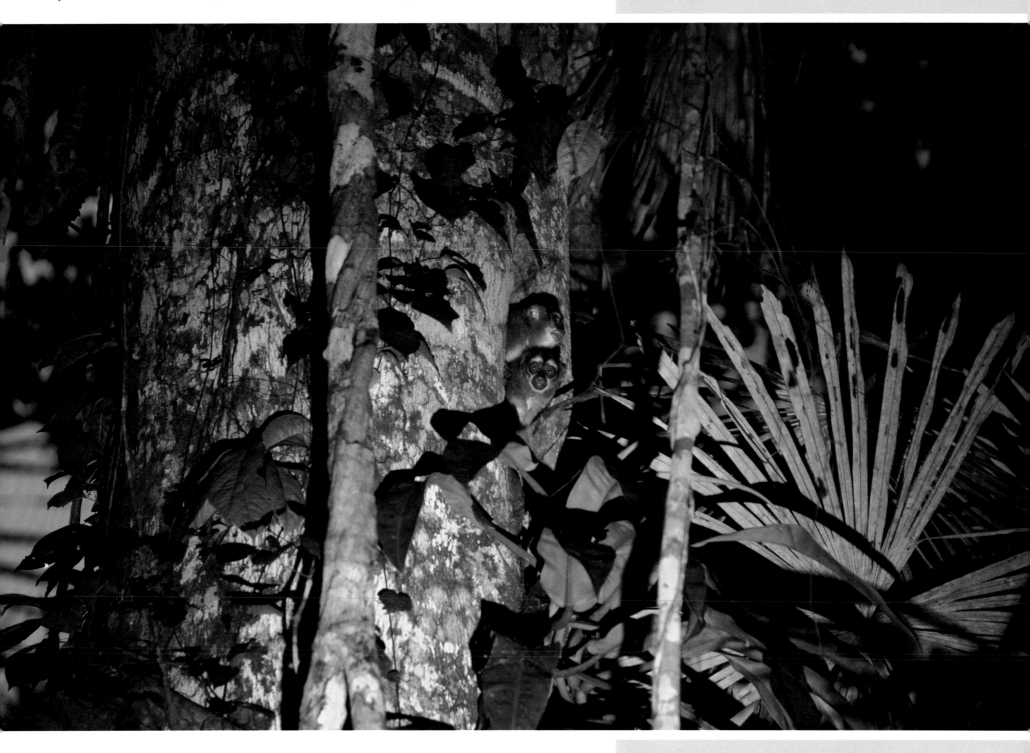

I was taken across the lake where the otters live hoping to catch sight of them in the early morning but without success. I then went into the jungle and up to a viewing platform in the canopy, to see the wonders of the jungle spread out before me. Again in the evening we went out looking for the otters with no luck but found night monkeys instead, which is another 'first' for me.

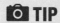 **TIP**
Local knowledge cannot be beaten for obtaining information.

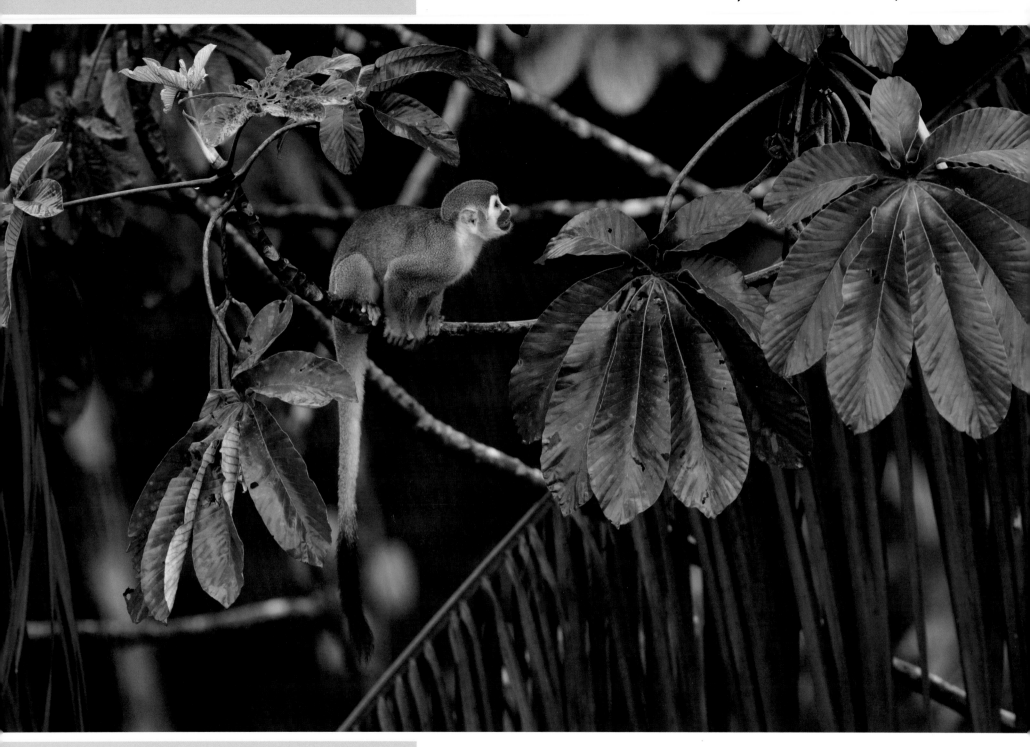

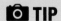 **TIP**

Telephoto lenses bring the subject closer to you.

My plan for the day was to stay near the Centre, so that if the otters came across the lake I could capture their images. The otters don't have strict timetables of eating, sleeping and playing, so it was a waiting game. While I was waiting I had the opportunity to take photographs of squirrel monkeys jumping from tree to tree. No otters appeared that day.

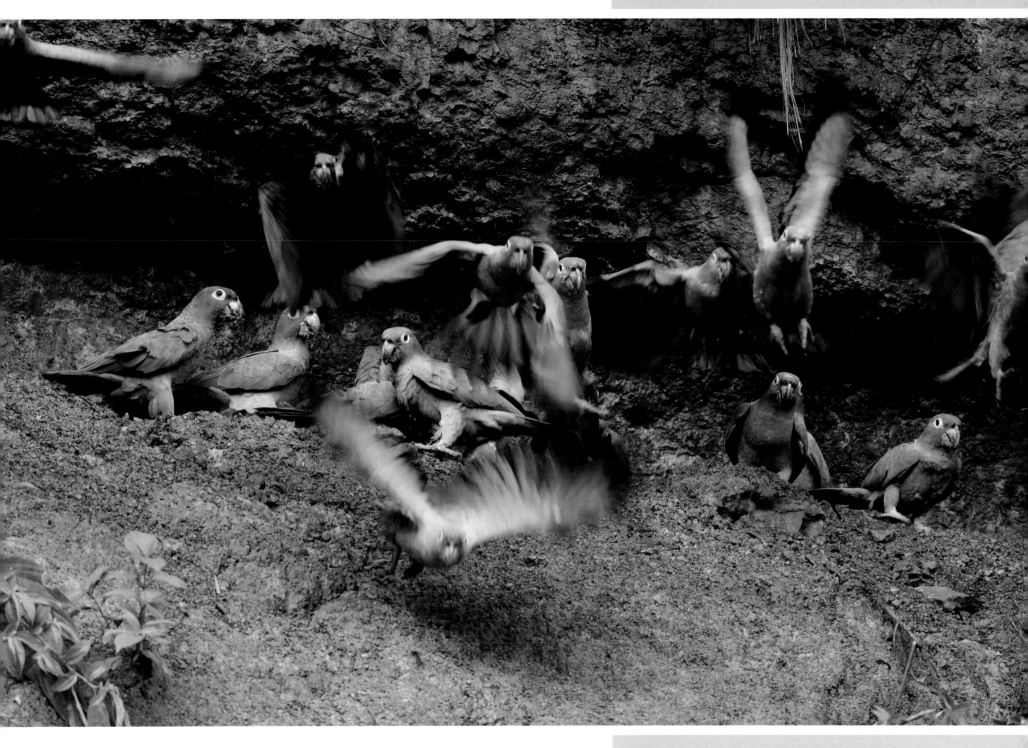

Today I went to a parrot 'lick' where hundreds of parrots come down for the salt that is in the clay. Each species has its own time of day so you could be there all day photographing different parrots. Due to other tourists not understanding the rules of being quiet in a hide, photography was very difficult.

📷 TIP
The parrots closest in the image are out of focus giving movement, created by shallow depth of field.

📷 **TIP**

A reportage image of a jungle's disappearance.

I didn't see any giant otters – apparently they were seen crossing the lake whilst I was at the parrot lick! That's the beauty of wildlife photography – it's about luck, patience and getting out there. On the trip back to Quito it was depressing seeing the oil companies building roads into the Amazon jungle – how long will it be before the wildlife disappears?

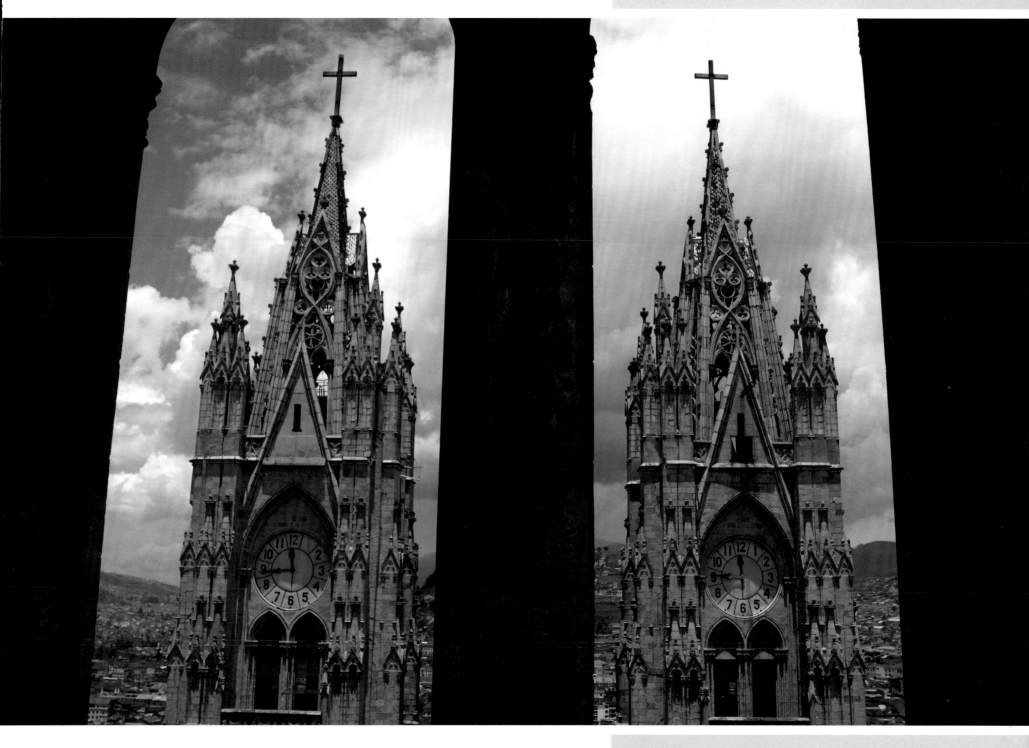

My last morning in Quito before an evening flight to Spain and then London. I enjoyed being a tourist and went up La Basilica Towers. It is possible to climb to the top of one of the twin towers that stand 83 metres high. There is a coffee shop with views over the city, or you can go right to the top of the tower for panoramic landscapes.

📷 **TIP**

Make sure subjects are central in an image where verticals matter.

📷 TIP
Carry a small compact camera with you so you can take images discretely.

Had an upgrade to business class on my flight from Quito to Madrid, which was amazing. I was served champagne on the flight and could also sleep with my legs fully stretched out. Woke up refreshed for the second leg of my journey from Madrid to London and then on to San Francisco – 20 hours plus flying, and across the time zones.

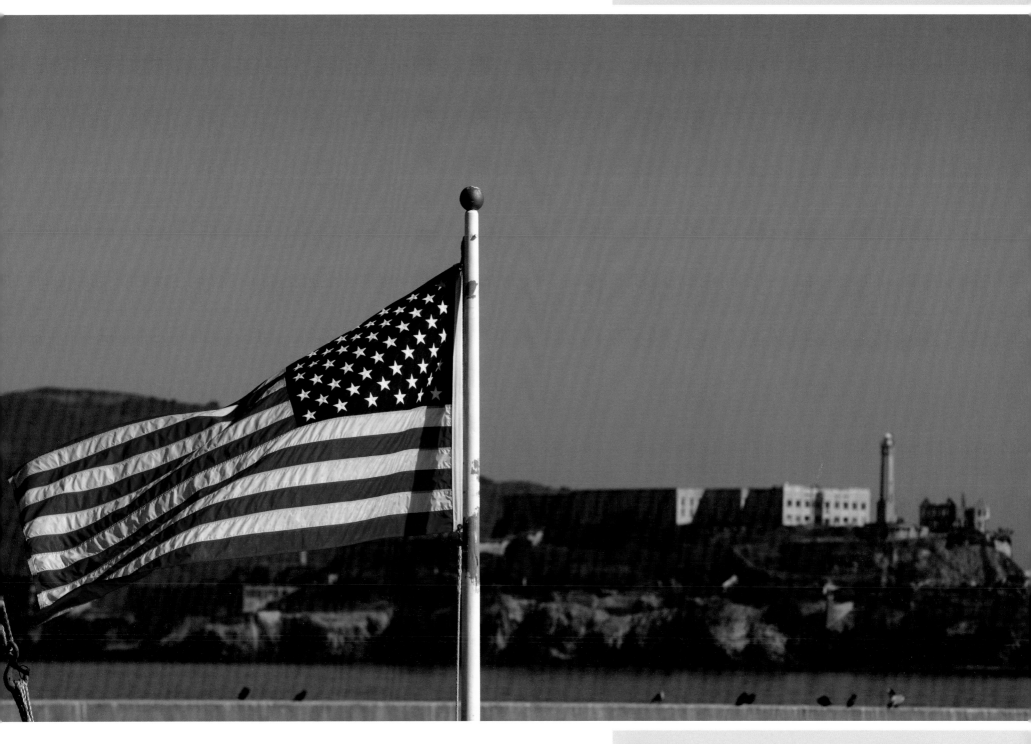

Well, I have arrived in the United States of America, and I am here for six months, hoping to see as many national parks as possible. My trip will bring other exciting events into my life as you will see as my time in the USA unfolds. Jetlag not as bad as I expected due to being able to sleep on the first leg of my lengthy journey back across the Atlantic.

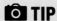 **TIP**
Including a national flag with an icon of a country/place creates a stronger image.

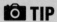 **TIP**

A short focal lens will enable you to get the sky with a wide angle and capture the gradient from the sunset to the night.

The sight of the Golden Gate Bridge at sunset was breathtaking - the bridge is one of the most famous in the world and was completed in 1937. Today it is still the second longest suspension bridge in the USA and one of the most photographed bridges in the world.

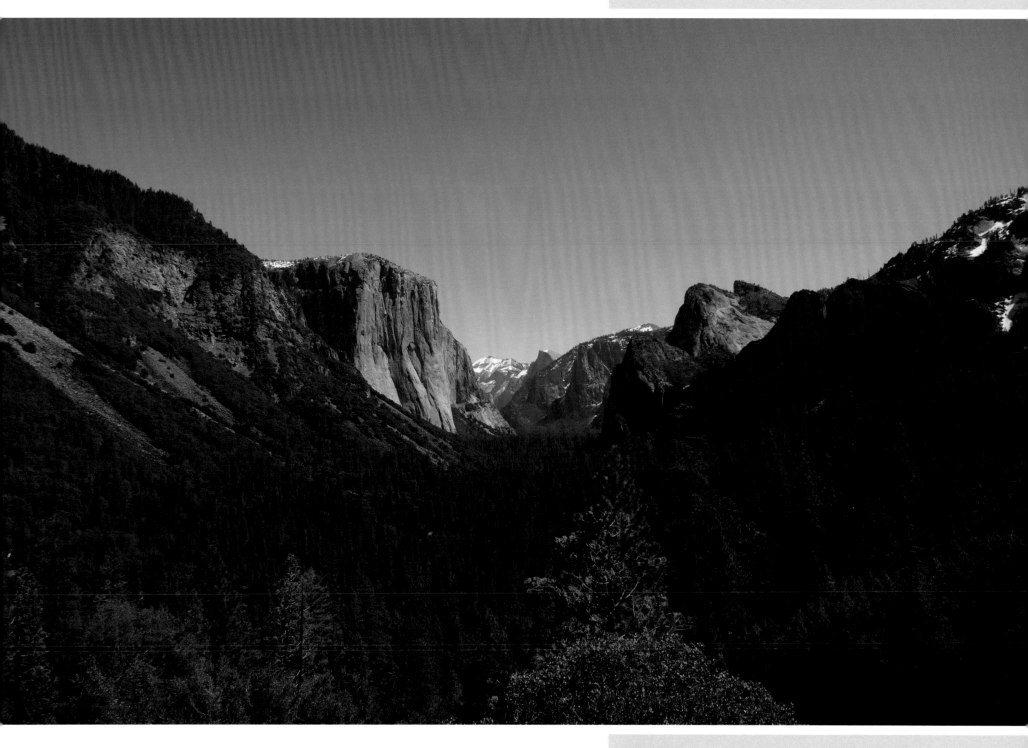

Yosemite National Park is 1,189 sq miles and is visited by 3.5 million people each year, most of whom only spend time in the 7 sq miles of the Yosemite Valley. I had no choice but to do the same as snow prevented me from travelling further. Yosemite is internationally recognised for its spectacular granite cliffs, waterfalls and giant sequoia trees.

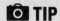 **TIP**

Wide-angle lenses are a must for landscape photography to capture the vastness of such an area.

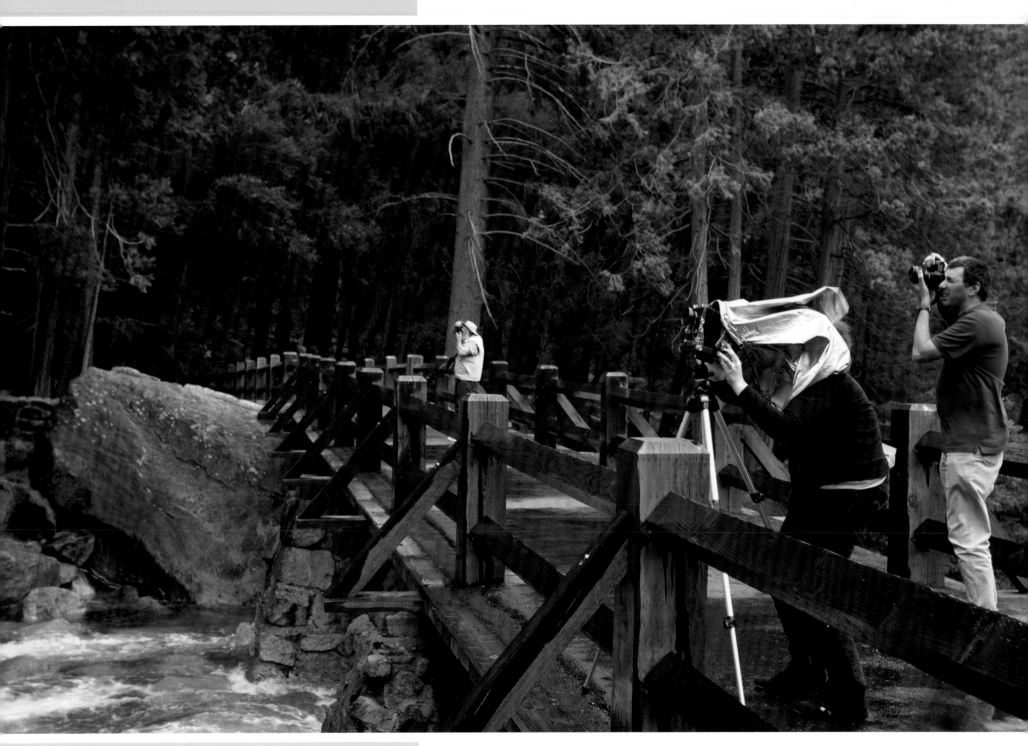

📷 TIP

A plastic bag takes up hardly any room in your pocket or camera bag but could provide a vital accessory in protecting your camera from spray, rain, dust or just from water. Clean the lens immediately after use with a soft cloth.

Yosemite, like any of the national parks in the world draws photographers to capture its beauty. It is 3$^{1}$/$_{2}$ hours' drive from San Francisco – and the El Capitan cliff is one of the most popular rock climbing destinations in the world. Here at Lower Yosemite Falls photographers with different types of cameras try to capture the falls with all their might.

The Yosemite Valley represents one per cent of the park area and this is where most visitors arrive and stay. The park is not just famous for its landscapes, it is renowned for its wildlife. I saw bobcats, deer and ground squirrels and managed to capture this grackle in display mode trying to attract a mate.

 TIP
One-third of an f stop plus or minus in exposure can make the difference in detail on light and dark images.

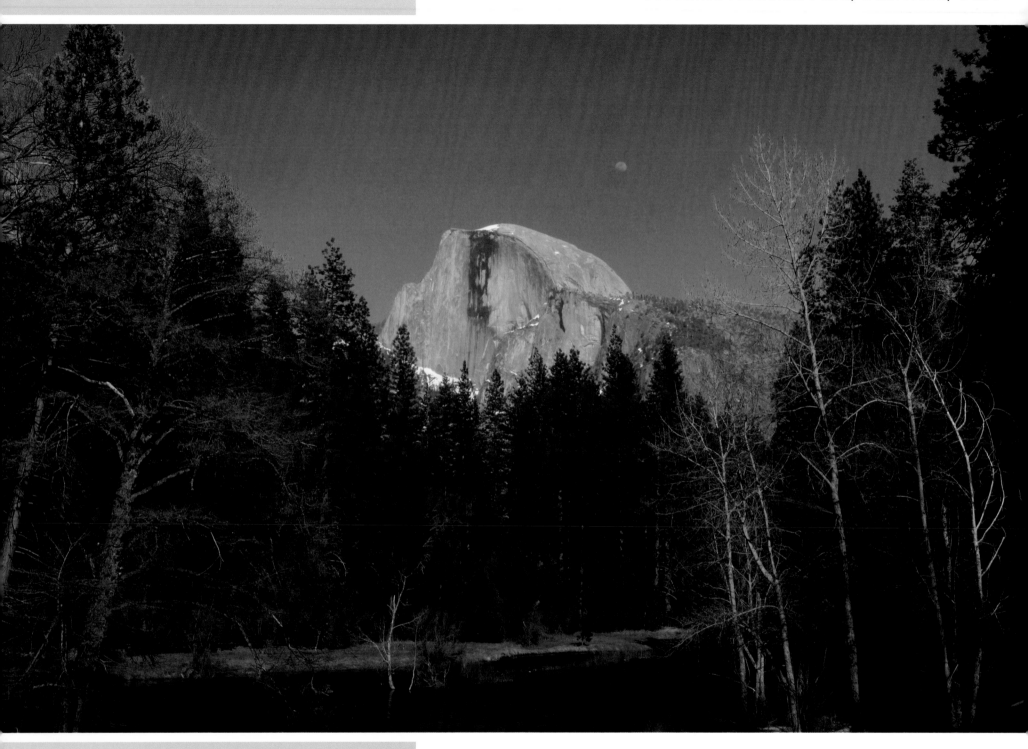

📷 **TIP**
All national parks run free events – check availability.

Ansell Adams was an American photographer and environmentalist best known for his black and white photography. He founded the group F64 which in turn created the Museum of Modern Art, Department of Photography. I went on a photographic morning following in his footsteps, trying to achieve his imagery in black and white.

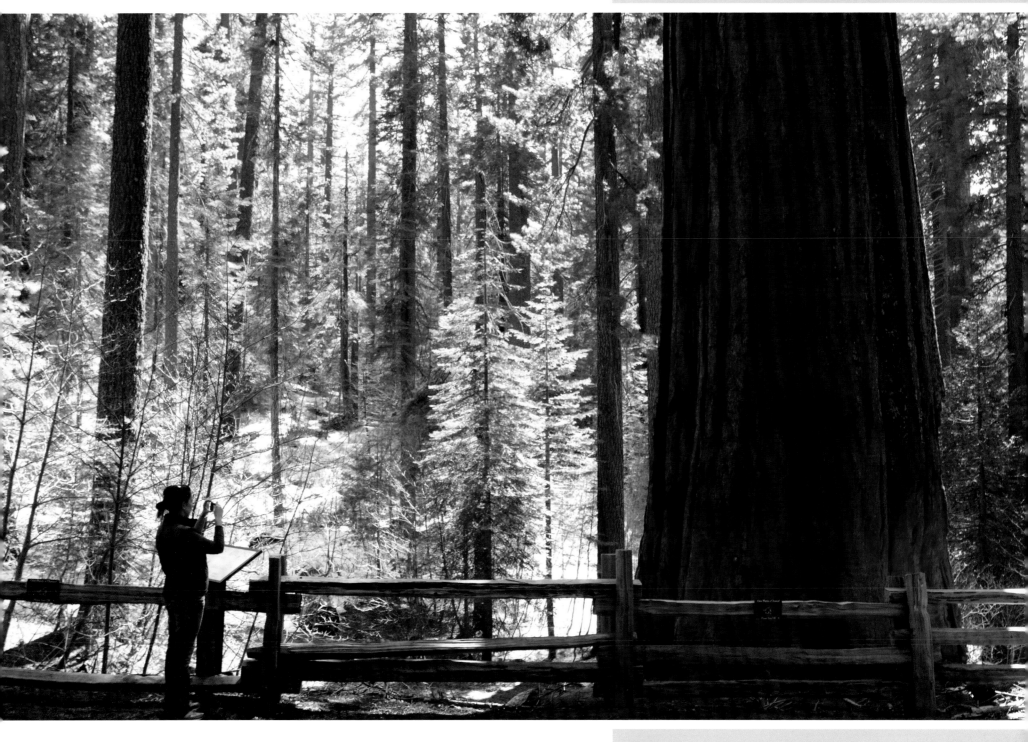

A visit to Yosemite wouldn't be complete without seeing the giant sequoia trees. These are the fastest growing trees in the world and have the biggest girth, having survived for two to three thousand years, or even longer. Some of the largest trees measure 35 ft at the base and up to 300 ft in height.

📷 **TIP**

A sense of scale is achieved by including both large and small subjects in an image.

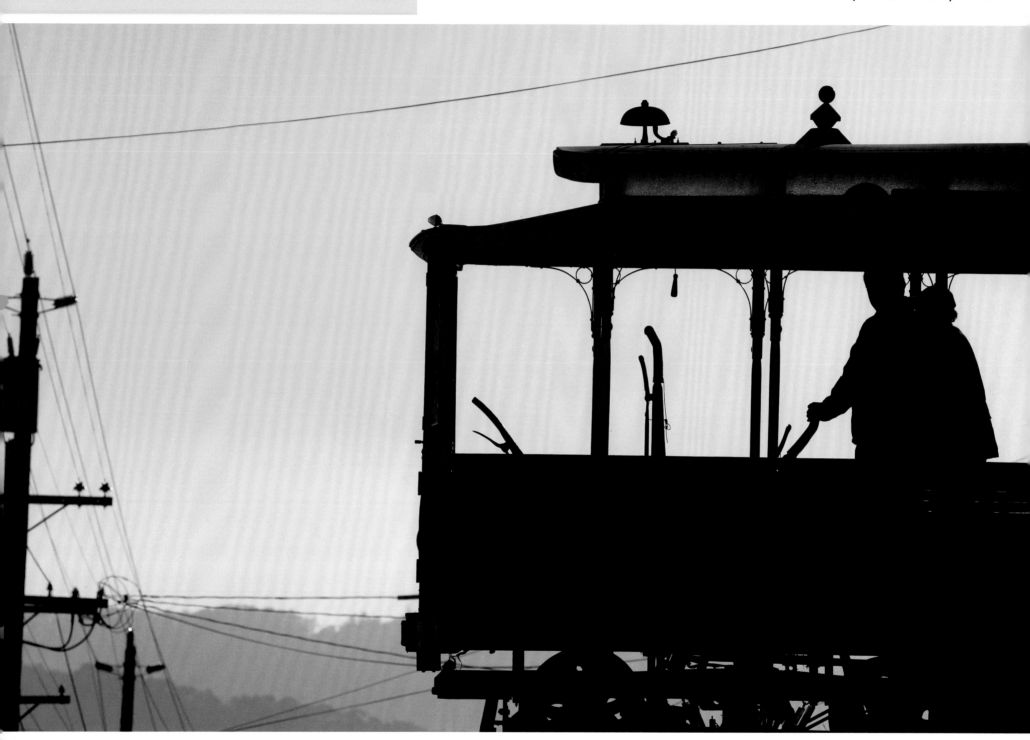

📷 TIP
Silhouettes are created with a strong backlight source, therefore creating under exposure for foreground objects.

San Francisco was an amazing city, I wish I'd had longer there. There is so much to see and do. Trying to take a photograph that everyone recognises but from a different perspective is quite a challenge. I decided the trams were my image of the day, and spent all my time whizzing about on them looking for the right image, but one that was different.

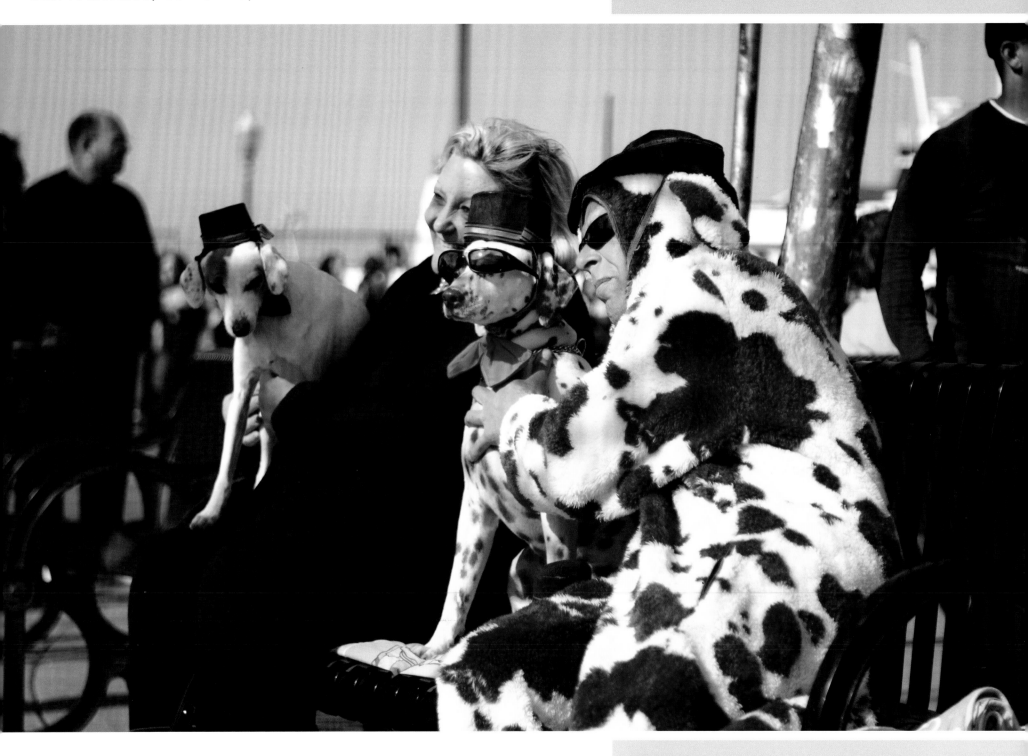

Fisherman's Wharf claims to be the most visited tourist attraction, and is full of restaurants, bars and galleries. It has famous sea lions at Pier 39 which bask on the pontoons in the midday sun. There are also street entertainers who pose with you to earn a few dollars - this entertainer is dressed like his dogs! Boat trips leave from the waterfront to the island of Alcatraz and under the Golden Gate Bridge.

 TIP
Humour is good in photography.

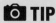

TIP
Recognisable images tell a story without words.

Travelling is not just about sightseeing, it is about visiting friends and family too. While in the States I was invited to stay with my friends Ken and Julie who I had met in Norwich, England. I had to fly from San Francisco to LA and then LA to Oklahoma before meeting up with them again.

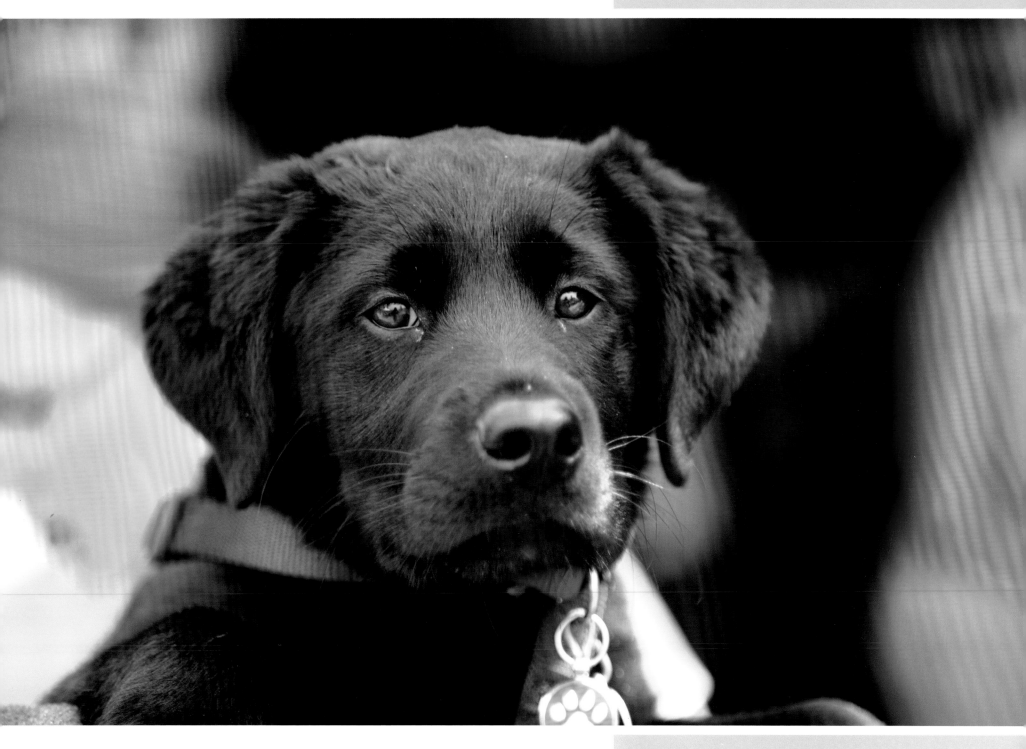

Ken and Julie are trained rescue handlers with their Labrador called Molly. If there was a national disaster, they would be called to help find people trapped in buildings or under rubble. We went along to the Heartland Lab Rescue Day to support this rescue centre for Labradors in Oklahoma and Kansas who are no longer wanted by their owners.

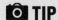 **TIP**

Portraits – your eyes are drawn to his, the sharpest focal point.

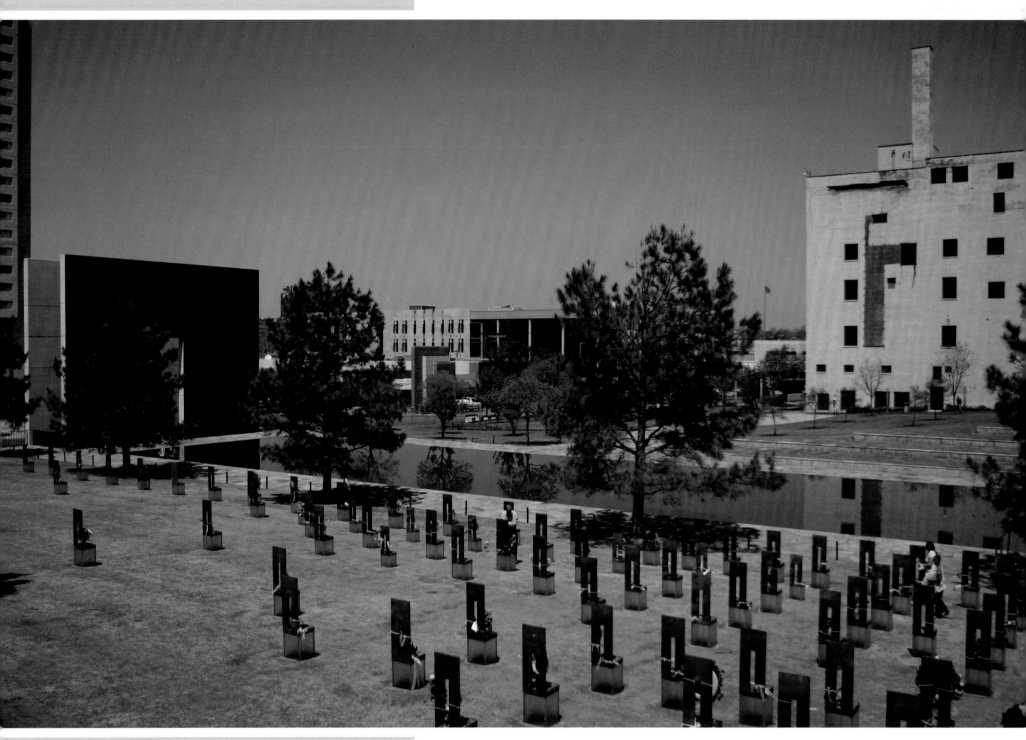

📷 TIP

A higher vantage point shows the positioning of the chairs, each representing a person who died.

Oklahoma City suffered the largest terrorist attack on American soil in history before the September 11th attacks. The bombing occurred on April 19th 1995. It remains the deadliest act of domestic terrorism in American history and resulted in the destruction of the Federal Building, with 168 lives lost and 800 people injured.

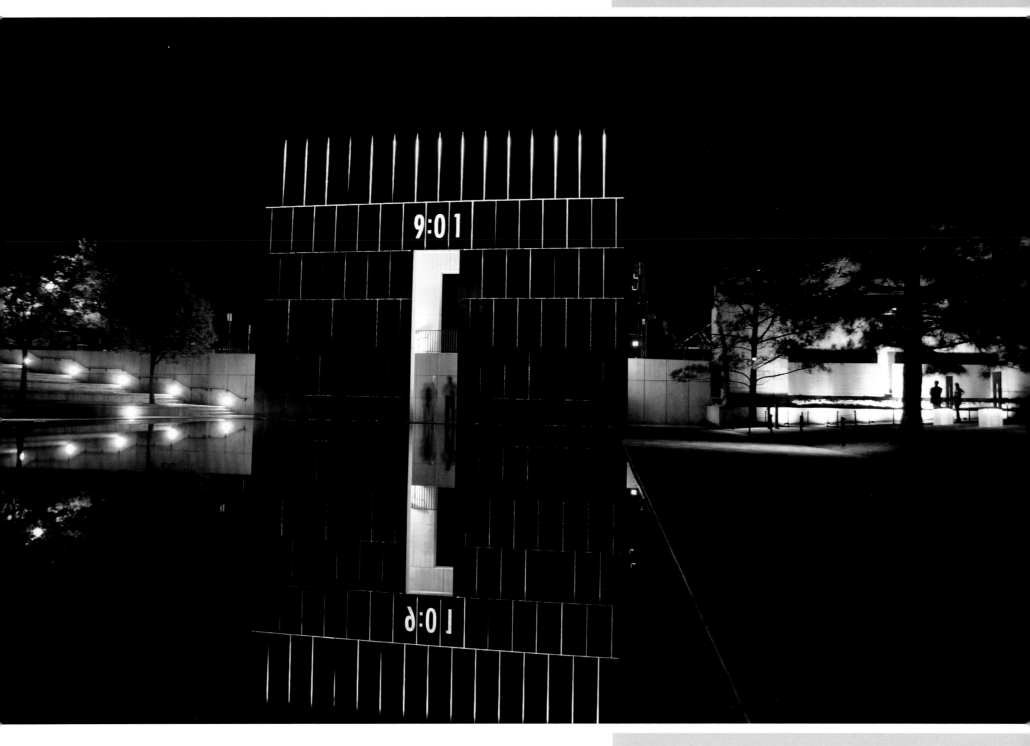

'We come here to remember those who were killed, those who survived and those changed forever. May all who leave here know the impact of violence. May this memorial offer comfort, strength, peace, hope and serenity.' This memorial is one of the most moving places I have ever been to and there is always someone here – it doesn't matter what time you visit.

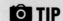 **TIP**
Not using flash gives the picture more depth of stillness and tranquillity.

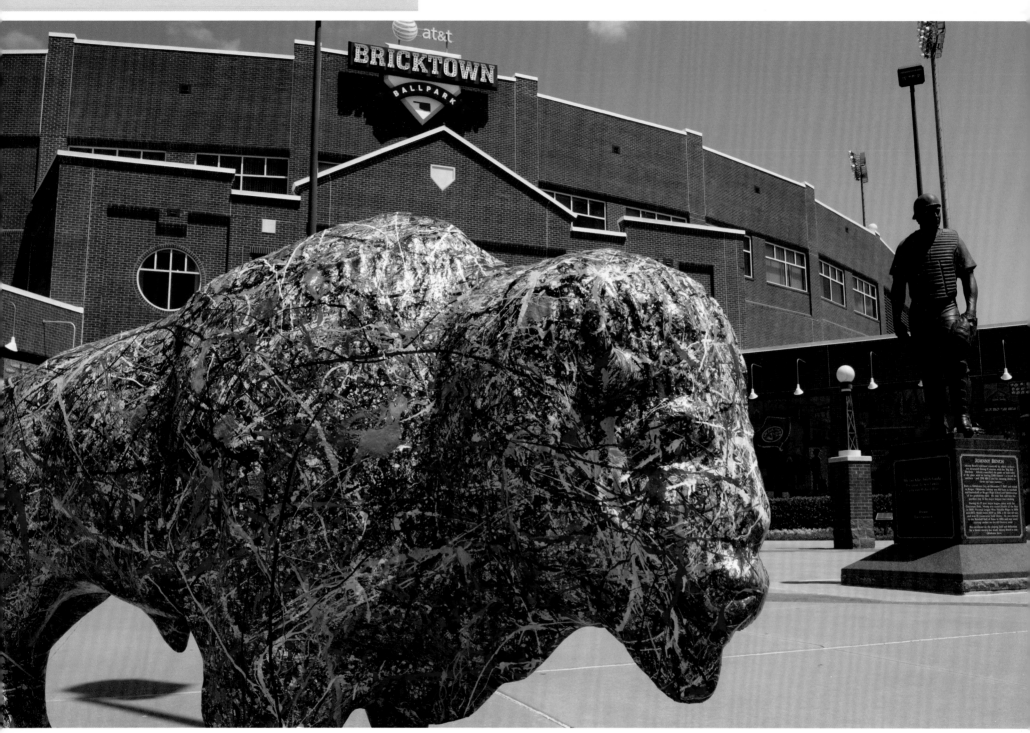

📷 **TIP**

A large object in the foreground minimises the background, which is unavoidable.

Bricktown Baseball Park is home to the Redhawks who play minor league baseball. I am not sure what that means compared to our football leagues and I could not get to a game to find out, which was a pity. In a lot of American cities you will find large decorated animals dotted around. The town of Cody had bears in its streets.

Bricktown was once a major warehouse district and the original site of the city. It is now a growing entertainment centre with the baseball park, large cinema, navigable canal, shops, bars and restaurants including Toby Keith's 'I Love this Bar & Grill'.

📷 TIP

Look for strong colours within an image.

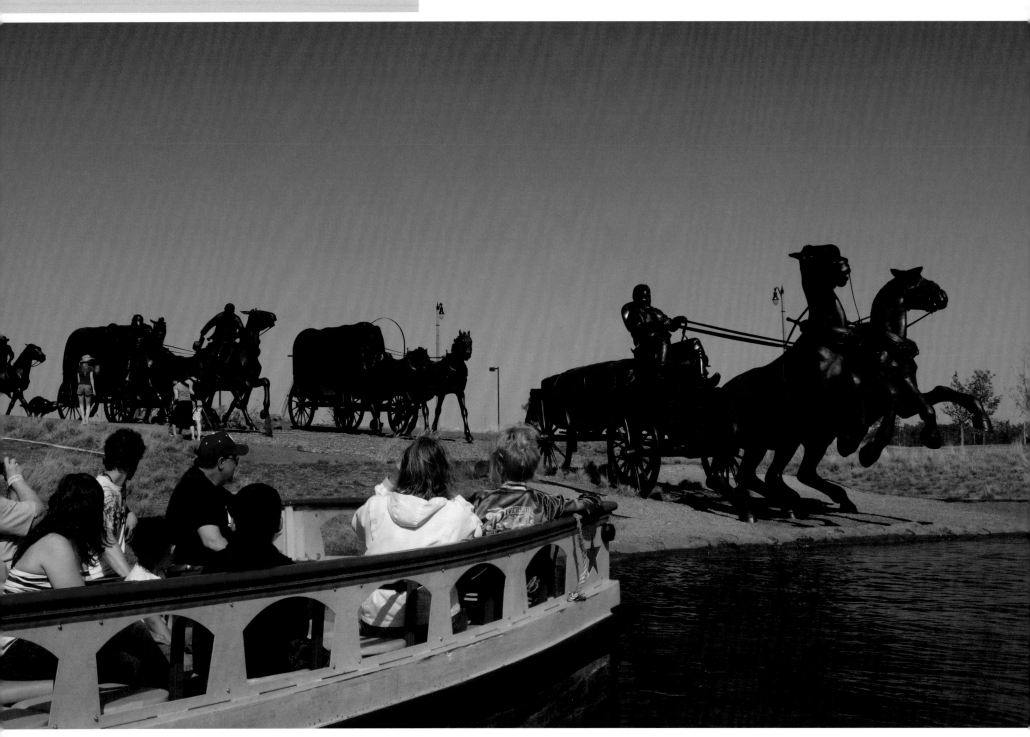

📷 **TIP**

The photographer's choice – do you have something in the foreground or not?

The Land Run Memorial is dedicated to the first Oklahoma Land Run of 1889. It was the first land run into the unassigned Lands. The land run started on the 22nd April 1889 at high noon with an estimated 50,000 people lined up. When completed the monument will have over 45 individual sculptures. It will measure 365 ft in length, making it one of the largest bronze sculptures in the world.

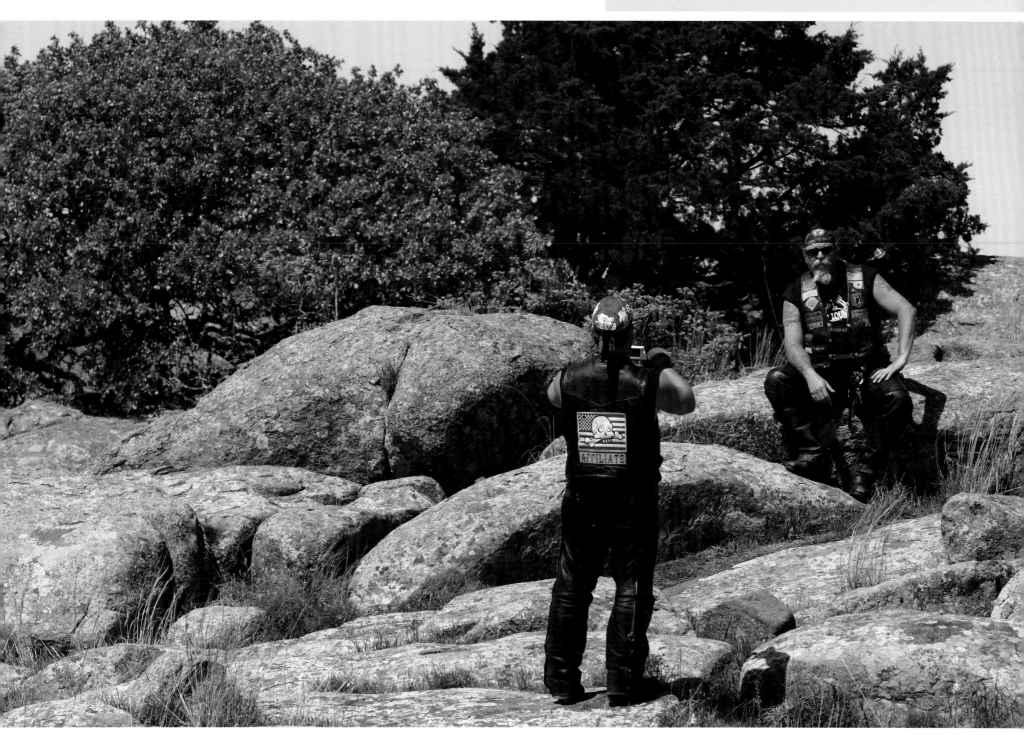

The Wichita Mountains are located in south western Oklahoma and are a favourite for hikers, rock climbers and also bikers, who drive to the top of the granite knob before returning down the winding roads. The wildlife refuge protects buffalo, elk and deer on a 59,000 acre site. Photography is all about personal memories and events in your life, including Harley-Davidson bikers!

📷 **TIP**

A compact camera can sometimes give you more flexibility than a SLR for casual/social photography.

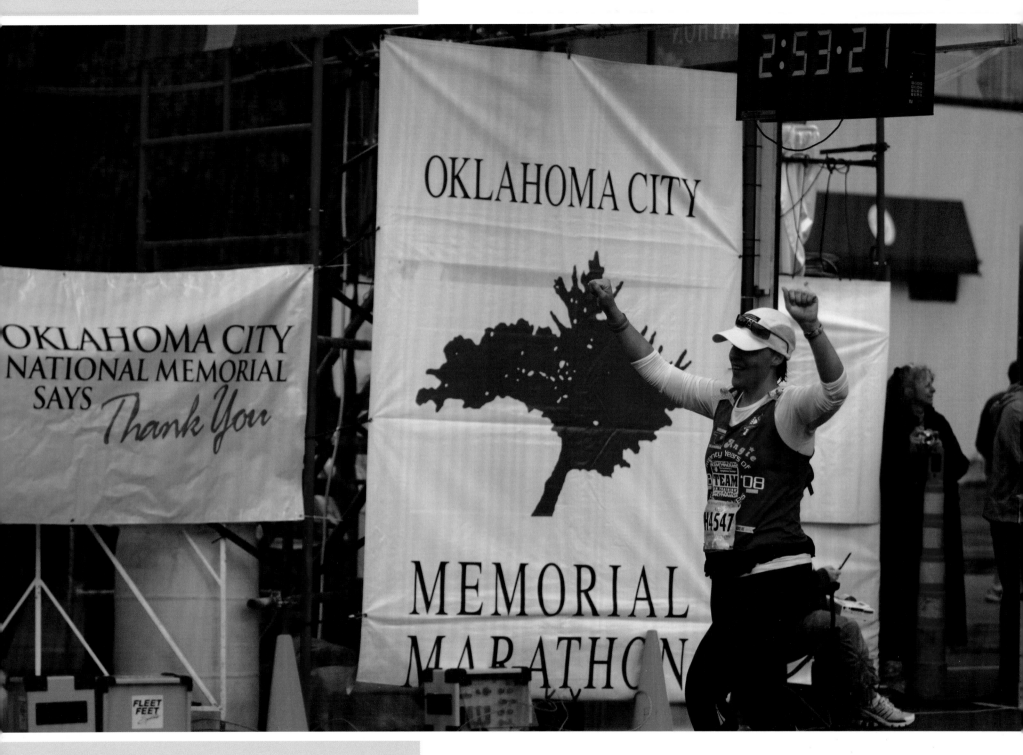

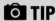 **TIP**

Speak to organisers to see if you can get a vantage point from which to take your images.

On April 19th 1995, a great wrong was done in Oklahoma City. On this day in April the forces of fear and hate are beaten by love and compassion: the Oklahoma City Memorial marathon is a race that is not about running, it's about life. Banners line the marathon course, 168 in all - one for each victim.

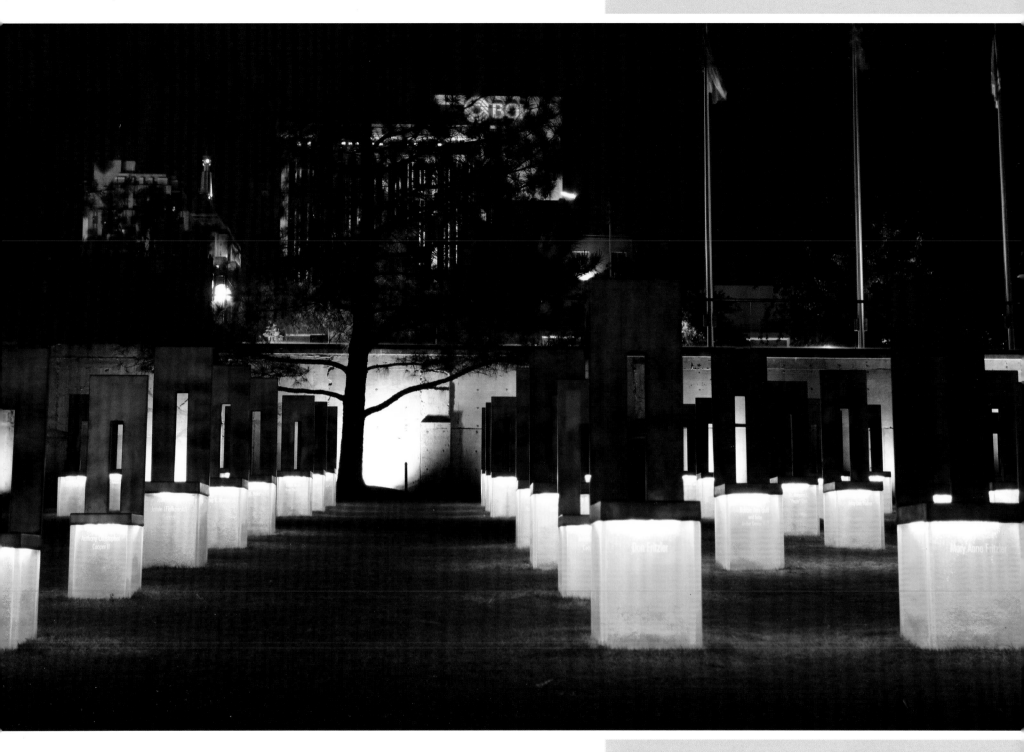

One hundred and sixty-eight chairs are lit up at night – with every chair representing someone who died. The smaller chairs are for the children.

📷 **TIP**
Revisiting at different times of the day/night gives unique photographic opportunities.

 TIP

Portrait photography can be either in a studio where you have control
of the lighting and you can change the background settings, or out on
location with more natural backdrops and lighting.

I was asked to do a portrait portfolio by Photodesign while I was in Oklahoma. This is Robyan
Montgomery, 'The Coolest Cat you will ever meet!!!' – her own words.

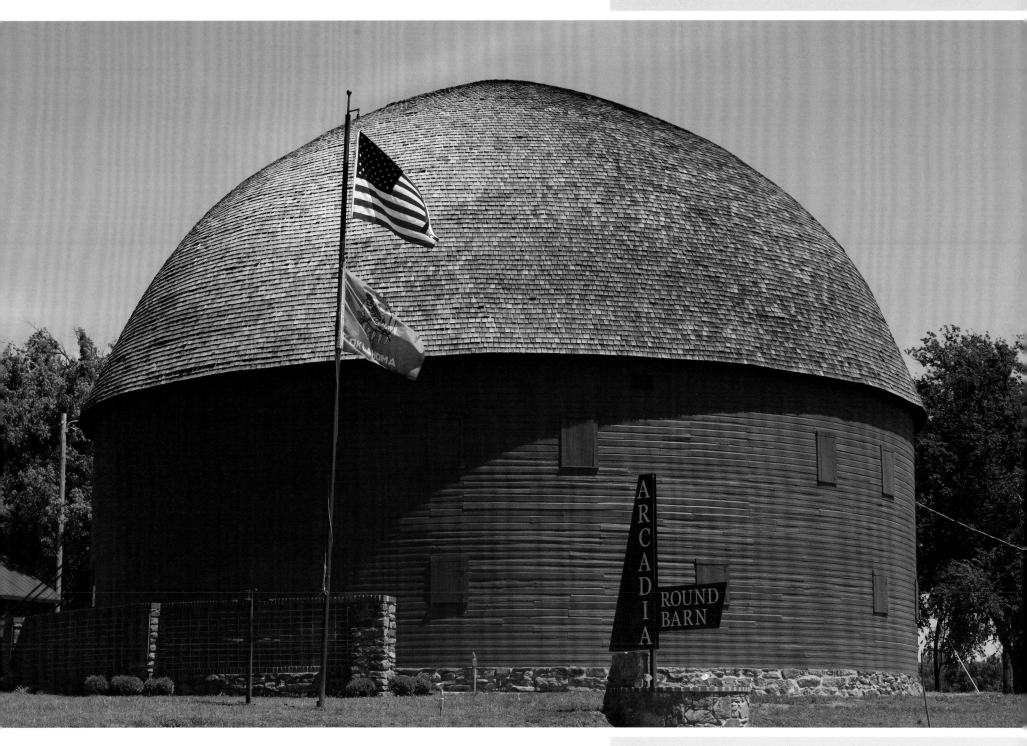

The Round Barn at Arcadia was built in 1898 and originally served as a home for livestock and a place where dances were held for the local people. Round barns were particularly associated with the Shaker community. What makes this barn special is that it is a landmark on the famous Route 66.

📷 **TIP**
Unusual subject matter makes interesting photography and can possibly earn recognition for your work.

 TIP
Local events give different photographic opportunities that you might not see in your own area.

The Edmond Art Festival takes place on the first weekend of May. Nearly every kind of artistic expression is represented, including paintings, sculptures, pottery, jewellery, metal and glassworks, photography, as well as live music. A huge variety of local food is also sold, from homemade lemonade to Indian tacos.

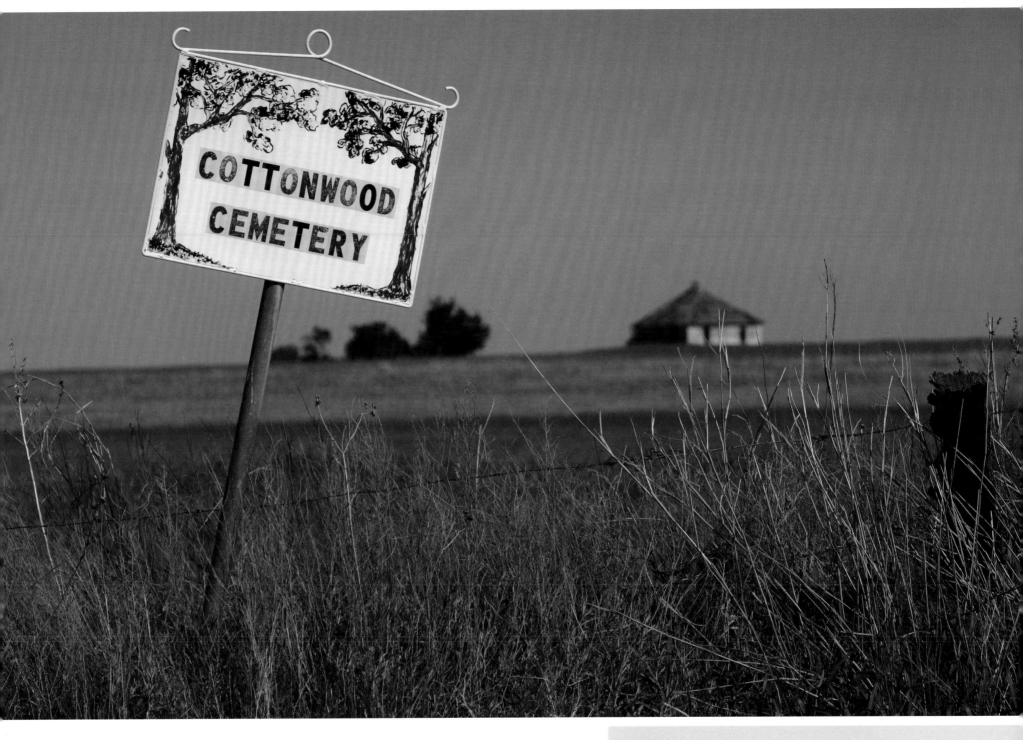

I found this cemetery while driving around Oklahoma, but there was no sign of the graveyard. I asked a local farmer if he knew where the cemetery was and he replied that he didn't have a clue and he hadn't even noticed the sign. I have looked online and found a Cottonwood Cemetery but it is nowhere near this location. Where have all the graves gone?

📷 TIP
Unique signage like this may provide the photographer with amusement, but not everyone will share the humour.

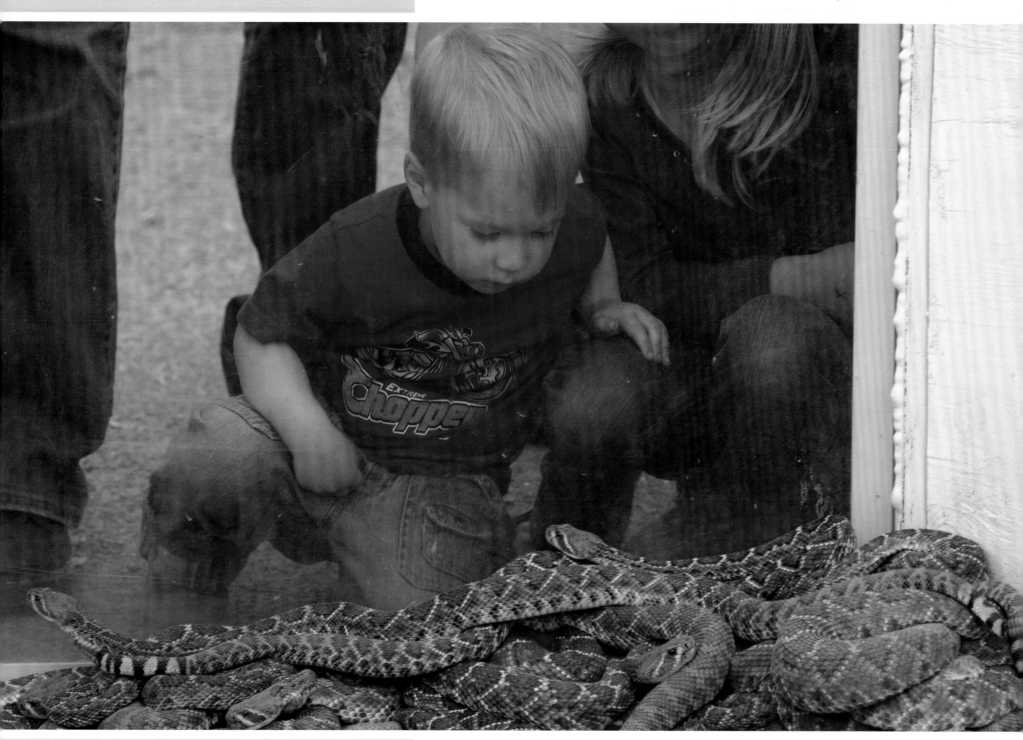

📷 TIP

The fascination on the small boy's face looking at the snakes is a photographer's dream – get down to his eye level to capture the expression.

Taking my advice from Day 103, I found that different parts of the States have Rattlesnake Round-up days where they go out and catch rattlesnakes, and drain their venom for use in antidotes at the local hospitals. The snakes are then placed in a perspex holding pen until they are released back into the wild.

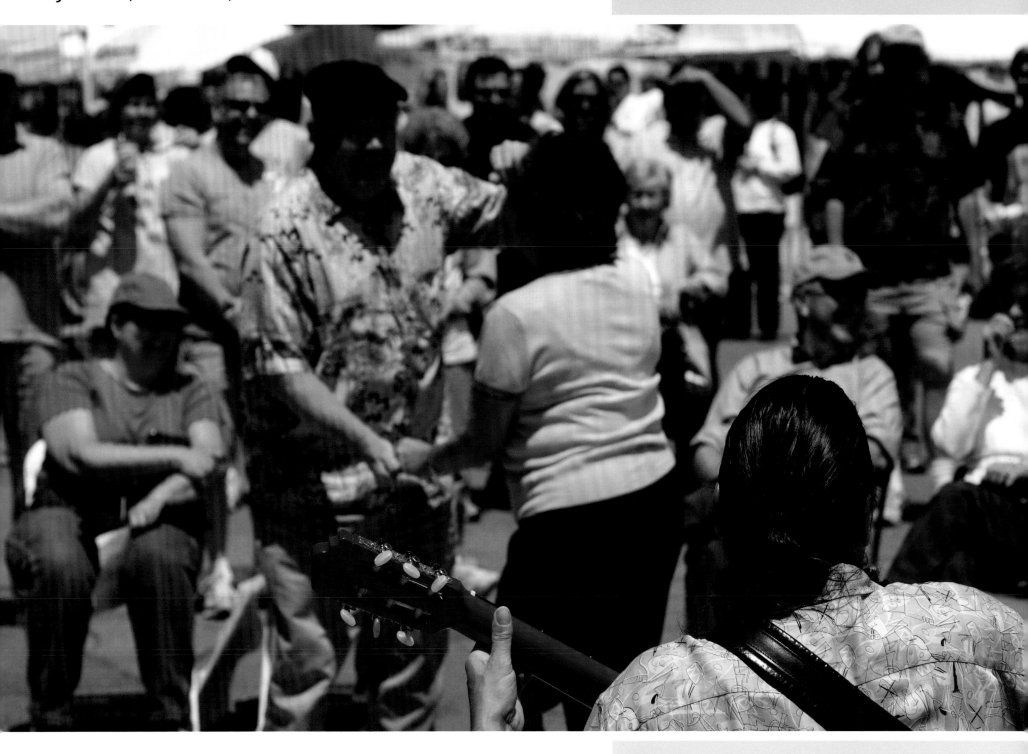

I went back to the Edmond Art Festival as I heard one of the world's best guitarists was playing today. His name is Edgar Cruz – people come from miles around to hear him play and to dance in the streets. The way he finger-plucked the guitar was amazing and I sent him photographic images that I had taken that day.

📷 **TIP**

I made a mistake; I should have focused on the couple dancing and not on the single person in the foreground. A photographic opportunity missed.

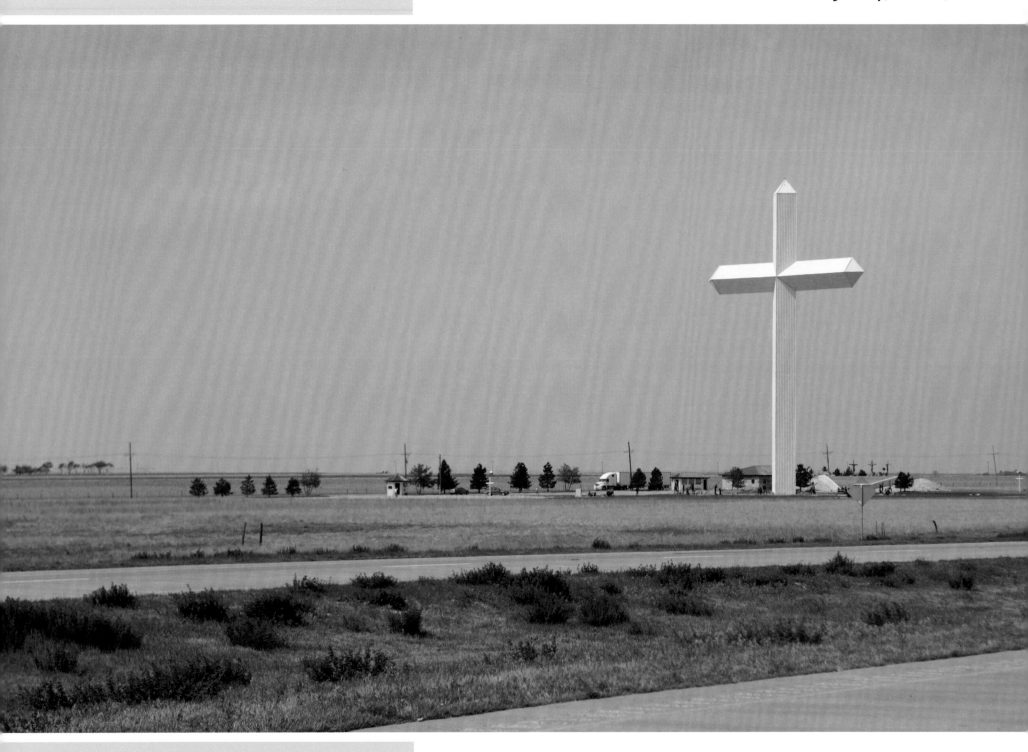

📷 **TIP**

Placing the cross on 'the line of thirds' has given a greater perspective to the image, complemented by the small buildings which add additional height to the cross.

A travel day. Driving in America is very easy as most of the roads are straight, bypassing the towns and enabling you to cover vast distances. Views along the road were often boring though – apart from this giant cross that reminded me of our own 'Angel of the North'.

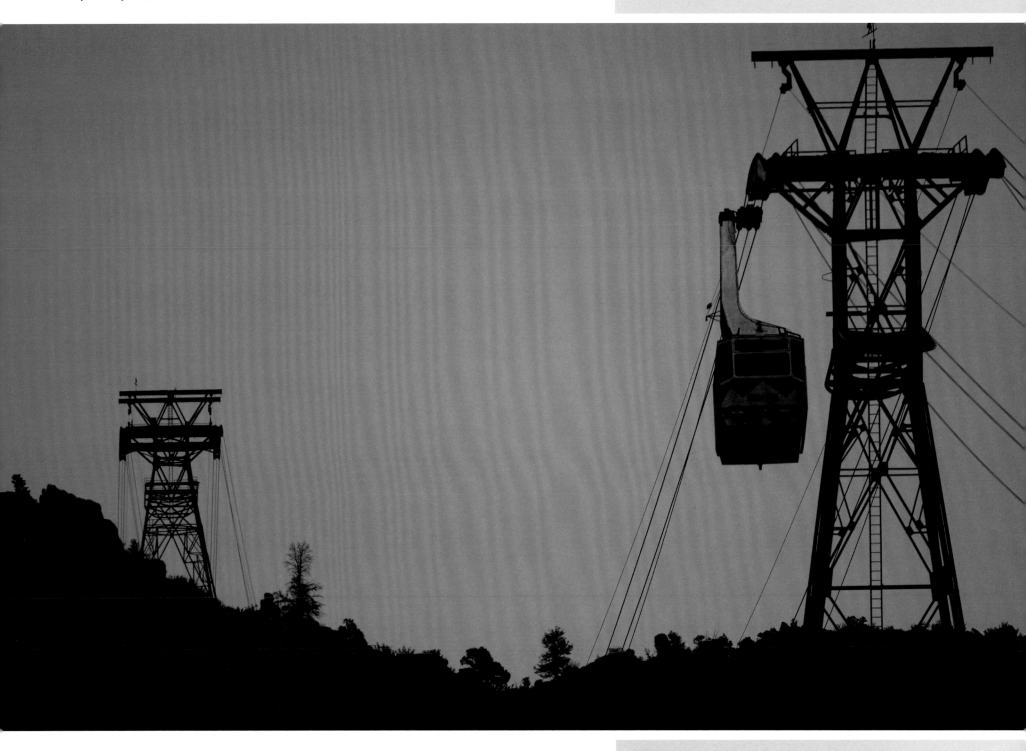

My first overnight stop is at Albuquerque, a delightful place in the State of New Mexico. I wish I had longer here and would like to come back in October to see the most photographed event in the world – the Albuquerque International Balloon Fiesta, where 700 balloons lift off in a mass ascent.

📷 TIP

By using a telephoto lens perspective is flattened, reducing distances which are actually greater than the image portrays. Evening light produces a silhouette.

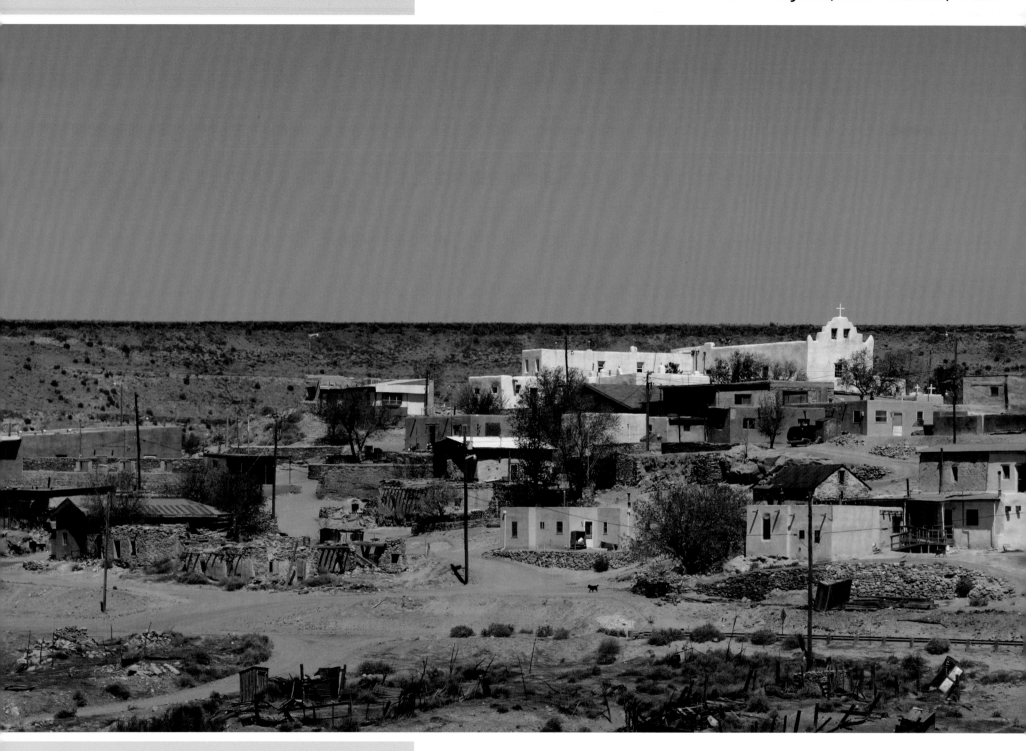

📷 **TIP**

All my rules of photography are broken in this image – no rule of thirds, nothing above the horizon line, however the textures in the structures are good and everything is in sharp focus using an f stop of f22!

A driving day through New Mexico to my destination of Williams in Arizona. Travelling through New Mexico I came across a refuge town of Pueblo of Laguna, home of the Pueblo Indians from the 1692 Spanish re-conquest.

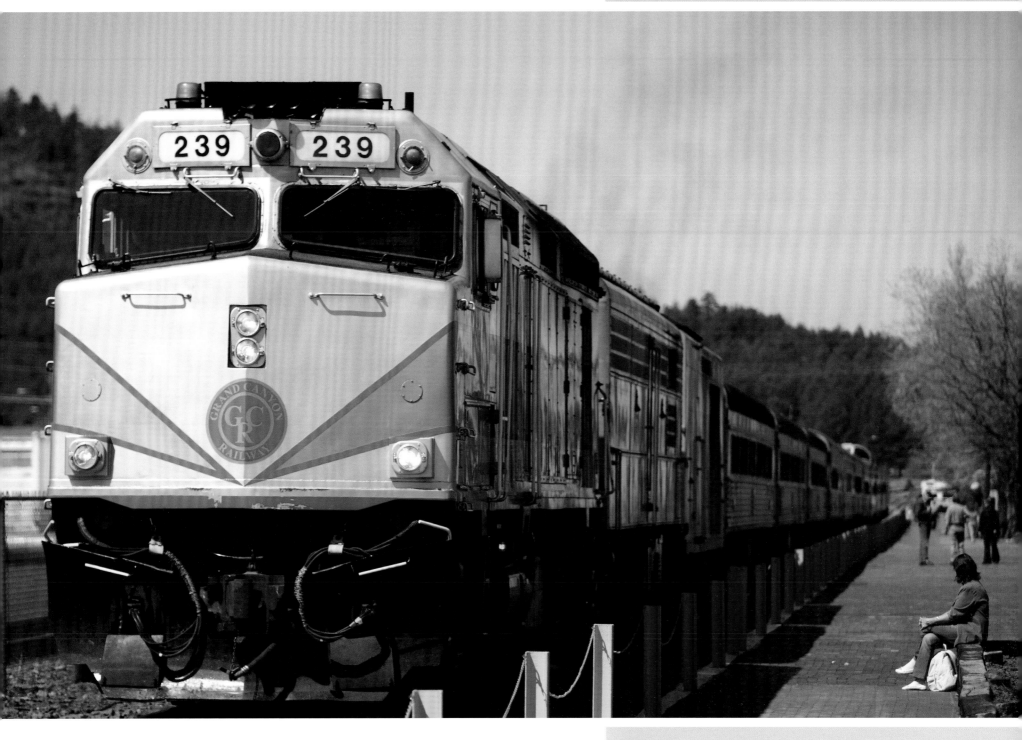

Williams is where I am staying for the next six days. It is so central for everything around here and the town is only 60 miles away from the Grand Canyon. You can catch a train from here to the canyon rim, see a gunfight before you board and even get held up later on the train!

☉ TIP

Leading lines – your eyes follow converging lines which create a strong image, together with the perspective of the passengers against the huge train.

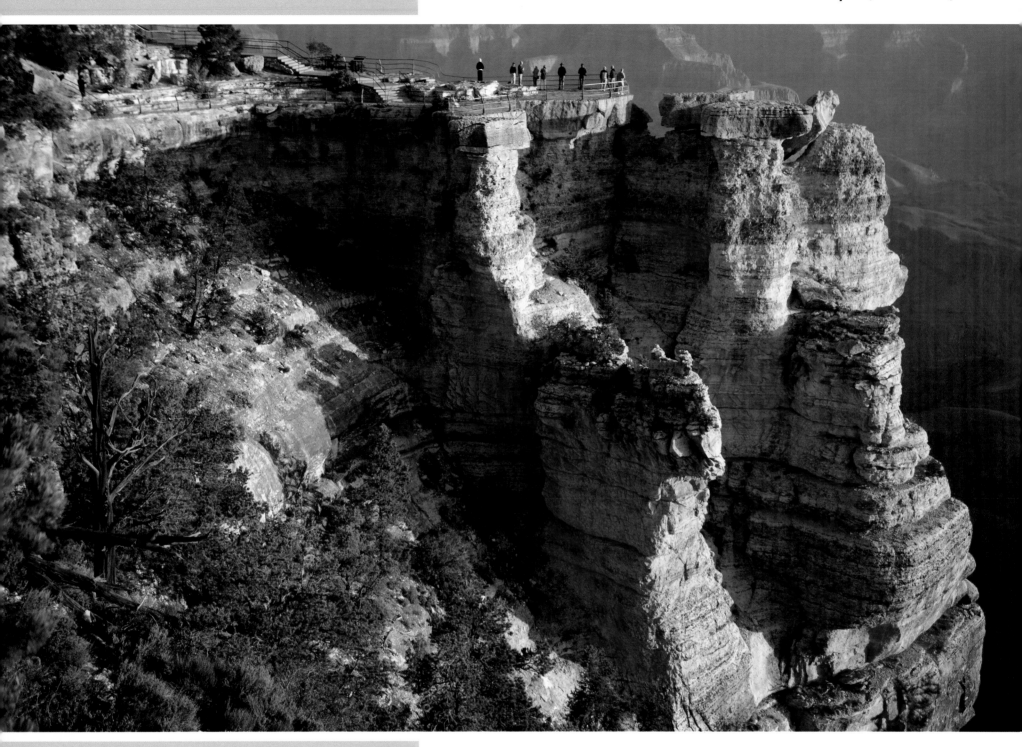

📷 **TIP**
Early mornings and evenings give the best light. At other times the light is too harsh.

This is one of the most amazing places on earth. Carved out by the Colorado River, the Canyon is 277 miles long, up to 1 mile deep and ranges from 4-18 miles wide. It took 3-6 million years to form and erosion still continues to alter its contours today. Five million people visit here every year, so I'm not the only one with it on their 'bucket list'.

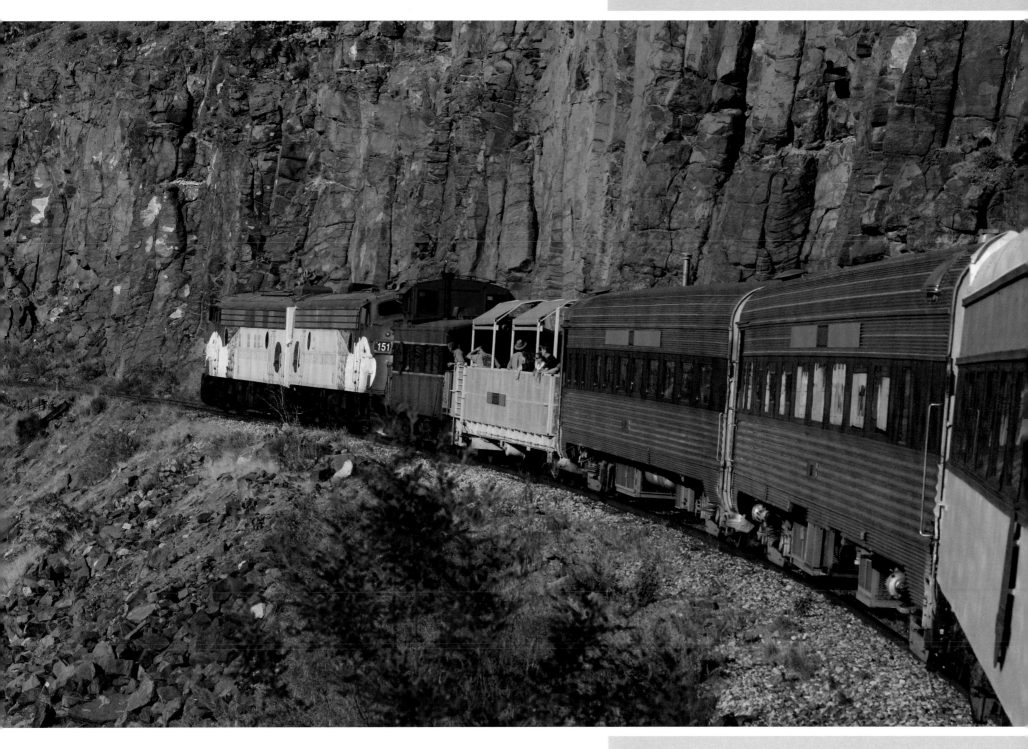

This railway is an amazing train ride through the Verde Canyon in open air viewing cars, giving perfect photographic opportunities, or in renovated passenger coaches. The journey is very picturesque with red rock pinnacles and bald eagles flying overhead. The trip takes four hours and includes a special event which varies according to the time of year.

📷 TIP
Curves in an image have the same dramatic effect as leading lines.

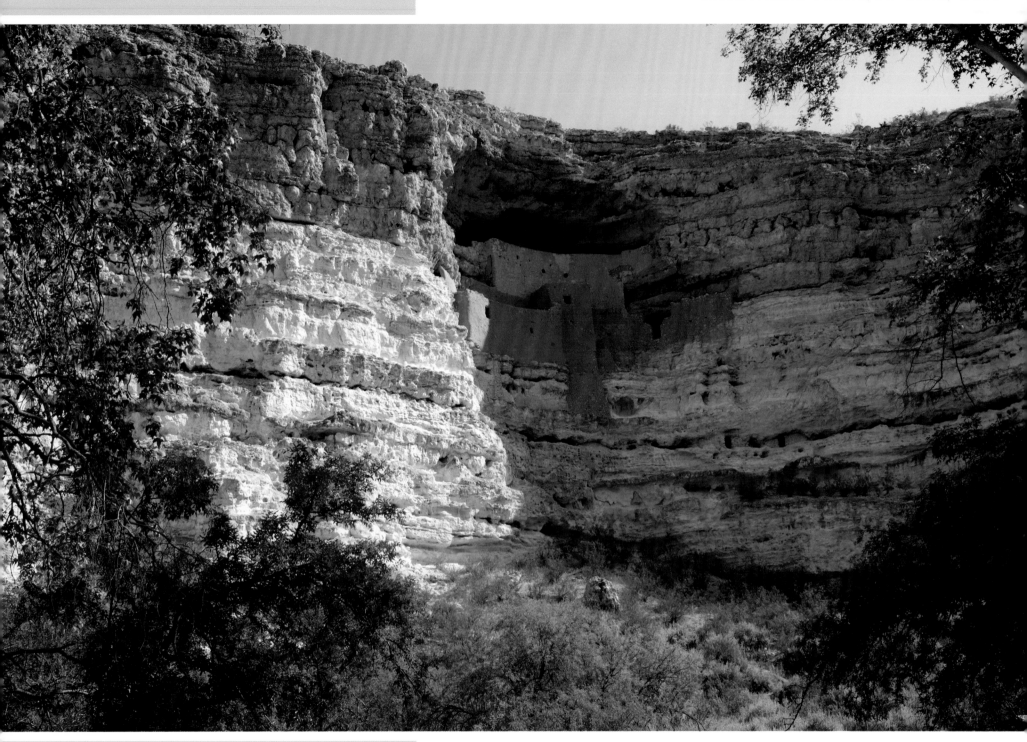

📷 TIP

Framing the subject with trees to hold the image in is something that should always be considered when taking landscapes.

The Montezuma Castle is the last known record of the Sinagua Indians. No one knows why they abandoned their habitation of this castle, which is one of the most well preserved cliff dwellings in the USA. The five storey stone and mortar dwelling contained 20 rooms and in 1425 it was home to about 50 people.

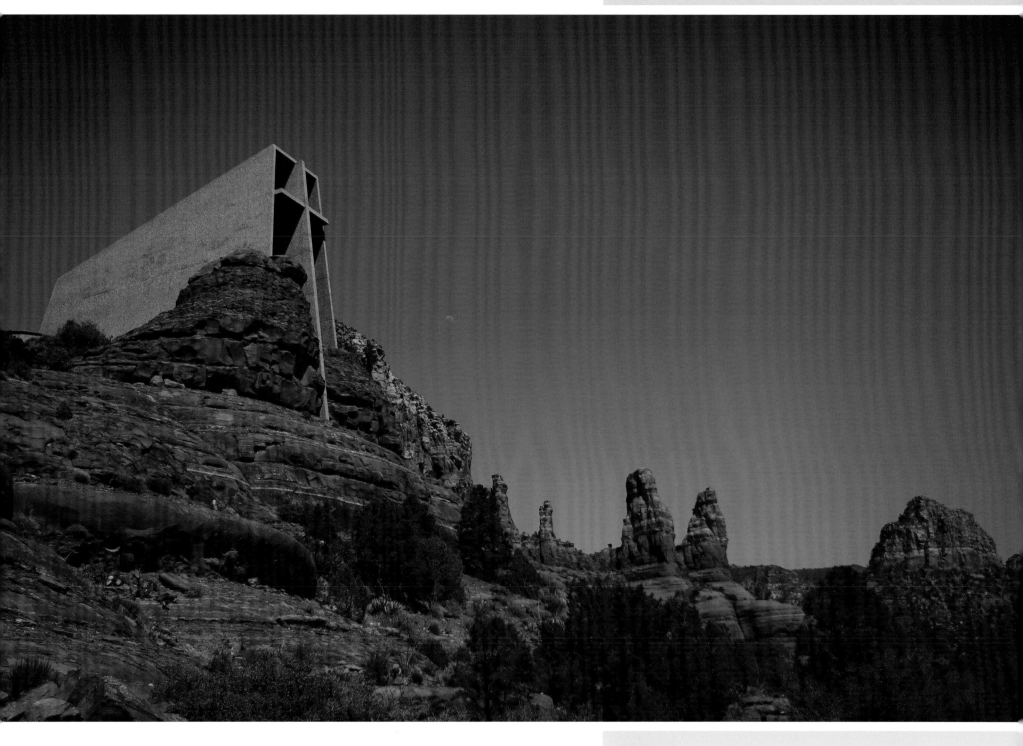

A beautiful part of Arizona with red rugged rocks towering into the blue sky. On one of these rocks is the Church of the Holy Cross built in 1956. Most modern churches have little of photographic interest compared to ones built centuries ago, but this place of worship is inspiring, set among the red rocks of Sedona.

📷 TIP

Keep a diary of places that you wish to return to e.g. cathedral rock, red rock crossing and many scenic drives – a holiday in itself.

📷 TIP

The wet surface has given me reflected light. Look for these opportunities to help with your photography.

What a difference a day makes. I got back from a lovely day in Sedona, planning another visit to the Grand Canyon and along the rim to the Desert View watchtower. Amy, my hotelier, laughed and said 'there is snow coming tomorrow, you won't see a thing in the canyon'. To my surprise at 4.30 am the whole area was covered in snow and it took me three hours to drive 60 miles.

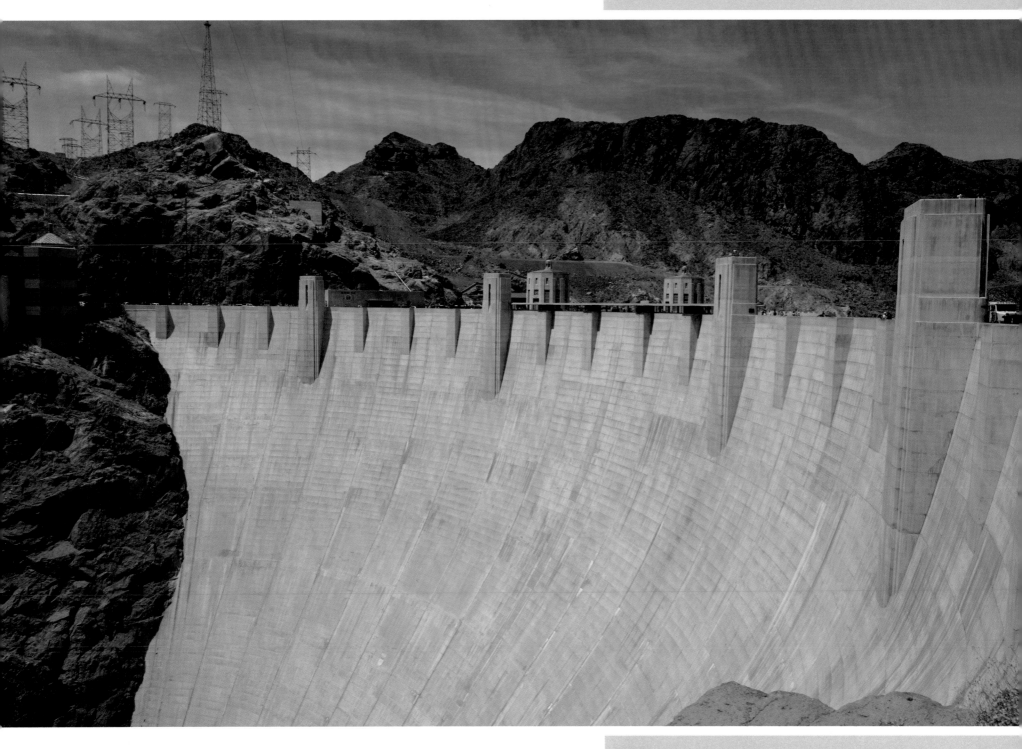

After the weather yesterday, I woke up to clear skies ready for my drive to Vegas. I would be passing through the Hoover Dam – another tick for my 'bucket list', I almost felt like a twitcher, just ticking things off. The Dam is bigger and more impressive in real life. In 1985 it was designated a National Historical Landmark and at 726 ft high and 1244 ft long it's definitely worth a visit.

📷 TIP

Wide-angle lenses helped me capture the magnitude of the size.

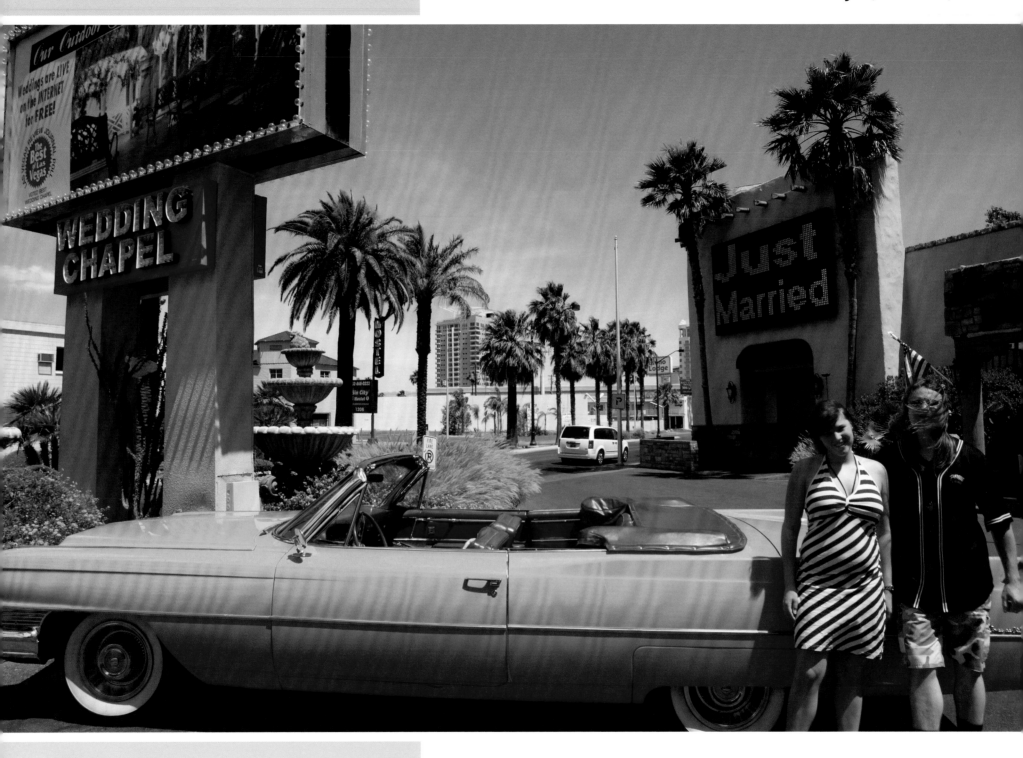

☐ TIP

Using people in images can help set the scene.

Las Vegas is open 24 hours a day but it offers more than just gambling. I had always wanted to go there but wasn't sure if I would enjoy it on my own. There are more wedding chapels than casinos here, each one more outrageous than the last. There are plenty of free things to do from seeing the Bellagio Fountains to the largest golden nugget in the world. Another tick in the box.

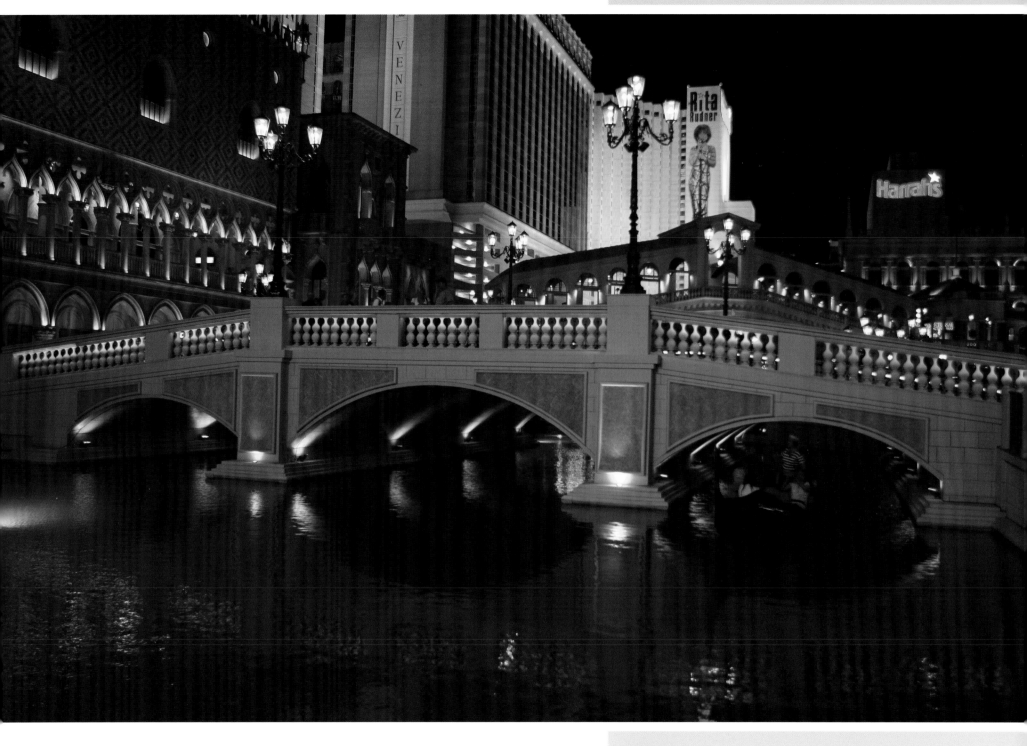

Everything about Vegas is amazing! The hotels all have free attractions inside! From the Chocolate Waterfalls of the Bellagio to the lions at MGM, the volcanic eruptions at Mirage, or even being in Venice. The hotel restaurants aren't expensive to encourage you to go in and hopefully have a gamble while you are there. You can see many top shows in Vegas too.

 TIP

Flash and tripod are best but the alternative is to use a higher ISO if these are not available.

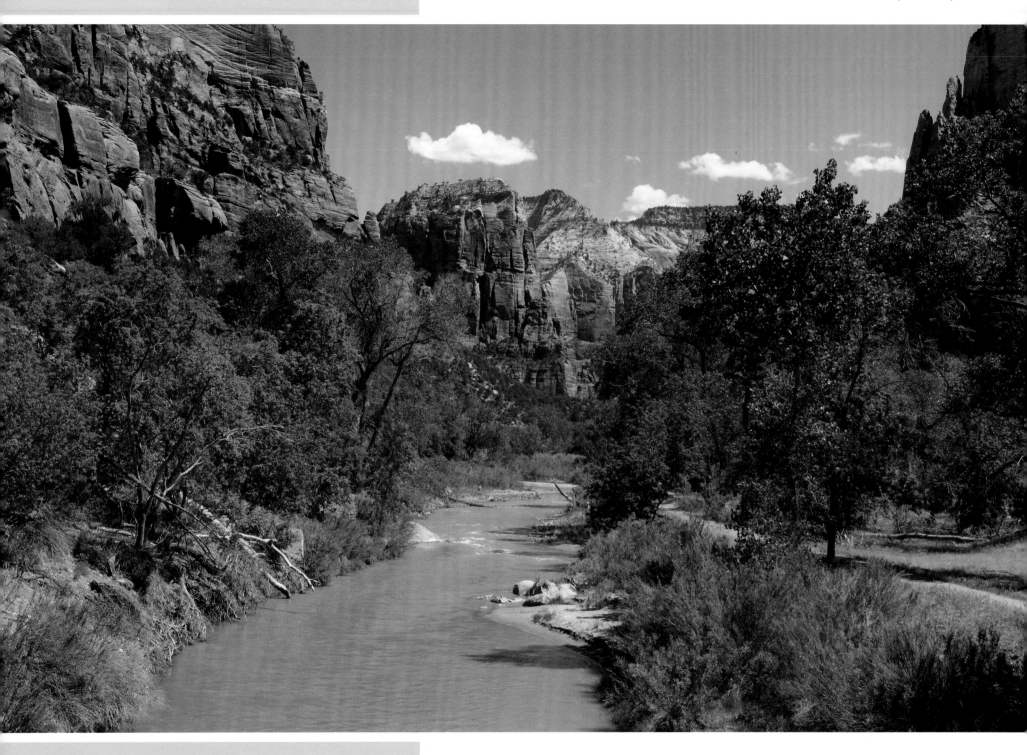

📷 TIP

Only take the necessary equipment for your trip.

Zion National Park is three hours drive from Las Vegas and I am only here for three days – not enough time to do the park justice, especially as half of it is in shadow from the high mountains due to the time of the year. You can't take your car into the park and you have to use the hop-on buses that run every 15 minutes, so in the high season it can be a bit crowded if carrying all your photographic gear!

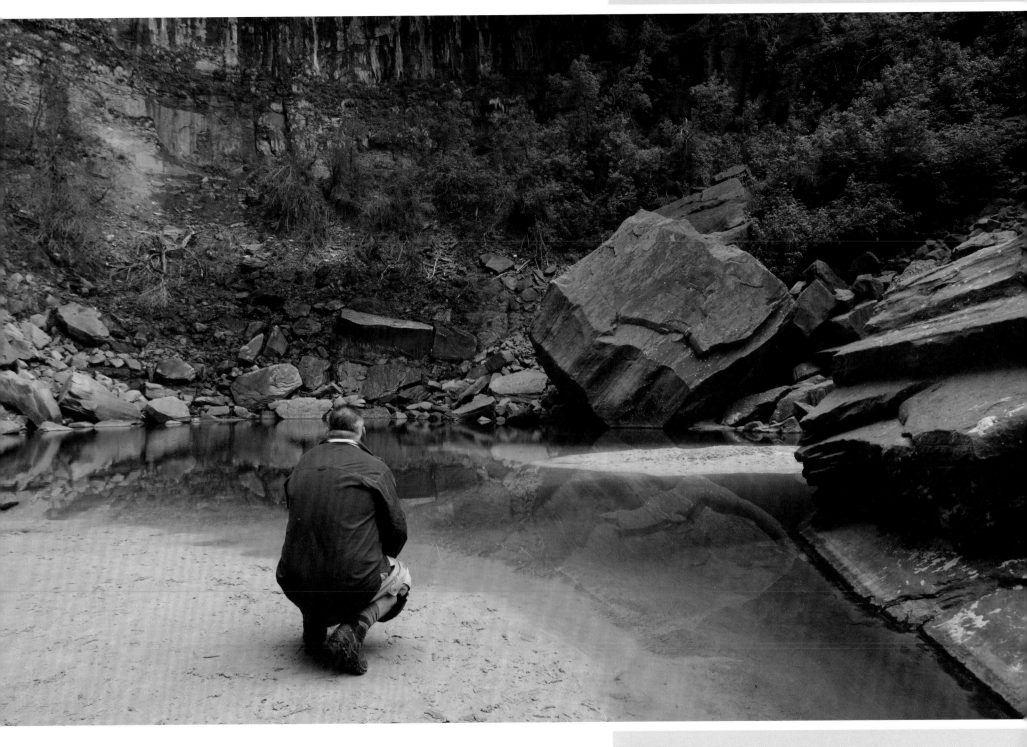

Zion is famous for Angels Landing, the Altar of Sacrifice, the East Temple and many other trails. Today I decided to walk to the Emerald Pools but it didn't live up to the hype as you will see from the image. However I have been lucky so far with more highlights than disappointments - you have to experience the lows to get the highs.

📷 TIP

Never be disappointed in what you photograph because if you don't make the journey you will never know.

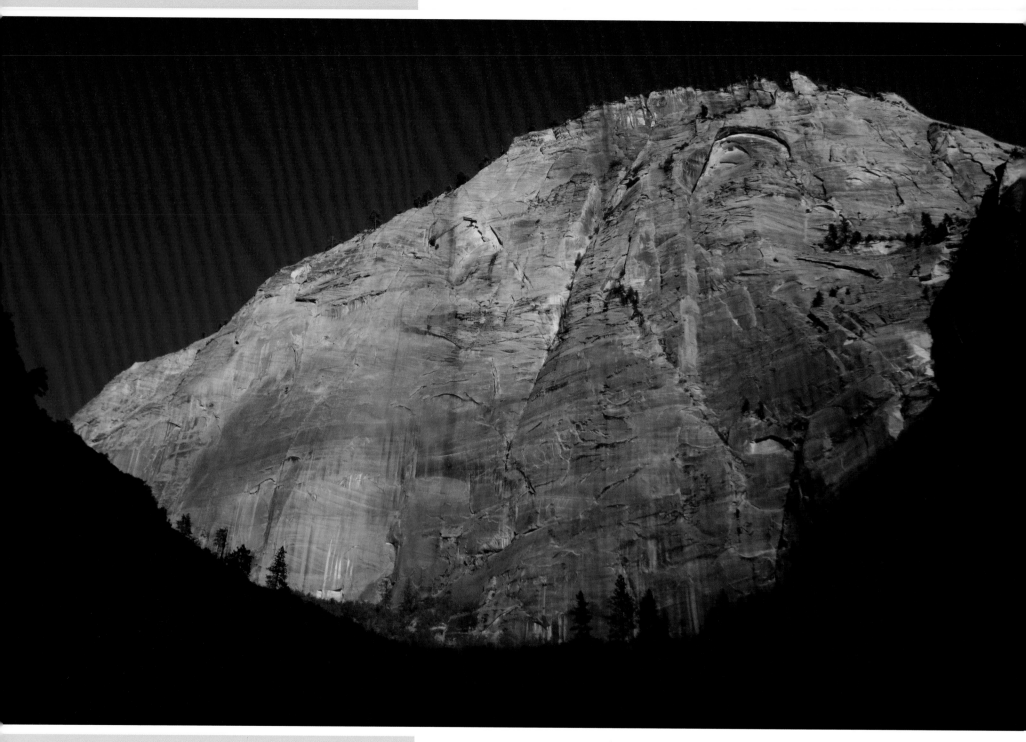

📷 TIP

Arrive early for sunrises and sunsets and find a good position for your tripod.

Weeping Rock is one of Zion's best known oasis. The short walk to the Rock offers an endless variety of experiences from the smell of wildflowers to the noise of the canyon tree frogs, which sound like goats bleating. Weeping Rock is named after the little streams that run down the face of the cliff, coming from Echo Canyon.

You will be amazed at the shifting arcs of crescent-shaped dunes and salmon-coloured sands against the blue skies and deep-red sandstone cliffs. This is a photographer's paradise but it comes with a price - the sweeping dunes have become a massive playground for quad bikes and off-road enthusiasts.

📷 TIP

Be prepared for remote location photography. Take care of your photographic equipment and also yourself. With this image in the desert I took water and a groundsheet to lie on, protecting me from the hot sand.

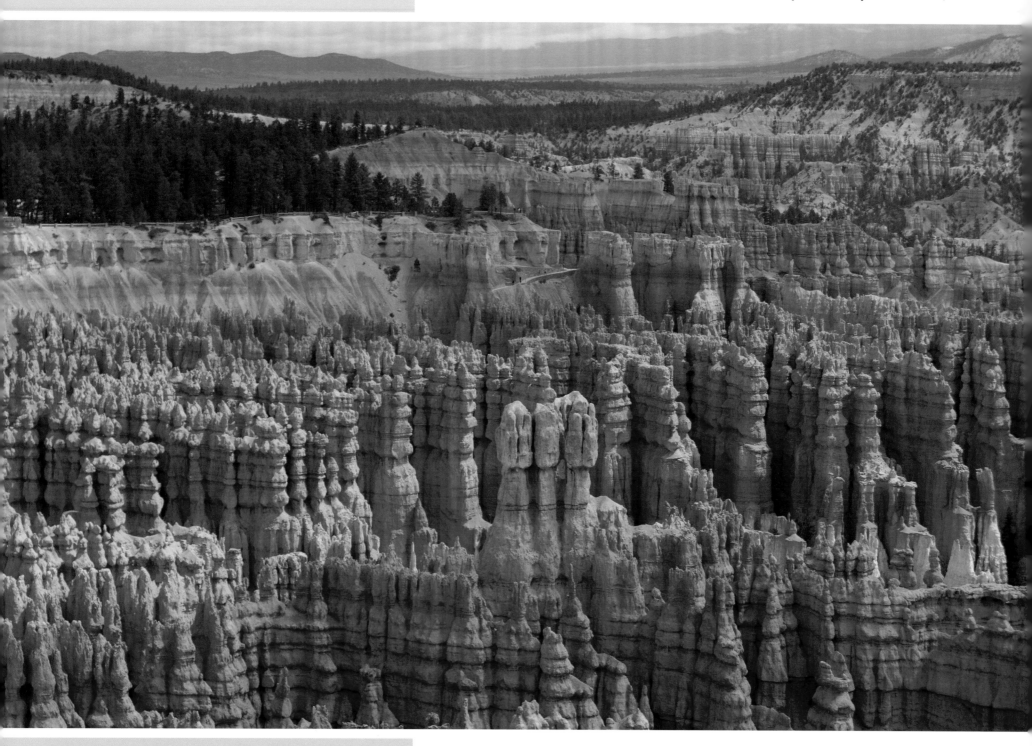

📷 TIP
Try and build in extra time for a second visit in case the weather lets you down.

Bryce Canyon is just one of the many canyons that form a series of horseshoe-shaped amphitheatres. Erosion has carved the colourful limestone into thousands of spires, fins, arches and mazes. The colour changes with the light and the weather changed all the time. I don't know where the snow blizzard came from but it cut my day short!

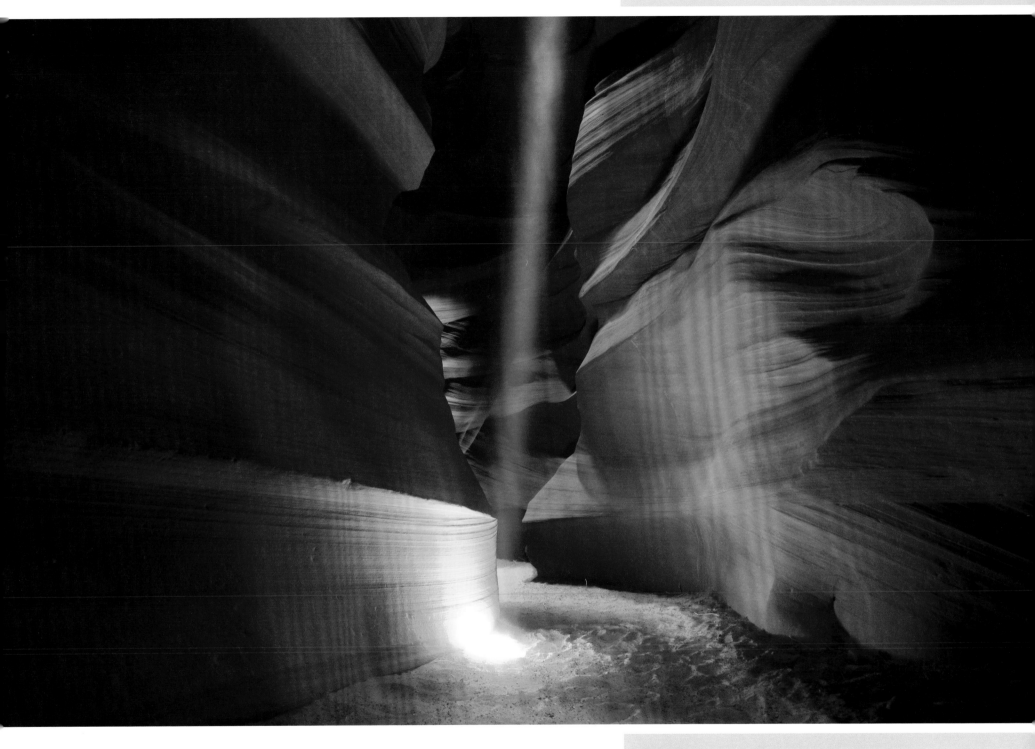

Antelope Canyon in Page. At noon a shaft of light beams down through a hole in the sandstone - a unique sight.

📷 TIP

If you really want special images you have to plan ahead. I had always wanted to achieve this image so I had to arrange this tour nine months in advance. I also had to hope the weather would be right as I only had one day and one opportunity. Normally I would try to put a weather window in, but this wasn't possible.

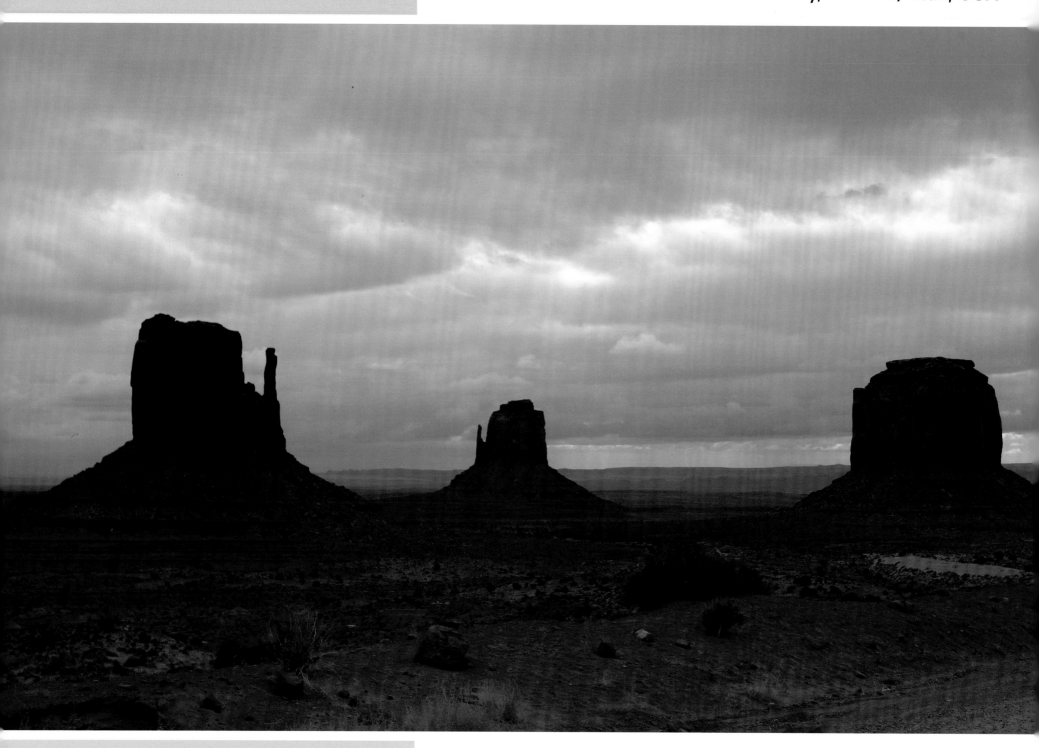

📷 TIP

Dark skies can achieve a moody image – sunshine is not necessary.

This valley lies within the range of the Navajo Nation Reservation and Highway 163 is the famous road that goes through it. The landscape is instantly recognisable from being featured in so many films, especially by the director John Ford and starring John Wayne, e.g. *The Searchers*. Other films that have used the location are *Back to the Future III*, *Mission Impossible II*, and *Forrest Gump*.

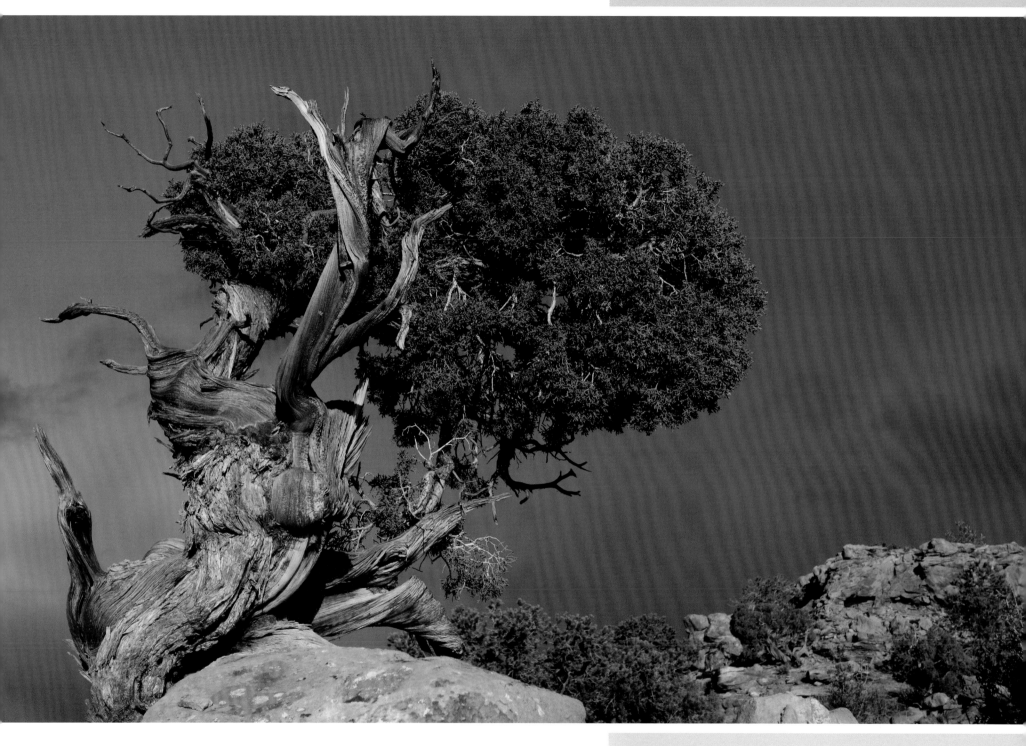

This national park is a colourful landscape with countless canyons and the Colorado River running through it. A 4x4 is needed to get around the park, unlike Archers National Park which is a short distance away.

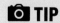 **TIP**

Images stir emotions. While taking this image, in my head I could hear my mate Chris saying 'not more trees' – whenever we were out on photographic days I would always take tree images.

📷 **TIP**

Use people to maximise perspective.

I was really keen to see and photograph this park as it has over 2,000 natural sandstone arches, including the world famous Delicate Arch – what they don't tell you is that it is a three-mile hike to see it. The extraordinary features of the park create a landscape of contrasting colours and textures; the only sad part was that I couldn't stay for the sunset as I had a long drive to my next destination.

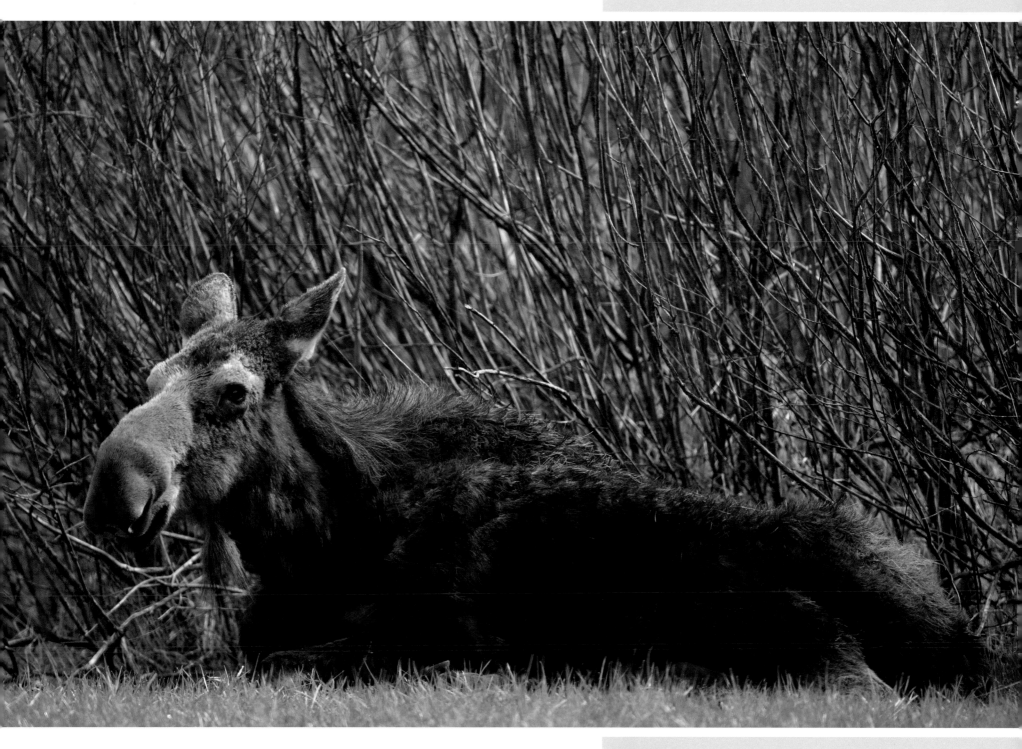

Grand Teton is my favourite National Park in America and joins onto Yellowstone. It was especially difficult to know what image to put in this book to represent the day. Knowing the park well, I had several images in my mind from Oxbend and the sun rising over the mountains, to Jackson Hole itself. The image I chose was for my Dad as he went to Alaska and never saw a moose!

 TIP

Lying down gives me the eye-level perspective of this female moose.

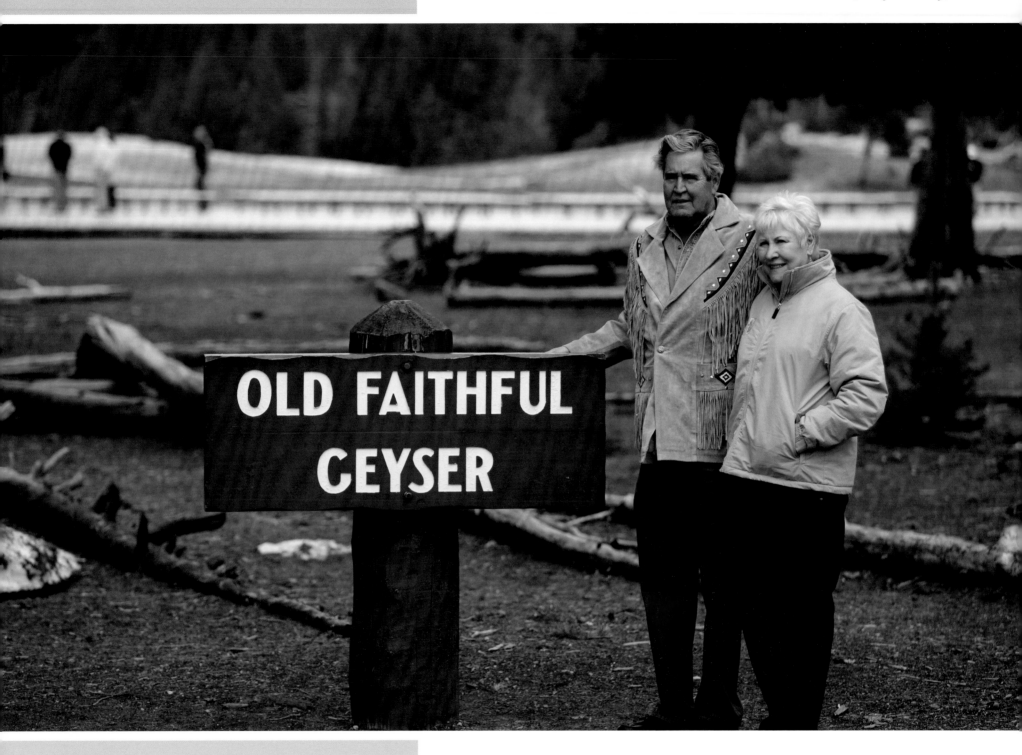

OLD FAITHFUL GEYSER

 TIP

Using people and signs can give your photography a humorous slant.

The park was established in 1872 and was the first of its kind. It is known for its wildlife and many geothermal features especially the Old Faithful geyser. The park covers an area of 3,468 sq miles comprising lakes, canyons, rivers and mountain ranges. The Roosevelt Arch is located at the north entrance, and the plaque reads 'for the benefit and enjoyment of the people'.

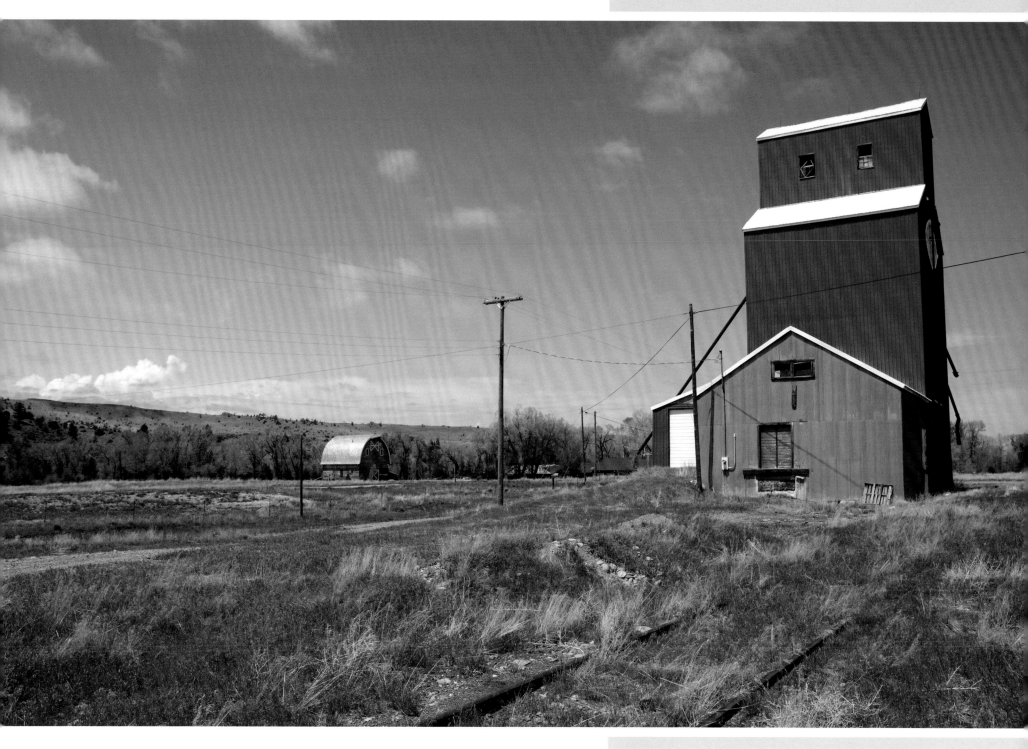

I have finally made it to Montana where I hope to do some very special photography - this is the reason I have had to keep on the move and be strict with myself on the length of time I could spend in any one place. I will be going to the Glacier National Park to take images of its wildlife and lakes. This is the most northern national park in America, and is only seven miles from the Canadian border.

 TIP

Use the thirds rule to create a good image.

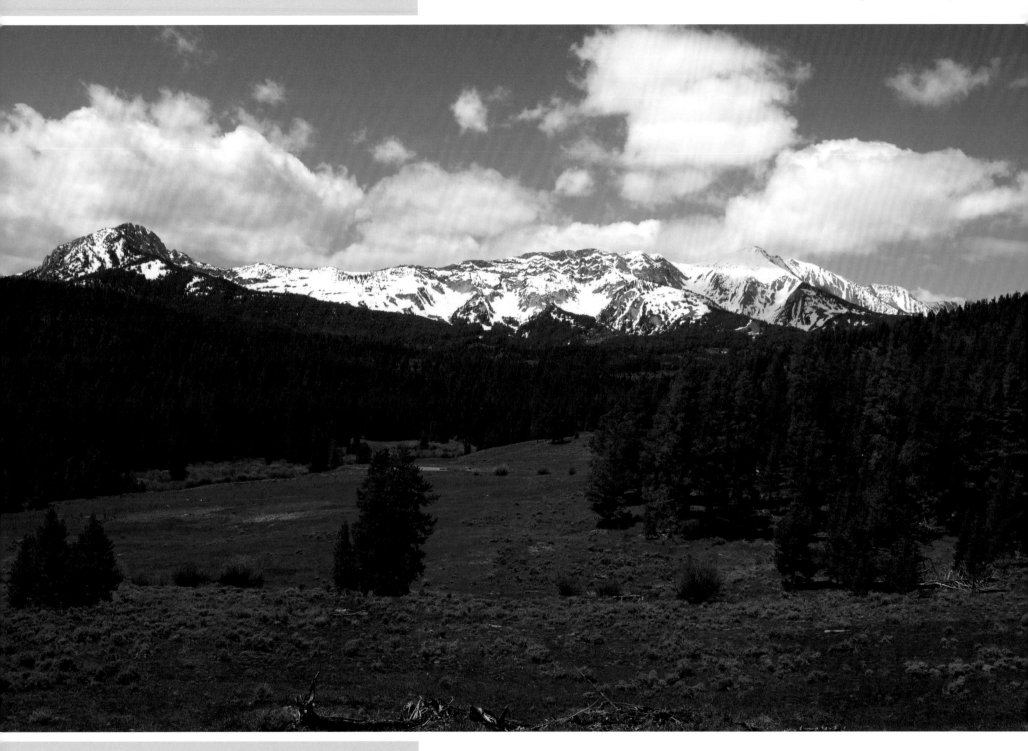

📷 **TIP**

Choice of lens – this image has been taken with a wide-angle lens; perhaps I should have used a telephoto lens and isolated the snow-capped mountains for a better image. A landscape photograph doesn't always have to be with a wide-angle lens.

In the south western part of Montana, Bozeman is a thriving town approximately two hours from Yellowstone. The landscape around this area is lovely and the snow-capped mountains and meadows were only 20 minutes away from Bozeman itself.

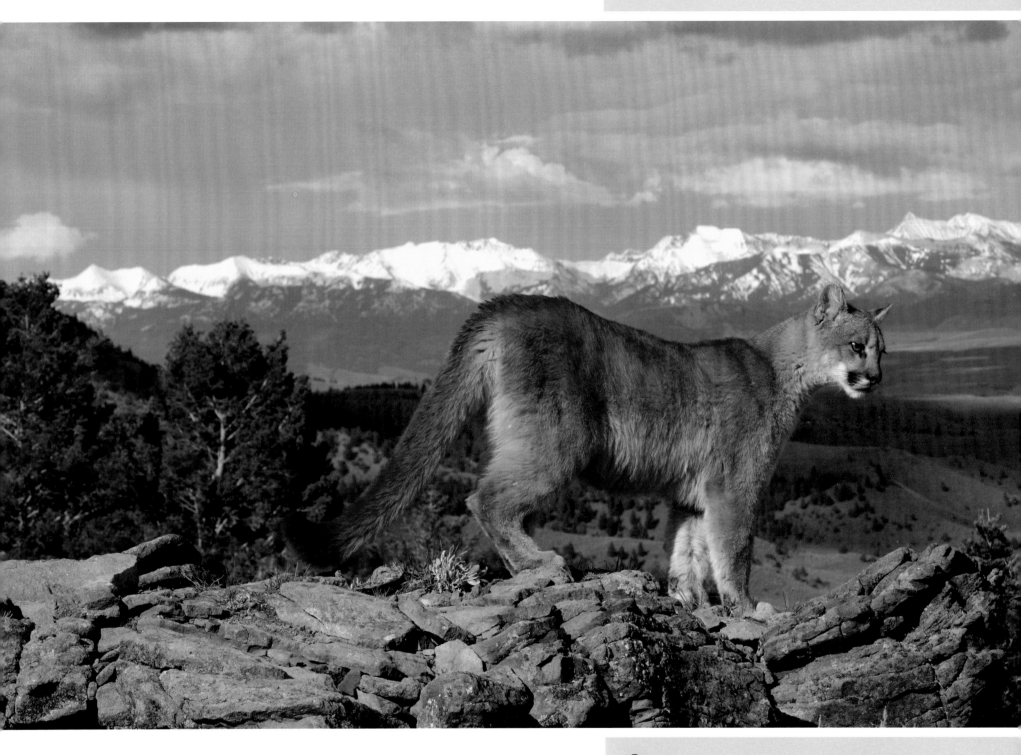

Animals of Montana is a very special place run by Troy and Tracy. Troy is a professional animal trainer and his animal actors live in the Montana mountains where the climate is dry and cold, allowing them to grow shiny, healthy, winter coats. His animals are highly trained, experienced and popular in both the photography and film industries. I have come here to take images of these animals in a 'once in a lifetime' opportunity.

📷 TIP

If you wish to be photographically correct, the puma/mountain lion should be moving into the picture instead of out, but stunning images don't always conform to rules.

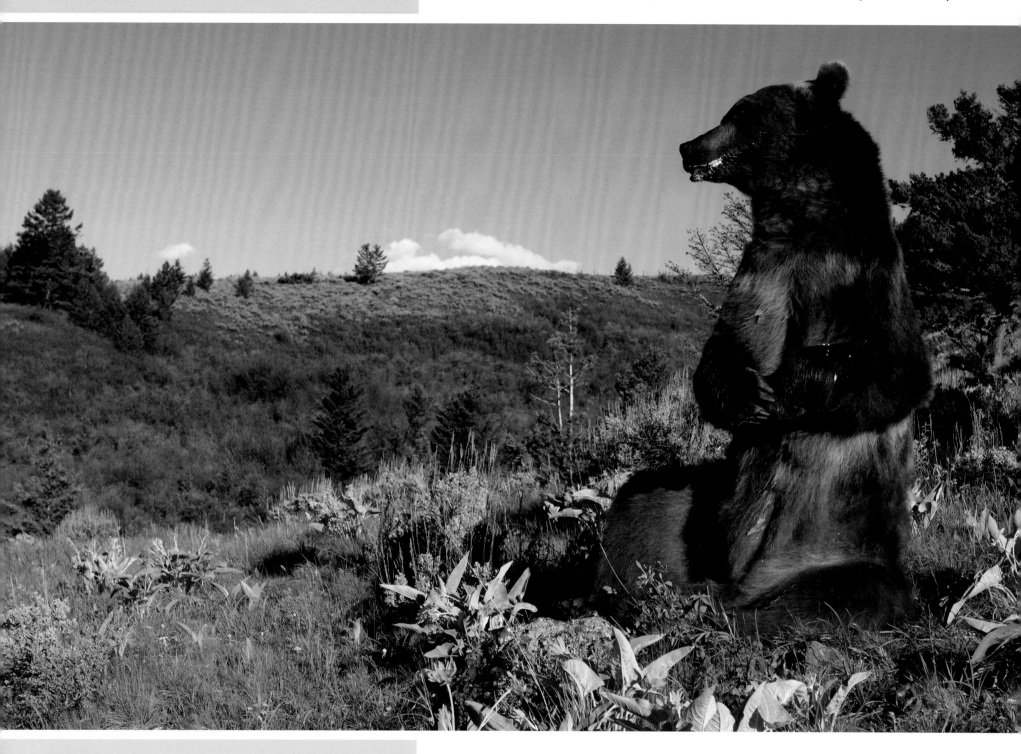

📷 TIP

As I was in controlled conditions, I could use my wide-angle lens to show this grizzly bear in its natural environment. An f stop of f16 ensured sharpness front to back for this image.

Photo shoots like these have been used over the years by many professional photographers to capture the amazing photographs that you need for world class imagery. As long as you don't claim that the animals or birds are wild then you are not breaking any rules of wildlife photography. I have actually seen other zoos and reserves offering this type of photography, but you can't beat Troy's place and the understanding he has with his animals.

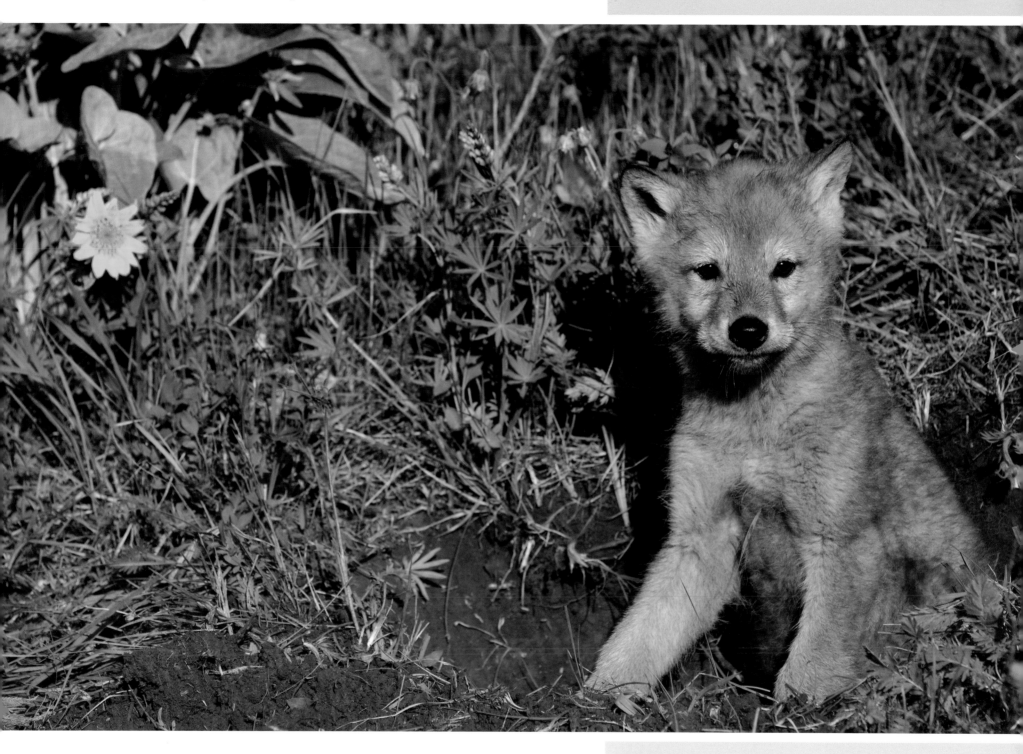

Using natural habitats and early morning or evening light, gives you maximum opportunity for world class photography under controlled conditions. During my visit I took images of many North American species including mountain lions, grizzly bears and wolf pups all in their natural surroundings out in the spectacular mountain ranges and wilderness.

📷 TIP

To find a wolf pup in the wild and repeat this image would be nearly impossible. This type of photography is always welcomed by photographic libraries and agencies.

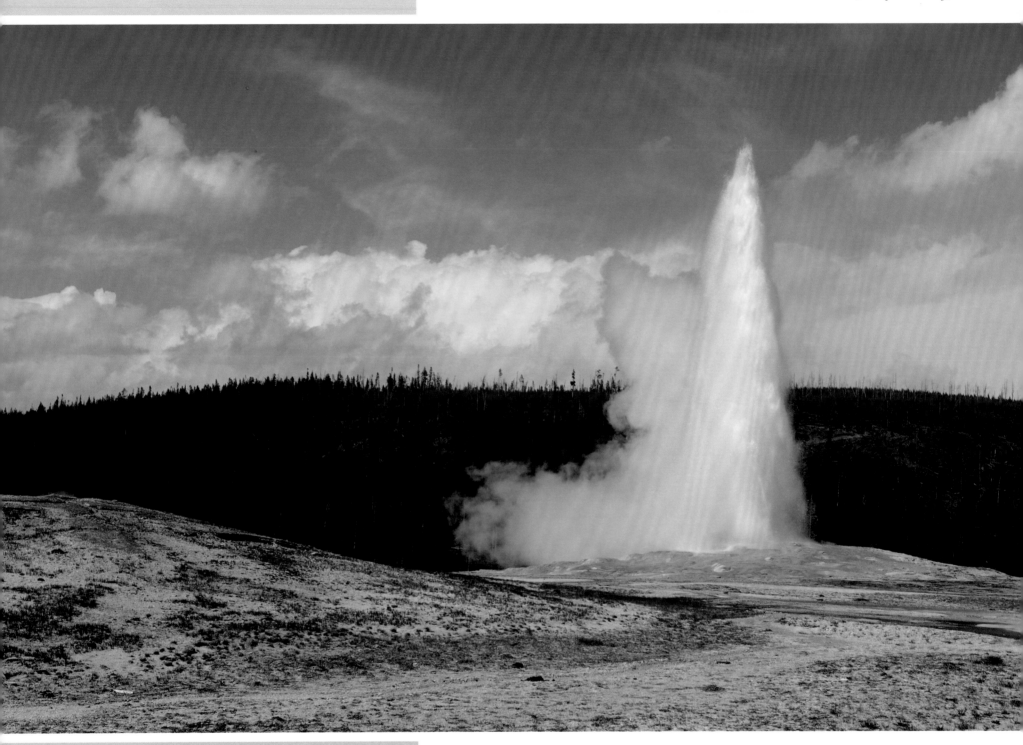

📷 **TIP**

Sharing knowledge with others is learning itself.

With Yellowstone only two hours away I went back there with John Torre, a fellow photographer I met at Animals of Montana. We left at 5 am to get a good day in the park. I had bought a National Park card which lets you in free for a whole year to all the national parks. It was John's first time in Yellowstone and it is always a pleasure to share your knowledge with someone.

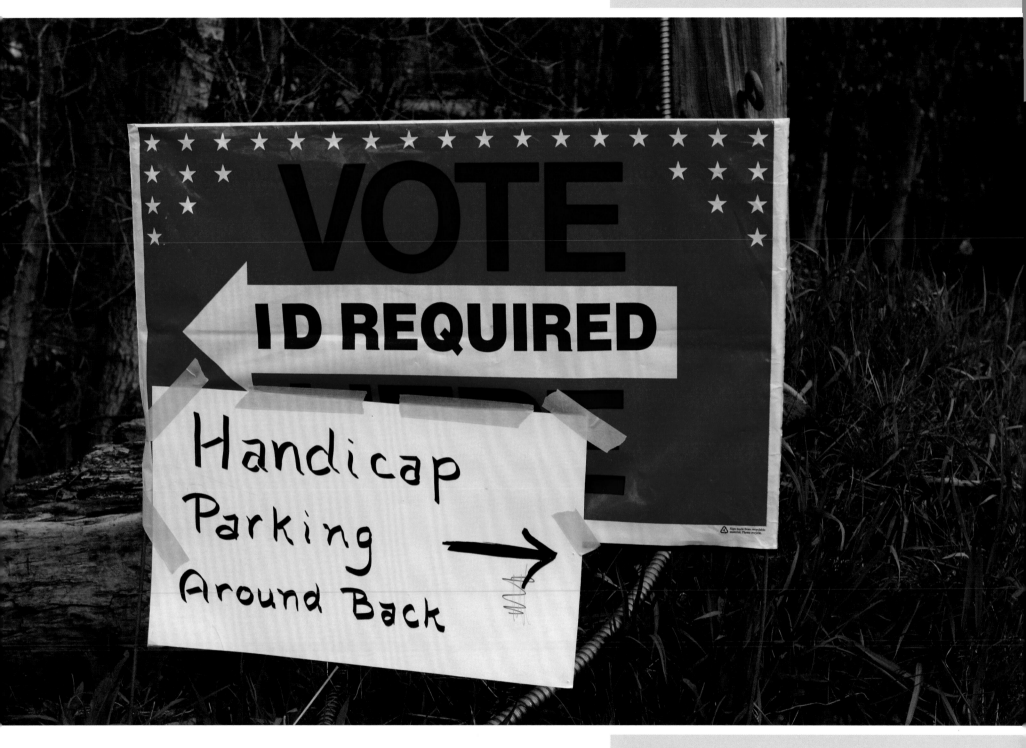

The race for the White House is in full flow and the people of Bozeman are invited to vote today. My humorous slant on life made me think that the signage was inappropriate as those with disabilities appeared to have further to walk than those more able! Other peoples' thinking is not always in tune with my own.

📷 **TIP**

Caption photography can be humorous and informative. Select your topics with care.

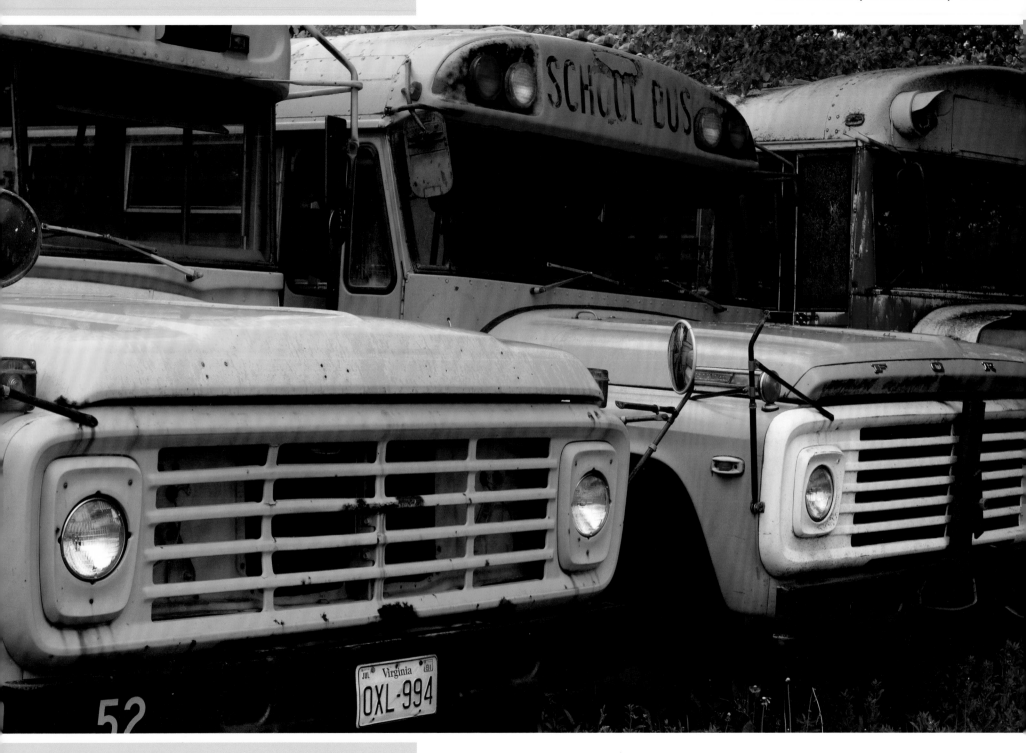

📷 **TIP**

Filling the frame can give a different perspective to your imagery.

Yellow school buses left in a field to rust away is my image for today. With no particular plans and nothing in mind to photograph, it was a case of just driving around to see what inspired me. Seeing these yellow buses, which are part of the American way of life, spending their last days derelict and forgotten I thought I would immortalise them forever.

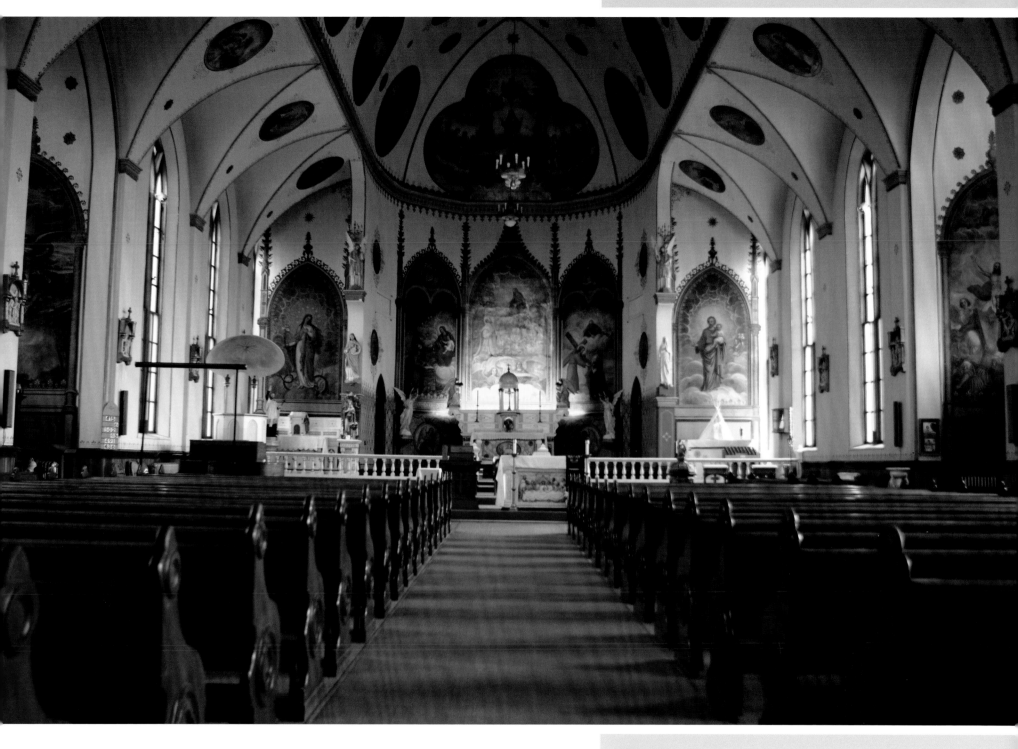

This was one of those days when the travel bug hits you. I want to keep exploring and travelling to find hidden gems like this. St Ignatius Mission was built in the early 1890s and is beautiful inside. This Catholic Church is unique because its walls and ceilings have over 60 original paintings by Brother Joseph Carignano. Two paintings are special because the Salish Lord and the Lord's Mother are both painted in native American form.

 TIP
Natural light versus flash?

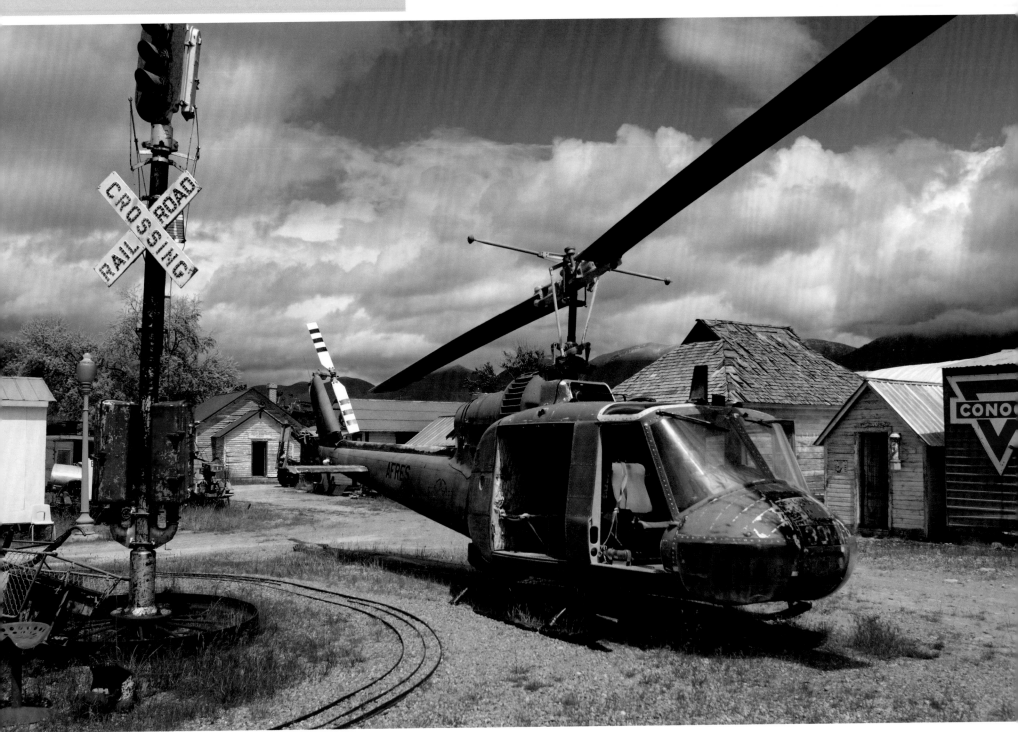

📷 TIP
Straight and curved lines keep the eye concentrated on the focal point of the image i.e. the helicopter.

The city of Polson was my next port of call and again, like yesterday, I found a little gem. The Miracle of America Museum is unique and all about American history and way of life. What makes this museum special is that it is all the work of Gil and Joanne Mangles who started the museum in 1981.

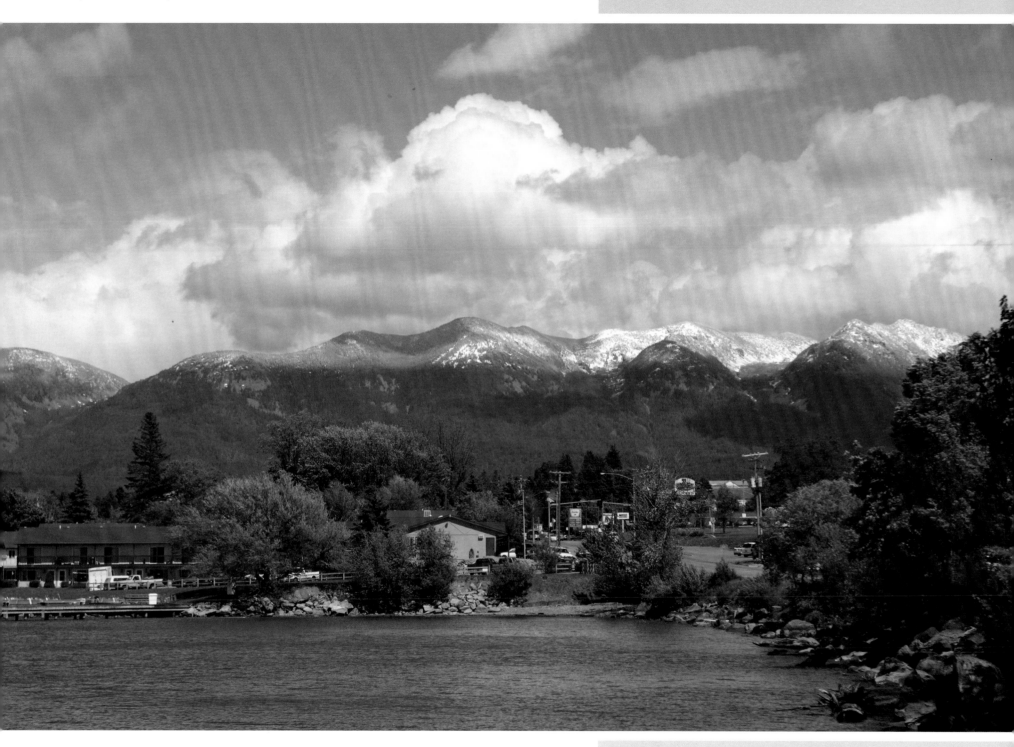

Polson was not somewhere I had intended to stay but with the last two days so full and exciting, I needed to sleep and plan the next leg of my trip. Polson is nestled at the south end of Flathead Lake which covers 192 sq miles and has cherry orchards alongside the water. Polson also has a micro brewery which I enjoyed sampling before resting my weary head.

 TIP

The thirds rule works, giving a well-balanced image of this delightful scenery.

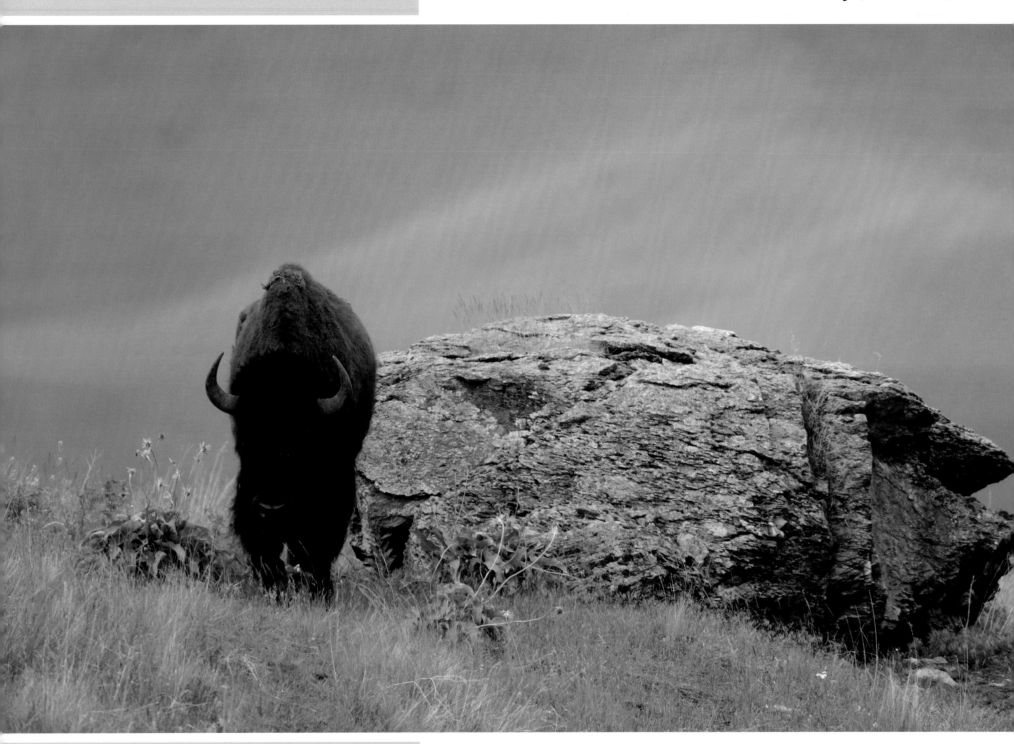

📷 TIP
Wildlife parks give you the opportunity to take images and close-ups from the safety of your vehicle – a portable hide.

The National Bison Range was established in 1908 and is one of the oldest wildlife refuges in the USA. The park was set up to save the American bison – it has over 350-500 head of bison as well as other wildlife. The park is open grassland so it is a great place for excellent wildlife photography.

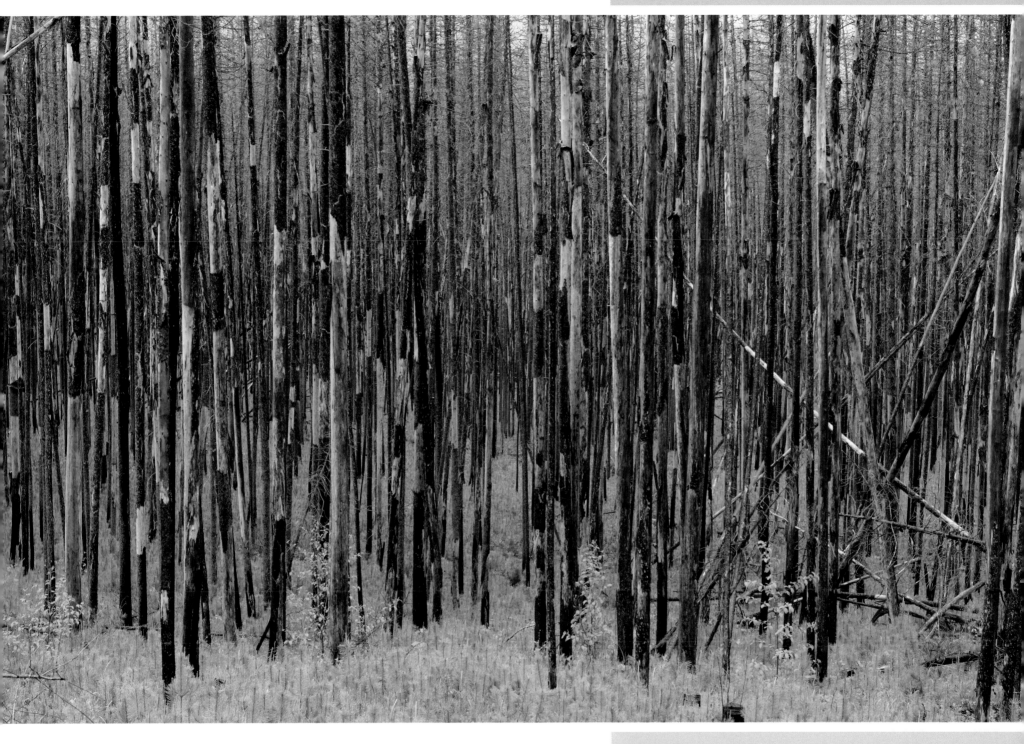

This park was established in 1910, and was home to the Blackfeet Indian in the winter – their reservation now borders to the east of the park. In 1932 the Going-to-the-Sun Road was completed and is the only route that ventures deep into the park, giving access for hiking. With heavy snow six months of the year the park is not easy to explore.

 TIP

Look for patterns and contrasting colours in your photography.

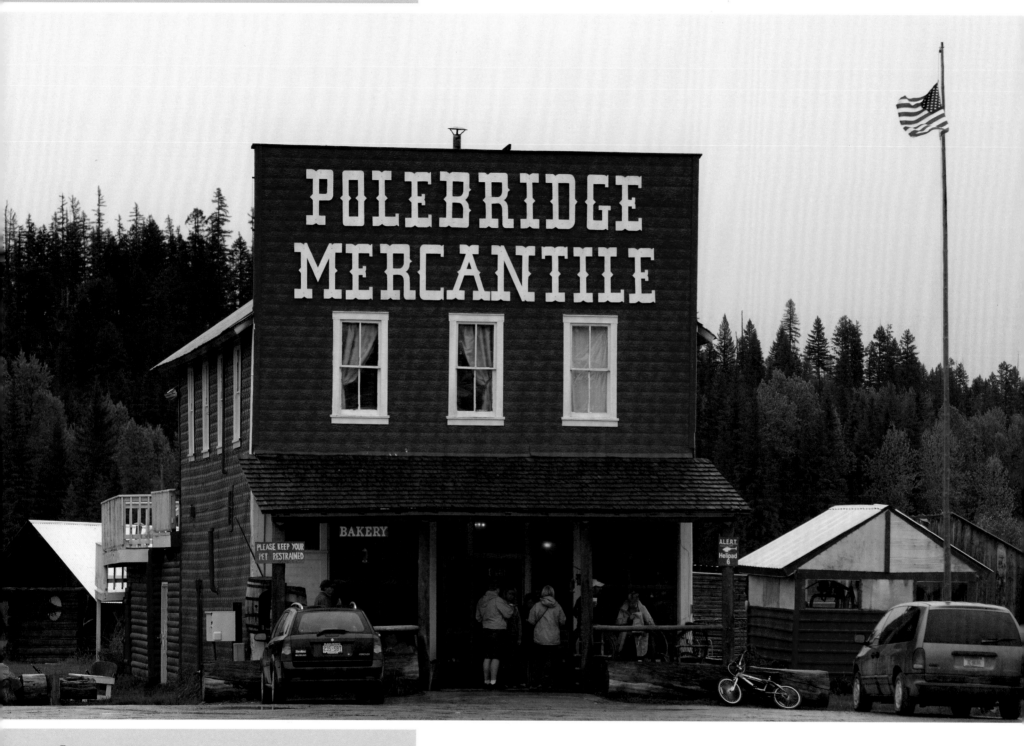

📷 **TIP**
A bland sky doesn't help images – look for clouds to break up the vast grey expanse.

Polebridge is next to Glacier National Park and is a sleepy little town of 25 inhabitants. It has a mercantile which sells the famous cookies that people travel up from the park to buy. The local bar serves beer in jam jars and Polebridge has one of the best hostels I have ever stayed in. It is called the Northfork and has a hot tub where you can relax and look up at the stars with a glass in hand!

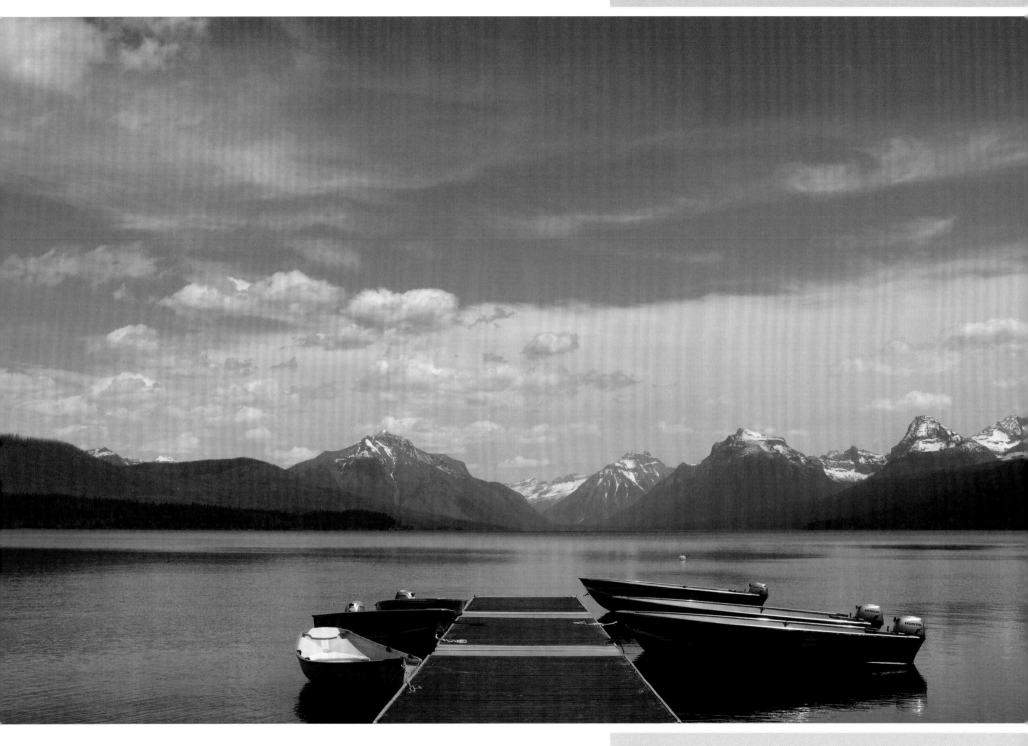

Glacier National Park is 4,102 km sq, and has over 130 named lakes, thousands of species of plants and hundreds of species of animals. Due to the park's remoteness the wildlife that is here is more plentiful but you still have to look for it. McDonald Lake is the largest lake in the park at ten miles long and more than a mile wide. It lies in a giant bowl and is surrounded by thick forest and towering mountains.

📷 TIP

Popular tourist attractions can be busy places. Early morning photography avoids the crowds, but saying that, I could have taken the same image with people in it giving a different picture.

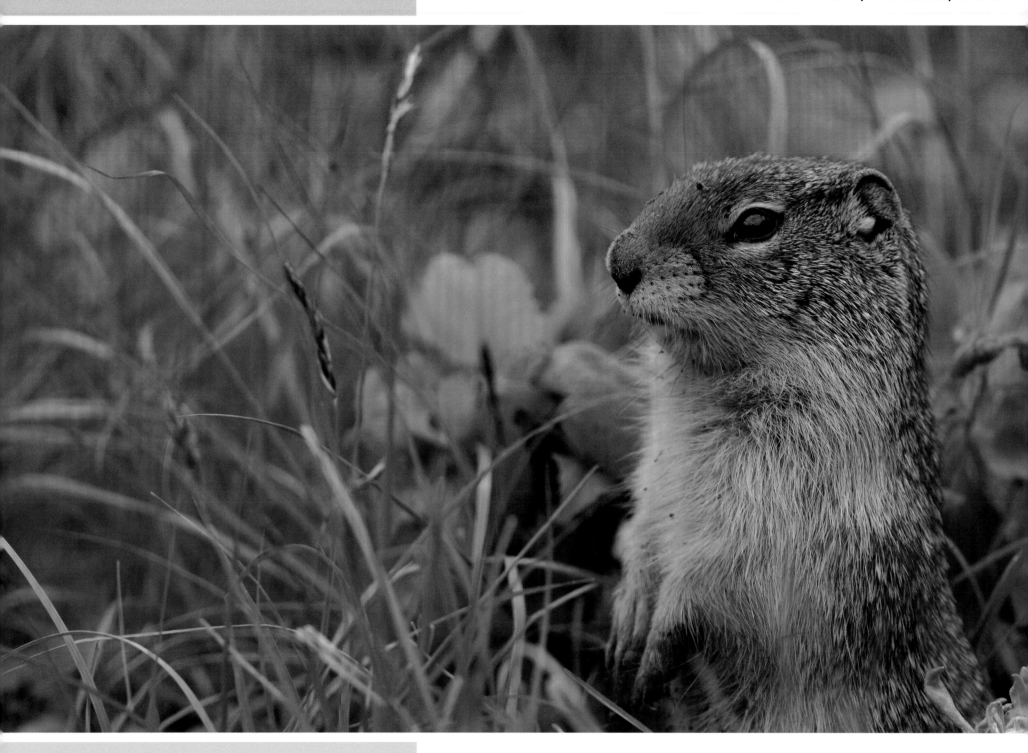

📷 **TIP**

By watching the behaviour of this Columbian ground squirrel from my car, the squirrel wasn't threatened by my presence. Using a beanbag placed on the window, I was able to photograph the squirrel coming in and out of his hole all day long. By using a long prime lens and a stop of f8, the background is blurred but retains a little definition, enhancing the close-up of this creature.

One of the reasons for going to Glacier National Park was to photograph their wildlife, especially mountain goats.

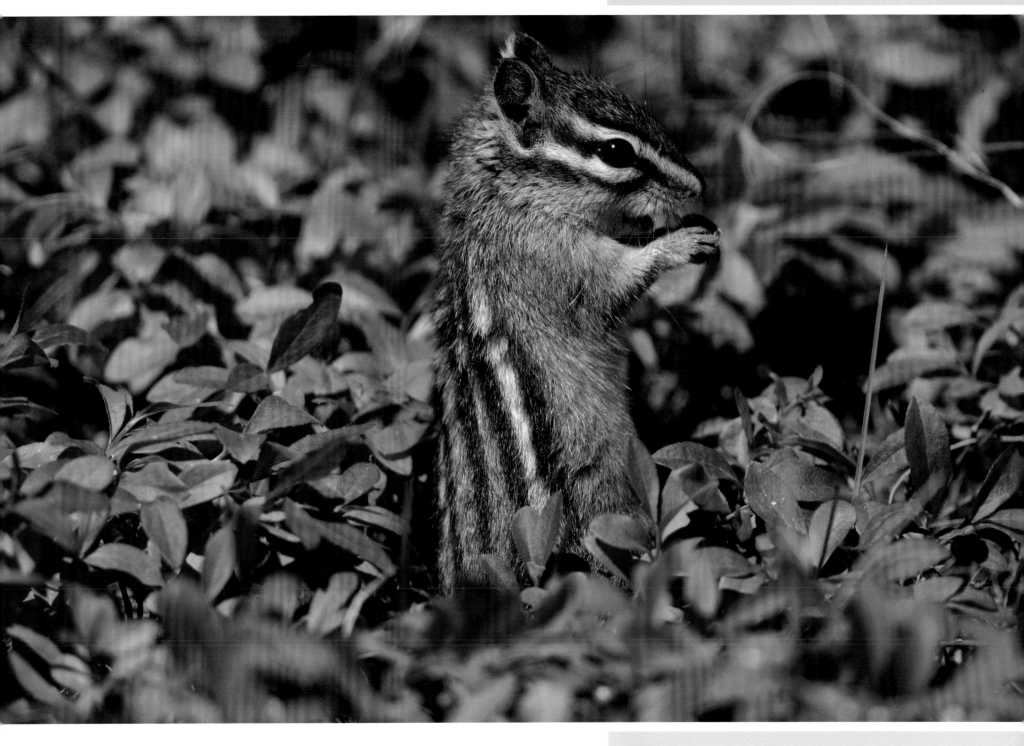

There were no mountain goats because of the heavy snows which made access to the higher slopes impossible. So chipmunks were the order of the day.

📷 **TIP**

By lying down I managed to become invisible, and was at eye-level with the chipmunk. After a while it was accustomed to me being there and carried on with its natural way of life, eating berries and scurrying around. The catchlight in the eye makes the image come alive.

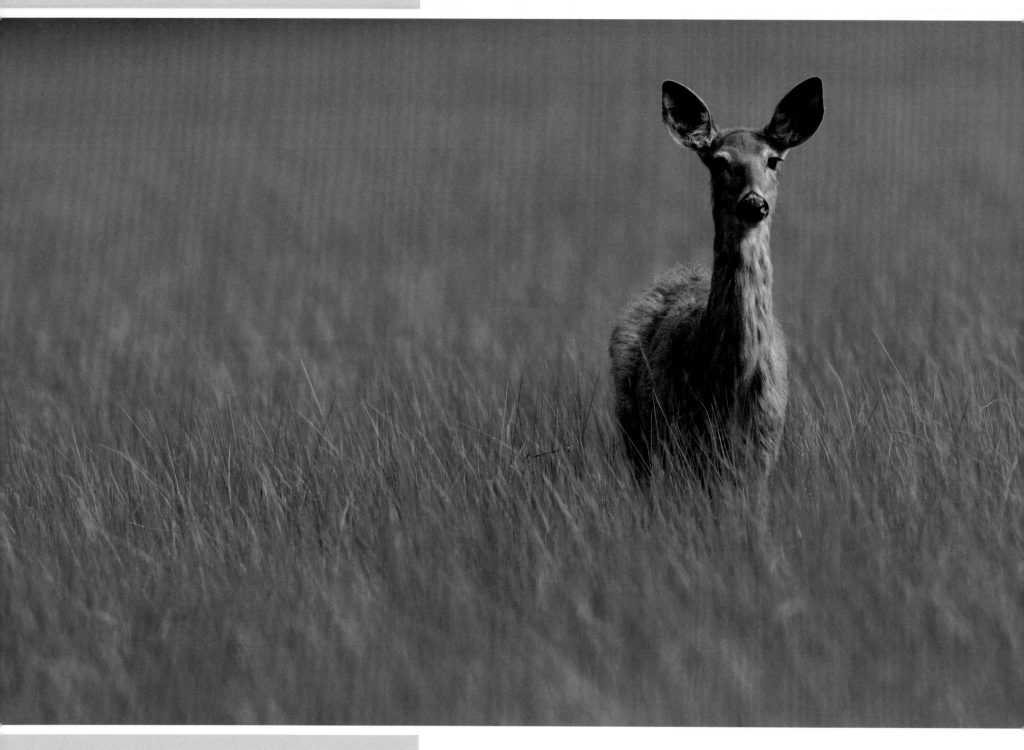

📷 **TIP**

My wildlife fieldcraft helped me achieve this image of a white tailed deer surrounded by lush green grass. The doe was on the far side of the meadow when I saw her. I positioned myself at the edge of the clearing and stood very still, knowing that deer are inquisitive by nature and would come closer.

The previous day I had noticed deer in a nearby meadow, so today's objective was to photograph the deer in a background of all one colour.

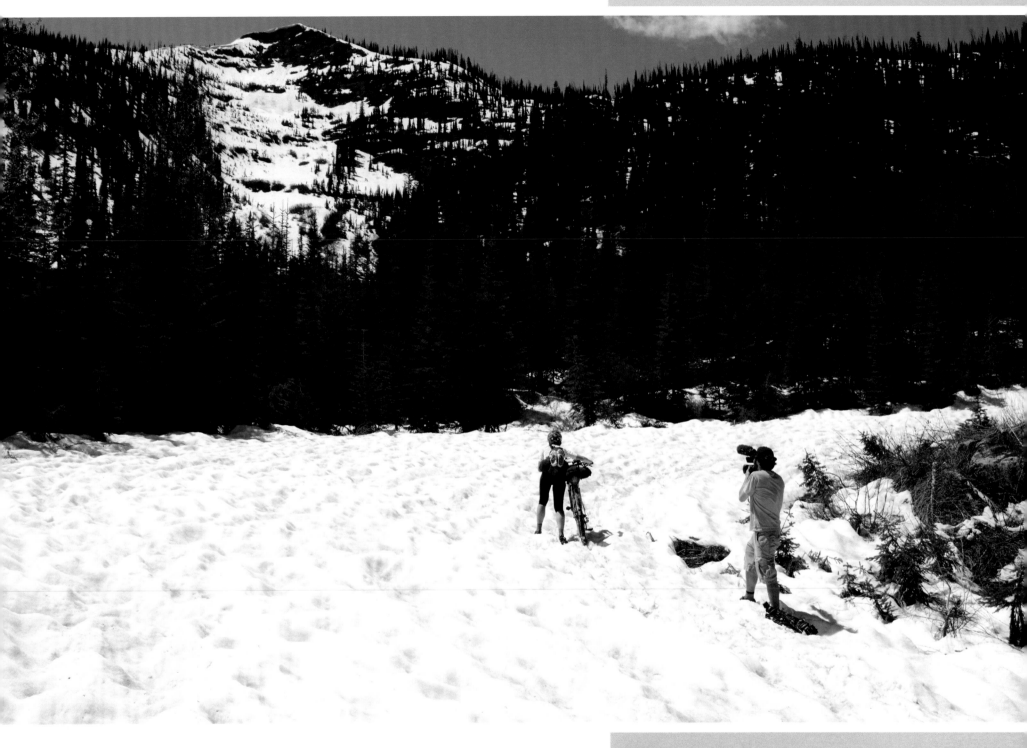

While I was staying at Northfork hostel, a documentary crew were filming the Great Divide Race. At 2,500 miles long, the route is the longest and most challenging off-road bicycle tour in the world. The race starts in Montana and ends in New Mexico. Riders are self-supported, carrying everything they need for the race.

📷 TIP

Most modern cameras have good built-in light metering systems, but as this image has vast areas of light and shade bracketing or an independent light meter would have improved it.

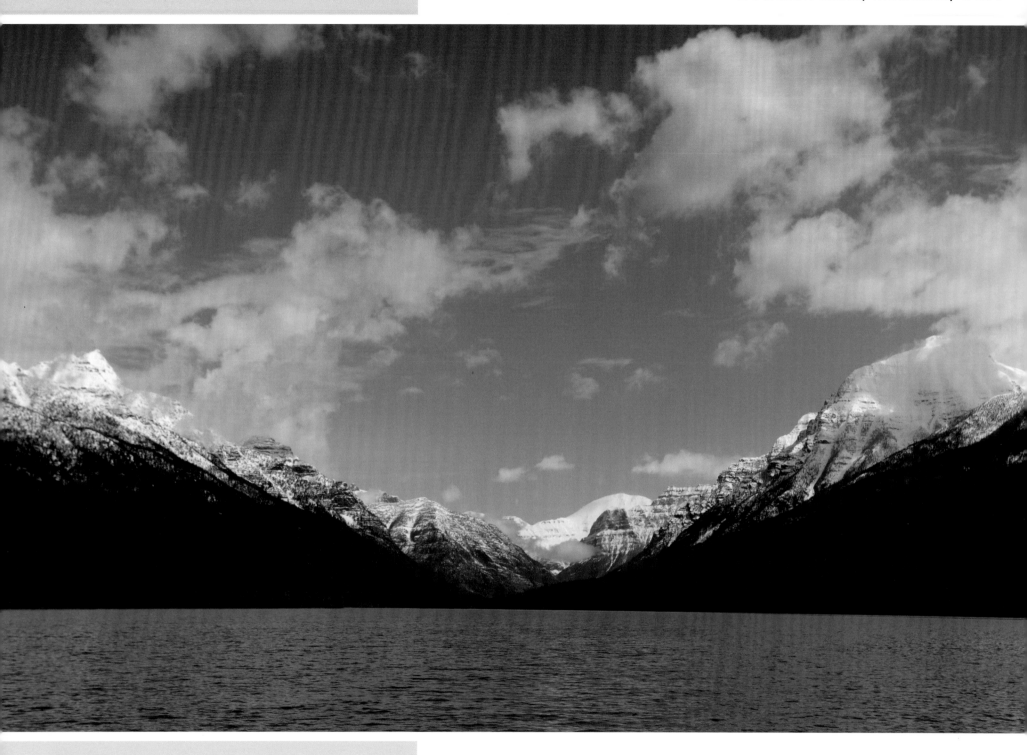

📷 TIP

Cloud formations focus the eye in dramatic landscape images.

Bowman Lake rivals Lake McDonald in scenic beauty. Like McDonald it sits in a deep bowl surrounded by thick forests and towering mountains, but it stretches well into the mountains providing a stunning sight of towering mountains rising out of the lake. Since Bowman Lake is fed entirely by snow melt the lake has very clear water and remains cold all summer long.

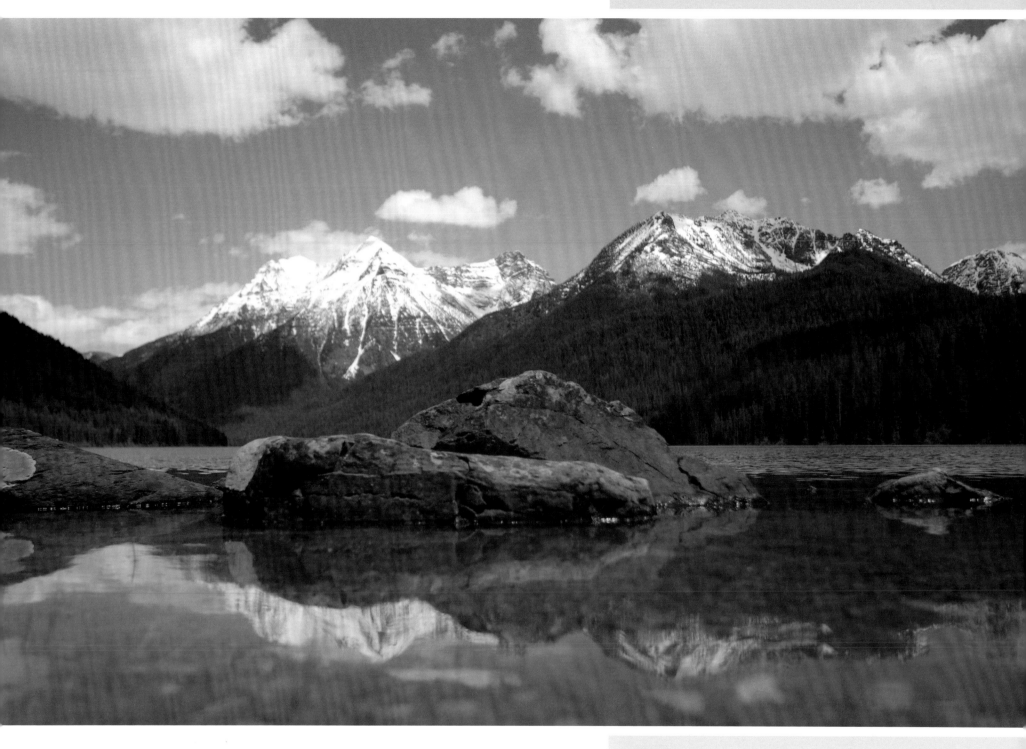

Quartz Lake can only be reached by a 13-mile round hike. The trail head is located at Bowman Lake on the south side. This is a strenuous hike over the loop trail and at least half a day is required to do this amazing walk on the mountainside. I was keeping my senses open for bears but only saw deer, I did however find mountain lion tracks.

 TIP

Reflections can give a totally different effect in landscape photography.

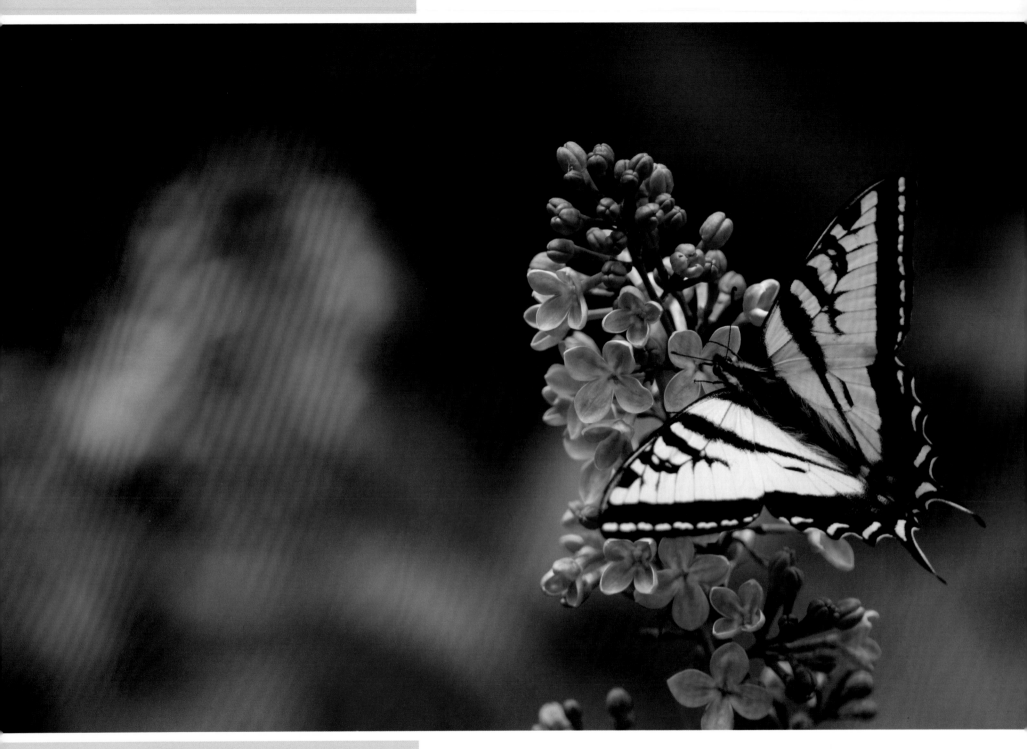

📷 TIP

Butterflies make wonderful subjects but are one of the most difficult as they are often very active and fly off as soon as you come into range. Know your species and what they feed on. Patience is a virtue.

With the sun shining and flowers blooming the swallowtail butterflies come out to feed on the nectar. Ethics of a wildlife photographer – 'take nothing but photographs, leave nothing but footprints, kill nothing but time'.

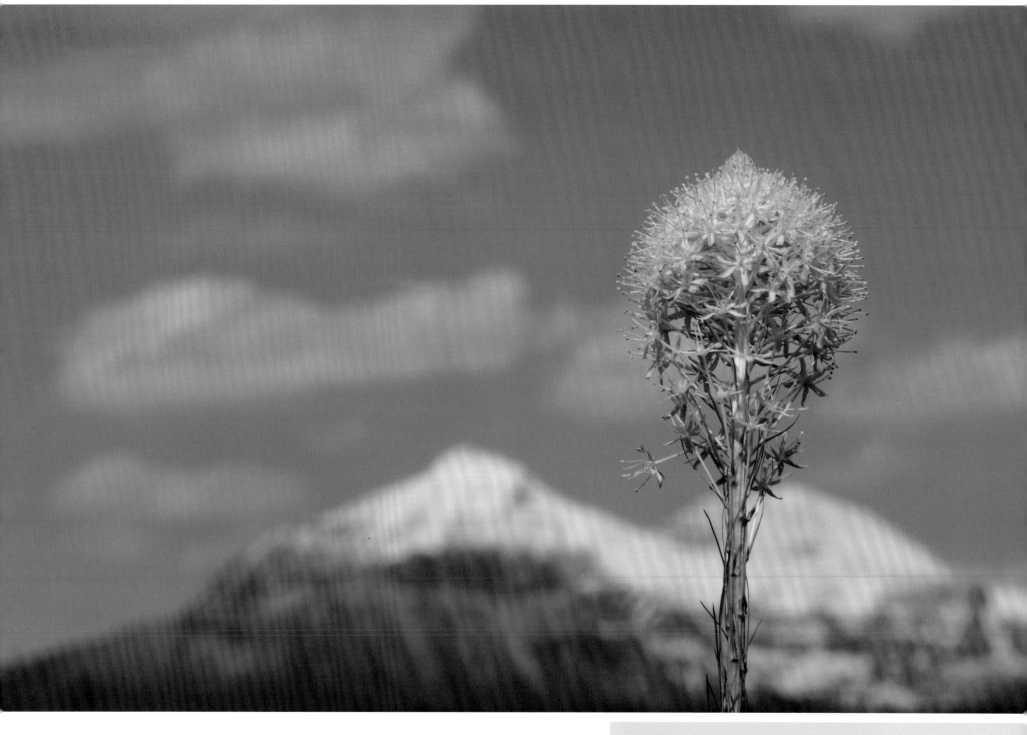

Glacier National Park has over a thousand species of plants, bear grass being one of the most prolific. My challenge today was to capture this plant, which can grow up to 60 inches tall, in its natural setting.

📷 TIP

By getting below the flower head I could shoot upwards and capture this flower with the mountains in the background. By shooting upwards you can achieve a clear background for foreground subjects.

📷 **TIP**
Specialist filters can add additional interest to the photograph.

Decisions had to be made and although I was enjoying my time in Glacier National Park, more heavy snow meant the Going-to-the-Sun Road was still blocked and wouldn't be clear until late July. Further adventures in the National Park were going to be very limited, so I decided I would move on and 'see what was around the corner'.

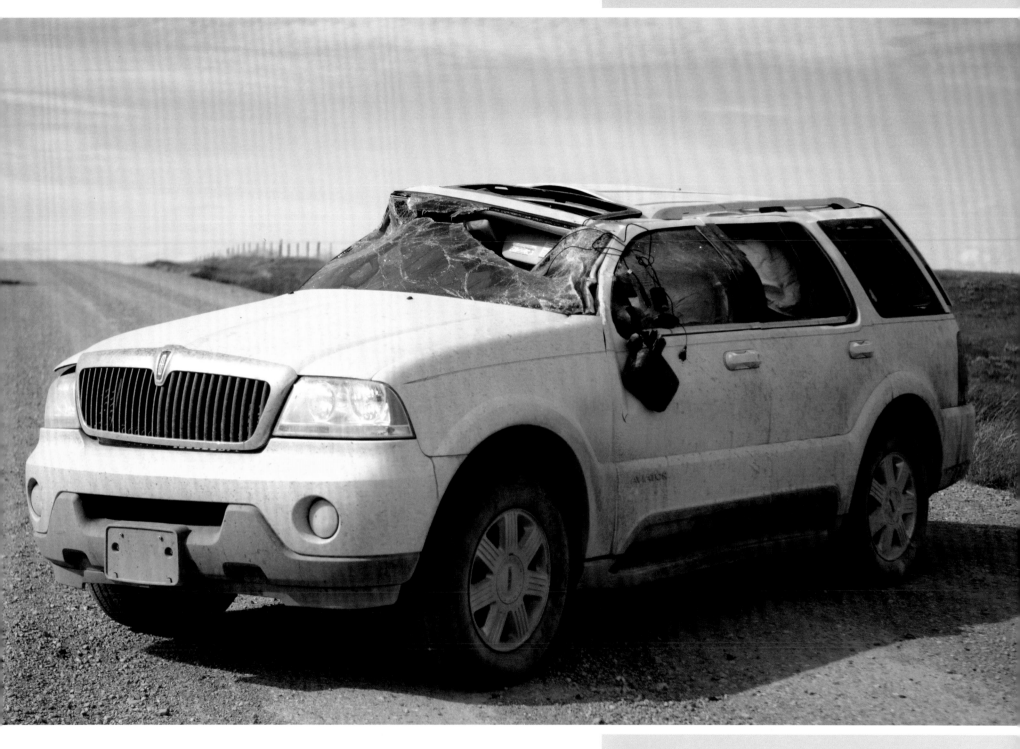

While travelling on this road the tarmac went to gravel, and my vehicle over-turned and rolled three times. I crawled through the sunroof with no broken bones and only a few cuts. The State Police arrived, took my statement and documents and praised my driving since if I had been going too fast I might not have lived to tell the tale. Modern day heroes are still around - thank you Cole McAlpin of Chucks Paints at Cutbank who helped me get on my way.

⬛ TIP

Ensure your photographic equipment is in a protective camera bag and never leave equipment unprotected – it is expensive to replace!

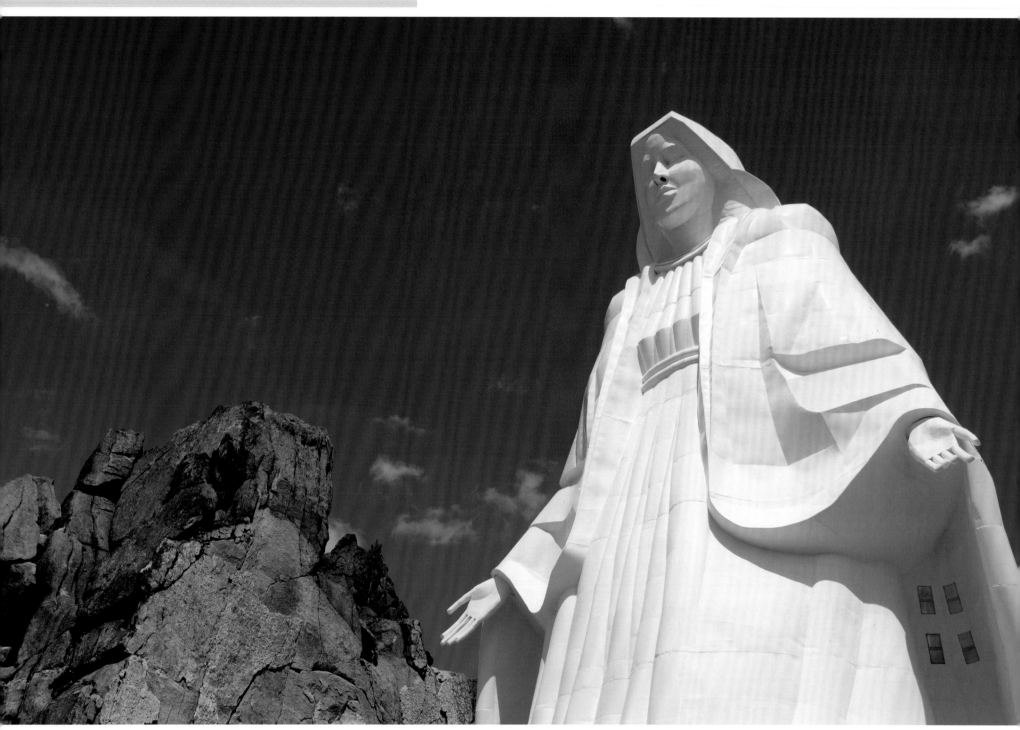

📷 TIP
Reflected light can burn out detail in your images; take care with your exposures.

After resting in a hotel and sorting my car out, I drove to Butte and was inspired by the 90 ft statue of the Virgin Mary, nicknamed 'Our Lady of the Rockies'. It is the brainchild of Bob O'Bill. Around 1979 his wife was battling with cancer, so in his prayers he promised the Virgin Mary that if his wife survived he would erect a 9 ft statue in his own yard. After his wife's recovery, Bob proved as good as his word but this developed into the statue as we know it now.

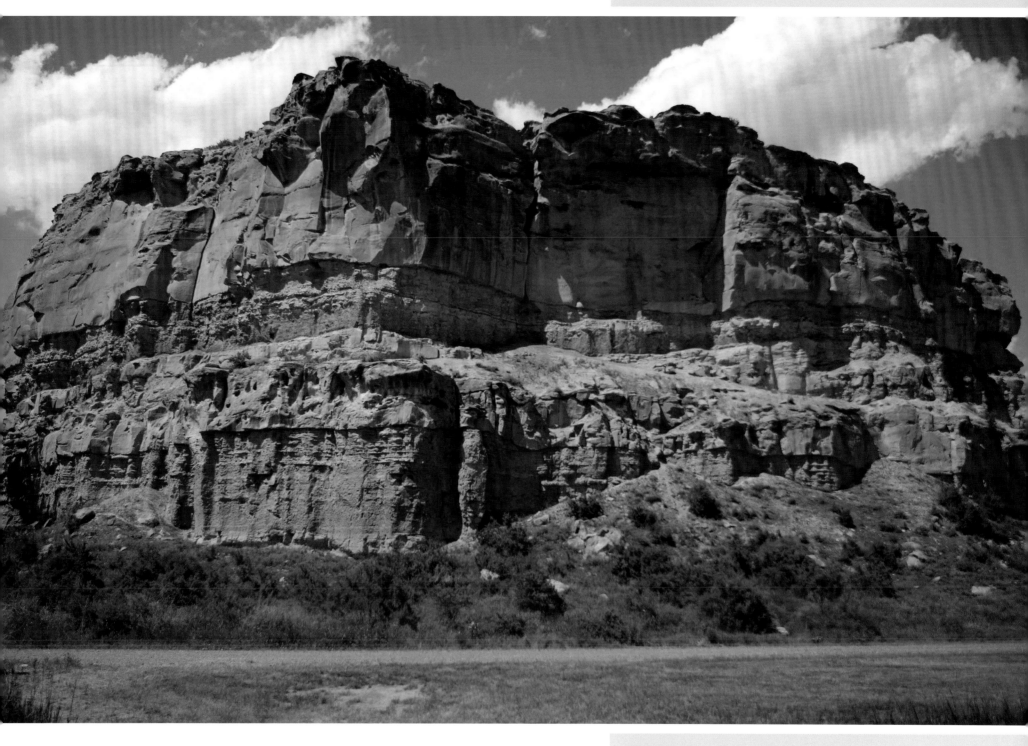

Pompey's Pillar National Monument is located in south central Montana and is one of the smallest national monuments in the USA. The pillar features a number of native American petroglyphs as well as the signature of William Clark dated July 25th 1806. Clark was co-leader of the Lewis & Clark expedition, which became the first American overland expedition to the Pacific coast and back.

 TIP

History is preserved through photography.

📷 **TIP**
A difficult image to capture detail – experiment with flash.

The Pictograph Cave at Billings was home to generations of prehistoric hunters. Two of the three caves contained evidence of habitation dating back over 4,500 years, and over 30,000 artefacts have been identified from the caves. The site is considered to be one of the most significant archaeological sites in Montana. Further excavation may reveal more interesting facts.

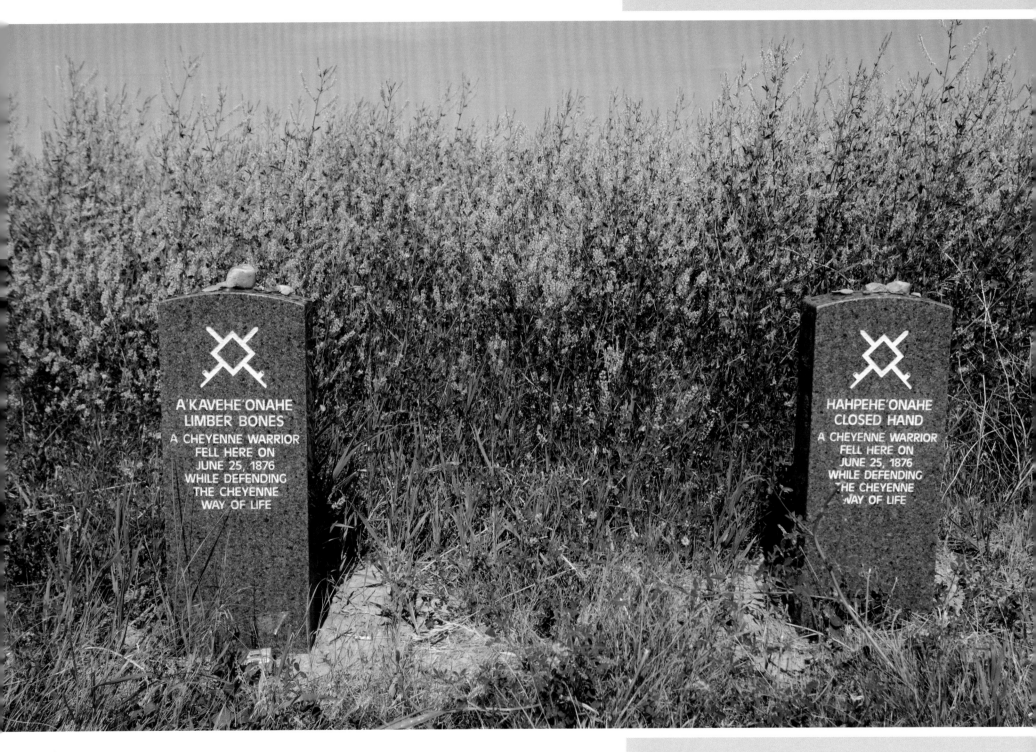

I wish I could say this day was planned but it wasn't. Looking in the local newspaper the night before, I saw it was the anniversary of the Battle of the Little Bighorn. Of course I thought of Custer's last stand and hoped to get an image of where he fell for the book. I was surprised that it was the Lakota, Cheyenne and Arapaho Indians celebrating their victory over the white man. Nothing to do with Custer himself!

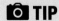 **TIP**

Check news for local events.

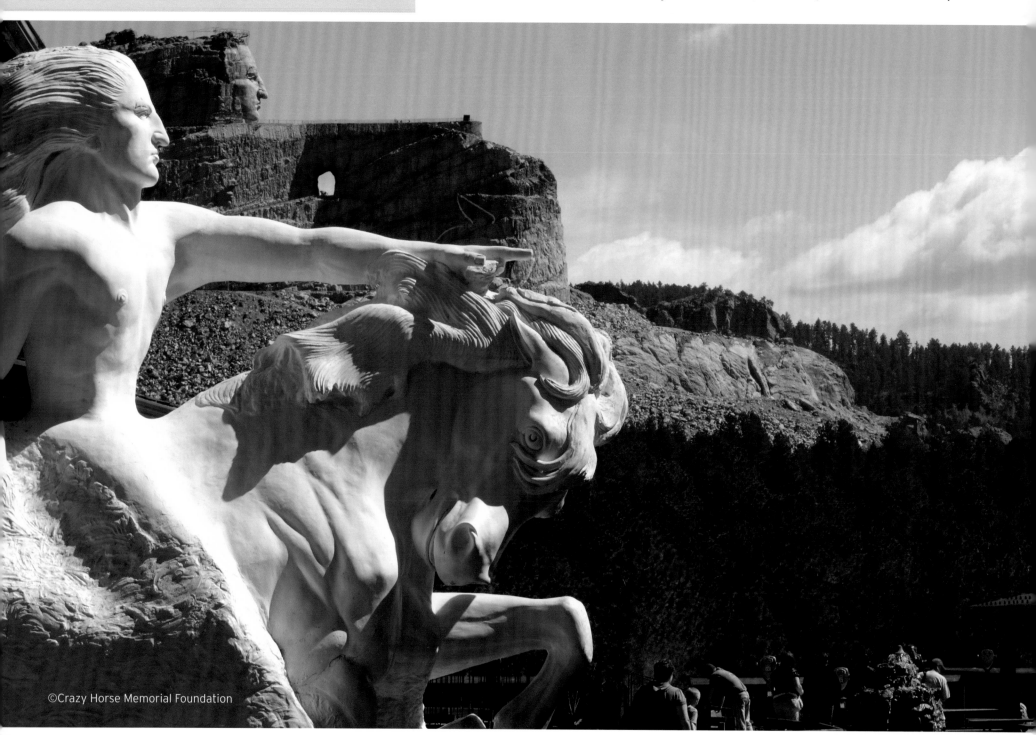

©Crazy Horse Memorial Foundation

📷 TIP

Consider copyright issues and permission to take images.

Yesterday I was told by the Cheyenne newspaper editor who I took photographs for, that it was Ruth Ziolkowski's birthday of the Crazy Horse Memorial Foundation. Special events were planned but I wouldn't be able to take images of the Crazy Horse for publication without her permission. I arrived at 10.30 am and after speaking to a number of people including Ace Crawford, I was granted permission to photograph the mountain.

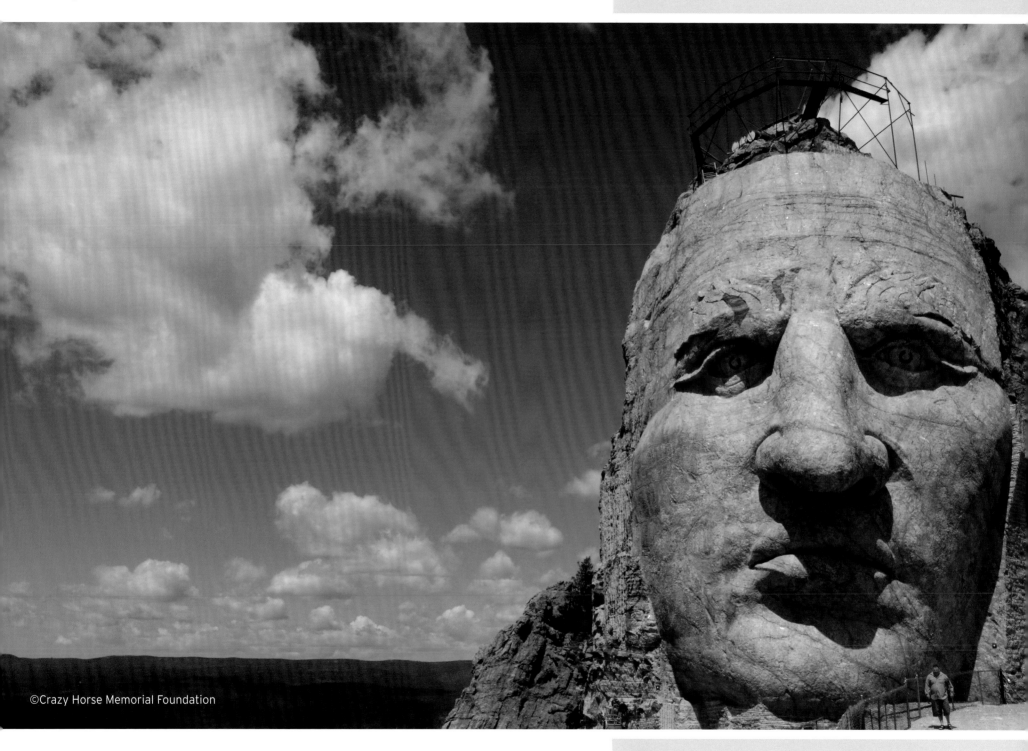

©Crazy Horse Memorial Foundation

Sculptor Korczak Ziolkowski began the mountain carving in 1948. He was asked to by Chief Henry Standing Bear in a letter which stated 'my fellow chief and I would like the white man to know that the red man has great heroes too'. So the dream was born. After yesterday's events I was invited back and given the great honour of being taken to the top of the memorial. 'Never forget your dreams' – K. Ziolkowski. My dream was this book.

▣ TIP

Using the self-timer button on your camera, means you can be in your own special photograph if there is no one around to take it for you.

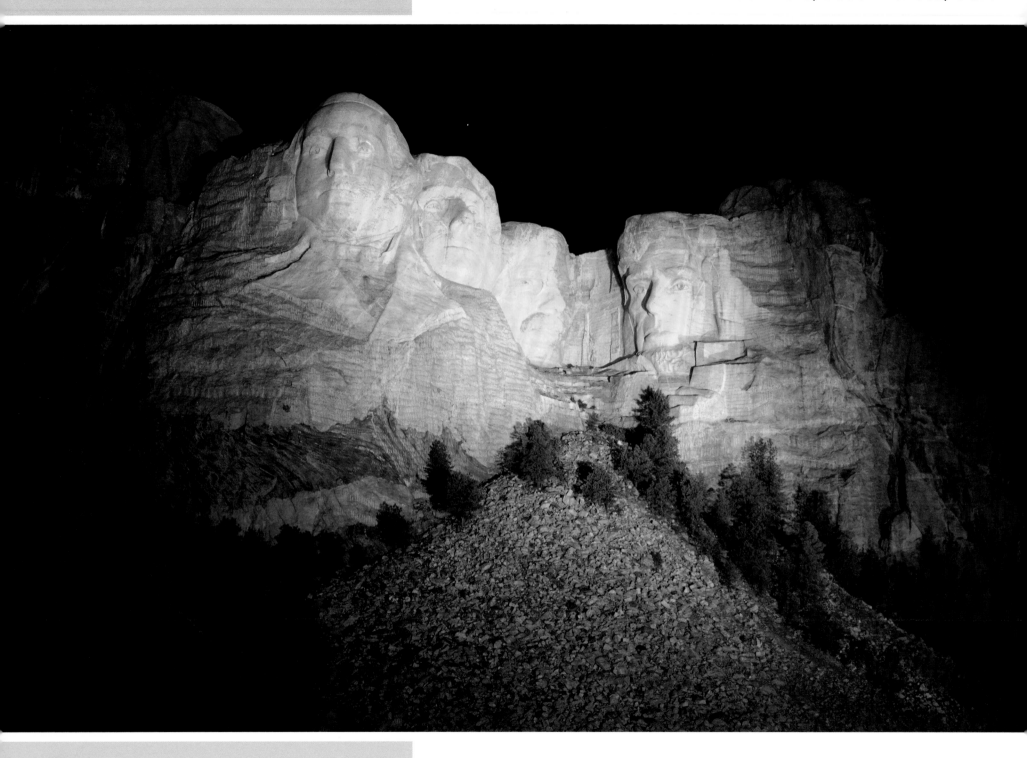

📷 TIP
Try to take images in a different light; night photography can be very rewarding.

Mount Rushmore is only nine miles away from the Crazy Horse Memorial. Both are amazing wonders of this world. The Crazy Horse Memorial is so large that the Presidents on Mount Rushmore would only fit into the back of the head of this amazing statue. Mount Rushmore represents the first 150 years of history of the USA. Each sculpture is 60 ft high.

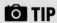

Mount Moriah Cemetery has the graves of many Wild West legends but two stand out in particular and are side by side. These are 'Wild Bill Hickok' and 'Calamity Jane'. Her dying request was 'bury me beside Wild Bill'. 'Wild Bill' was murdered by Jack McCall during a game of poker.

◉ TIP
Go to the local cemetery for interesting gravestones and local history.

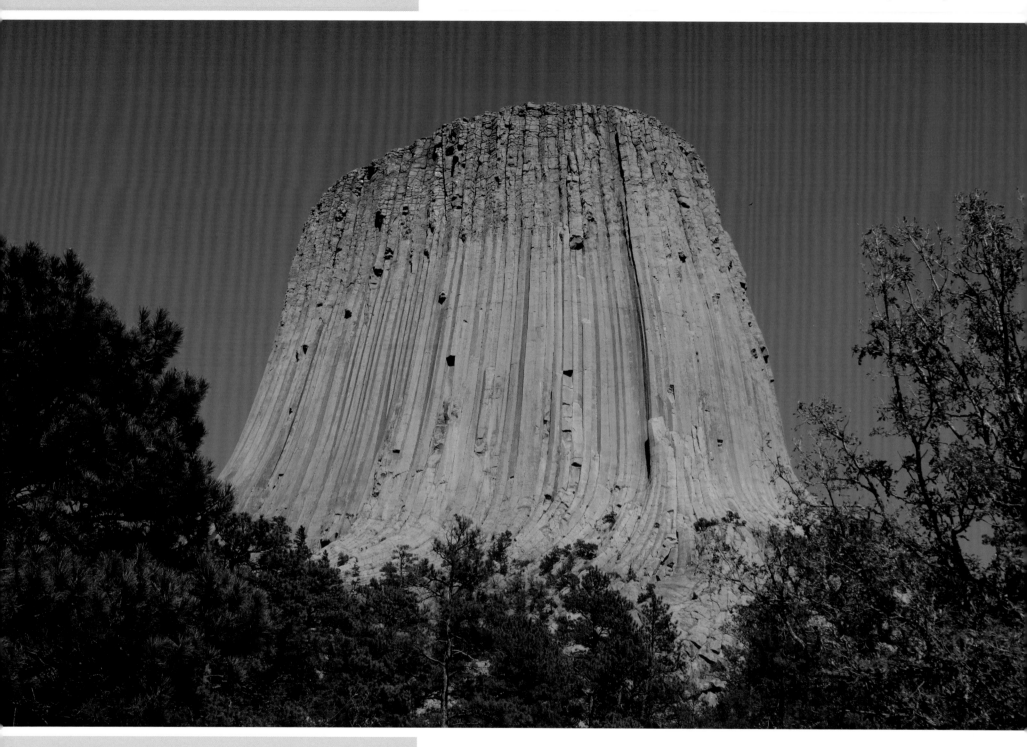

📷 **TIP**
Though the image looks straight-forward, due to its size the perspective is quite difficult. Take time exploring different angles.

The Devil's Tower was America's first natural monument in 1906 and it is about 2,200 million years old. Made of magma (molten rock) it is a sacred place to several Indian tribes. The rock is used for mountaineering but is more famous for being the mountain in the film *Close Encounters of the Third Kind*.

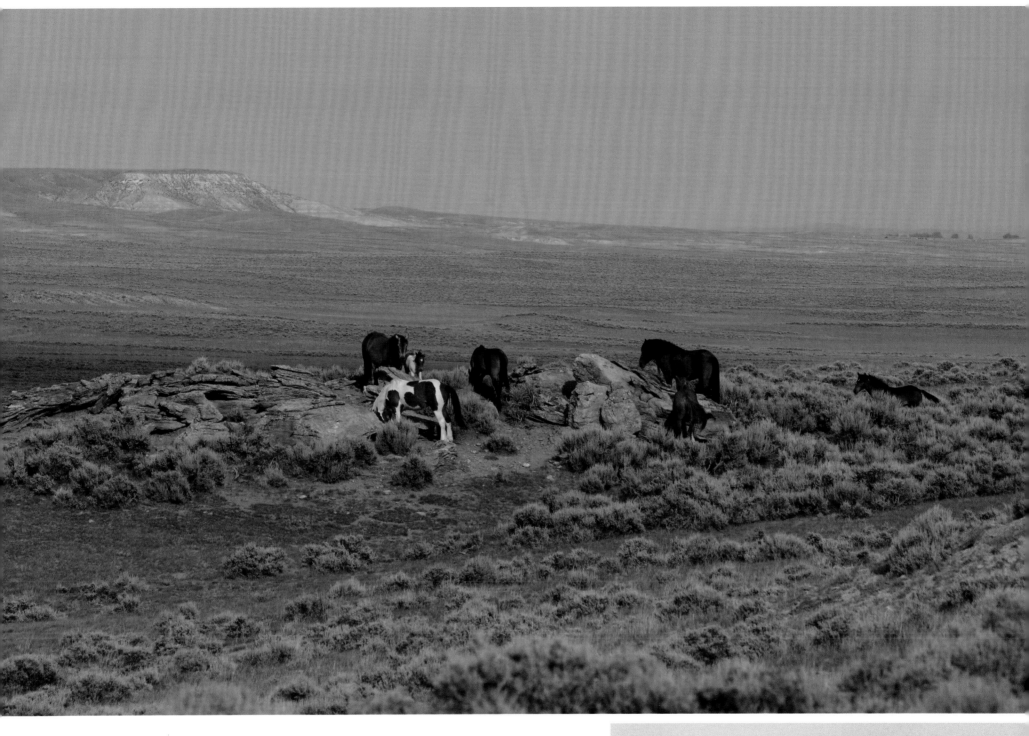

This is the home of the wild mustang. The land has changed little since prehistoric times, when people came to take advantage of the relatively snow-free winters and year-round sunshine in the foothills. You can take tours from Cody to see these magnificent horses. Mustangs have lived here for over 200 years and are descended from the horses of Portugal and Spain.

📷 **TIP**
Try to place wildlife in their habitat, showing the environment in which animals live – it gives the 'whole picture'.

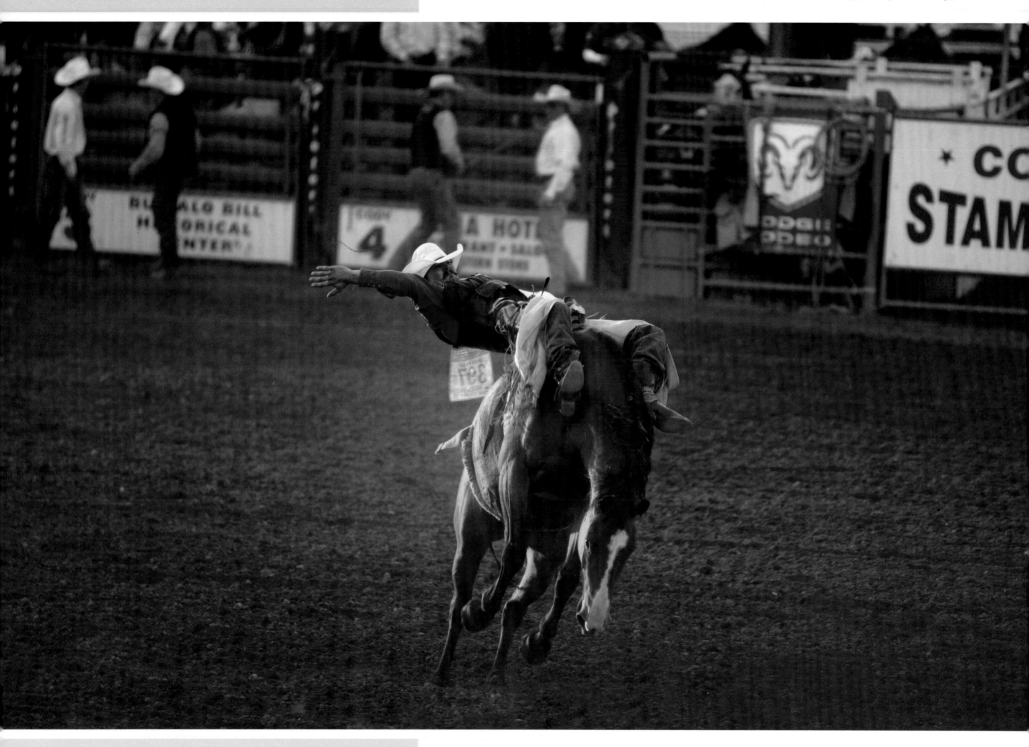

📷 TIP

Action photography – images that move at speed are difficult to capture due to how long the camera takes to focus, and shutter speeds used.

Cody was founded in 1895 and is named after William Frederick Cody primarily known as 'Buffalo Bill'. Rodeo is very important in the culture of Cody, which calls itself 'the Rodeo capital of the world'. During the Independence Day celebrations Cody holds a stampede, which is one of the largest rodeos in the USA.

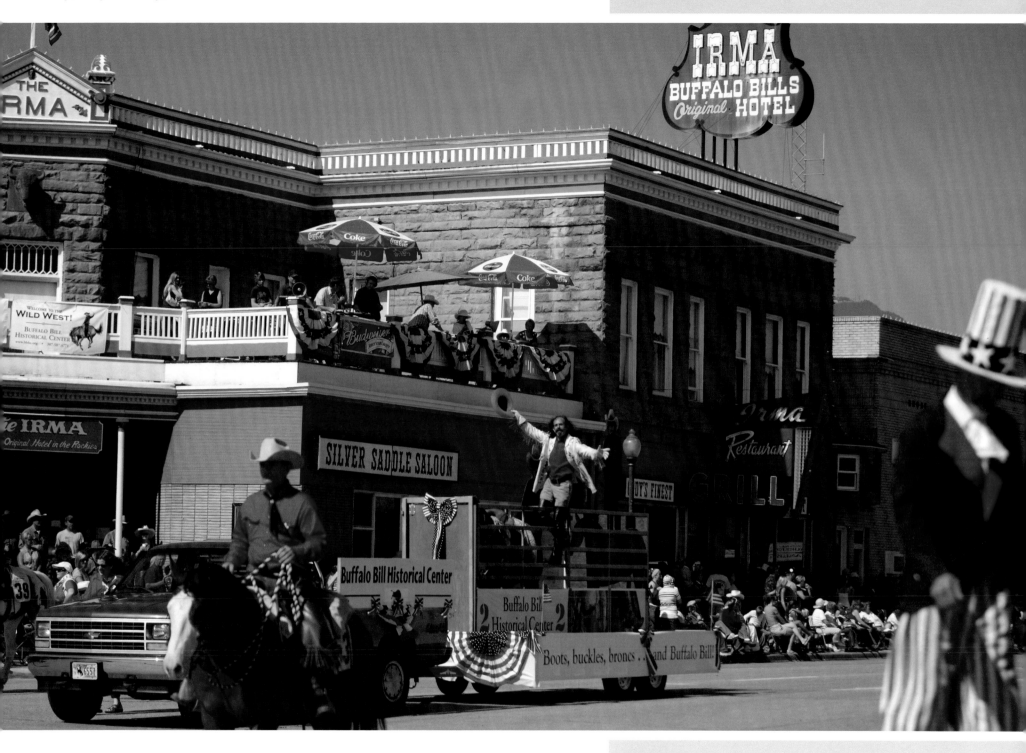

Cody's Stampede Rodeo parade passes through the city every day that the rodeo is on. Cody is a good place to stop if you are passing through the east gate of Yellowstone National Park. Buffalo Bill made his city here. Go and have a drink in his hotel, Hotel Irma, and watch the legendary gunfight outside every night.

📷 TIP

Vantage points need to be worked out – always arrive early to set up for your photography.

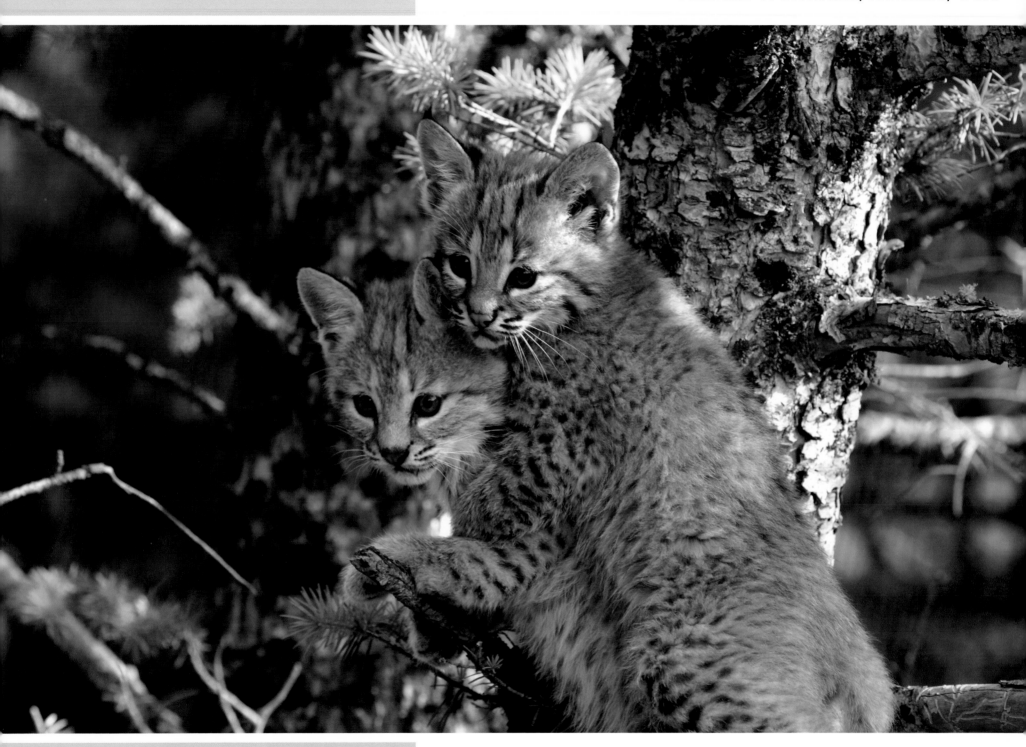

📷 TIP
The 'Ahhh...' factor of any baby image, whether it's human or wildlife, always works well. Cute images are a great seller if done well.

Back to the Animals of Montana – I had such a great time that I arranged a second visit to capture more fantastic images. The only disappointment of the day was that Bozeman itself didn't seem to have any 4th July celebrations or any information regarding events.

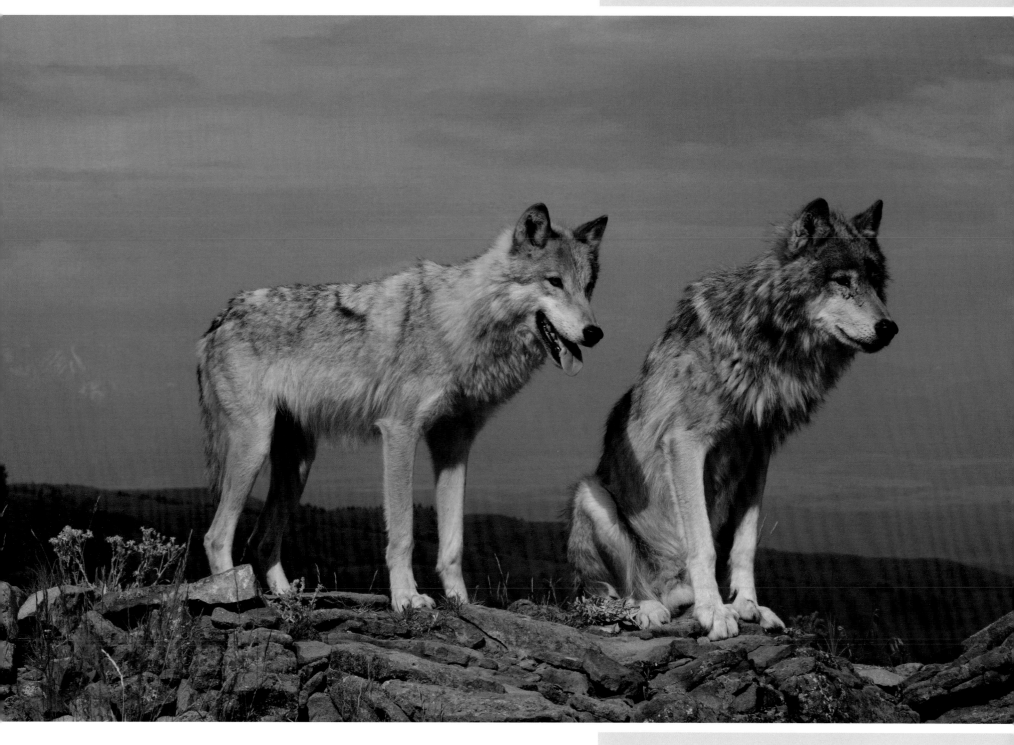

Wolves were the order of the day – I wanted a photograph of a wolf howling but this didn't happen. Even though the animals are trained you cannot make an animal do something it doesn't want to do. It looks like I will have to come back for that image.

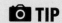 **TIP**

Early morning photography is the best, giving a soft light before the sun rises too high, creating harsh light and making contrast difficult.

This image of the puma flying through the air gave my Mum kittens when she first saw it on my website! She thought I had been up to my old tricks and getting too close to wildlife again. A good friend reassured my mum that I was in 'controlled conditions' which confused her even more!

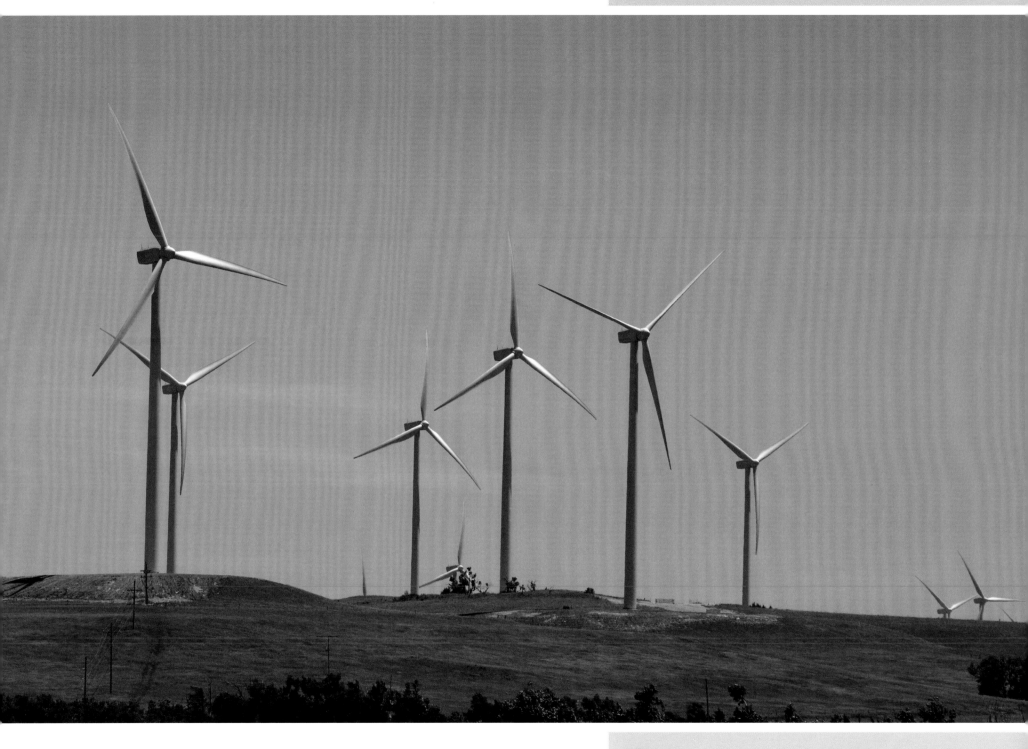

Driving day to my next location and wind farms were all the way down Highway I35. These are important as they help to save our planet but nobody wants them on their own doorstep.

◉ TIP

Look for architecture and man-made subjects in landscapes showing conflict of the natural world in the countryside. This photograph shows future generations what we did to try and save our planet. Photography is all about history and preserving 'a moment in time'. Whether it is right or wrong is another question.

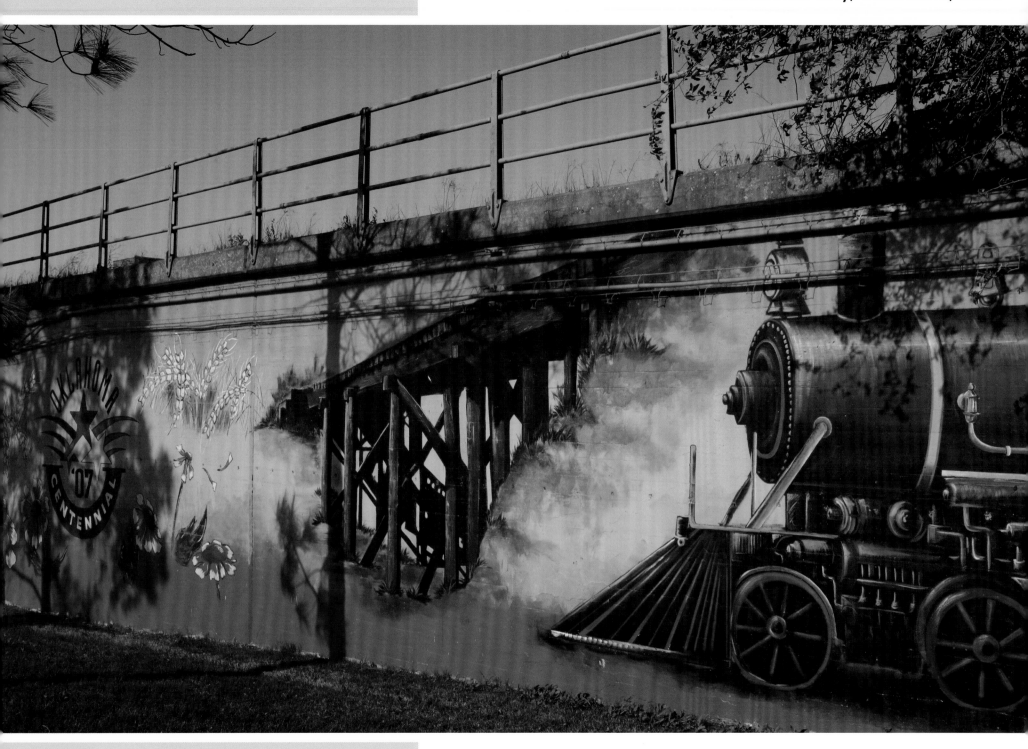

📷 **TIP**
The evening sun gives the image a warm glow that you wouldn't get at midday and shows the importance of light.

Overnight stop in Oklahoma. I must admit I have a thing about photographing graffiti – I'm not sure if it's the texture, the different styles or freedom of speech. Whether it should be on someone's building is another matter, but wherever I have travelled around the world I have seen and photographed graffiti.

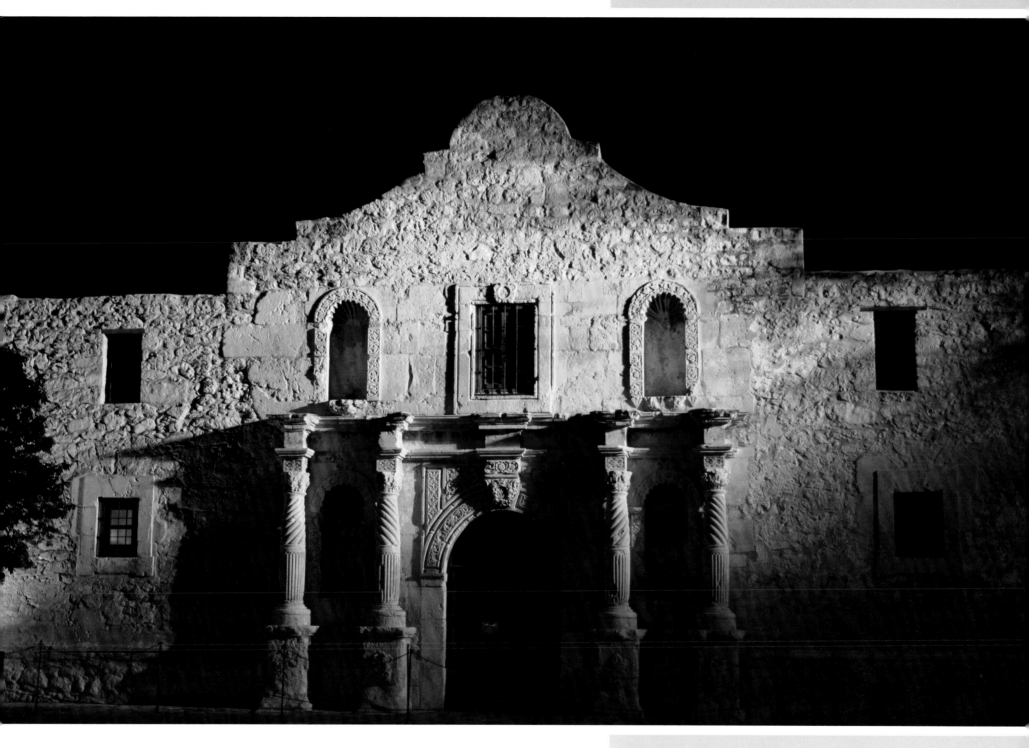

The Alamo - there is no doubt that the battle has become highly symbolic. People worldwide continue to remember the Alamo as a heroic struggle against overwhelming odds. It is a place where man made the ultimate sacrifice for freedom - 189 Texan defenders held out against 4,000 Mexican troops. I was very disappointed that there was no statue or plaque for one of my childhood heroes, Davy Crockett.

📷 TIP

Using flash can burn out details in an image, whereas the use of natural light whenever possible creates a more subtle image.

📷 **TIP**

In architectural photography sometimes you find more than one element that gives scale to your image.

The capital of Texas and a building that looks very similar to the White House. It was completed in 1888 as the winning design in a national competition. The style is renaissance revival based on fifteenth-century Italian architecture. Texas paid for the construction not in dollars but in land, some three million acres in the Texas Panhandle that would later become the famous XIT Ranch.

San Antonio with its famous river walk has everything from hotels, bars and restaurants to cruising down the river. The 2$^{1}/_{2}$ mile river cruise with commentaries is the second largest tourist attraction in Texas – the number one being the Alamo.

📷 TIP

By placing a recognisable icon in your image, it can say where you are without words. In this image it was the Torch of Friendship (top right-hand corner).

📷 **TIP**
Curved lines and reflections take the eye to the centre of the image.

San Antonio is the second largest city in Texas and the seventh largest in the USA. It is a very popular tourist destination – other sites to visit are SeaWorld, the 40 ft tall cowboy boots at North Star Mall and the Japanese Tea Gardens. San Antonio is famous for its Tex-Mex cuisine too.

The Sam Houston national monument stands 67 ft high alongside Highway I 45 North. While I was at the Alamo I noticed there was no monument to Davy Crocket. Apparently this is because by law each state can only have two national monuments apart from Washington. Texas's other monument is to Stephen Austin (Father of Texas).

📷 **TIP**

Using a person's image gives perspective of size.

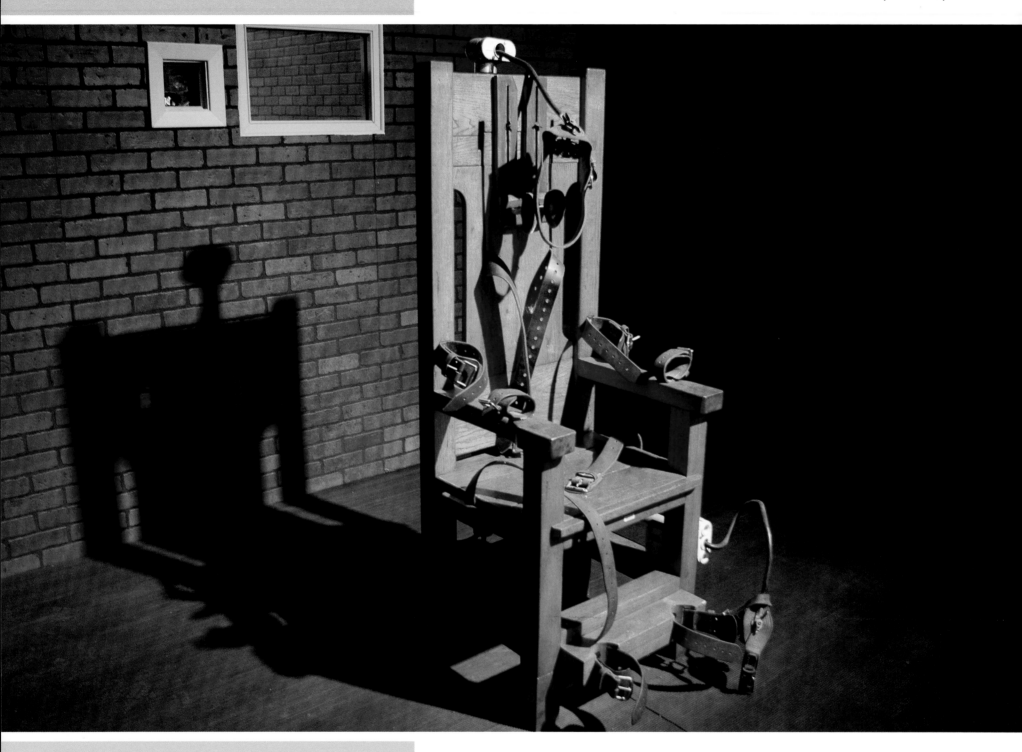

TIP

In poor lighting conditions you can increase your ISO to stop camera shake, but this increases the grain in the image. (If no room for a tripod in your equipment, pack a monopod!)

'Old Sparky' is the nickname given to electric chairs in general. The chair in Huntsville Prison was used from 1924 to 1964. During that time it saw the deaths of 361 prisoners – the death penalty is still in place in Texas and a lethal injection is used now.

After my trip to Texas it was back to Oklahoma to spend some more time with my friends Ken and Julie. Coming back from Texas I was watching the sun go down, hoping that I could find a place to pull over and capture the last moments of the day. How many times have you seen a sunset in the car when you can't stop?

📷 TIP

Photography is about luck at times. I found my parking spot and was able to capture streaking clouds and the disappearing sun.

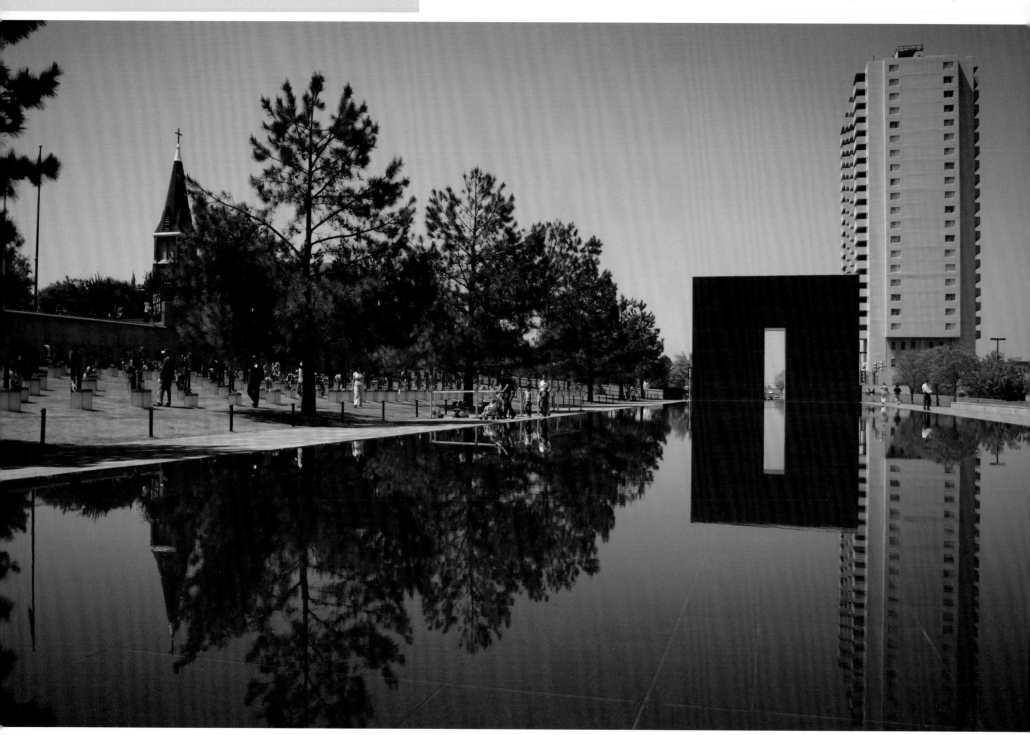

📷 TIP

Reflections are always darker than the original view and where you stand alters the angle of the reflection itself. This in turn can create different photo opportunities to explore. Always experiment.

Arriving back in Oklahoma I visited the National Memorial again for a different image. I noticed last time that the water in the memorial was very shallow and perfect for reflections.

Day 180 and slightly homesick. Thank you Mum for the e-mail that you sent. 'Looking up at the moon from wherever you are, you know loved ones can look back at the moon and think of each other.'

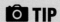 **TIP**
Your choice of lens makes a huge difference to the type of image that you can get with your photography. In the last moon image I used my telephoto lens to bring the moon closer, this time a shorter lens creates a sense of space.

📷 TIP

By using a telephoto lens and zooming in, tight cropping avoids other distractions outside and around the image. Can you see the angel?

Visiting museums or art galleries can give you inspiration for your future images; the only downside is that you often aren't allowed to take photographs. This was the case at Oklahoma but I was allowed to photograph the glass sculpture in their window.

This stained glass window was the only perfect thing in the Indian village. The Indian homes were in need of repair and the information and pictures online were misleading, but in their defence they did give me free admission and apologised for the state of the museum.

📷 **TIP**

Stained glass windows are especially good at midday when the light is not good for other photography. So in the heat of the midday sun why not find a stained glass window to photograph!

TIP
Because the image is off centre it suggests movement as there is room for the subject to travel to the right of the frame. An image must have space to travel to...

Has this graffiti been done by another traveller? Its style is very different from the almost fine art of the previous Oklahoma graffiti (Day 171). When do artists do it – is it done at night with someone holding a torch?

With family and friends so far away the internet gives you the opportunity to keep in touch with everyone, and also helps you to meet new friends on your travels. I met Hazel on Facebook – we went for dinner and had so much in common. I couldn't believe that I had met a fellow Brit in Texas. It's a small world.

 TIP

Portrait photography normally involves the eyes of a person but I used sunglasses to capture the relaxed pose and catchlight.

📷 TIP

A classic example of leading lines from every angle taking your eyes to the centre of the wheel. The image is off centre so the furthest lines draw you in. The bold red colour also helps with the contrast. If the image was a paler colour, the strong lines would be lost. Look for strong colours in photography.

This image was taken in a bar and shows that you can find subjects anywhere.

One of my challenging days when photography was hard for no rhyme or reason.

📷 TIP

I had wanted to take an image of cowboy hats but I couldn't find anything that I liked until I saw this cowboy hat shop in Austin. An odd number of hats balanced the image, and by moving the pink hat to the foreground; this enhanced the overall image. Do not be afraid to play around with colours and repetitive shapes.

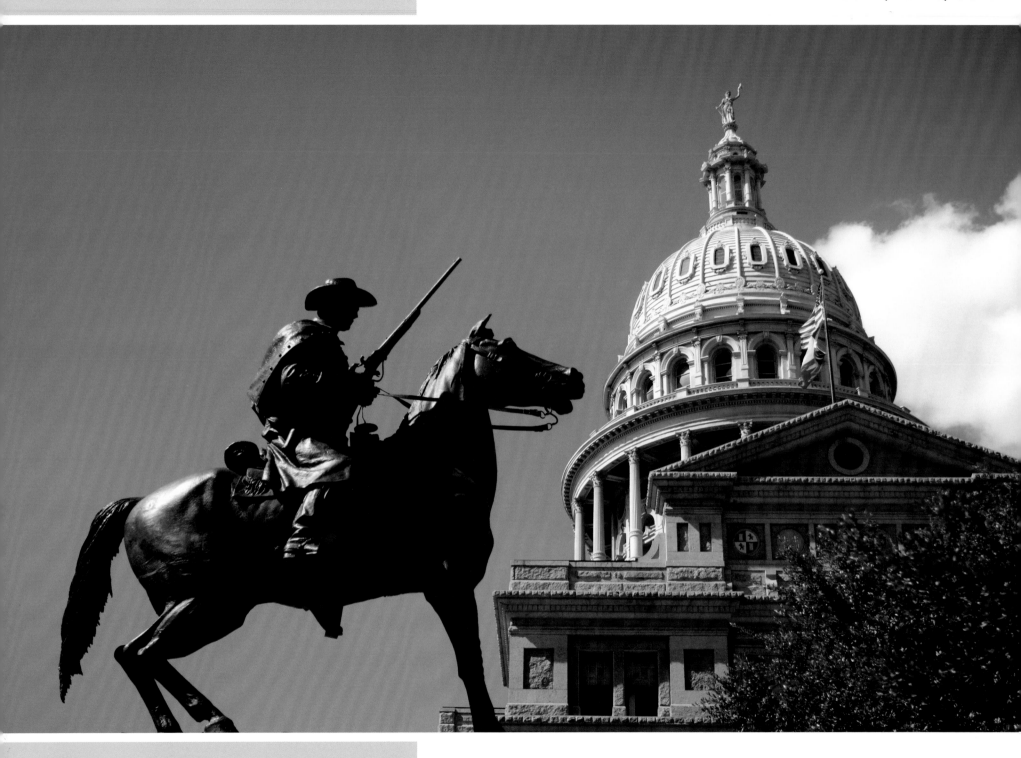

◉ TIP

Passing under the statue of a Texas Ranger against the white building, your exposure needs to be plus one third of an f stop to keep detail in the very dark areas of the image. Exposure tip: Large white areas - 1/3 f stop, large black areas + 1/3 f stop.

Sightseeing day and a guided tour round the Capitol building. It was nice to see a huge painting of Davy Crockett on the right-hand side as you enter. He hasn't got his statue at the Alamo but he has pride of place in this Capitol Building.

Another reason for staying in Austin is to witness a natural event that mankind has helped bring about. So often we destroy natural habitats but sometimes we give them back unexpectedly. Bats breed under the Congress Bridge, at dusk millions of them will emerge from the shadows filling the sky in a dark mass. This in turn creates a tourist attraction.

◉ TIP

Without local knowledge I was in the wrong place to capture the bats – I needed to be on top of the bridge or on one of the boat tours that leave from the other side of the river. Look around you for signs of others local knowledge when watching specialist events.

TIP

Eyes are very important in an image as they show so much emotion; the happy couple are transfixed while Britney's mum's eyes are filled with tears of happiness.

A wedding is always a happy event and Hazel asked me to capture her friends' wedding. So this image in the book goes to Brian and Britney whose wedding was arranged in two days - I even drove them to the reception. Brian and Britney your secret will never be told!

A long drive to Oklahoma for another special occasion that I have to photograph tomorrow night. I needed to check the layout of the building and the lighting facilities at the Edmund Jazz Club so that I didn't get it wrong on the night. I could have travelled up on the day of the event but didn't want to risk either breaking down or checking details at the last minute.

 TIP

Check exposures carefully where reflected light is involved.

 TIP

Due to the fact I couldn't use flash I had to find the right location to use side lighting from the available lighting.

Edgar Cruz and his brother Emmanuel Cruz III, are both very talented people in their own fields of music and painting. They were holding a benefit evening for their nephew Ryan Cruz who has Duchenne muscular dystrophy – I was asked if I would donate my time and images to this cause and had no second thoughts.

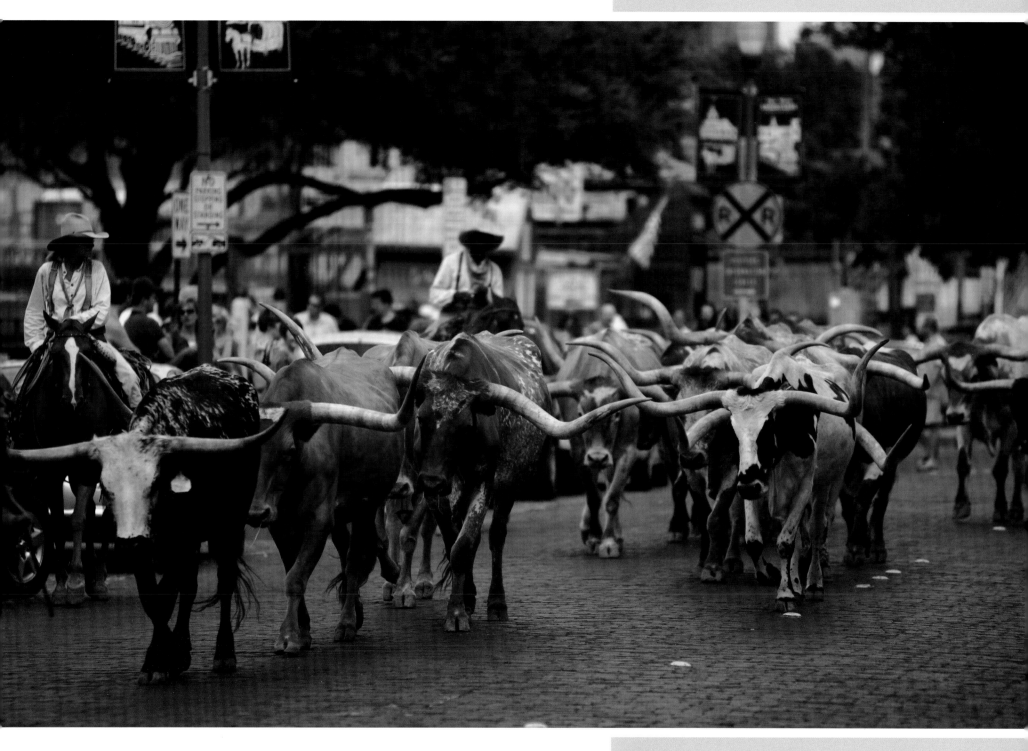

Every day Fort Worth has a longhorn cattle drive from the station to the stockade just as they would have done many years ago. This is a major tourist attraction as it is the only place you can see a cattle drive. The longhorns' horns measure two metres from tip to tip – I couldn't go all the way to Texas without seeing a longhorn!

 TIP
Photograph historical moments.

📷 TIP
Digital photography allows you to change the ISO in every shot. This can be extremely useful at times.

The lone star of Texas is a reminder of the State's struggle for independence from Mexico. The lone star can be found on the Texas State flag and the State Seal today. Texas is a giant of a state at 268,820 sq miles – compared to the whole of the UK which is only 93,259 sq miles! Texans are known for their large welcoming hearts, 'friendship' is the State's motto and the people of Texas live by it.

The San Jacinto Monument rises 570 ft above the battleground where Texas won its independence on April 21st 1836. The monument honours all those who fought for Texan independence and it remains the world's tallest memorial tower. It was difficult to convey the scale of such a tall tower with no landmarks or buildings nearby - the only reference to height is the flag poles and tree levels at the bottom of the image.

📷 **TIP**
Always look for photographic markers to define scale in images.

📷 **TIP**

Carry a short step ladder to take images above the fencing line creating far better images but maybe risky here!

Texas is one of the USA's leading oil producers but their independence is so important that even their oil containers have murals painted on them. I was slightly concerned that after I had taken this image I might be stopped, as I don't think I should have been taking images of this nature in today's political climate but I wasn't challenged and had my image for the day.

Houston Space Center. 'Houston we have a problem ...' – this is where it all happened. The image of mission control and the space ship is real. I am not into technology and space but this really opened my eyes and the tour was brilliant. Seeing the space centre and where the astronauts trained for weightlessness was well worth a visit. I was surprised that I was allowed to take an image of mission control when photography is not permitted in an art gallery!

📷 TIP

Check photography is allowed in cultural buildings, museums etc.

📷 **TIP**

Timing for the right image is all important. This small boy was amazed by Saturn 5, the perspective of his size against just part of a rocket is amazing and his expression of wonder says everything. I only had seconds to take this image before the exhibit became full again as the next tour bus arrived. Body language in photography tells its own story.

Having a free day, I took the opportunity to see the exhibitions on space travel at the Space Center.

Stewart Beach on Galveston Island. I could have been back home in the UK but it would have been black-headed gulls on the posts going out to sea instead of pelicans. Not all images have to be award-winning ones – I took this because it appealed to me. If I had had my long lens I would have isolated a pelican on a post but it wouldn't have had as much appeal as this image!

📷 TIP

Another thing to carry in the boot of the car is a pair of wellies. These would have been useful to stop my feet getting wet.

📷 TIP

Make a project of your local area, you never know when landscapes may change either by 'act of God' or 'act of man'. Thanks to all the earlier photographers who documented our landscapes in the nineteenth and twentieth centuries.

Every image can become an historical image over time. If I had not taken this image it could have been lost for ever as this view no longer exists – just weeks later this beautiful outlet was totally destroyed by a hurricane.

Texas produces the most oil in all of the United States, so not having an image of an oil platform would have been doing the state an injustice.

📷 **TIP**
Silhouettes and sunsets can turn the ugliest man-made subject into an image of warmth. Don't shoot directly into the sun as this could burn your eyes. Set the camera up on a tripod or flat surface and use a self-timer or cable release.

📷 **TIP**

Images of famous places or people can be used for photographic quizzes and can help make some money for your next trip or photographic equipment.

November 22nd 1963, Dealey Plaza - where history was made. I was amazed that there was no plaque saying JFK was shot here, just the two white crosses on the road where he was hit by bullets. I sat on the grassy knoll thinking about what that day must have been like. The only thing that I could relate it to was where I was at the time of 9/11 and the death of Princess Diana.

I found the actual Dallas monument to Kennedy, which is in the form of a cenotaph located a block away from Elm Street. Dallas is a city full of skyscrapers and is the third largest city in Texas. Its historical importance comes from the oil and cotton industries and a famous television soap opera but it doesn't have the attractions of Houston and San Antonio.

TIP

Wide-angle lens is used to give the desired effect of the skyscrapers reaching the sky.

◉ TIP

The show was very crowded so I could only use a standard lens. Events can determine what lenses you use.

Leaving Texas again to visit my friends Ken and Julie. At the State fairground in Oklahoma they are having the Quarter Horse World Championships. Quarter horses are the most popular breed in the States as they are used in rodeos, horseshows and as working ranch horses.

A day in Bricktown shopping and looking for an inspirational image. This old warehouse made of bricks and full of adverts was my image of the day. To be honest it was really hard to find an image that I hadn't already taken – that was the challenge of this book and I knew I would get a day like this.

 TIP

A stop of f16 made sure all the adverts were in focus.

📷 TIP

A collection of images can work well in sets. Choose a subject such as sea birds, aircraft, flowers or even graffiti – you can get an amazing effect when you have more than 30 images in a similar style.

Exploring the town looking for graffiti for my project which is ongoing. I found this image earlier in the day but returned in the evening to capture it, so that the railway trucks had warmth in them from the evening light.

Oklahoma produces about three per cent of the national crude oil of the USA. It used to be more but is on the decline. Pumpjacks, which are the official name for nodding donkeys, are all over this flat State, some lying in fields in a state of disrepair. The image that I was looking for was the silhouetted straight hard lines of a nodding donkey against a flaming sunset. I never found a sunset with a donkey but the image remains in my head.

📷 TIP
Keep a photographic log of images that you wish to achieve with times of the day, location, specialist notes.

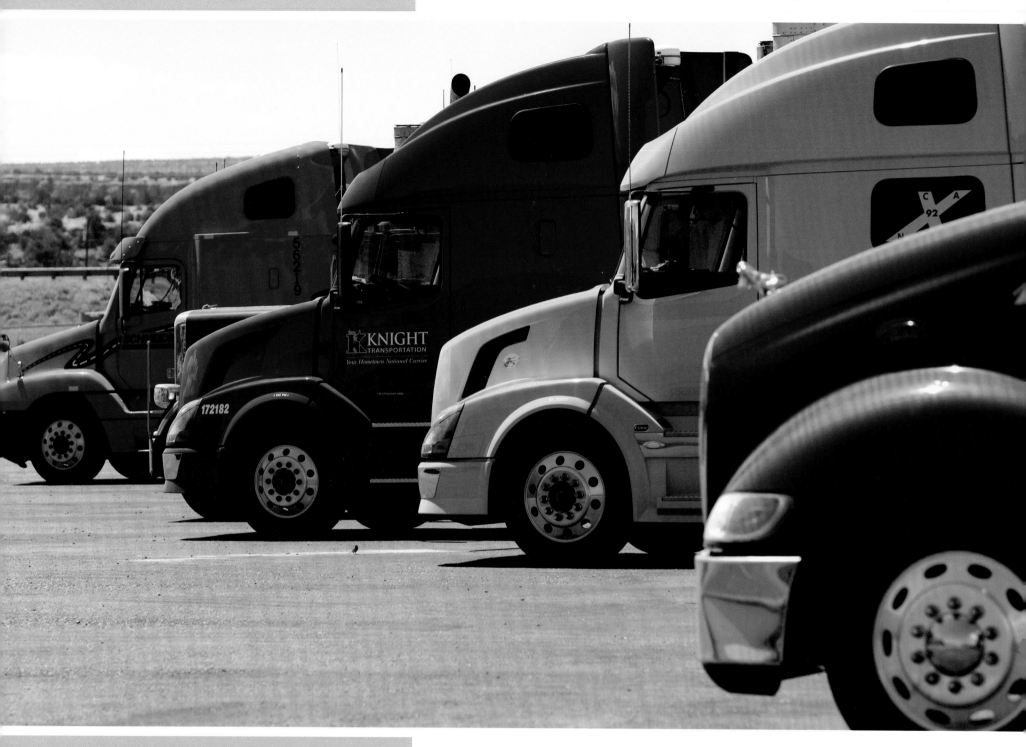

Powerful colours and strong images that you have in your head can come to life at any given moment. I wanted a series of trucks together to form solid blocks of colour. Even though the foreground vehicle is out of focus, it does not detract from the overall image.

If you see an image regularly you eventually have to take it. I often see the trucks at the service stations but never how I visualise them.

Robertson's ham sandwiches are to be found on Highway I 35. This great sandwich bar broke my journey up going to and from Texas. Doug Barger did great beef sandwiches, the only thing missing was the Branston Pickle. So the next time I stopped there I introduced Doug to Branston Pickle and got an American hooked on a British tradition!

TIP

Be aware of distracting power cables etc. in images. These can be removed with photographic software but this can make the photographer complacent!

TIP

Using my own advice of a photographic log, I wrote down what I was looking for.

With Oklahoma having so many tornadoes, wind turbines used to be the prominent source of power. These are dotted all over the flat landscape – I think they are far more attractive than the modern wind turbines that can be seen all over the world. This wind turbine was on its own and is my historical shot of past power. The image I am looking for is a wind turbine by a farmhouse in open countryside.

I went to the Firefighters Museum to get this image as it was a painting done after the Oklahoma bombing and it inspired Ken and Julie to train one of their Labradors, Molly, as a rescue dog.

TIP

The closeness of man and dog creates a powerful image – I wonder whether the artist used a photograph as her reference to do the painting? Selling your images to artists is a good source of income.

📷 **TIP**

In bland images, large cloud formations can be the focal point of your photograph, especially if the horizon is set very low.

Look and you shall find... While driving through Oklahoma I found the image that I was talking about the other day - my wind turbine beside a farmhouse or barn.

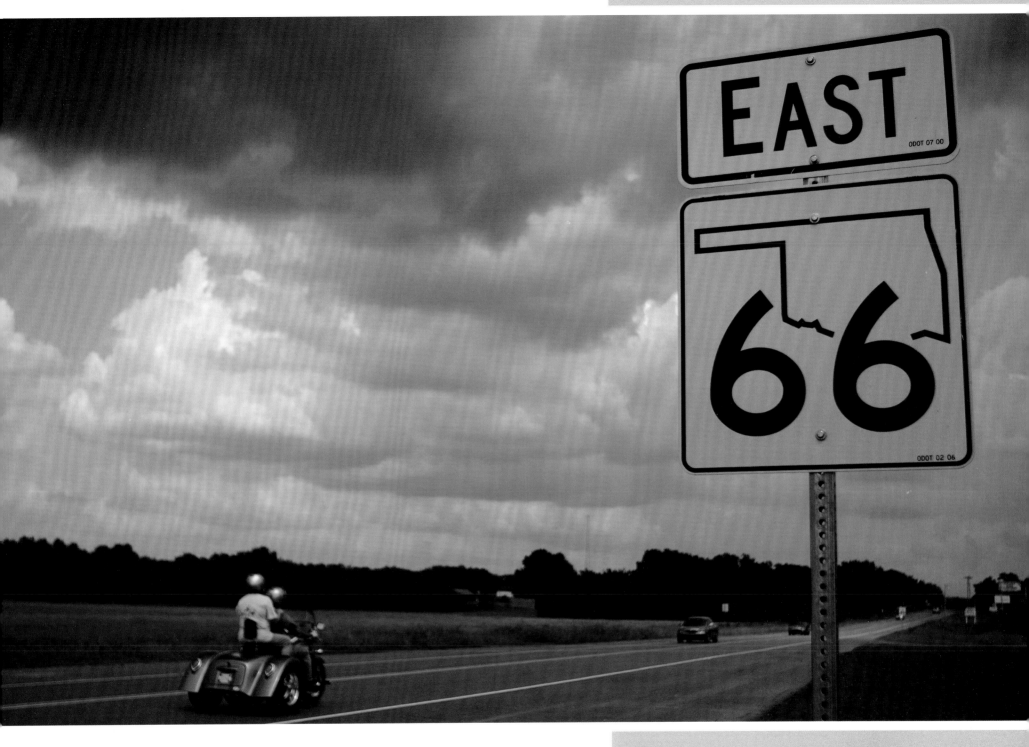

Route 66 is one of the most famous roads in the world and is approximately 2,400 miles long, passing through eight states from east to west. It is many a person's dream to drive it either on a bike or in a car, taking approximately four days.

📷 **TIP**

The sign in the foreground gives perspective by placing you on Route 66 as the lines of the road draw you in and out of the image. I just had to wait for a motorbike to come along to complete the scene!

📷 TIP

Exposures with natural light. If using a flash gun beware of the light reflecting back from the glass.

The National Cowboy and Western Heritage Museum has everything you ever wanted to know about the Wild West. One of the most impressive sculptures in the museum is 'The end of the trail'. It is 18 ft tall and four tons in weight. It was sculpted by James Earle Fraser for the Panama-Pacific International Exposition in San Francisco in 1915. It was supposed to be cast in bronze but the outbreak of the war prevented this.

This museum is John Hargrove's tribute to Route 66. Like the museum in Polson, John has done it all by himself and curious passers-by can enjoy scaled down versions of Route 66 icons. The museum is full of interesting things including a café. If you are just east of Arcadia you will find it on the north side of Route 66, where John will give you a warm welcome.

📷 **TIP**

The image of the car 'tickled me pink'. It is just a humorous image.

An American icon – the drive-in theatre was the creation of Richard M Hollingshead in 1928 when he put a Kodak projector on the hood of his car to show a movie against a white sheet. The reason that drive-ins became popular was the whole family could go out without hiring a babysitter. The peak came in the late 1950s and early 1960s but died in the 1980s due to real estate land becoming profitable, but it is now making a comeback.

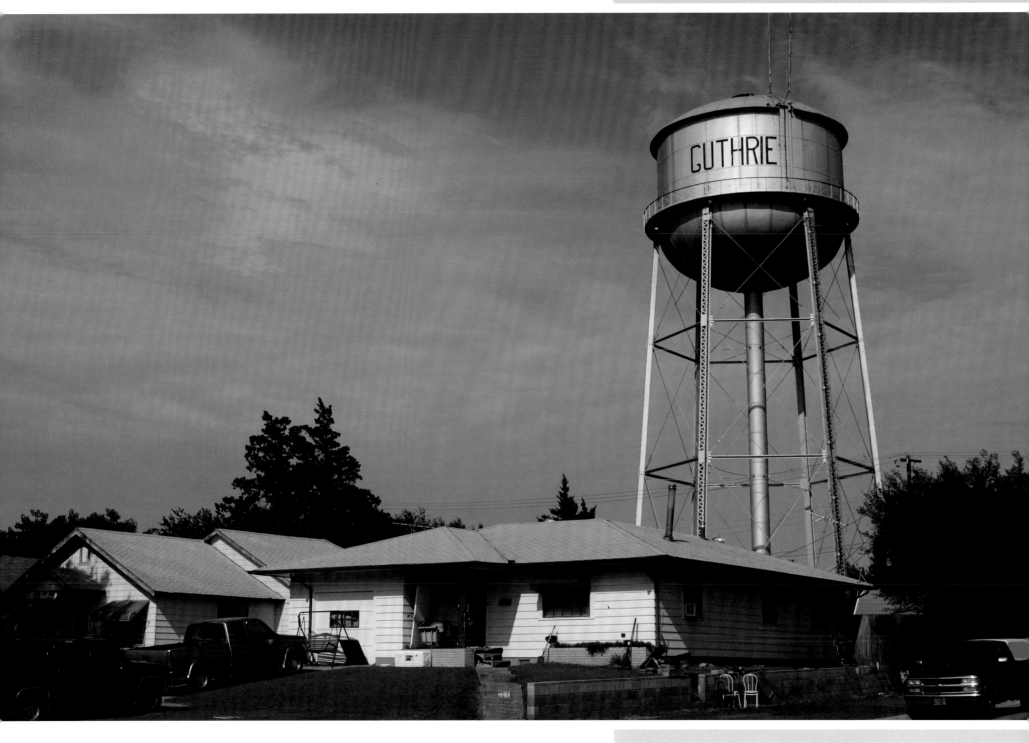

Guthrie was the first state capital of Oklahoma in 1907 but three years later fought and lost its battle to remain the capital. On the 11th June 1910 the State Seal was moved to Oklahoma City and the decline of Guthrie began. Guthrie's misfortune is its blessing today as many of its Victorian buildings are intact.

◉ TIP

The water tower in this landowner's backyard was interesting. Always be on the lookout for interesting or unusual images.

◉ TIP

Low-level images benefit from a right-angled eye piece attachment for your camera – it saves you getting on your knees.

Fire plugs (or hydrants) date from the 1600s when they had wooden plugs to fill the hole where the fireman had dug into the wooden water mains. Fire plugs stand on every corner in the USA and in various places around the world. They are also known as Johnny pumps in New York City where firemen used to be called Johnnies. The fire hydrant as we know it today was designed in 1869 by Birdshill Holly.

A gas station just outside Arcadia has the world's largest pop bottle at 80 ft tall. Inside the gas station there are over 2,000 soda pop bottles, a full service grill and soda fountain. A queue of people can always be found waiting to be served. This amazing gas station is the brainchild of Aubrey McClendon.

◉ TIP

Due to the size of this amazing bottle it was difficult to get the angles – this is where a tilt-and-shift lens would have come in handy.

📷 **TIP**

Due to the size of the museum and the amount of people inside I ended up taking images of fire engine bells and number plate signs. Filling the frame gave me a powerful image, especially with all the red writing. It doesn't matter that not all the plates fitted.

The rain clouds opened and I needed to do something indoors. So I decided I would return to the Oklahoma Firefighters Museum and photograph their old fire engines.

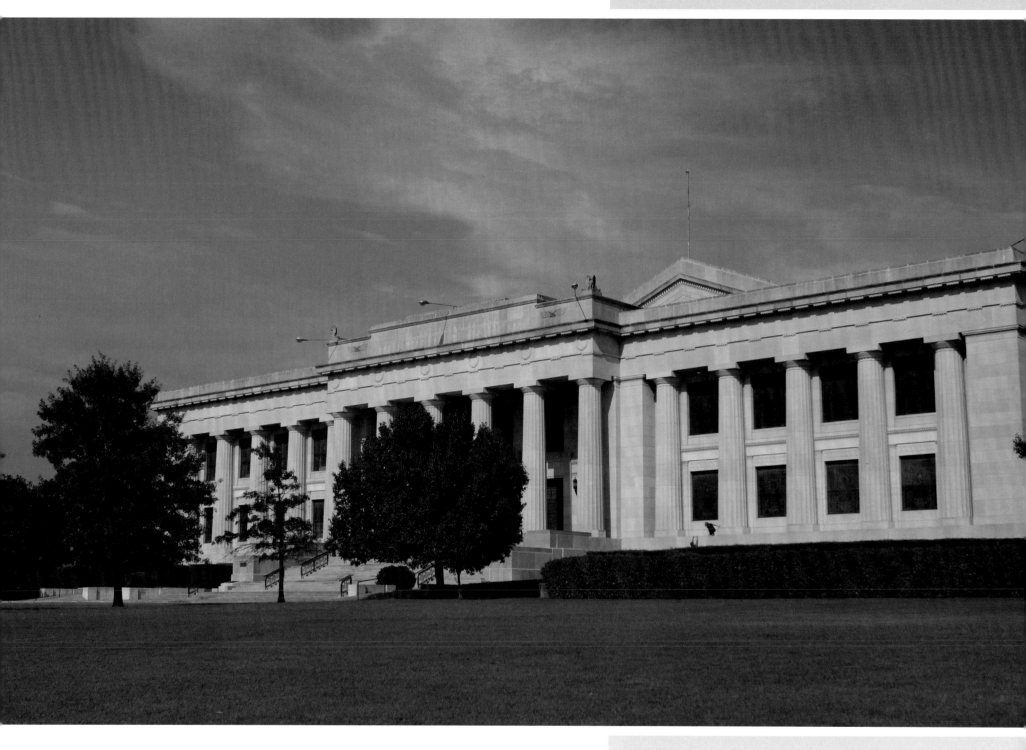

Guthrie has one of the world's largest Masonic Temples. Built in 1920 it is the great Temple of the Scottish Rite of Freemasonry. It also has a museum inside and offers guided tours but I only found out about these after I had visited.

 TIP

I wish you could have a wooden cardboard cut-out of a person in your camera bag to give an image scale when no one is around!

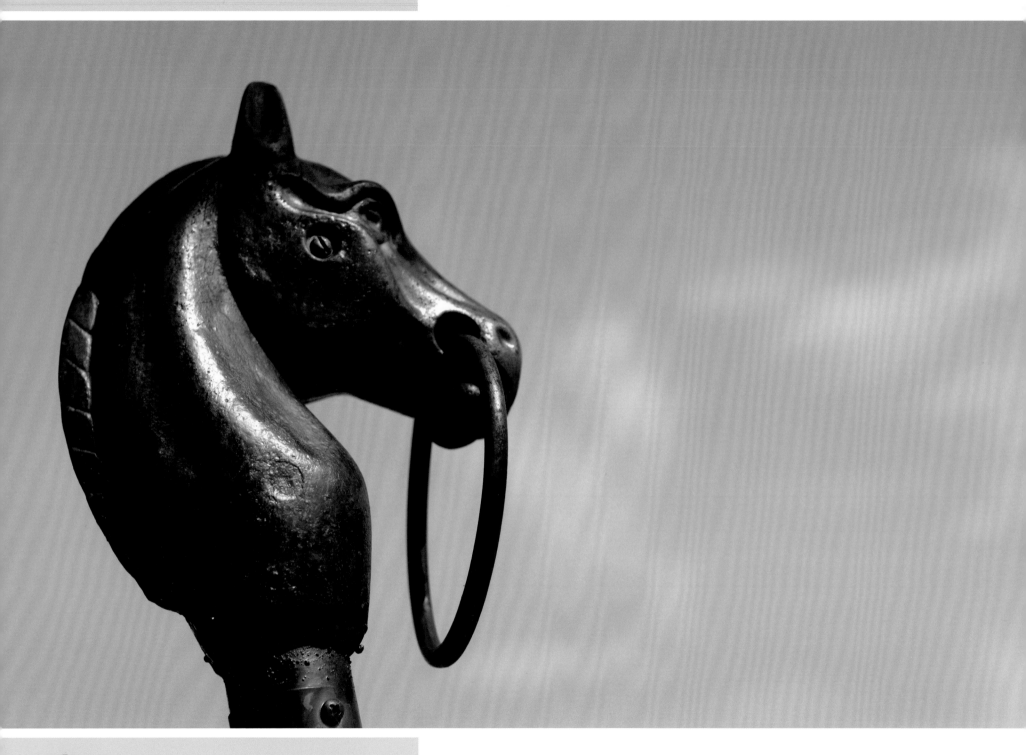

📷 TIP

Photographing from below means that you can put the sky in and avoid a cluttered image. I could have done that with the fire hydrant (Day 217) but it made sense to show the street in that image. Exposure: plus 1/3 of an f stop.

The nice thing about staying in a quiet town like Guthrie is that I could take images of historical buildings without being in the way or having people in my way. This old horse tie-up is one of many outside the theatre.

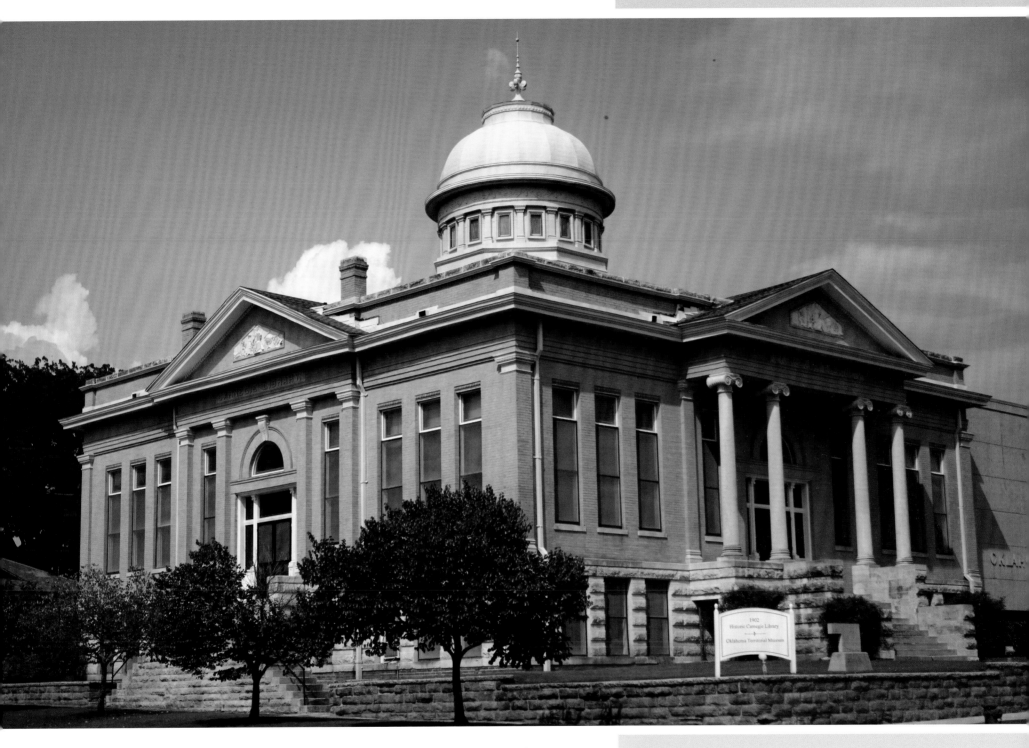

This is the County Courthouse of Guthrie and with the Scottish Rite of Freemasonry you wonder if there is a strong link with Scotland here. Pillars give this building a classical revival look. It was built in 1907 and designed by P. H. Weathers.

📷 TIP

Watch for converging verticals. Select your view point carefully – standing at the corner of a building ensures your vertical lines recede giving good perspective.

📷 TIP

Comparing new to old buildings is a good way of showing architecture through the ages. Tip for exposures: minus for large white objects like this building. Plus for large black images as on facing photograph.

From the classic to the modern, two totally different buildings in this unique town of Guthrie. But still no people – I did wonder whether it was a ghost town?

Born Marion Robert Morrison, John Wayne is one of my favourite actors, and many of his film locations have appeared in this book. Seeing him die playing Davy Crockett in *The Alamo* when I was eight years old brought a tear to my eye. It made me want to know more about Crockett, who then became another hero of mine.

 TIP
Faces and moving objects should always be looking or moving into the image.

📷 TIP
Keep all the rules of photography and everything will look well balanced.
This image is a record shot of social history.

Sno-cone is a cup filled with crushed ice and flavourings – so has plenty of 'e' numbers in it. This Sno-cone trolley was at Lake Eufaula, the largest lake in the State of Oklahoma. The reservoir was completed in 1964, and the dam is over 412 sq kilometres in area. This lake is popular for boating, fishing and hunting.

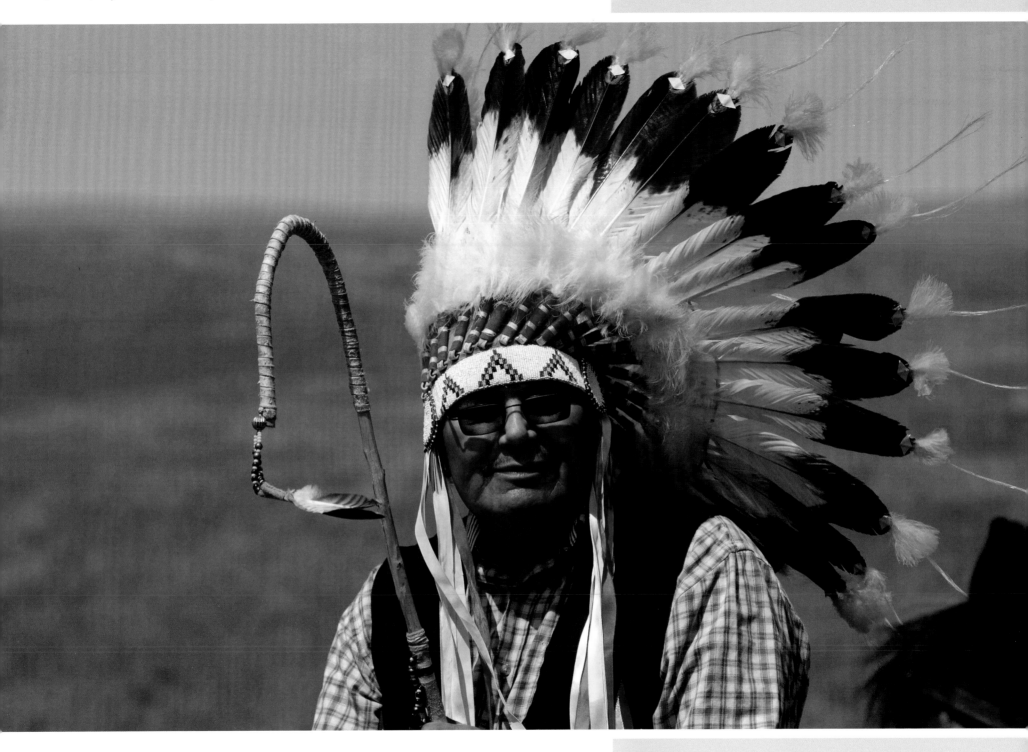

A pow-wow is a native American gathering involving traditional dances and ceremonies. They are becoming big tourist attractions, where in the past they were banned. Pow-wows are a way for the Indian tribes to communicate with each other, and play an important role for future generations.

TIP

Cultures and traditions are shown in this portrait, with space left on one side for any text that may be required.

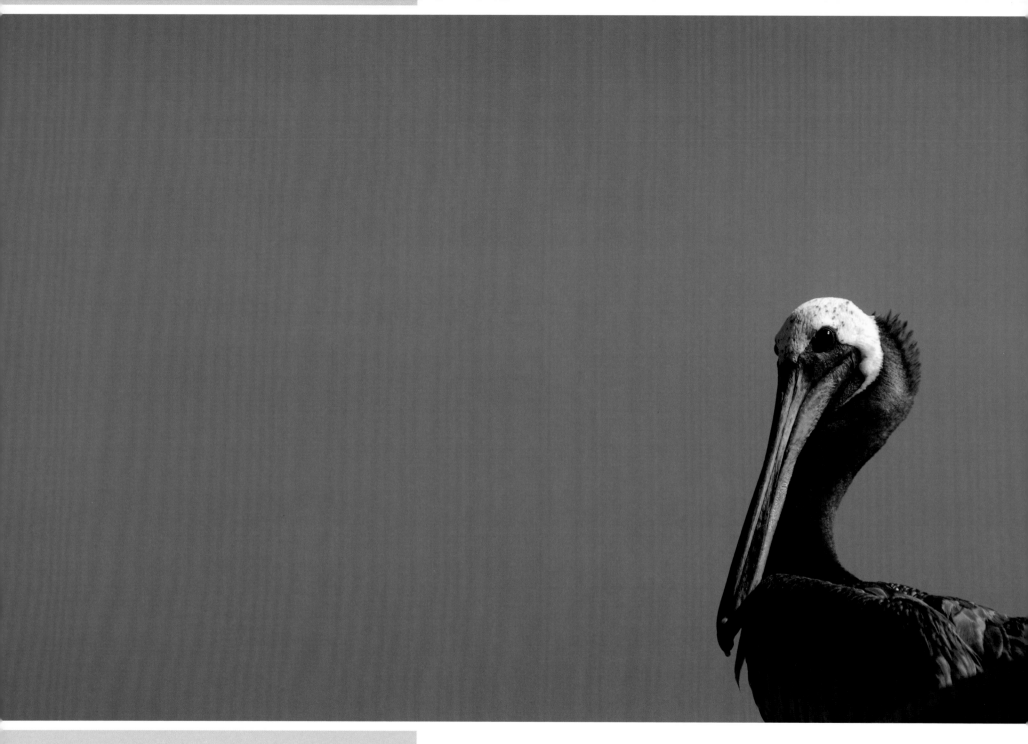

A day with great company.

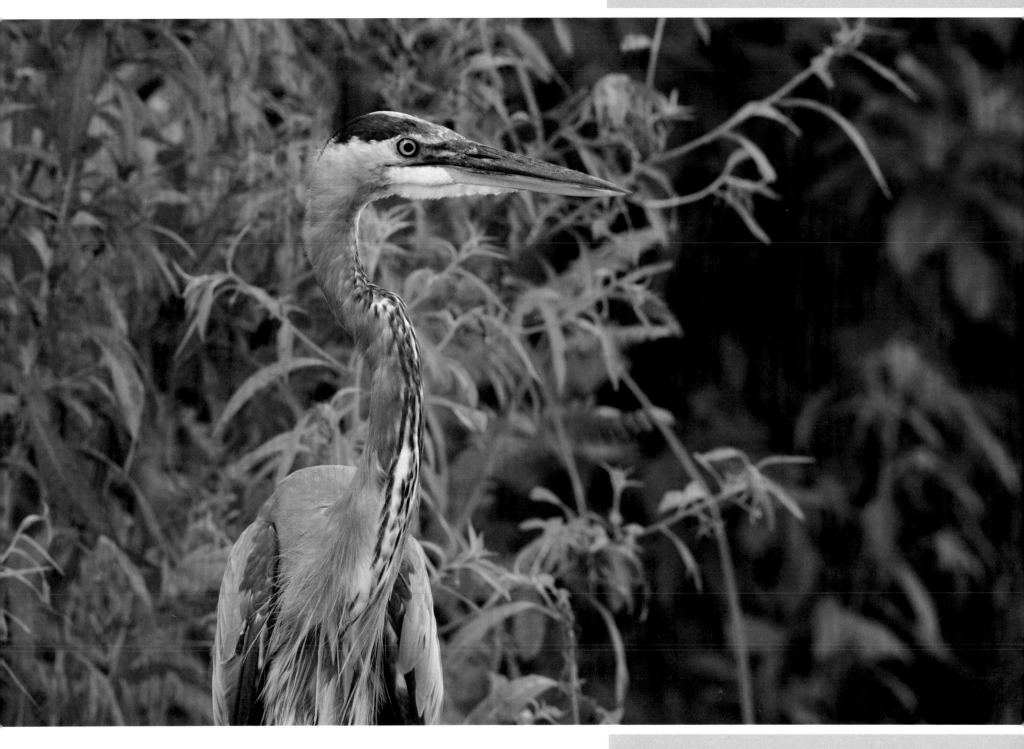

Giant blue heron fishing on the edge of Lake Texana. Herons will stand extremely still when fishing so that no movement distracts the fish until the heron is ready to strike (great movement image when it does). Herons make good images to photograph when like this, especially if you can get close to them but they can be a bit nervous and fly off.

📷 TIP

The green background blends to show the heron's beautiful plumage – get close to your subject whenever possible. Photograph wildlife in its natural habitat where possible.

 TIP
Keep your eyes and ears open at all times, nature has a wonderful ability to blend in. This image is perfect of an animal in its natural environment. The alligator has made himself like a floating log – no wonder people get bitten.

An alligator in camouflage waiting for dinner or just resting so it doesn't get pestered by photographers?

My last day in North America - it has been a wonderful six months. I have seen some amazing things but most of all have met some very special people and found some new friends. Hazel takes me to the airport. With so many hopes and dreams I leave with a heavy but brave heart hoping that we will see each other again soon.

📷 TIP

Compact cameras are ideal for keeping in the pocket to take images while your equipment is in the hold.

📷 **TIP**

Sunset times can change all over the world. In the tropics a sunset might only last for a few minutes, in other places it can last for hours. Check weather reports for sunrise and sunset times.

Arrive in Fiji in time to see the sunset – it is all that you would expect it to be. As I sit on the beach watching the sun go down my thoughts go across the ocean.

Walking along the beach thinking, 'I wish Hazel was with me'. I saw this image and my passion saved my heavy heart.

📷 **TIP**

Backgrounds are so important in your photography – make sure they are not cluttered or in direct competition with the subject matter. This flower with the smooth wind-blown sand and with only three colours works really well. The green leaves lead your eyes into the flower – I could have tried to move the twigs in the background but did not wish to disturb the sand.

TIP

It is often good to go somewhere just before the high season as it is slightly cheaper – just make sure everything isn't closed or the weather isn't extremely bad. Out-of-season trips are more productive as there are not large numbers of travellers around, but research might be needed.

Sunrise from the Travellers Beach hotel – I wake up to this sunrise every morning. It is lovely that Fiji is so quiet at the moment as it is low season, it means that I can have these moments to myself.

Writing on fresh sand is like an artist painting on a fresh canvas, and at the end of the day it will be wiped away ...

📷 TIP

Bracketing the image by using a -1/3 stop, correct exposure, and +1/3 stop, gives three different exposures – always make sure that the exposure is correct for important images. A picture says a thousand words.

Coconut husks after the fruit has been taken out. A mixture of shapes and textures – it is almost as if something has been stolen from its heart and the bright orange husk is its wounded flesh. It looks a bit like a jumbled mess, just the way I feel inside. Photography often shows how you feel deep inside – this is why images are often very emotional because the photographer feels at one with the image he is taking.

My last day in Fiji and it poured down. After I had packed for my flight to New Zealand I sat outside watching the rain come down, looking for inspiration. My images had been sorted, e-mails replied to and it was going to be a very long day – one of the low points of travelling but you have to take the rough with the smooth. Maybe I was just missing someone?

 TIP
Simple everyday images can be very effective.

📷 **TIP**
Take care photographing images at midday due to the harsh lighting.

Auckland is popularly known as the 'City of Sails' because the harbour is often dotted by hundreds of yachts. It has also hosted two America Cup challenges. Sailing is huge in Auckland. I thought it was popular on the south coast of England where I come from, but 60,000 of the New Zealand's 150,000 registered yachtsmen come from the Auckland region.

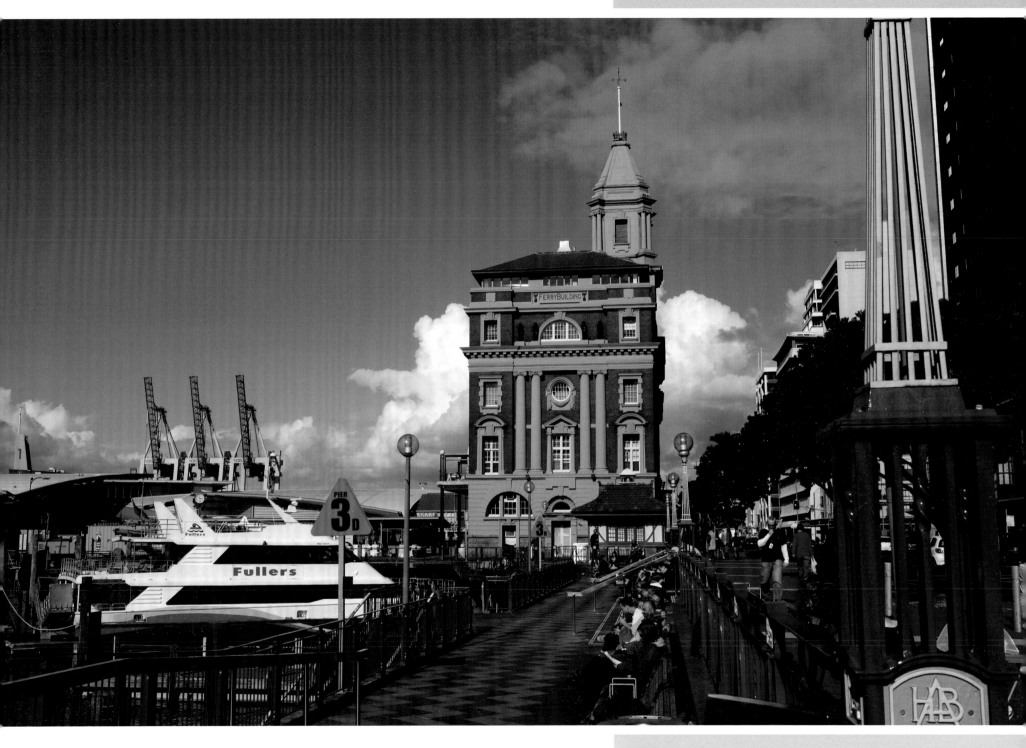

Queen's Wharf leading to the Ferry Building - this area has been expanded for the cruise ship industry as the majority of cruises around New Zealand begin or end in Auckland. Auckland is one of the few cities in the world to have harbours on two separate major bodies of water - the Tasman Sea and the Pacific Ocean.

📷 TIP
I like the modern with the old and the leading lines drawing you in to the historic Ferry Building. Plan your images carefully.

📷 **TIP**

Photograph modern art.

Symonds Street Cemetery had this unusual statue outside the entrance. Having photographed many statues I find it easy when the sculpture represents a person or persons, an animal or an event. But sometimes the subject is not always clear. This statue is intended as public art but I am not sure what the artist was thinking. On rare occasions statues themselves become historic and inspire their own historical events such as Crazy Horse Memorial.

The University of Auckland Clock Tower is an interpretation of perpendicular gothic architecture and was designed by Roy Lippincott. It was built in 1923-1926 after a competition was held to design a structure for the Arts and Commerce faculties. The building has become an important icon and landmark for Auckland and is opposite Albert Park in the centre of the city.

📷 TIP

An ideal balance of light and shadow creates good images.

📷 TIP

Great to practice your photography on, from flying and close ups to interaction. Get to know your camera.

There are many different types of gull all over the world. The size of a chicken or smaller, gulls can eat most food. They have learned how to live and breed near people. They are very intelligent and have a complicated system of noises and body movements that they use to communicate.

More graffiti - the artwork is so detailed in this image. The detail, textures and shadows in the dress are amazing right down to the spray can in her hand. Who is this? Is it based on someone? So many questions could be asked.

◻ TIP

Exploring a city or town by just walking around, you discover many hidden gems. When was the last time you walked around your local area and photographed something different?

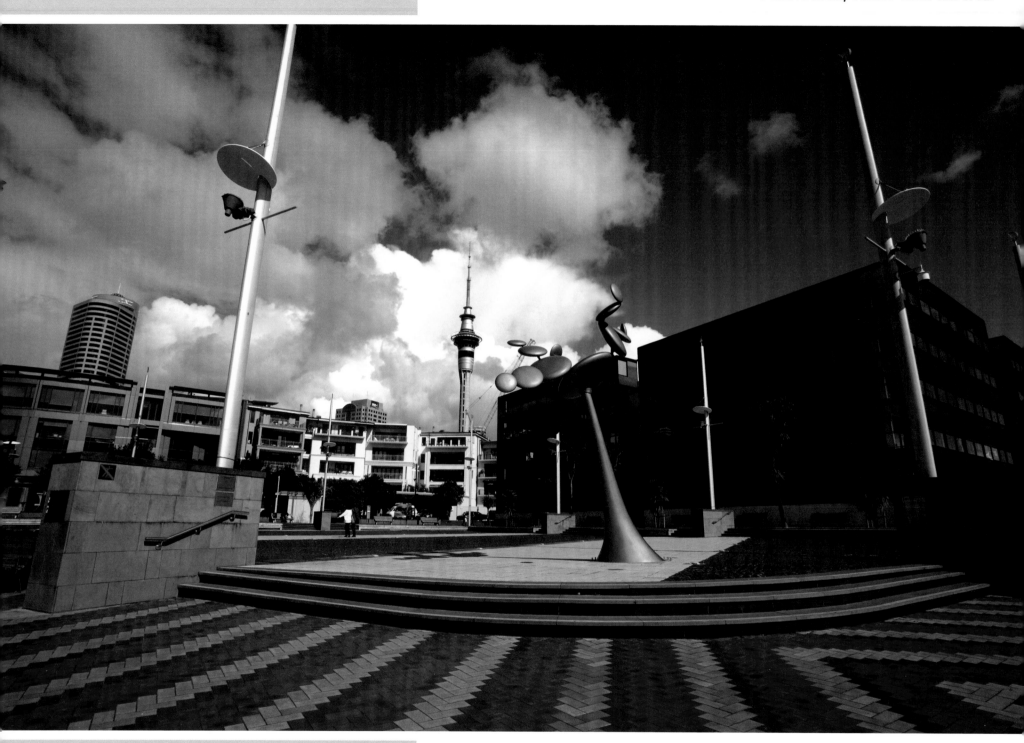

The viaduct basin is a marina and residential development in downtown Auckland. This was the venue for the America Cup. The sculpture in the middle moved. It was annoying as people would come up and touch it, so I would have to wait until it either stopped or people were out of shot.

Rental bikes are a great way to get around places, especially as car rental is so expensive. They are available all over the world and you can put your camera rucksack on your back and go off exploring.

📷 TIP

Camera rucksacks are great for transporting your camera gear around; also they do not look as obvious as a camera bag which a thief might target, and can be used as your carry-on luggage on aircraft. Cropped bicycles for colours and shapes – take unusual images.

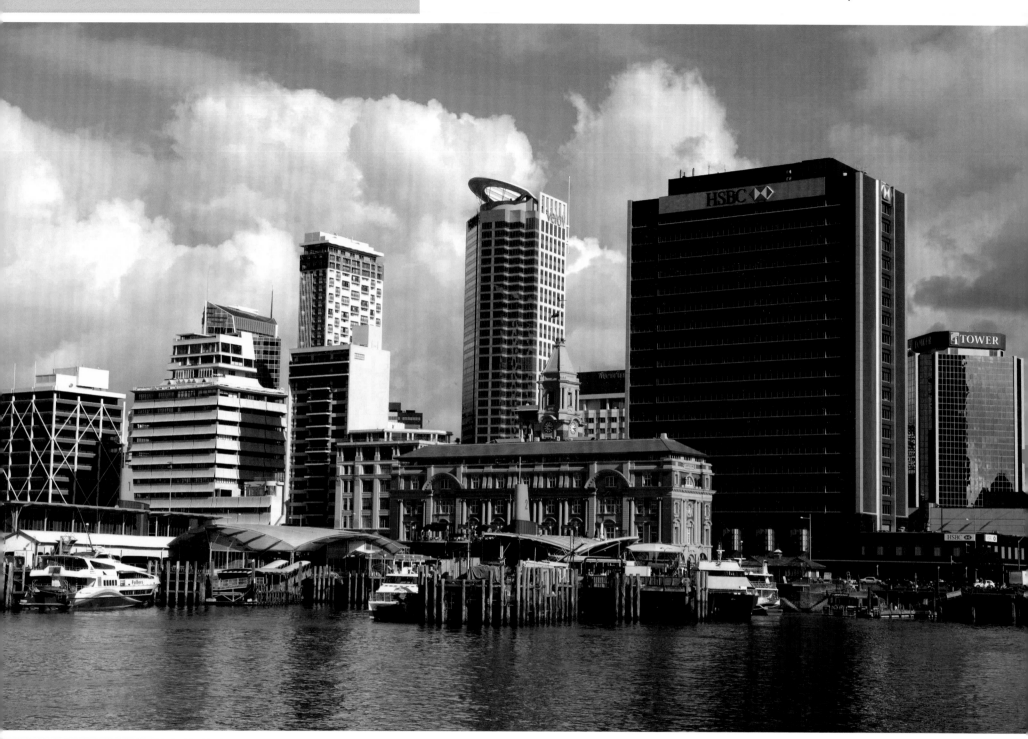

📷 TIP

Exploring every nook and cranny gave me the opportunity to photograph the old and the new buildings of Auckland harbour front. The picture is an almost perfect example of the thirds rule, f16 and upright verticals. By adjusting the focal length of the lens, the building on the extreme right could have been eliminated from the image.

This image has been taken from the Princess Wharf which was the old commercial part of the harbour. It has now been redeveloped into a multi-storey high-class development.

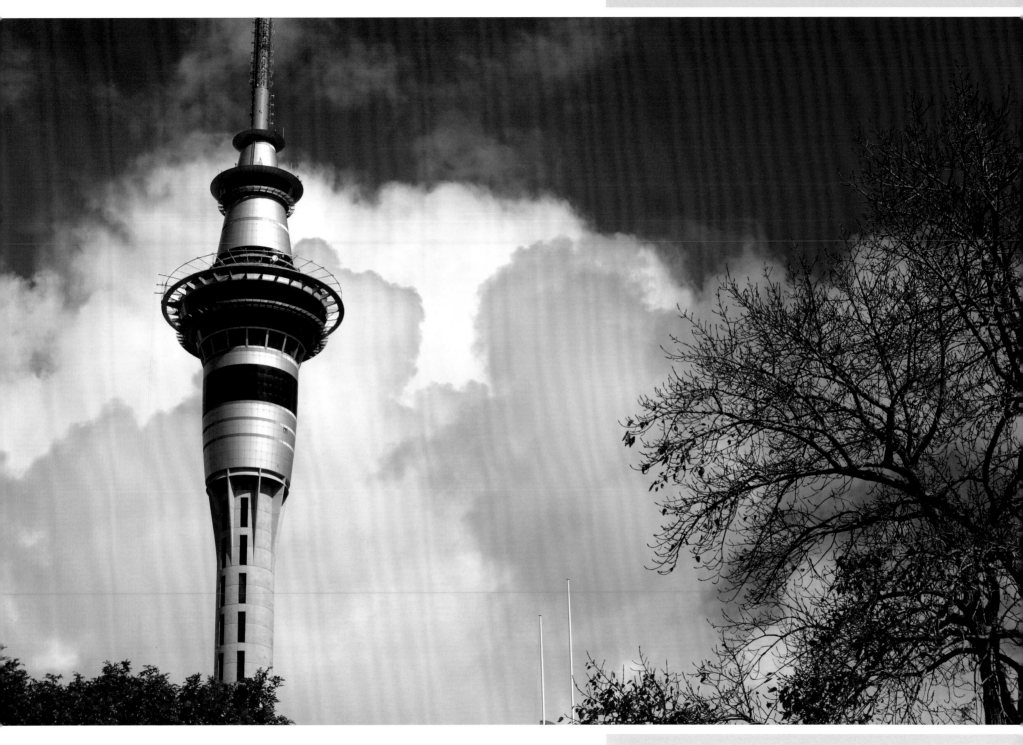

The Auckland Sky Tower can be seen from all over the city. It is the tallest freestanding structure in the southern hemisphere and gives you 360 degree views of the city. It is 328 metres high, has three restaurants, casino, sky walk and a death slide from 192 metres but is very expensive. I looked for days to find an image of this landmark in the city – I looked up at it from the streets, but I eventually found this image walking back through a park.

📷 TIP

Explore every nook and cranny but beware of your surroundings.

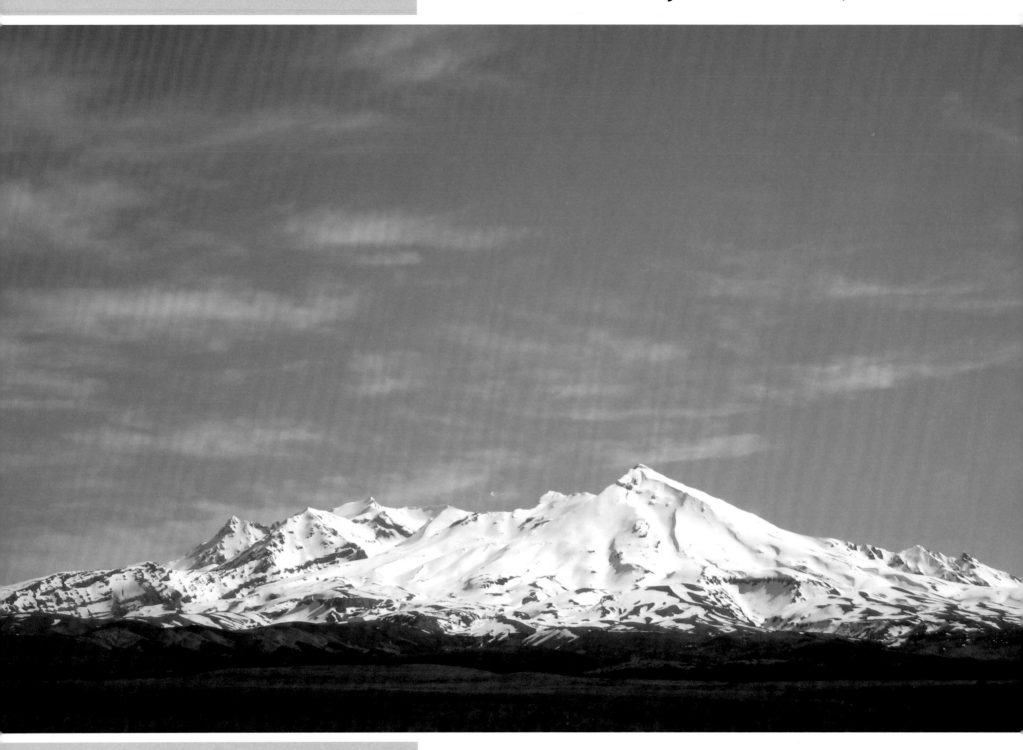

📷 TIP

I didn't really have long enough here but sometimes a country needs to be sampled before deciding to go back – which I will.

The coach journey from Auckland to Wellington was a really great way to see the North Island of New Zealand. I almost felt as thought I was back home, going through small villages and past sheep in the fields. The journey took about 10 hours but we did stop and view Mount Ngauruhoe at Tongariro National Park.

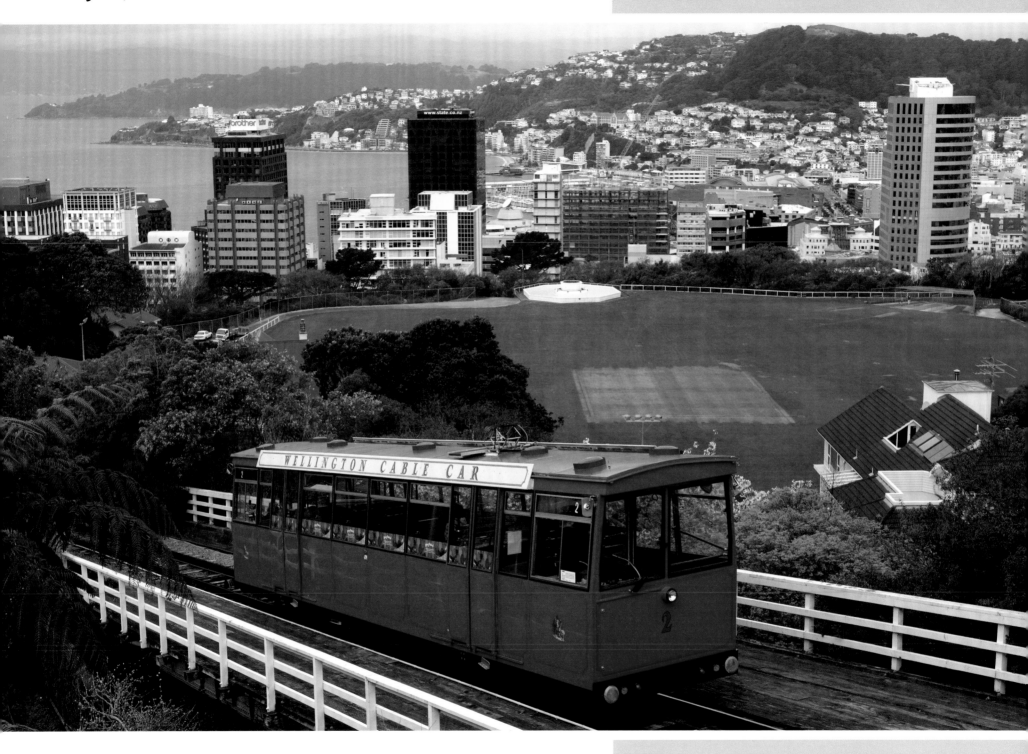

Wellington is the capital of New Zealand and is named after the first Duke of Wellington and victor of the Battle of Waterloo. Wellington stands at the south-western tip of North Island on the Cook Strait - this is the passage that separates the two islands. Wellington's café culture is prominent and the city has more cafés per capita than New York City. The Wellington cable car is one of the city's oldest and most popular tourist attractions.

 TIP
Find a high vantage point to take your images from.

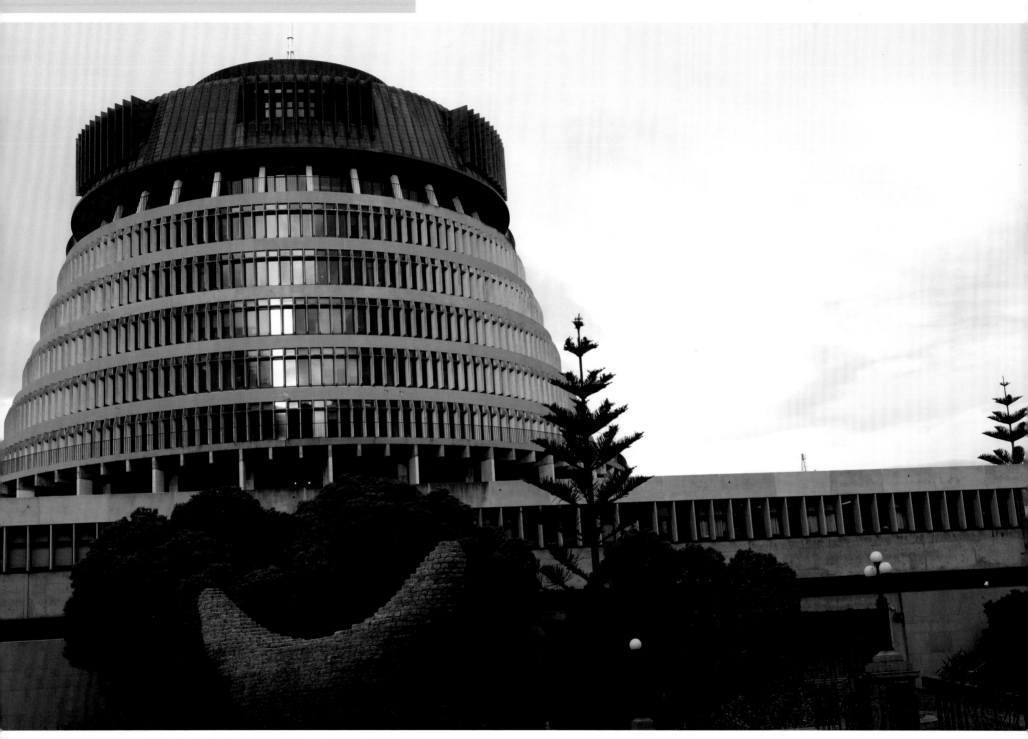

📷 TIP

Try black and white photography.

The Wellington Beehive is the popular name for the executive wing of the New Zealand Parliament building, designed by Sir Basil Spence in 1964. Though the building is an amazing design it is quite impractical as many of its rooms are wedge shaped, so it's hard to fit the furniture in! In the 1990s the beehive was going to be replaced but due to public disapproval this was never carried out.

The Wellington Botanic Garden is between Thorndon and Kelburn. It has many paths going through native forest and plant collections and was established in 1868. The gardens had a marvellous display of tulips but I was intrigued by a small figurine which gave contrast in my image. Suddenly this gentleman walked in front of my camera, bent down and spoke to the figurine. In an instant I had my image.

TIP

Watch for the unexpected.

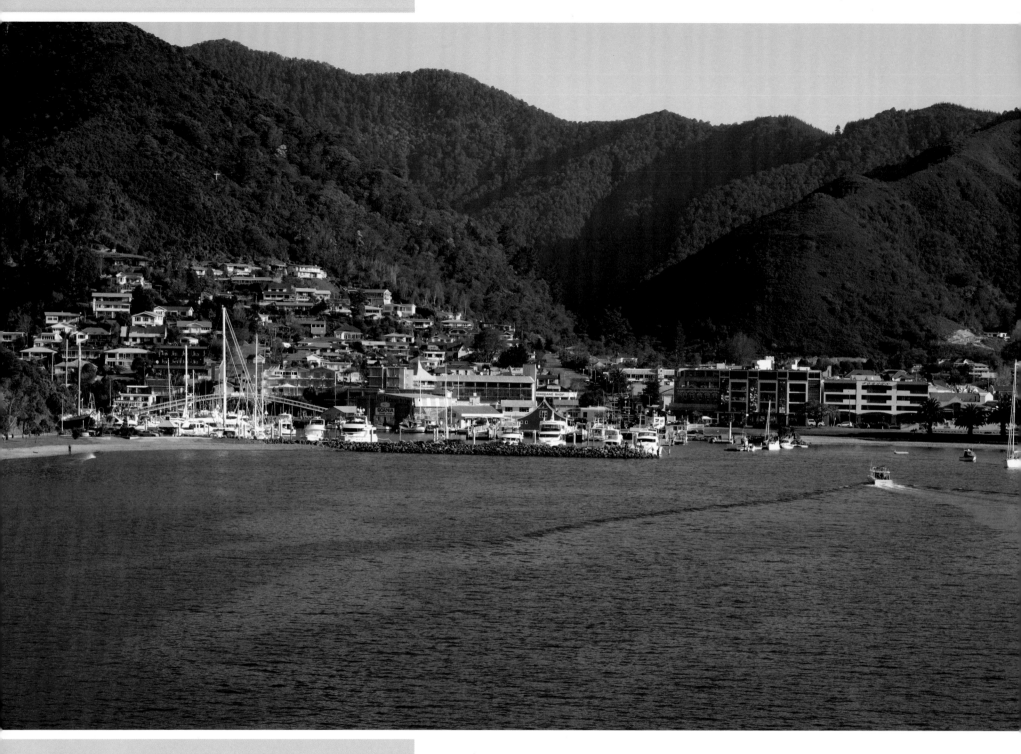

◙ TIP
Use different forms of transport to get different perspectives on images.

I caught the ferry from Wellington across to the South Island and arrived in Picton – gateway to the south – to start my journey to Christchurch. The South Island is very different from the North: apart from being larger it has fewer people and is divided along its length by the Southern Alps, the highest peak is Mount Cook. The South Island has large ski areas as well as glaciers and rugged countryside.

The Interislander Ferry takes 3-4 hours coming into the Marlborough Sounds, giving stunning scenery. It is worth a return trip even if you are just staying at Wellington. If you have a hire car you can leave it in Wellington and pick up another in Picton as all the car rental companies are there.

 TIP

Framing an image – I used the two large palm trees to frame the traveller on the seat as he looked out onto the Marlborough Sounds.

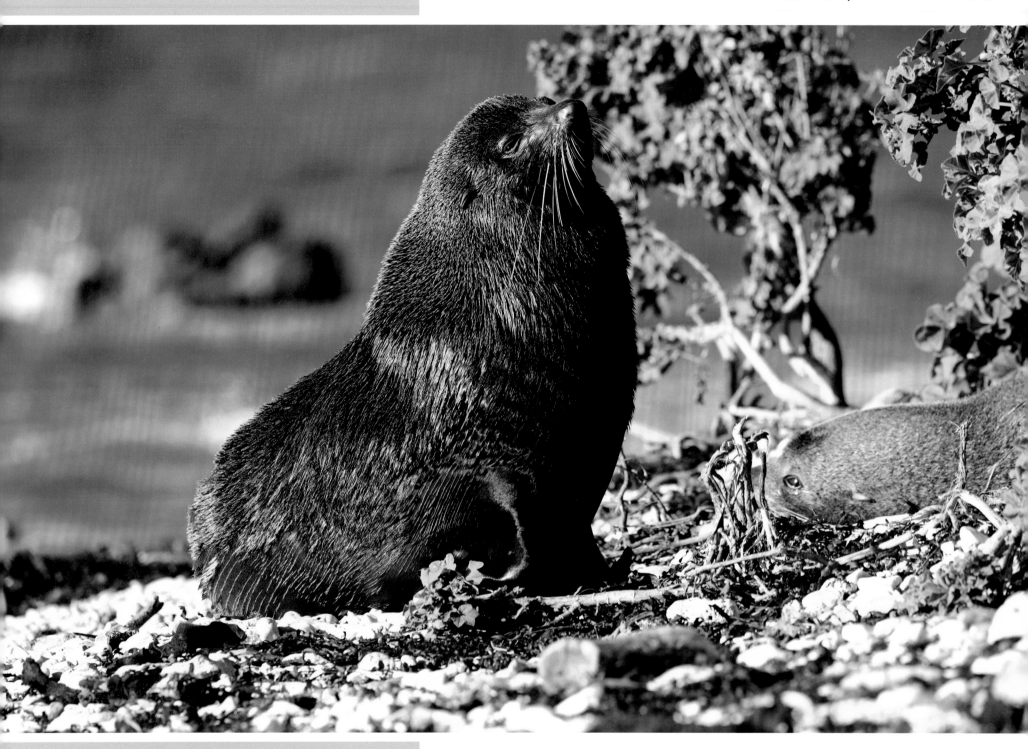

📷 TIP

By getting on to my knees I am smaller and less of a threat to this large male fur seal looking after his female. Keep your distance and respect wildlife while taking images.

I catch the coach service from the ferry terminal to my next destination of Kaikoura. This wonderful place has an abundance of marine life due to being a peninsula. It has a large colony of southern fur seals that can be seen on the eastern edge of the town.

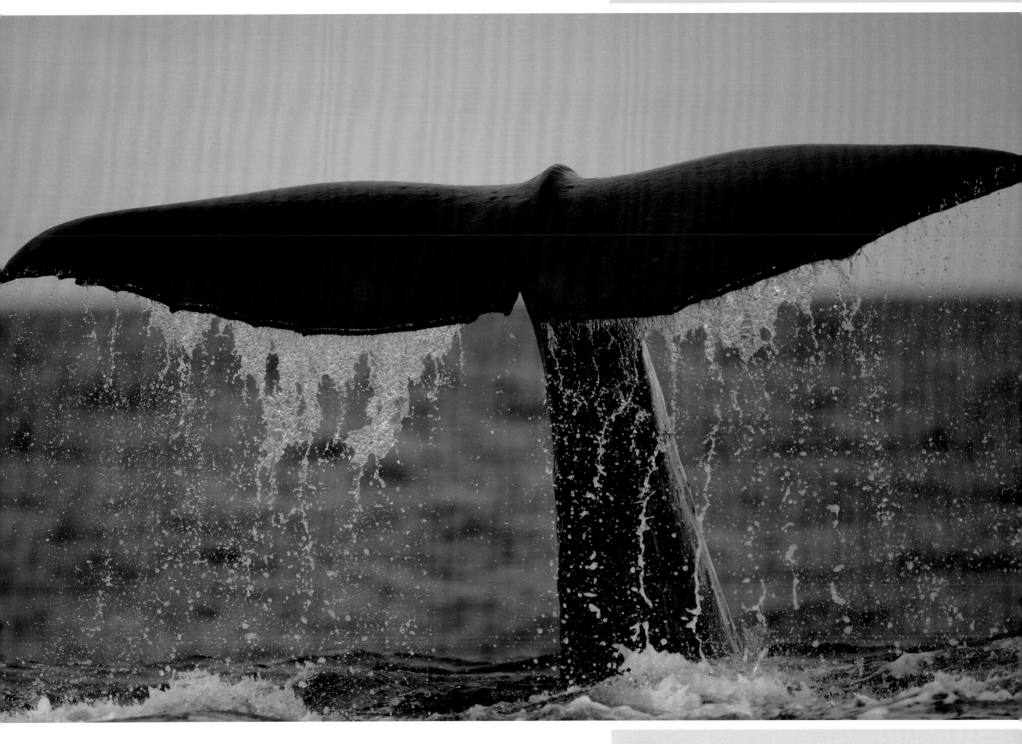

I came here for one reason: it is one of the best places in the world to see sperm whales, due to the huge oceanic trench off the peninsula. It is 5,249 ft deep and provides a rich feeding ground all year round. Albatrosses are also a common sight.

📷 TIP

Be alert and ready to take images. Sperm whales don't surface for long and then dive again for at least 40 minutes. That is why this difficult-to-compare image is my favourite in the book.

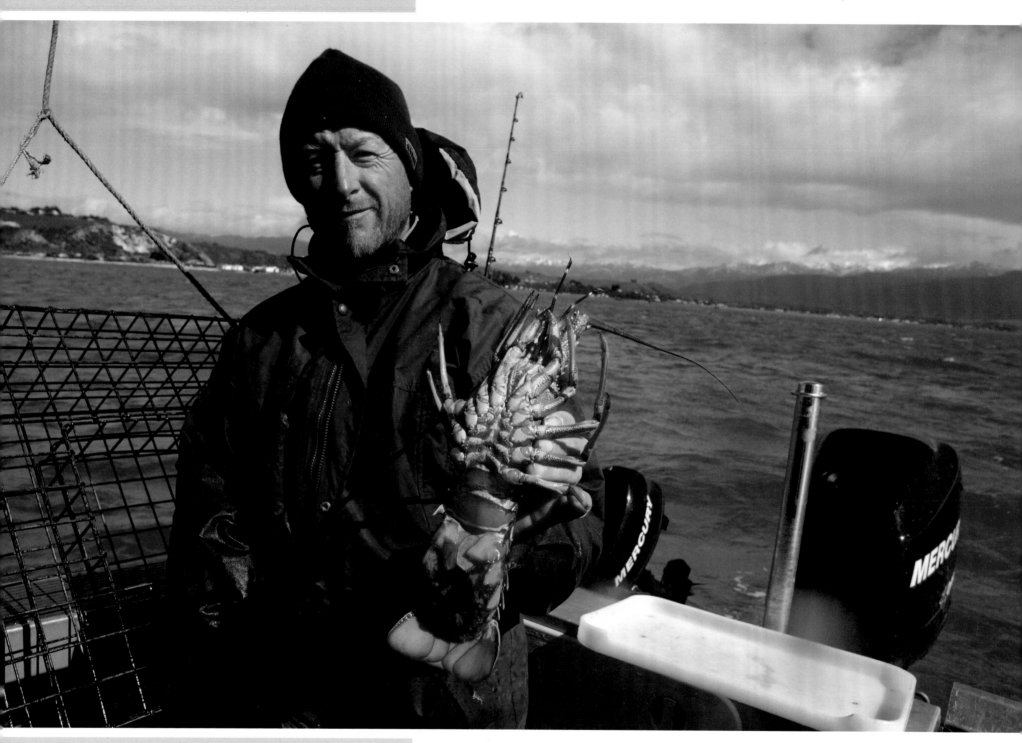

TIP

Always be polite and speak to people – I met Gerry Diedrichs through Sandy who worked for the whale watching company and he invited me to go crayfishing with him, enabling me to capture this image.

Kaikoura developed as a centre for the whaling industry and the name translates as 'meal of crayfish'. The industry still plays a role in the economy of the region; every New Zealander is allowed to catch six crayfish a day.

Apart from the wildlife, this magical place has a branch of the Southern Alps that nearly comes down to the sea. These are called the Seaward Kaikoura Mountains and give a fantastic backdrop to the town. I wish I could have stayed here longer but due to travel arrangements and meeting up with an old friend in Christchurch it wasn't possible. Kaikoura has wonderful sunrises over the ocean and sunsets that disappear behind the mountains.

TIP

Always establish the points of the compass when visiting new places.

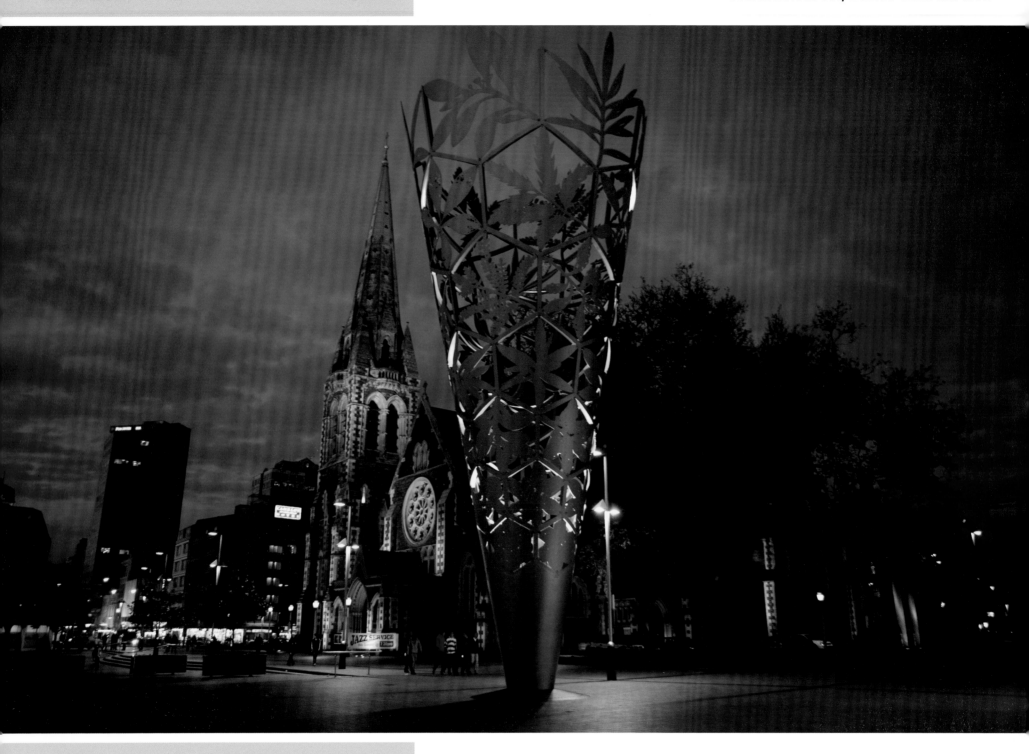

 TIP
Night photography is best taken at dusk, just before night falls.

I travel the 180 km from Kaikoura to Christchurch on the coach, arriving at midday. Christchurch is like a mini England with the River Avon flowing through the city and even offering punting on the river. Christchurch also has some of the cleanest and purest drinking water in the world, coming straight off the Southern Alps.

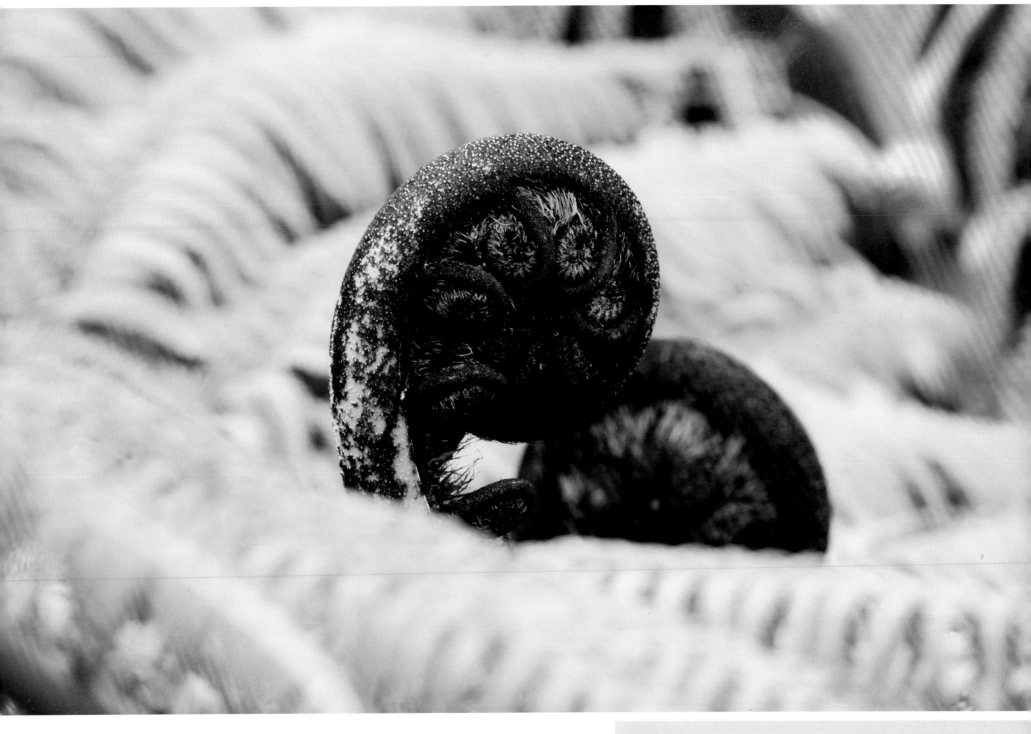

There are about 190 species of native ferns in New Zealand and it is the unofficial symbol of this country. A curled fern is called a koru.

📷 TIP

A shallow depth of field was used so the background was not a distraction to the koru. Though I prefer my images not to be central sometimes you have no choice. Focusing on the centre of the fern shows a fern within a fern.

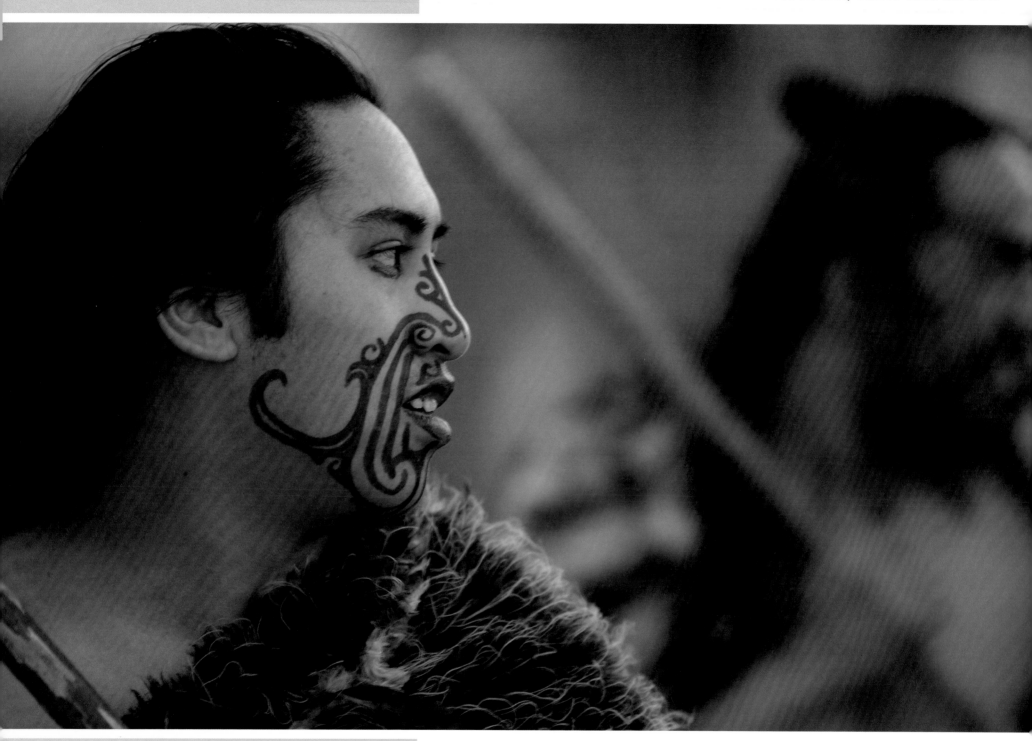

📷 **TIP**

The face of a Maori, using different techniques combining depth of field and filling the frame.

The Maori people arrived in New Zealand over 700 years ago. I went to the Tamaki Heritage Village for a re-enactment story of a traditional Maori tribe and the turmoil that they faced choosing between the old and new ways. I went with Jeff and his partner Debs who I met on my South American overland tour.

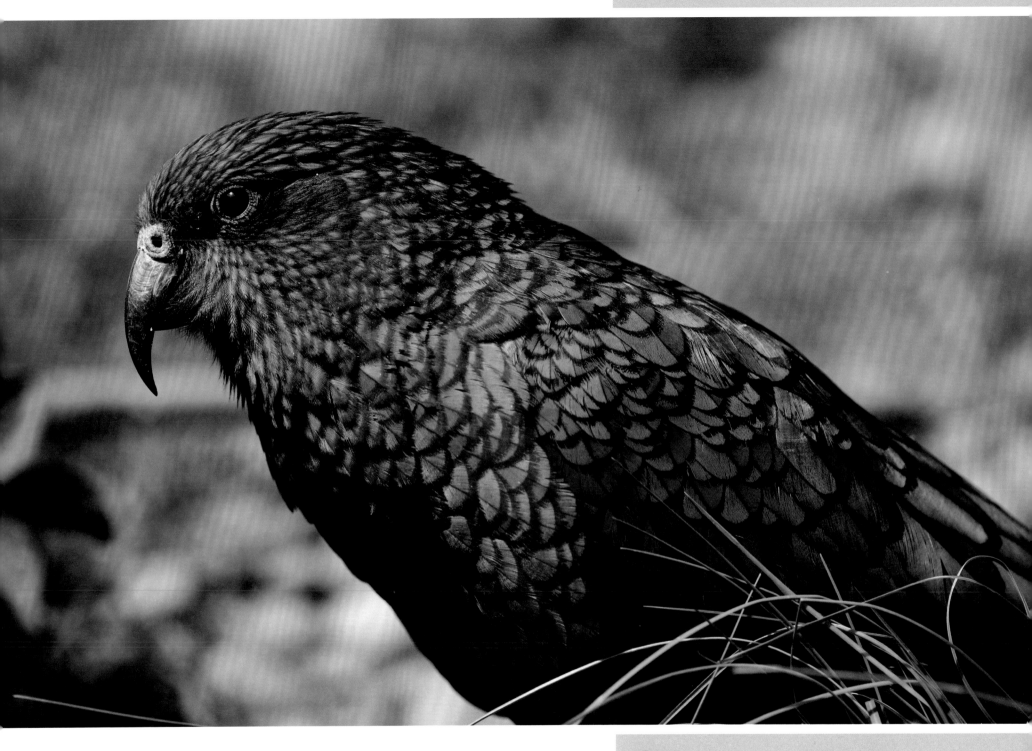

Kea parrots are legendary for their intelligence and curiosity. They used to be killed for bounty as they preyed on livestock, especially sheep, but received full protection in 1986 when farmers gave up their legal right to shoot any kea that tampered with property or livestock. This is helping to save one of the world's alpine parrots.

📷 **TIP**
Due to the location of the birds it was only possible to photograph this one under controlled conditions (wildlife sanctuary).

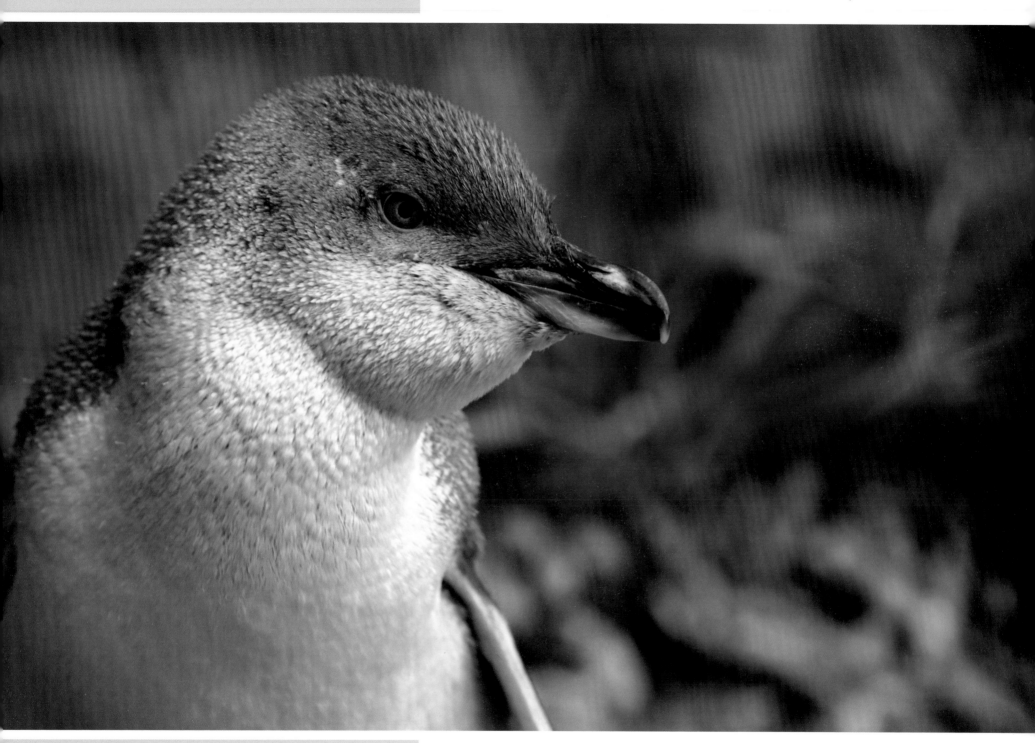

📷 **TIP**

Filling the frame helps to disguise the fact that the bird is in captivity and not in its natural habitat.

The blue penguin is the smallest species of penguin in the world at only 16 inches tall and owes its name to its indigo blue plumage. It is found on the coastlines of southern New Zealand and Australia. I couldn't go down to the coast to see them so found them at the International Arctic Centre near the airport, which rescues injured birds.

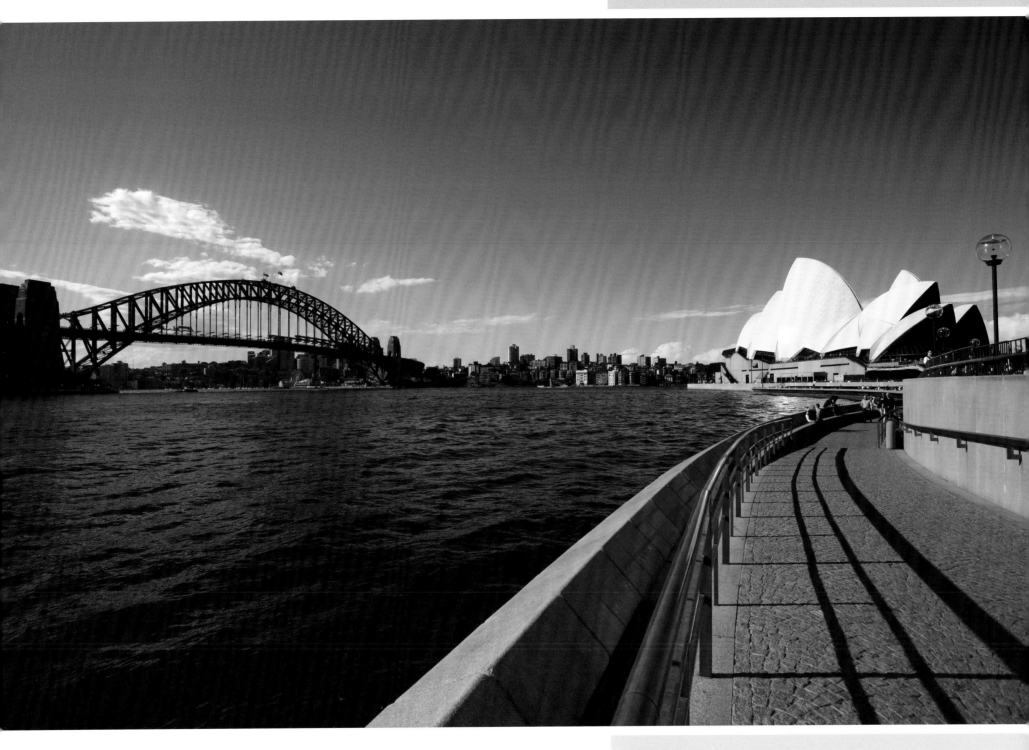

Sydney, the largest city in Australia and another tick on my bucket list. The city is built around Port Jackson which includes Sydney Harbour, giving the city its nickname 'The Harbour City'. It is famous for the Opera House, the Harbour Bridge and its beaches, but due to the expense of getting around I have to think carefully about where to visit.

📷 TIP

Leading lines of the harbour wall and the shadows of the railings take your eyes to the Opera House. Always look for an aspect that will draw you into an image.

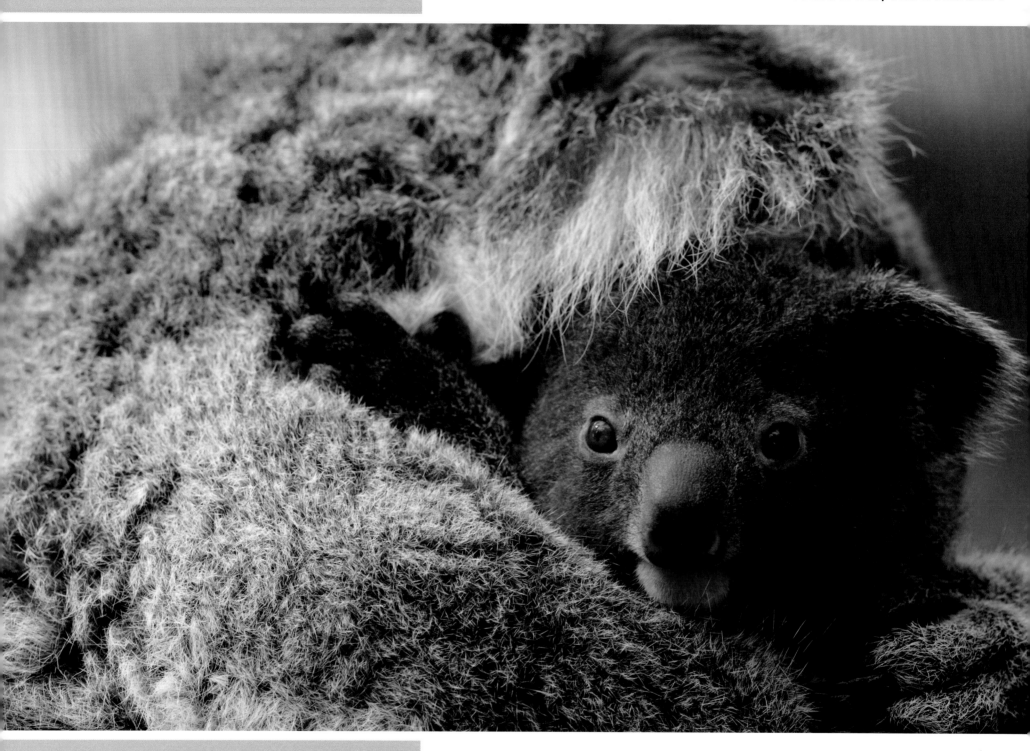

The koala bear, although not a bear, was given this name by early settlers due to its similarity in appearance to the teddy bear. The koala is found in Eastern and Southern Australia but not in Western Australia or Tasmania. Due to its diet of eucalyptus leaves the koala sleeps for 16 hours a day. Baby koalas are called joeys like all other Australian marsupial babies that live in their mother's pouches.

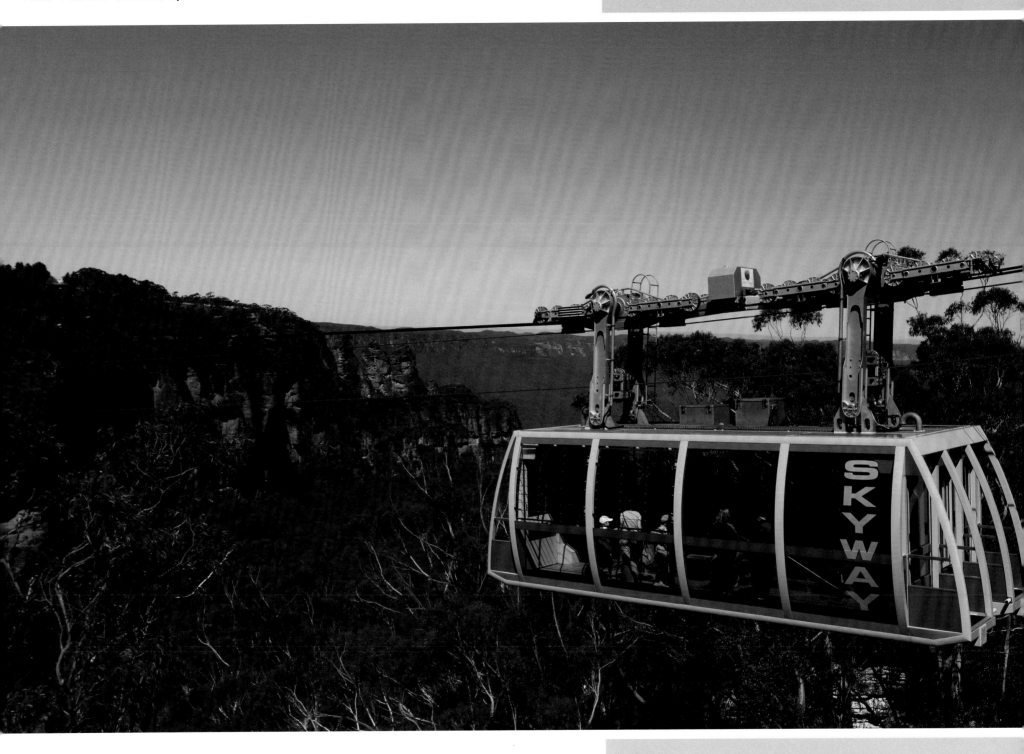

The Blue Mountains are about 50 km from Sydney and are one of the oldest ranges in the world. I was surprised to find that the landscape was more of a plateau, with deep gorges rather than high peaks. The Three Sisters are a sandstone rock formation and a well-known attraction. You can go across in a cable car to get amazing views.

📷 **TIP**
I have always wanted to keep the images interesting and inspirational – a different platform for photography.

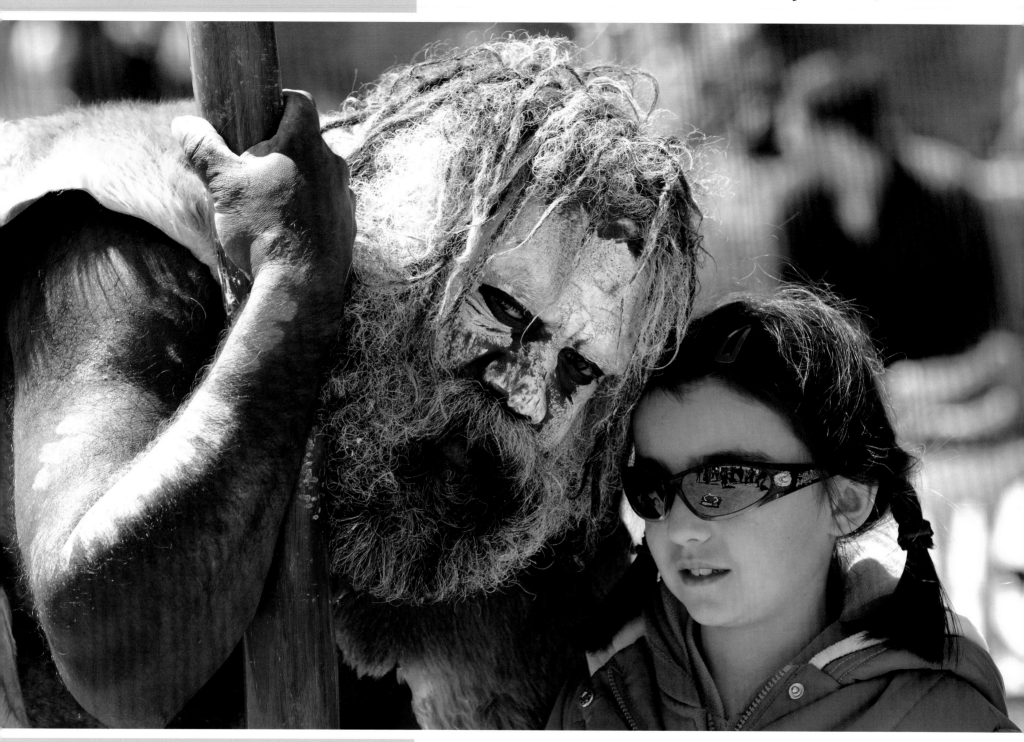

 TIP

Candid photography often produces lively portraits.

Aborigines only make up 2.6% of the Australian population as over half of them died from smallpox when settlers brought it across in 1788. They are the indigenous people of Australia who lived as hunter-gathers and were semi-nomadic due to changing food availability. Each tribe or nation spoke a different language most of which are extinct.

Manly is one of Sydney's northern beaches and is a 30-minute boat trip from Sydney Harbour. The beauty of taking this ferry is that when you come back you get the famous image of the Opera House and Bridge together. I spent a lovely day watching the surfers on the beach and planning my next three months. I have decided to go to South Africa earlier due to the exchange rate.

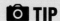 **TIP**
The contrasting dark skies and white tops give this image energy and vibrancy – another example of candid photography.

📷 **TIP**

Peoples' expressions as they watch wildlife will either show their passion for it or not – this small boy is mesmerised by the cassowary.

This zoo in Sydney is all under one roof and great to go to when it is raining like today! This small boy reminded me of my younger self when I had to be dragged away from the gibbons at London Zoo with me kicking and screaming! I wanted to capture the wonders of nature and how it affects you.

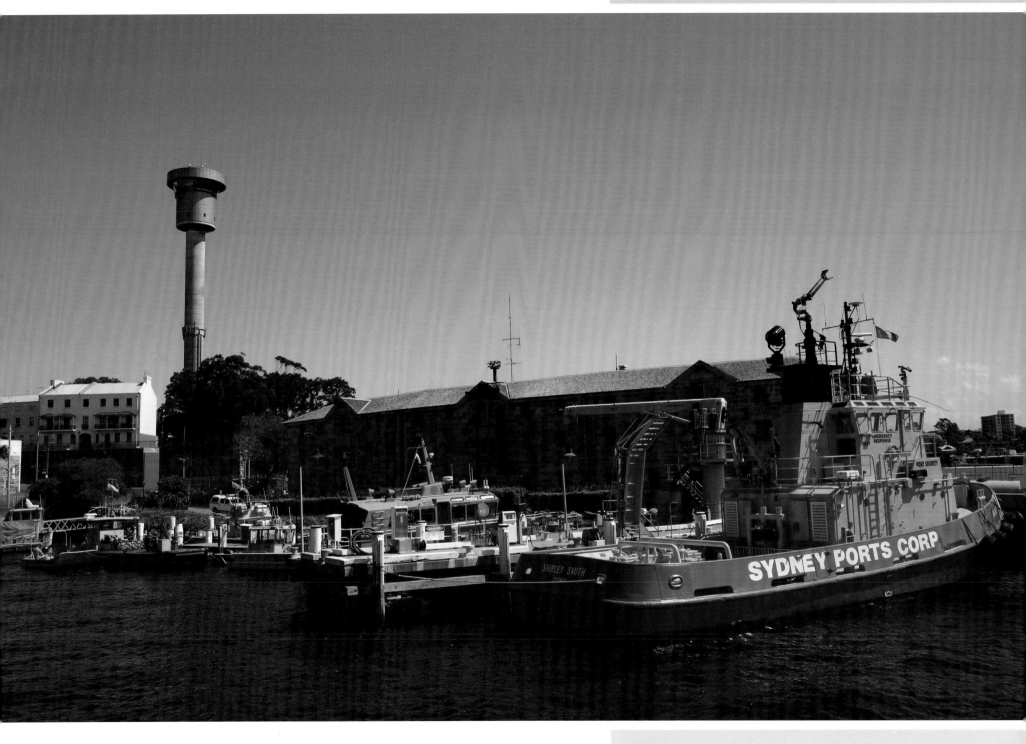

With the sun shining again and my walking boots on it was time to explore this multi-cultural city, which has been voted one of the top ten cities to live in. It is surrounded by national parks and beaches as well as having museums, art galleries and a lively nightlife giving birth to famous bands such as AC/DC and Inxs. Sydney is also famous for its gay pride parade held in the last week of January.

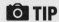 **TIP**

Photography is all about memories.

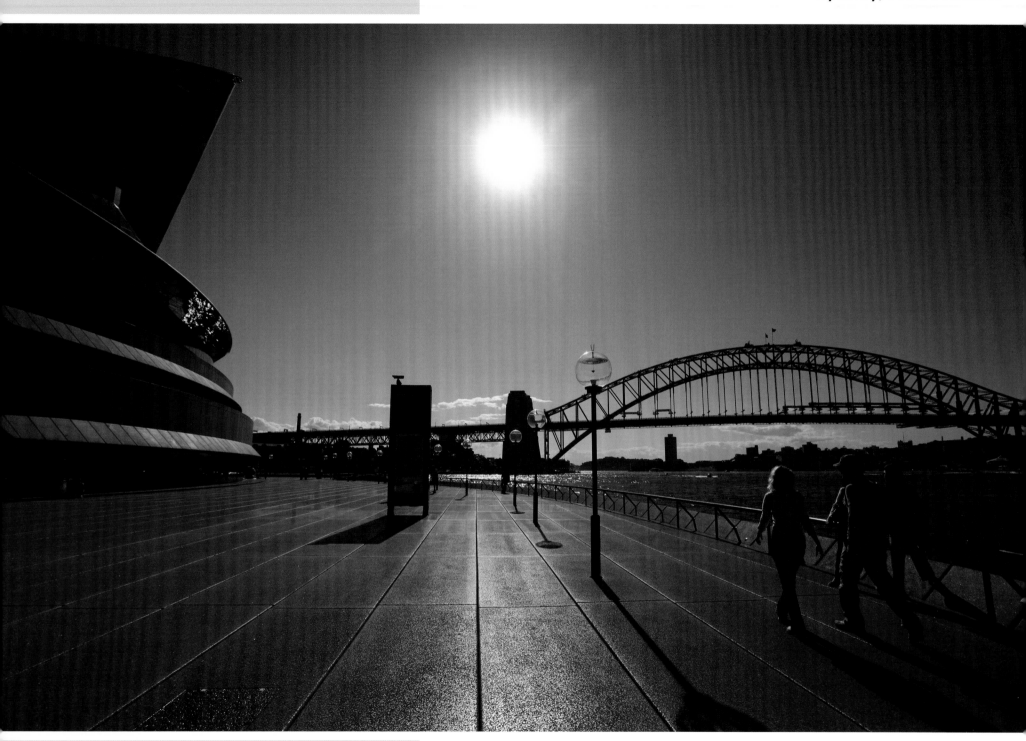

📷 TIP

Shadows create fascinating images on their own but are also beautiful when paired with their parent object. By looking at the shadows you can tell whether an image was taken in the morning, noon or afternoon. Don't be frightened to use shadows in your images – they can add mystery, volume and depth.

Sydney Opera House and the Harbour Bridge in the twilight of the evening sun.

A giant red kangaroo, another iconic image from Australia. As I am leaving earlier than planned I won't be able to get the image that I have in my head of this marsupial. I have waited for years to capture the whale's fluke, I hope I don't have to wait as long to capture the spirit of the kangaroo.

◉ TIP

A central image is rare for me but with the curved back and equal distances it makes a balanced photograph.

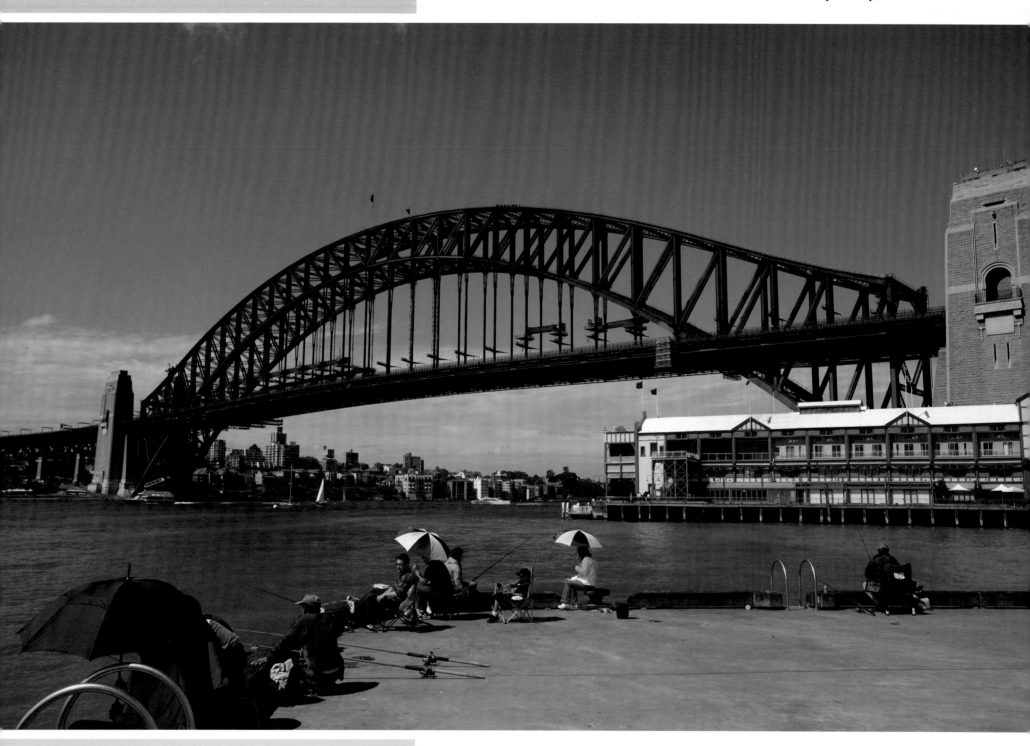

📷 **TIP**
Shadows tell the time.

The Harbour Bridge carries rail, vehicles and pedestrian traffic between Sydney central and the north shore. The Bridge and the Opera House (either together or separately) are iconic images of Sydney. The Bridge is the world's widest long-span bridge and tallest steel arch bridge, measuring 429 ft from top to water level. It is a popular tourist attraction, including the famous Bridge Climb that started in 1998.

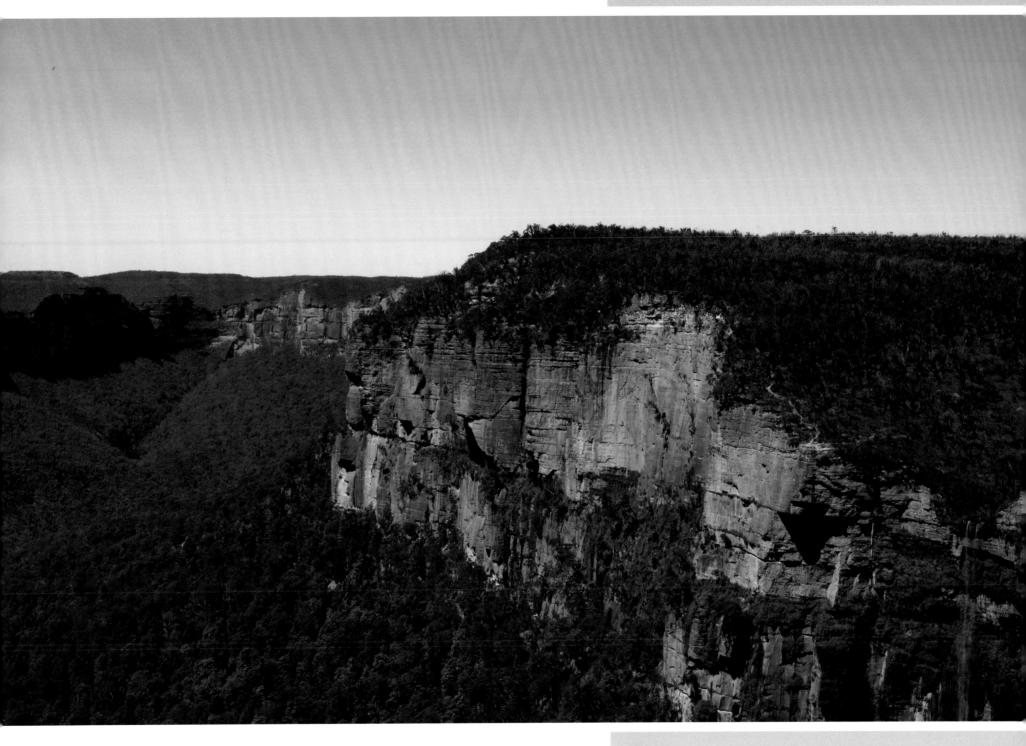

Staying in youth hostels gives you the chance to meet fellow travellers. Today I was asked whether I would like to share the petrol costs to Govetts Leap. This is a popular vista in the Blue Mountains with spectacular views and the gorse gorge. The waterfall at Govetts Leap is the tallest single-drop waterfall in the Blue Mountains but due to lack of rain the falls were not that impressive when I visited.

 TIP
You can buy software to make your own panoramic images.

📷 **TIP**
By changing your shutter speed and aperture (f stop) you can freeze or blur water in images.

Hyde Park is named after the original in London and is famous for its magnificent fig tree lined avenues. The park has many features including the Archibald Fountain, Captain Cook's statue and a 125 ft obelisk decorated with Egyptian features (it is actually a sewer vent). At the southern end of the park is the Anzac Memorial and Pool of Remembrance.

My last day in Sydney and there is only one place that I could be. The Sydney Opera House was designed by Jorn Utzon and completed in 1973. It has become a great iconic building of the 20th century, known throughout the world as a symbol for not only a city but a whole country and continent. It was formally opened by HM Queen Elizabeth II but the architect was not present.

◻ TIP

Remember images are free and endless in digital photography – shoot every angle.

 TIP
Facial expressions tell a story.

I arrived in South Africa not knowing how the next three months would go. The only thing I knew was that I was being picked up at the airport by a driver from Mufasa Backpackers. I didn't know at the time how this twist in fate of arriving early would change my future travel plans and allow me to meet some of my family that I had never seen before. Mufasa work with a local children's home as well as running safari holidays.

Mufasa - my gateway to Africa. It is a family-run youth hostel with en-suite rooms, private rooms and dorms, just 20 minutes from Johannesburg Airport. It is set in a lovely garden with a large swimming pool. Inside it has a snooker room, bar, communal kitchen and TV room. Juan & Toini with their son Daniel made this a lovely place to start my tour of South Africa.

◉ TIP

With nothing in the foreground the image is lost – using people can create better images.

📷 **TIP**
Open gates lead you into an image and also frame it.

Juan took myself and another guest, Alan, to his River Camp just outside Phalaborwa. It is a very rustic camp where you sleep in tents overlooking the river. We cook our own food which we brought from the local town, storing it in the fridge in metal boxes so the local monkey population cannot steal it. Juan checks the camp for wildlife as it is on the Oliphant River with the Kruger Park directly opposite.

Hippos swim up and down the river and at night graze on the grassy banks. The distinctive sound of hippos makes the hairs on the back of your neck stand up. I feel so at home in Africa – once you have been to Africa it gets into your blood and you always want to return.

📷 TIP

By lying down on the river bank I could get eye-level photographs of the hippos. I made sure that when they dived down I stood up, as I didn't know where they would resurface. Be aware of hidden dangers in photography.

📷 TIP
By having more than one camera body you don't have to keep swapping lenses at that vital moment. Beware of dust particles.

Photography can be a waiting game. In the safety of the camp I put my feet up on the fence with camera and binoculars at the ready, waiting to see if anything came down to the river to drink – sadly nothing did. Instead it was a day to relax and watch the clouds go by.

The view from my tent as I wake up every morning. Juan said I could stay here for as long as I wanted but without a vehicle it would be difficult to get around and the local wildlife is not as plentiful as I had hoped. Juan then told me that his driver had to go away on tour, and asked if I would like to help them pick up guests from the airport and stay at Mufasa free of charge.

📷 TIP

As the tent is always there, it makes a perfect photographic hide. Use all opportunities.

📷 TIP

Not having a tripod I couldn't use an f stop of f16 to get everything in focus. I could have tried, but didn't want to risk camera shake. Sometimes compromises have to be made.

I decided to take Alan on a nature walk using my wildlife knowledge and skills to show him the tracks along the dusty road and to see whether anything was about. We found no paw prints along the track so we hadn't been visited by lions or leopards at night, but we found a male giraffe browsing on the vegetation.

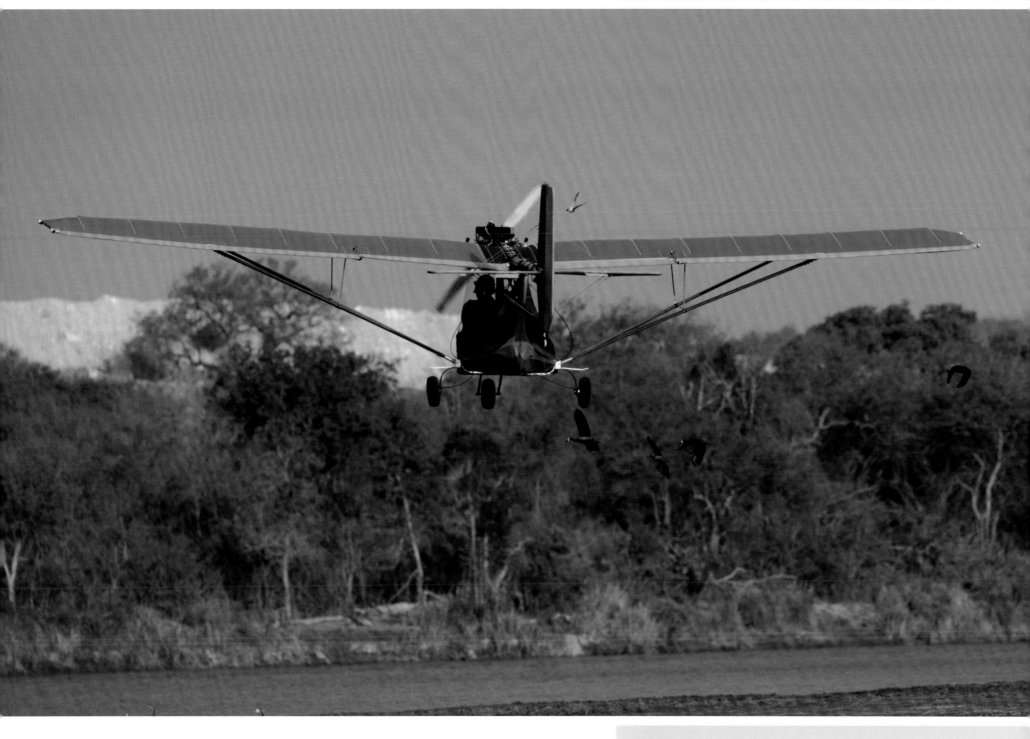

Flying would be an amazing way to take images of wildlife and local places of interest, but you are not allowed to fly over the Kruger National Park in a microlight. Juan told me a flight over a private game reserve could be arranged. I couldn't afford it this trip but with a new friend and connections I am certainly looking forward to my next visit.

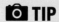 **TIP**

Aerial photography is expensive but can give you totally different images.

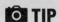 **TIP**

Look for wildlife in its natural habitat.

Today we came across one of my favourite antelope. Male kudus, like many other antelope, can be found in bachelor groups but more often they like solitude. The horns do not grow until a male is 6-12 months old, twisting once around two years of age and not reaching the full two and a half twists until they are six years old. The horns can be made into musical instruments called Shofar used in Jewish ceremonies.

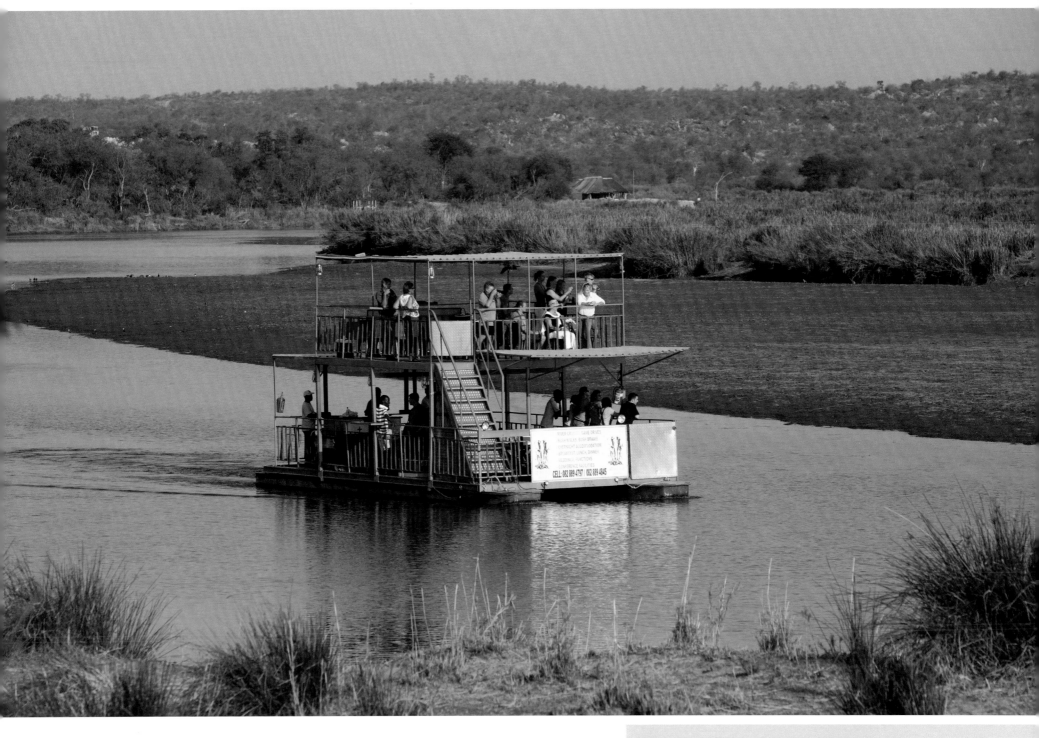

After watching the boat gently drift down the Oliphant River looking for wildlife, we head into town for more supplies and to check my e-mails. This provided me with a great sense of excitement as I had just heard from some of my South African family who wanted to meet up with me for the first time, when I returned to Johannesburg.

 TIP

Using boats gives you an opportunity to photograph wildlife from a different perspective. Boats don't scare wildlife.

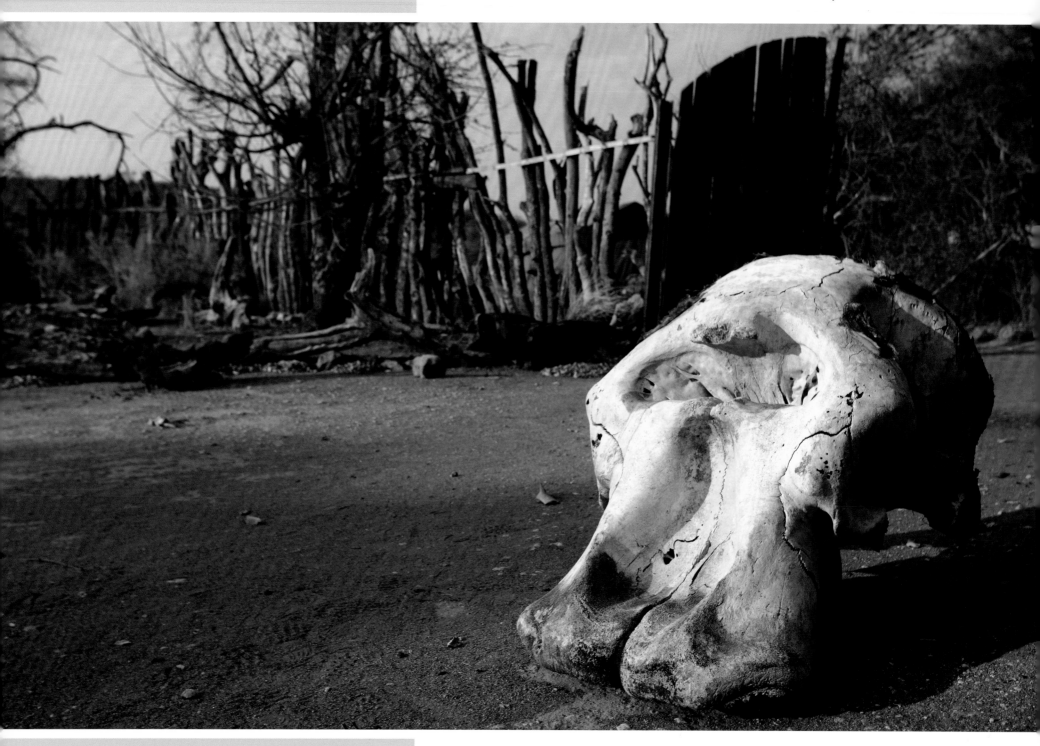

📷 TIP

I wear knee pads while doing low-level photography to save my knees from getting damaged. You might look foolish but it works when you are on your knees for a long time, especially doing wildlife photography.

A relaxing day in the camp while Juan went to a meeting. I could start planning November and what I would like to photograph in Johannesburg. The evening meal was always fun as we put out fresh eggs to watch the mongoose family roll them over and eat them. A rustic view of the camp, using the elephant's skull as a prime focal point. The length of the shadow under the skull shows the time to be early evening. Exposure -1/3rd.

I have been teasing Juan about the lack of elephants that we had seen, which up until now had been a 'big fat zero'. He had commented on how many elephants I would see in and around the camp, so to prove me wrong we went and found an elephant browsing about a mile away!

📷 **TIP**

Depth of field is shown by the foreground and background being out of focus, with the only sharp area of the image being the subject i.e. the elephant. An example of a shallow depth of field.

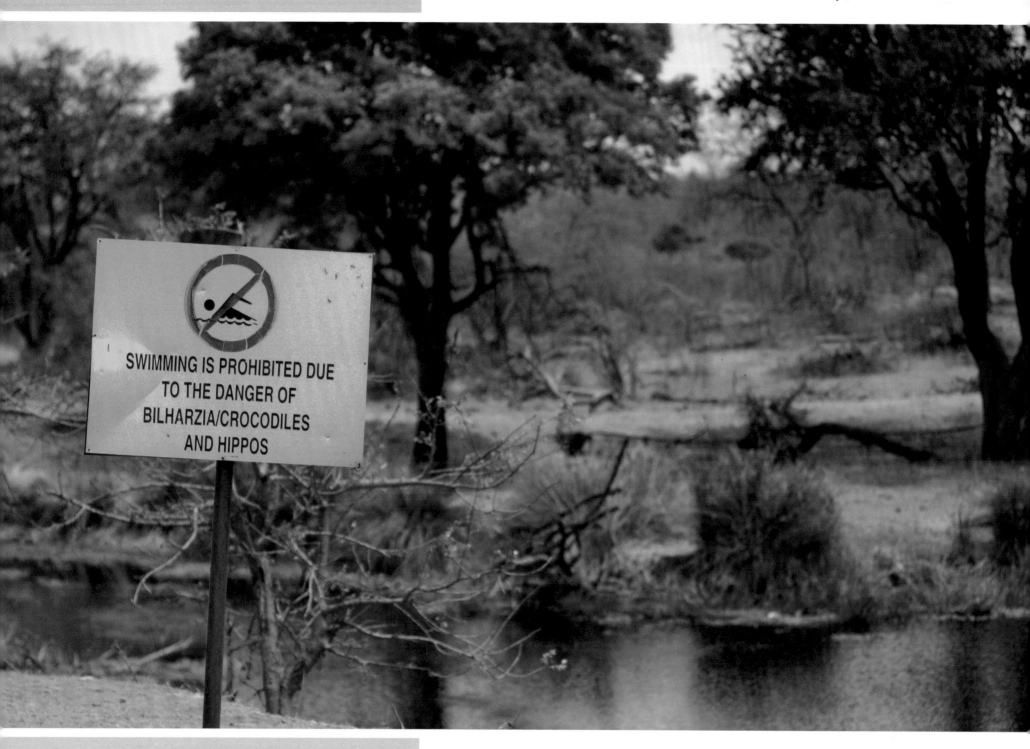

SWIMMING IS PROHIBITED DUE
TO THE DANGER OF
BILHARZIA/CROCODILES
AND HIPPOS

📷 TIP

Which should you use, JPEG or RAW? If you don't want to lose any information (data) contained in your image you should always shoot in RAW. Photographic software is designed to handle and process your RAW images so that you can edit and change your images.

My last day at the River Camp has been very relaxing and peaceful, soaking up the sounds of the bush. The local swimming sign provided me with a humorous but sensible warning.

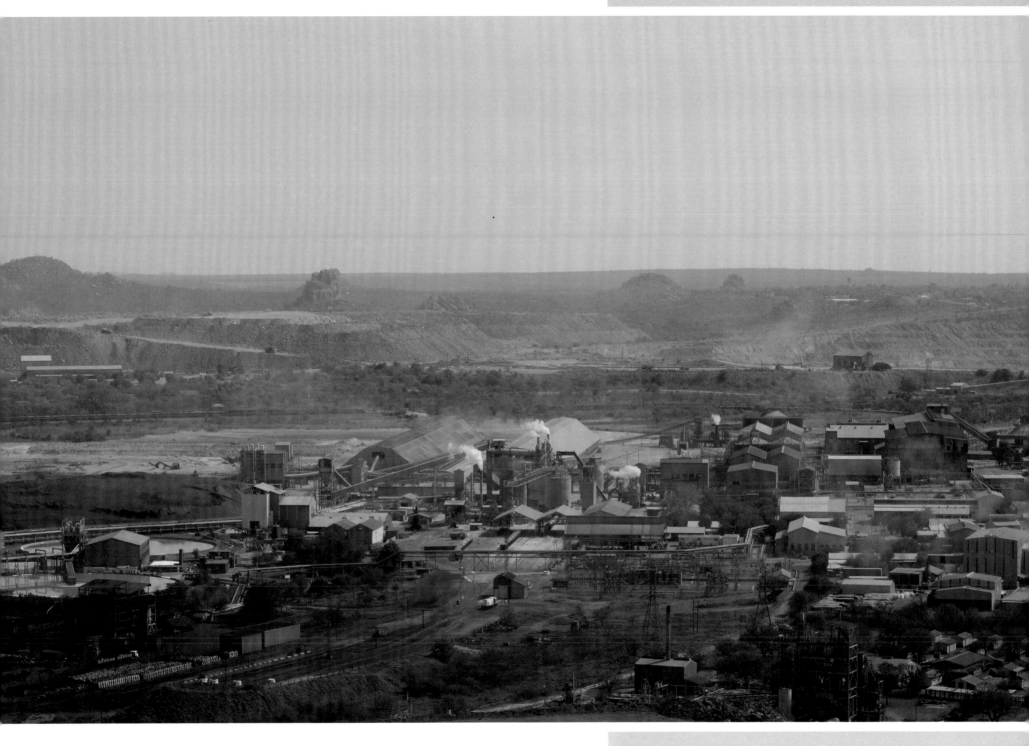

Mining in South Africa has been the main driving force behind the history and development of this country. Diamonds were found in 1867 at Orange River and there were gold rushes to Pilgrim's Rest and Barberton, with the biggest gold rush at Witwatersrand. Apart from diamonds and precious metals, it is the world's largest producer of chrome and manganese.

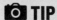 **TIP**
High viewing platforms and wide lenses can give an overall view of a large area.

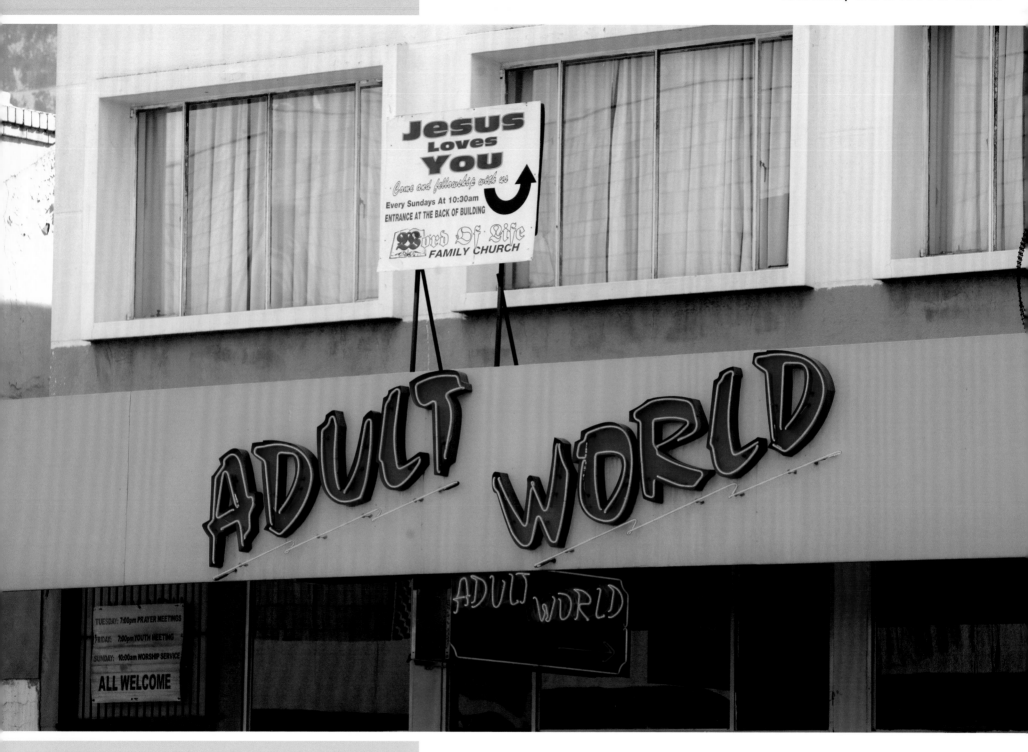

📷 TIP

Look for funny signs to make a picture.

Benoni was founded in 1881 and most residents were British miners. In 1886 a goldfield was found at Witwatersrand causing a major gold rush. Political tensions in this area caused the second Boer War in 1899 and in 1922 the rand revolt broke out throughout the mines. Thousands of white miners went on strike. The revolt lasted about a year and the miners were bombed by the air force. The local museum details this episode in the town's history.

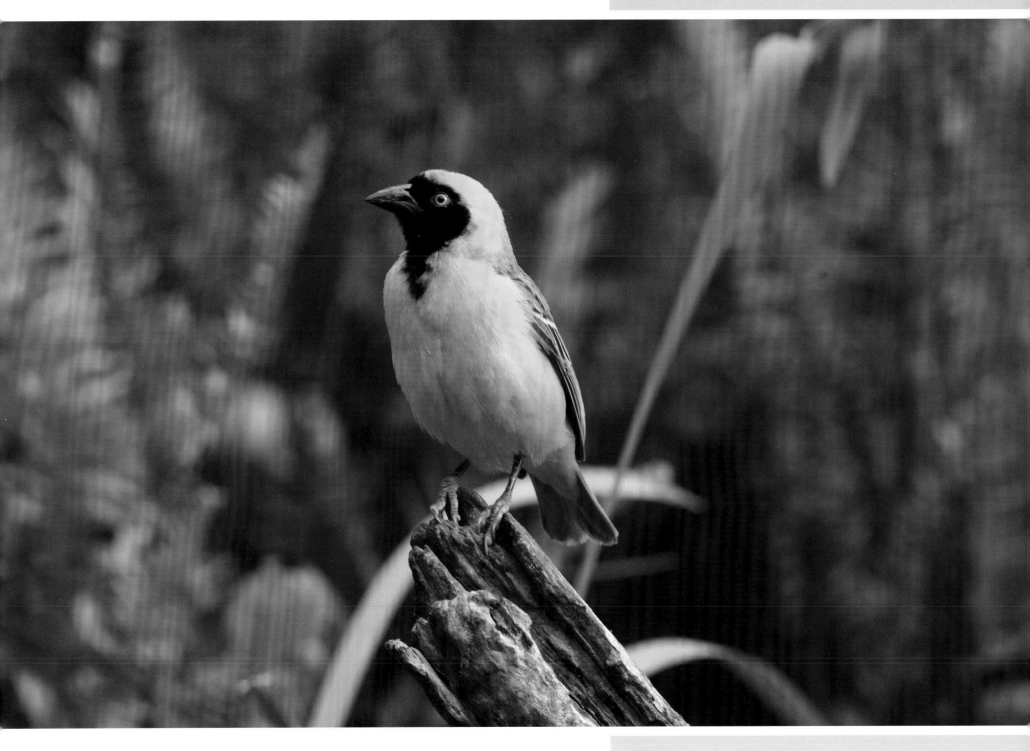

Weaver birds are common all over Africa. The male birds are often brightly coloured and use grasses to weave elaborate globular nests in bushes and trees. The nests are entered from beneath and the male hangs from it, calling and flapping his wings to attract a female. Some weavers build large communal nests, others are polygamous and build several nests.

 TIP
By placing a food source you can attract a number of birds to photograph.

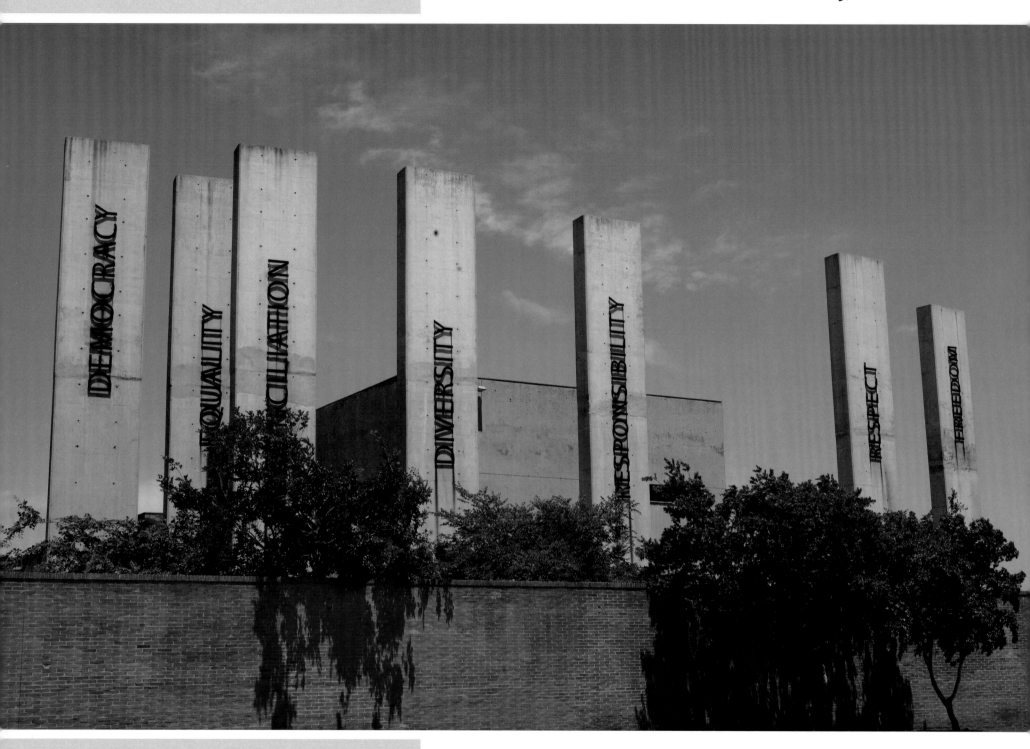

📷 TIP

Make sure images have your own copyright to prevent illegal use.

The Apartheid Museum is dedicated to illustrating apartheid and the 20th century history of South Africa. The term Apartheid – Afrikaans for 'apartness' – was a system of racial discrimination and segregation brought into law by a white government. The system propagated the notion that people other than those of European descent were sub human. The museum itself has an issue with its copyright name.

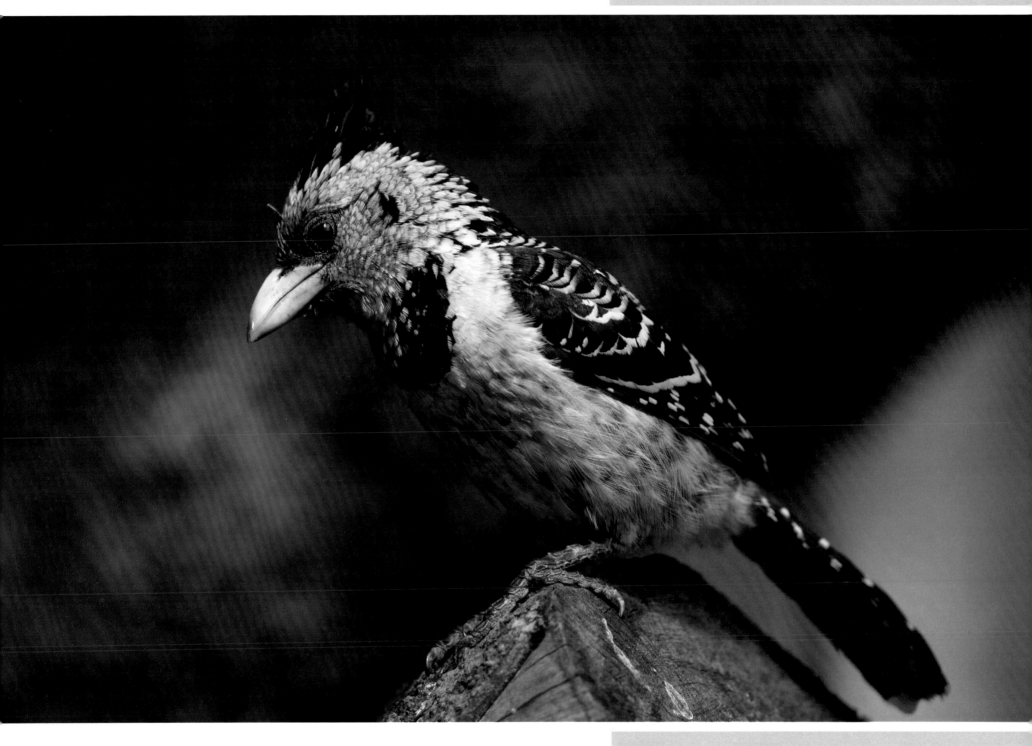

This crested barbet was taken at Mike and Sue's house – Sue is my second cousin who I had never met until a couple of days ago at the big family reunion. I found out that they are big wildlife lovers and often go to The Kruger, and have feeding stations at their house in Nigel. I spent many hours in their garden photographing the birds. A focal length of 500 mm was used to capture this image.

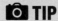 **TIP**

Permanent and portable hides in your garden, with a food and water source, attract wildlife and give you great opportunities.

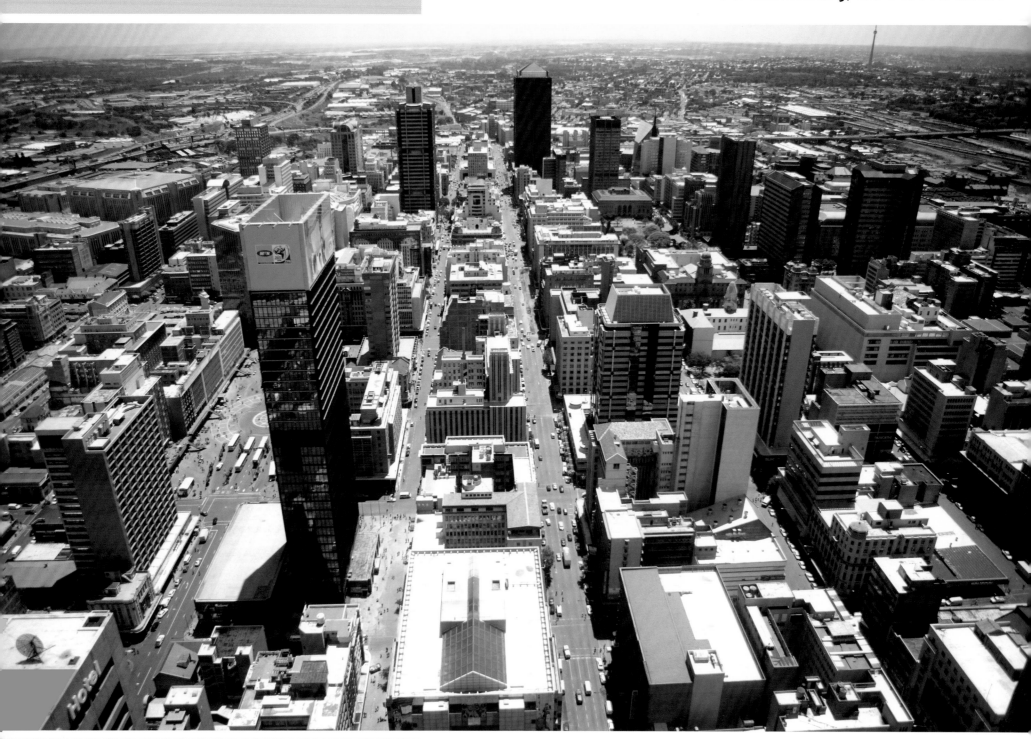

📷 **TIP**
Tall buildings give a marvellous platform for aerial photography.

The Carlton Centre is the tallest building in Africa with a viewing deck and restaurant at the top. On a clear day you can see Pretoria, 30 miles away. The only problem is that it is 50 floors up and there are no exits in the lift, so you are advised 'if Johannesburg has a power cut you are stuck'. Johannesburg often has power cuts!

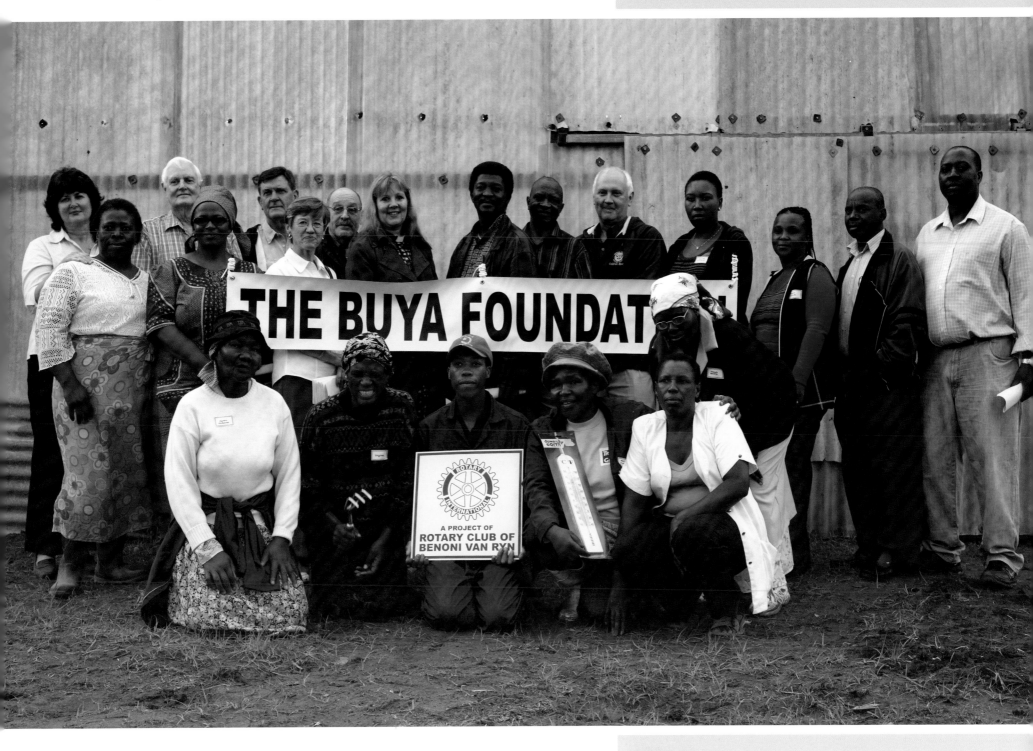

The BUYA Foundation and Rotary Club hand over a hothouse to the children's home, so they can grow their own food and give children a better diet.

TIP

Group photography is one of the most common types of photography. Here are some of the more common mistakes: subject blinks; people missing from image; group too far away or not all fitting into the image; subjects looking in different directions; no flash; no tripod; general organisation.

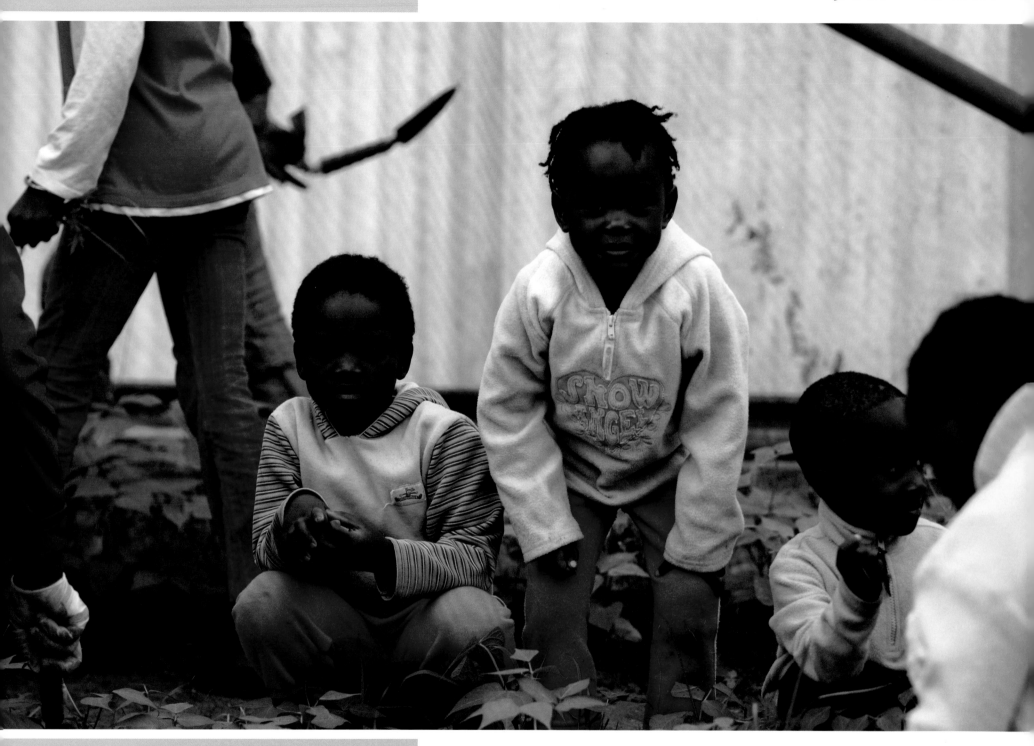

📷 TIP

Reaction when photographing people is always important – I didn't want the image to be staged and for the children to perform for camera. The only person who was interested in me was the young girl in pink and her expression says a thousand words.

I go to the local children's home to see how the children are doing planting and growing their own vegetables.

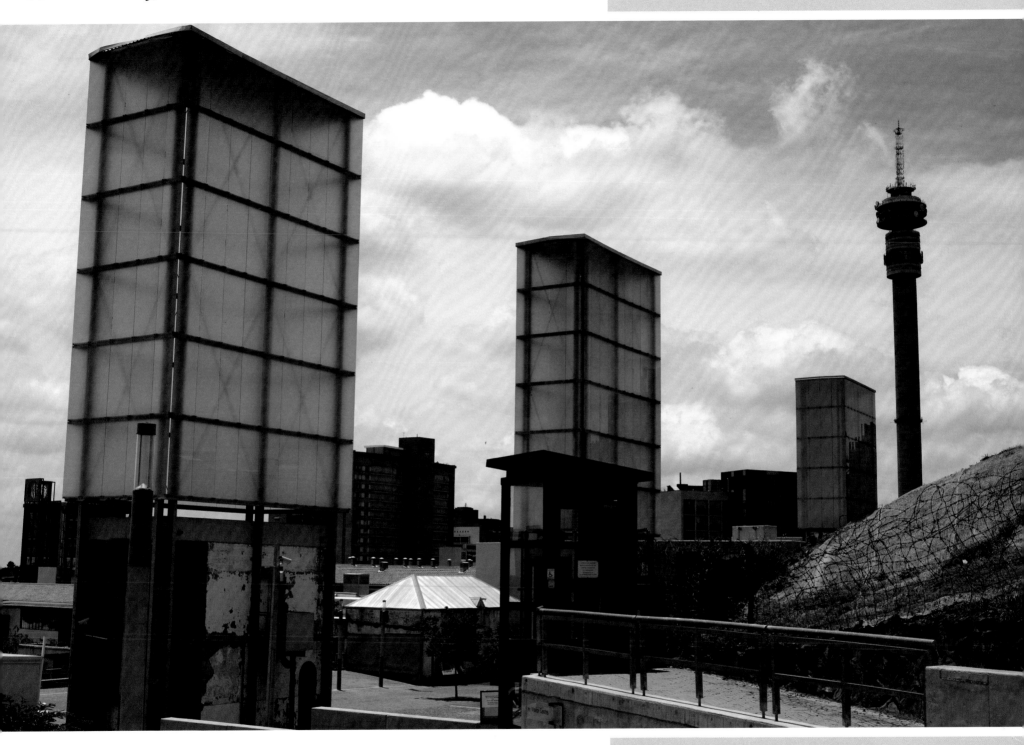

Constitution Hill is the site of the Old Fort Prison complex where thousands of ordinary people were brutally punished before the dawn of democracy in 1994. The site housed three notorious prisons: the Old Fort, the women's section, and sections 4 and 5 for so-called 'natives'. Number 4 is now a stark museum and remains as it was when closed in 1983. The Constitutional court opened in 2004 and was built alongside number 4 to acknowledge the past while moving towards the future.

📷 TIP

To get the image you want, you may have to walk around buildings until you discover the best vantage points – here it was behind the towers to get all three in.

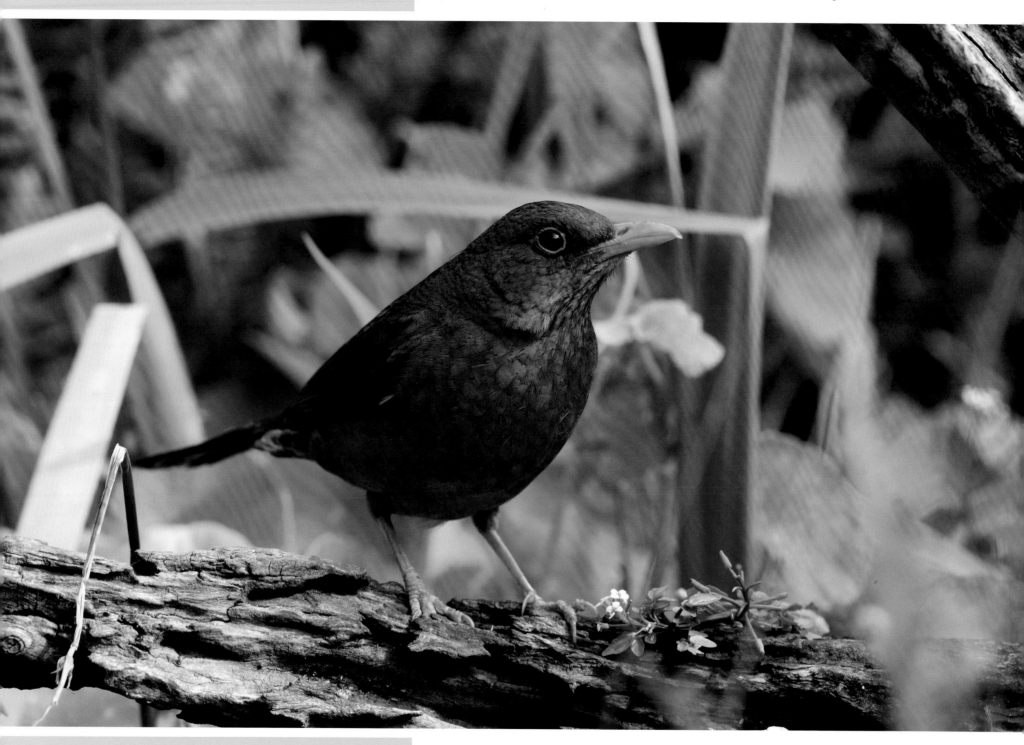

📷 TIP

Wherever possible achieve catchlights (reflections in the eye) in your photography as it brings images to life.

After my powerful and moving day yesterday on Constitution Hill it was lovely to go and photograph garden birds at Mike and Sue's. I told them where I had been yesterday and their reaction was interesting and different from my own, which was that of an outside observer. We decided to talk about our love of wildlife instead.

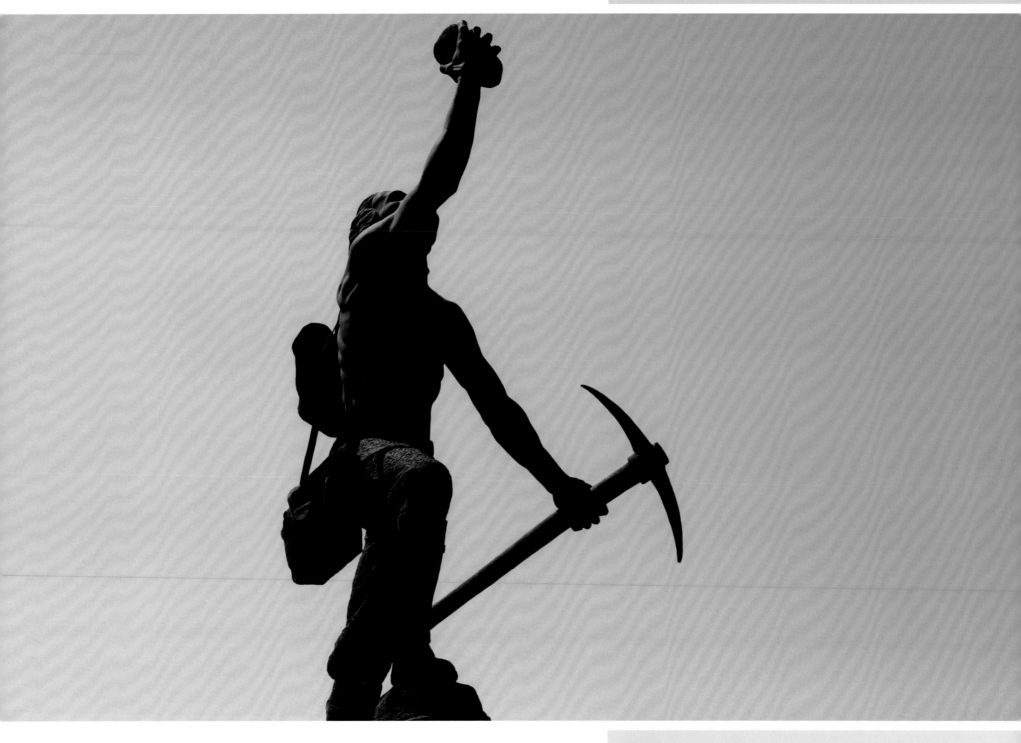

As you enter the city of Johannesburg from the airport, on the right-hand side is Settlers Park with a statue of George Harrison who discovered Johannesburg's main goldfield. The mesmerised prospector holds a piece of earth above his head.

 TIP
This image is silhouetted because I deliberately shot into the sun to give a striking image.

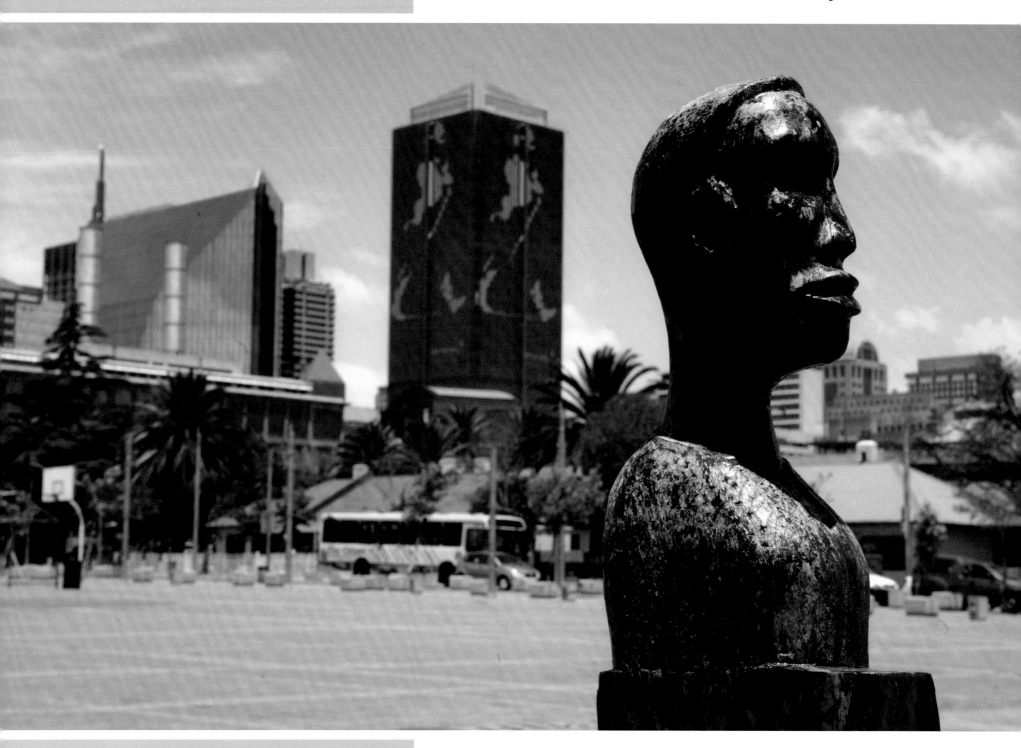

📷 **TIP**

Arrange images with contrasting subjects e.g. art and industry.

Johannesburg is known as the 'City of Gold' due to its location on Witwatersrand range of hills. It is the largest city in South Africa and covers a wide area, and yes, the city was affected by an urban blight - thousands of poor and mostly black people who had been forbidden to live in the city moved in the early 1990s. Crime levels were high but are dropping now due to investment.

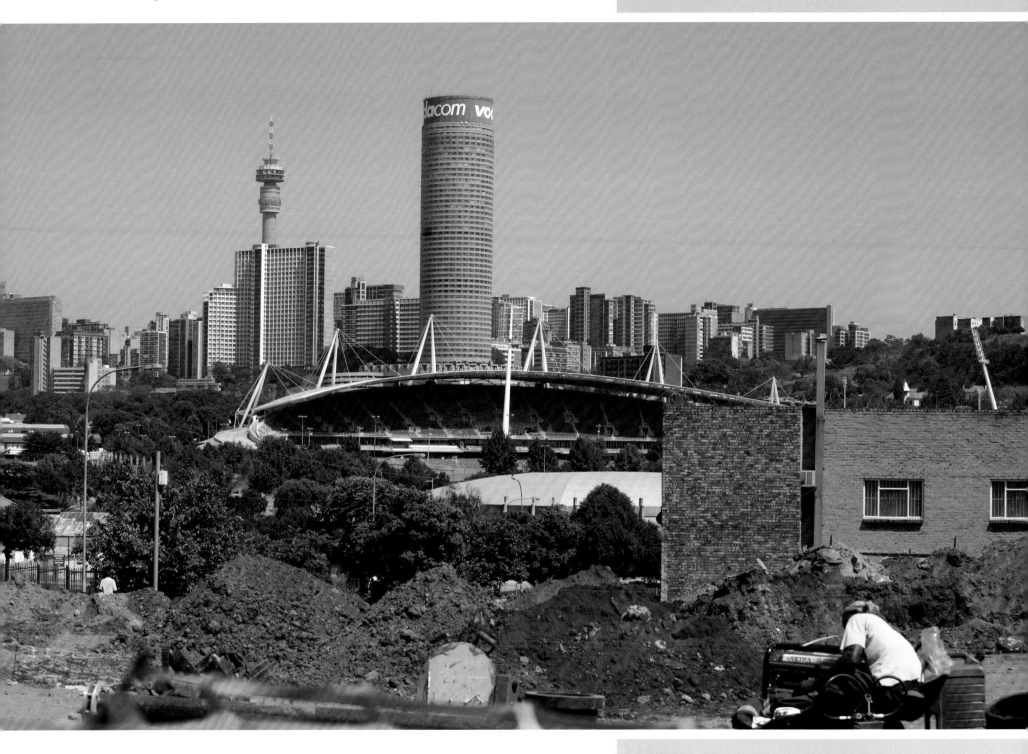

Ellis Stadium getting ready for the World Cup. Will the country be ready for the biggest competition in the world? The whole world is waiting for the answer to this question. I really hope so. Controversies are still going on and only time will tell – my biggest concern is about the transportation of large numbers of people to the matches and accommodation.

 TIP
If travelling make sure your camera is at hand to take impromptu images.

📷 **TIP**

I used my short lens to capture this football scene so the township behind the pitch and the habitat of where it was played could be shown.

Football is everywhere in South Africa and played anywhere – the fans are passionate when going to matches with hats, painted faces and a vuvuzela, which is a plastic trumpet about one metre long. Kaizer Chiefs and Orlando Pirates are the two big teams in the premier soccer league.

After dropping guests back at the airport I came back through the local area of Benoni to see this woman balancing items on her head – I have always wondered how it is done. The rest of the day was spent planning my trip to Pilanesberg National Park. Thank you to Ian for lending me his car while I was in South Africa, giving me the opportunity to do this trip.

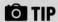 **TIP**

Record images of a way of life – this is different everywhere you go.

📷 **TIP**
Cheeky grins and expressive eyes make wonderful images.

As part of my duties with Mufasa I take guests to visit the local children's home. Children always come and see me and have a nice big smile on their faces. Maybe it is the big bag of sweets that I take! Africans take great pride in their appearance, especially when going to school and on Sundays when they go to Church.

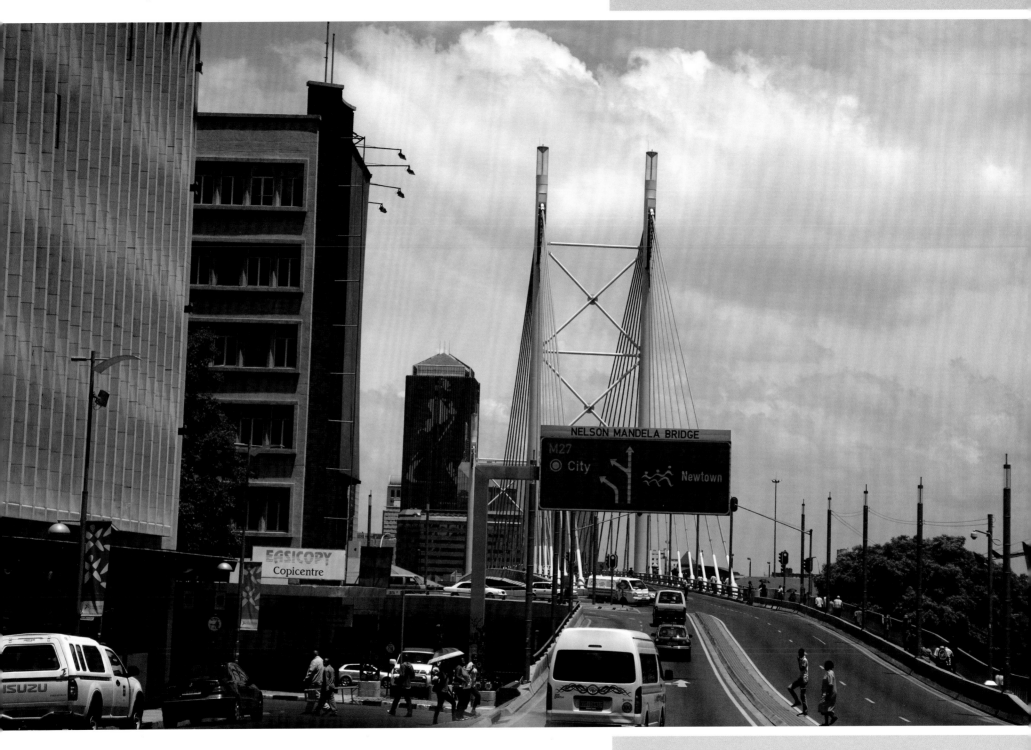

NELSON MANDELA BRIDGE

M27
City

Newtown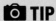

Nelson Mandela Bridge is constructed over 42 railway lines and is 284 metres long. The bridge links the areas of Braamfontein and Newtown and it rejuvenated the inner city when it was opened in 1984. Even the bridge has suffered from crime, with its copper wiring being stolen - now 24-hour video surveillance is in operation. Left for Pilanesberg in the afternoon.

📷 TIP

Don't click and drive when there is nowhere to stop and take images.

📷 TIP

I am very critical of my own photography and feel that, in theory, this image should have been on a third, showing more of the sky. Always review your own work.

Sunrise over Pilanesberg National Park, which is 2-3 hours drive from Johannesburg. The Pilanesberg Game Reserve is in the crater of a long extinct volcano. The park was formed in 1979 thanks to Operation Genesis which was the largest game resettlement programme in the country, with 6,000 animals being released after quarantine. Thank you Ian and Renee for everything.

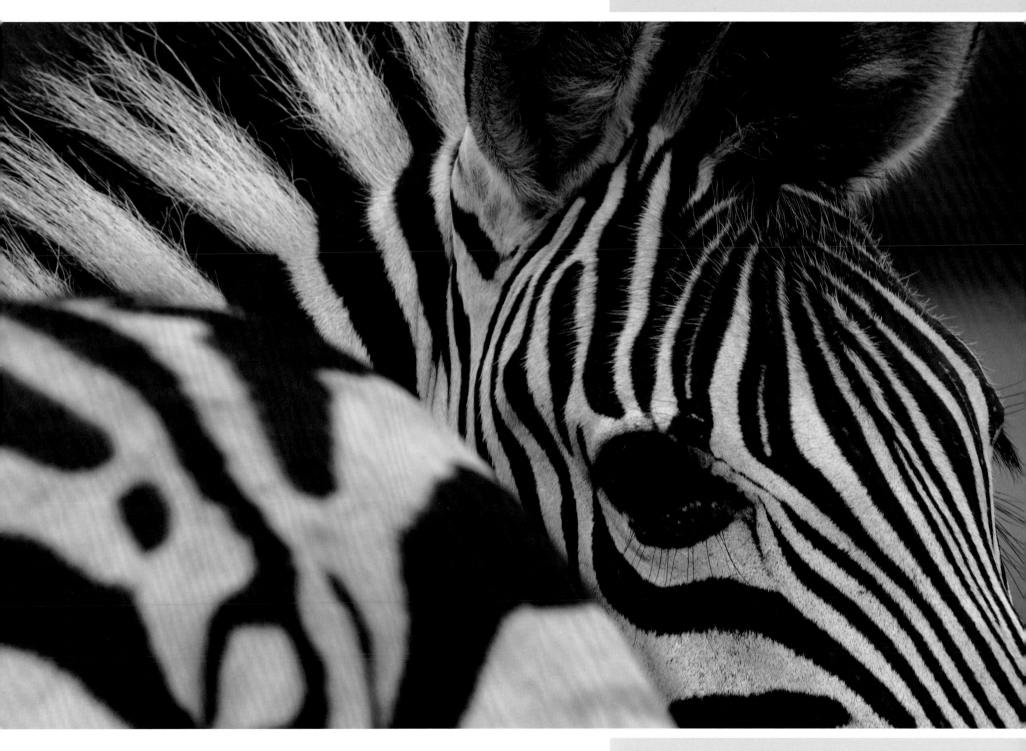

Zebra stripes are unique to each individual animal - the stripes and behaviour of these animals make them among the most familiar to people. However, Grevy's and mountain zebra species are endangered due to hunting for their skins and habitat destruction. The plains zebra are much more plentiful.

◯ TIP
With such a familiar animal I wanted to take a different approach by filling the frame and using leading lines to draw you into its eye. A stronger catchlight in the eye would have improved the image further.

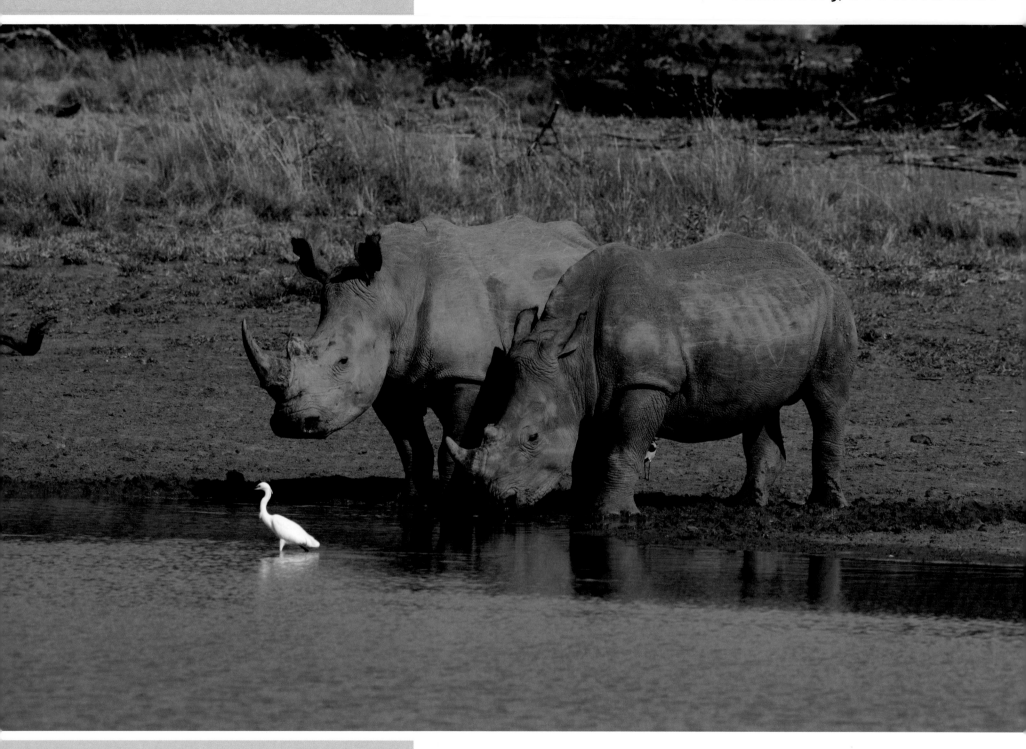

☐ TIP

Patience is a virtue.

The nice thing about this national park is that it has several hides by waterholes. Being a wildlife photographer I know that most living species have to drink, so it is just a case of arriving in the early morning and waiting to capture the image you want. So it was a real joy when these two white rhinos came to drink, with a little egret in the foreground to complete the image.

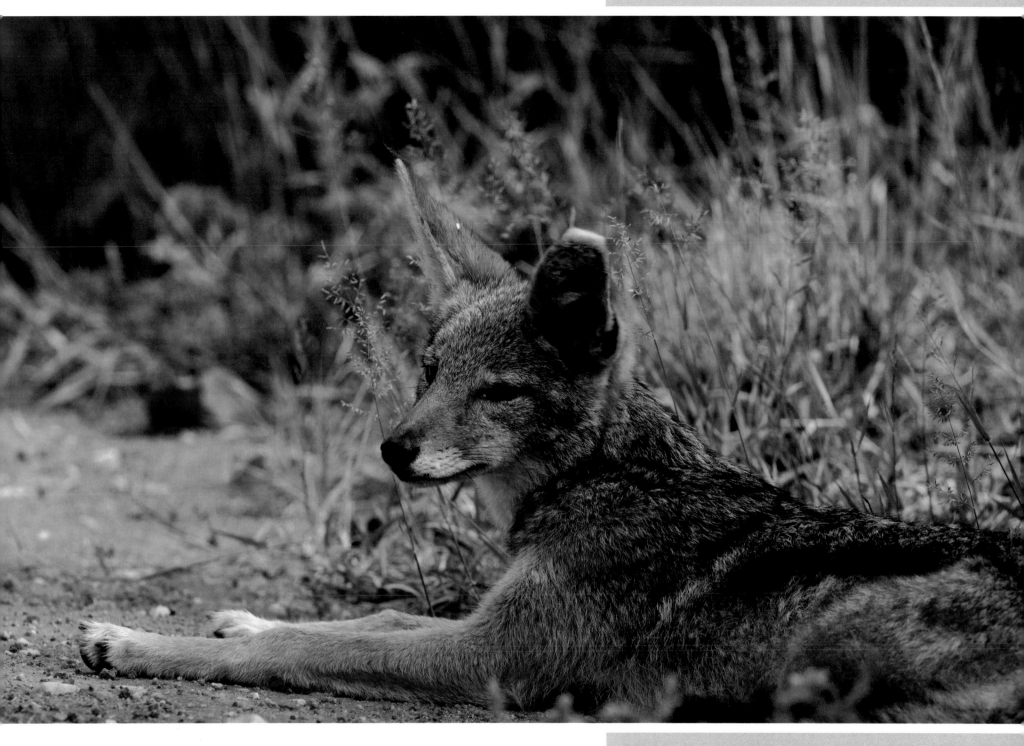

This is a young black or silver backed jackal. As its name suggests the most distinguishing feature is the silver black fur running from its neck to the base of its tail. Jackals live together in pairs, mating for life. Their habitats vary from open woodland, scrub and savannah to the bush.

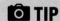 **TIP**

Speaking to park rangers gave me useful information about where to find this young mammal.

📷 TIP

Watch for animal behaviour.

Warthogs are identifiable by the two pairs of tusks from their mouths, which are used as weapons against predators, for digging and in combat against other hogs. Since the *Lion King* the warthog has been seen as a very loveable creature, before the film it was just a warthog. Now on safaris everyone asks 'can we see a warthog?' Warthogs are difficult to photograph and they normally run away with their tails up, so I couldn't believe my luck with this one.

The elephant is my favourite animal ever since my Aunt Betty introduced them to me at Southampton Zoo where she worked. These magnificent mammals have to be treated with respect even though they have no natural enemies. When I first saw a wild elephant in Kenya my whole body quivered. I have been lucky enough to take images of them all over Africa - may be a book for the future.

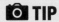 **TIP**

A subject moving into the frame gives forward motion.

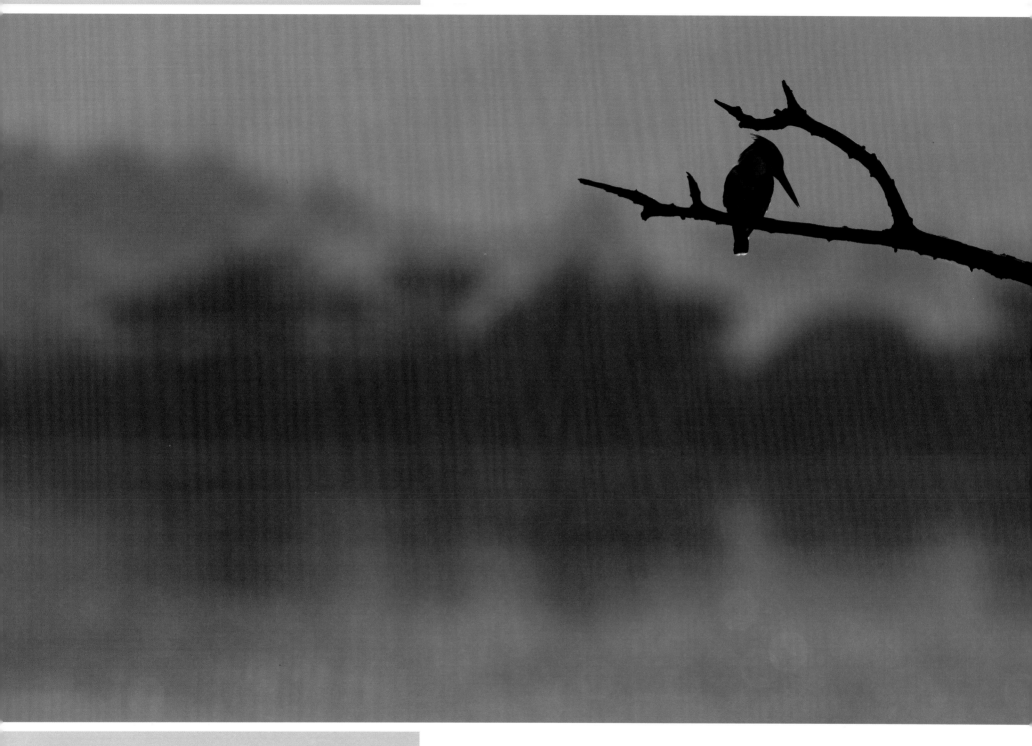

 TIP
Always turn a negative situation into a positive one.

Another hide gave me the opportunity to photograph pied kingfishers. The only problem was whoever built the hide wasn't a photographer as the kingfisher's perch was facing directly into the morning sun. Arriving early before the sun rises I can capture a silhouette of this kingfisher with the sun just breaking through, highlighting the tip of its tail to give it life.

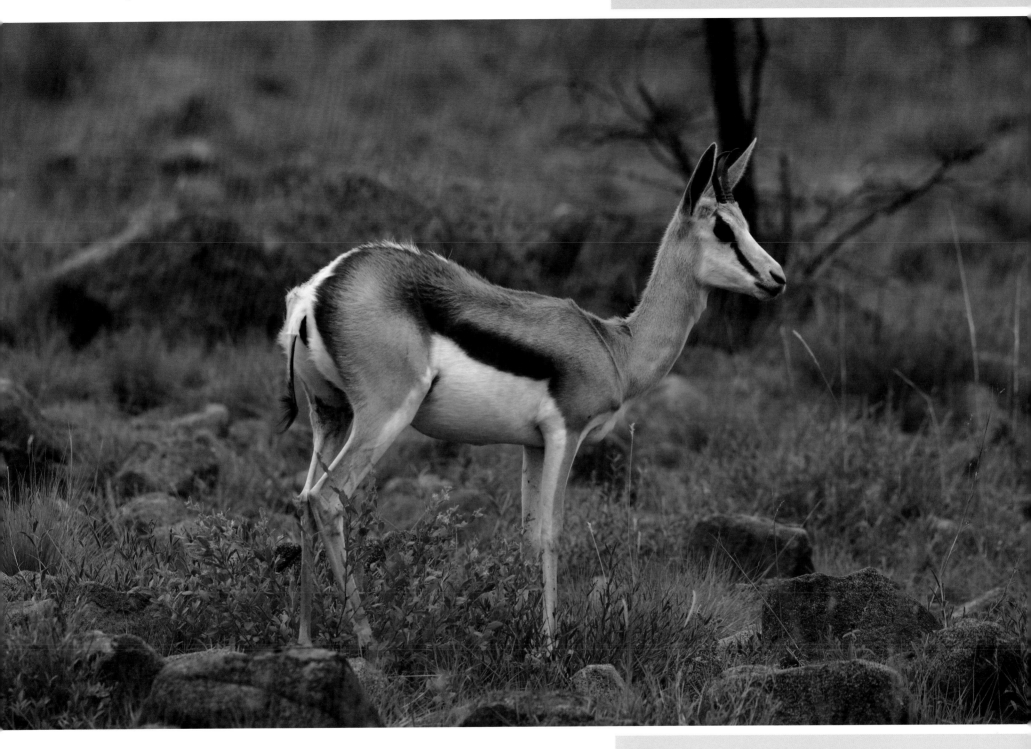

The springbok lives throughout South Africa and Namibia but is more famous as being a national symbol of South Africa under white rule. It was most famously used by the National Rugby Union team. Since the demise of Apartheid, sporting teams have been using the protea, which is the national flower of South Africa.

TIP

Images against a contrasting background show natural colourings, compared to images blending into habitats.

📷 TIP
Photograph every opportunity you have, I didn't here...

I couldn't come to Pilanesberg without visiting Sun City. This luxury casino resort opened in December 1979 to provide what was considered immoral entertainment at the time. In the 70s and 80s many music legends played there, and several heavyweight boxing matches took place. In 1985 the music industry became active against Apartheid and stopped playing at Sun City until recently.

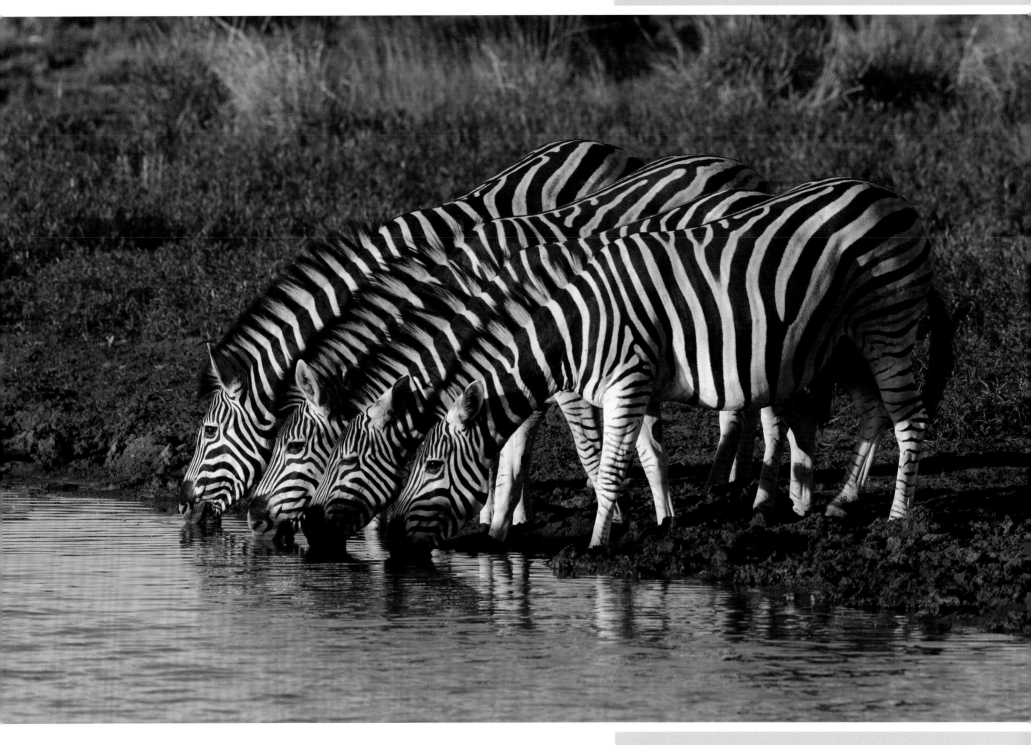

I made a decision that I would stay at this hide all day armed with flask, sandwiches and a cushion to sit on so that I could watch the activities of this popular waterhole. Mid-morning five zebra came down to drink, the fifth one is on the other side keeping a watchful eye. I would have loved a charge by lions, but you can't be greedy!

📷 TIP

A tight group doesn't require odd numbers to balance the image. This is a classic image with an f stop of f16.

📷 TIP

By completely blurring out the background you are not showing wildlife in its natural setting. Decisions have to be made about how you intend to use images – is it for commercial use or pleasure?

The southern red bishop belongs to the weaver family and is common in wetlands and grasslands of Africa, south of the equator. Believe it or not, north of the equator it is called a northern red bishop! The bird nests in colonies and forages in flocks. Natural behaviour is always interesting in an image. This red bishop is in display mode, his feathers are fluffed up and his black breast pushed out.

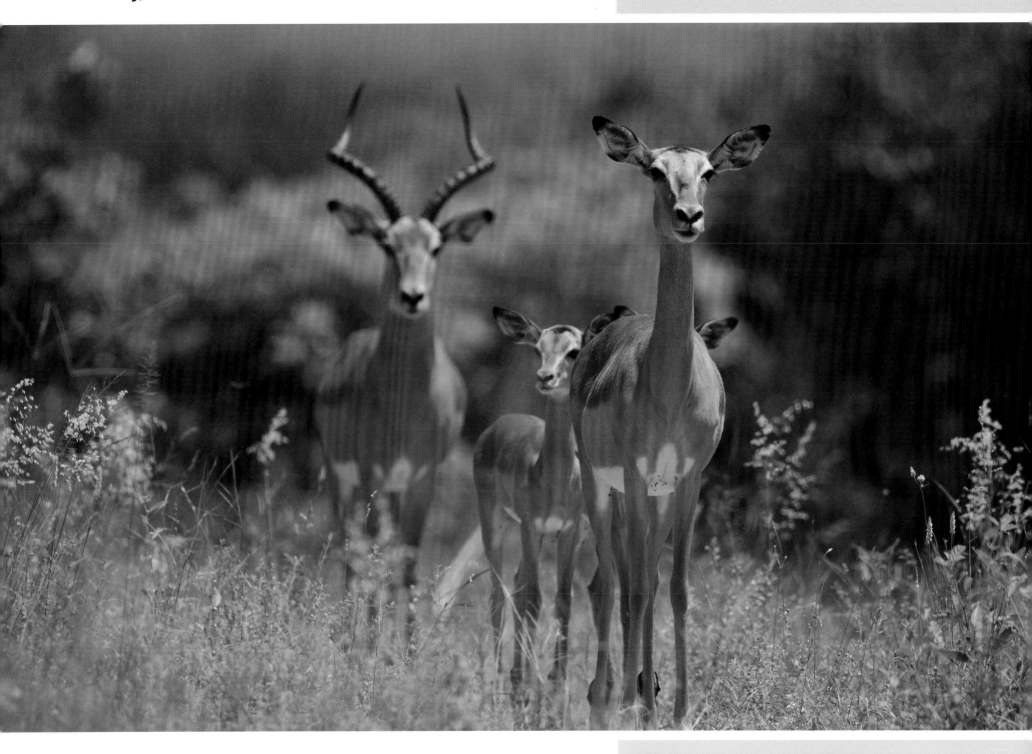

Impala, a medium sized antelope whose name comes from the Zulu language. They can be found all over Africa and have a characteristic 'M' marking on their rear. The males have lyre-shaped horns, reaching up to 90cm in length.

📷 TIP

Depth of field is shown here as the leading impala is in focus and the male is slightly out of focus. If the focus had been on the male, you would have got a totally different view point, creating a different picture.

📷 **TIP**
I have chosen this frame-filling image of hippos to explain the difference of the f stop. At f16 all the hippos would be sharp (tripod needed), at f5.6 only part of a row is in focus, depending on your focal point.

At every tourist attraction and along the road side you get curio shops, so I bought a hippo and asked could I take some images of their craftsmanship. Like impala these are common sights but local tradesmen need to be supported to discourage crime.

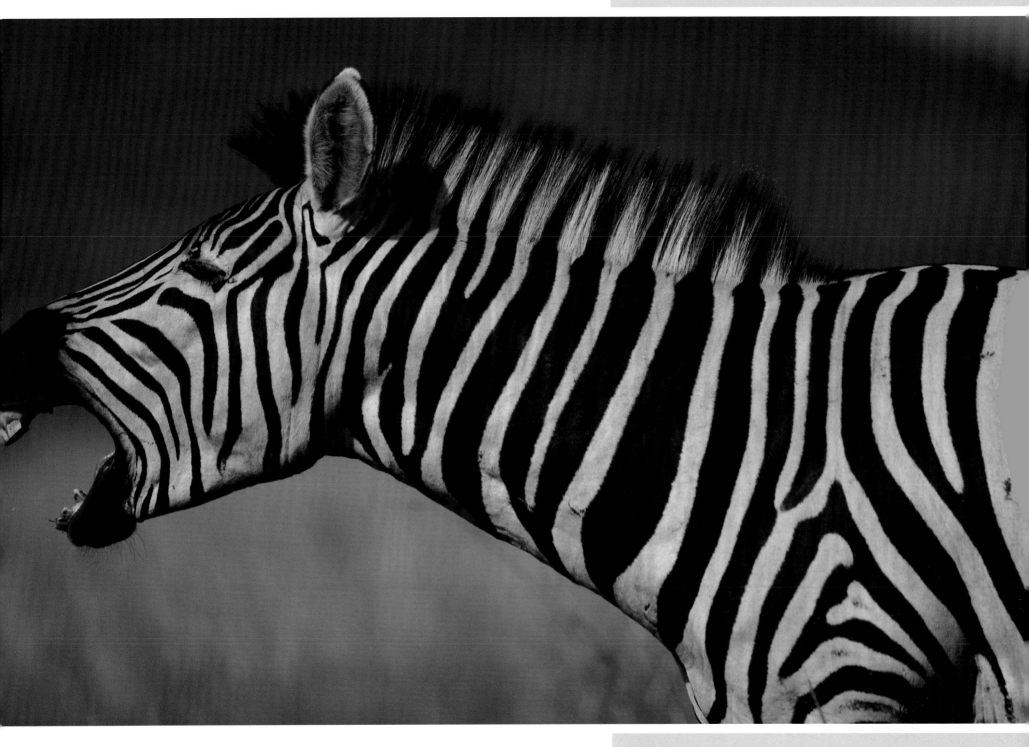

A comical image of a zebra braying but one that captures actual animal behaviour. By photographing animals that are more commonly seen, from ducks to horses, there are greater opportunities to study animal behaviour and capture it. Practising on local wildlife improves your chances with one-off opportunities. I was with a herd of zebra and captured over 30 different images in a short time from braying and dust rolling, to head shots and groups.

 TIP
Make sure your framing of the subject is correct.

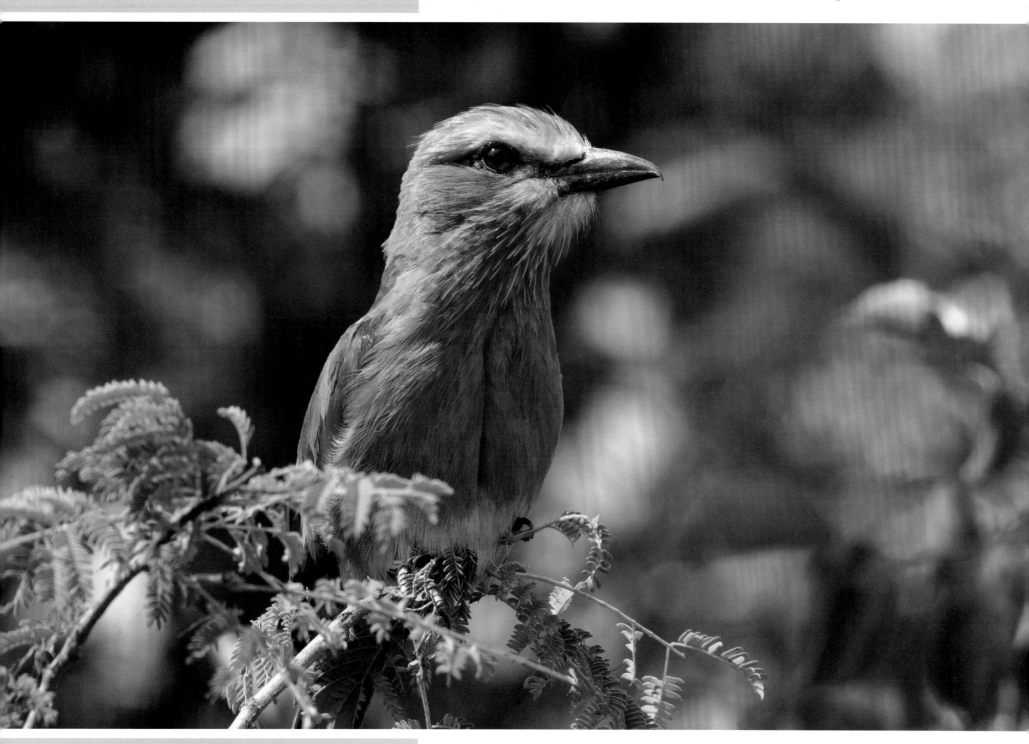

📷 **TIP**

Remember the catch light in the eyes - it makes the image sing.

The lilac breasted roller is usually found alone or in pairs, it perches conspicuously on the tops of trees and shrubs before swooping down on insects, lizards and snails. These colourful birds are always one of the first you will see on your trip to Africa. Today was my last day here; though Pilanesberg is smaller than the Kruger the water hides were excellent.

The Vaal Dam was constructed in 1938 and is 77 km south of Johannesburg International Airport. The Vaal Dam is bigger than the country of Luxembourg! It is also the venue for the longest inland yacht race in the world. Around the dam are holiday homes, one of which Ian and his family share, so after my trip to Pilanesberg I was invited to join them.

📷 **TIP**

The avenue of trees and the water's edge become your leading lines – they don't have to be straight lines.

📷 TIP

Sports photography, you need to capture the action using a fast shutter speed, upgrading the ISO if necessary to achieve the faster speed. I used a panning technique which requires a lot of practise as I moved the camera to follow the action. On the back of a boat this is difficult.

After a South African 'braai' (BBQ) last night, today was a very relaxed day. The only thing I was asked to do was to capture Sean on his waterboard doing jumps.

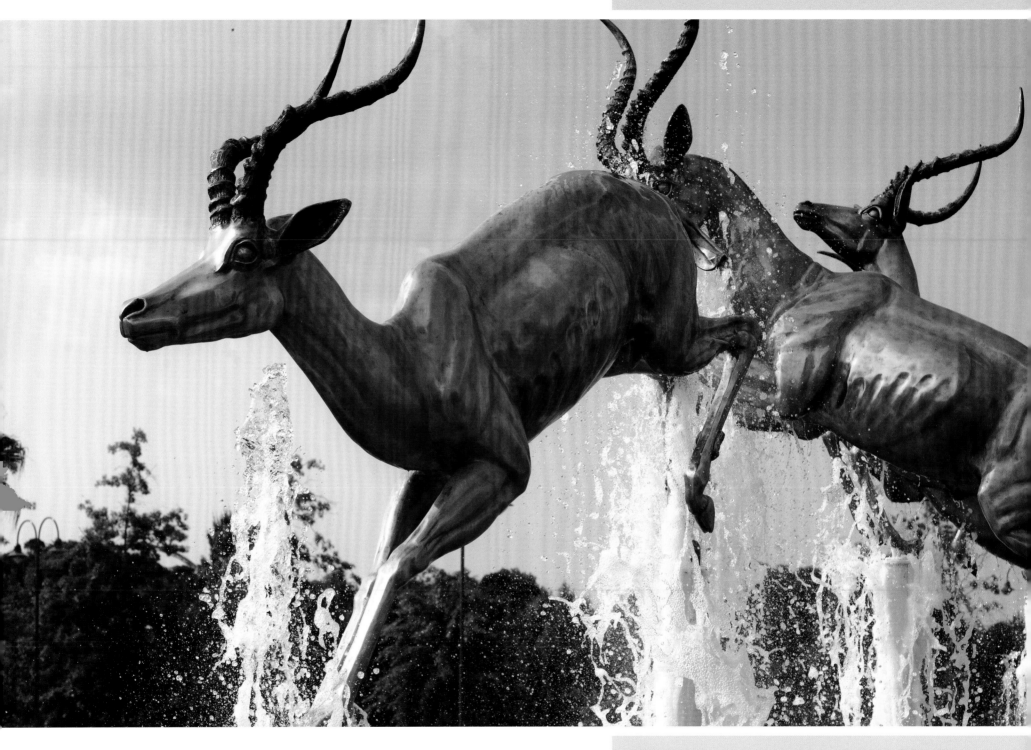

Statues of leaping impalas and fountains form the entrance of this establishment; casinos seem to be as common here as they do in the USA. All the casinos had nice restaurants and various forms of entertainment inside.

 TIP

Filling the frame and shooting upwards gives the effect of movement in these bronze statues, bringing them to life. Freezing water droplets is created by a fast shutter speed, blurring water is created using a slow shutter speed.

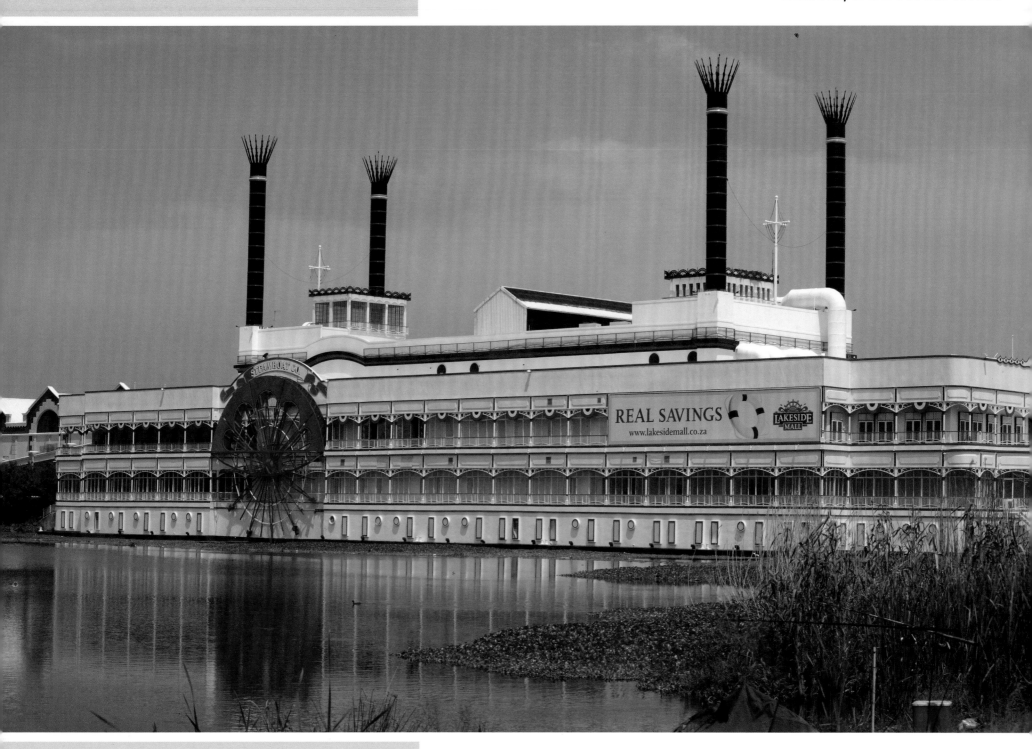

📷 TIP

Scan the whole viewfinder to check for distracting elements within your image.

South African shopping malls are mostly off the major roads and are very large and clean. I felt totally safe in them. This part of the mall is designed to look like a paddle steamer. The other side contains restaurants and cinemas. Tomorrow I am off to the Mpumalanga region.

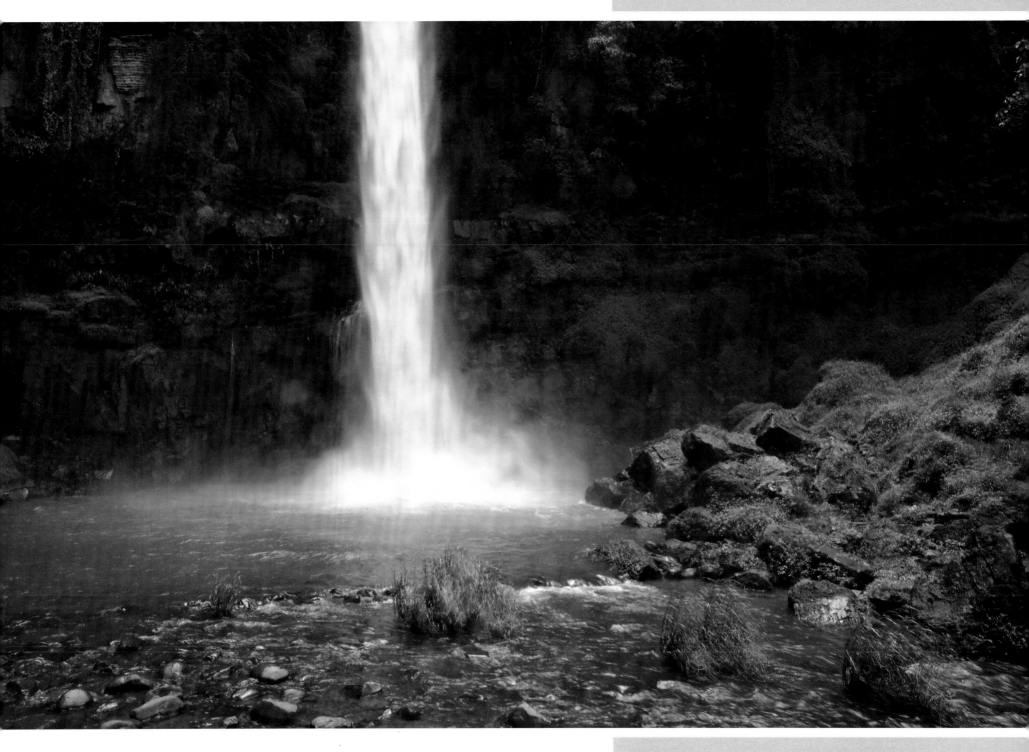

Sabie is 360 km east of Johannesburg and is a forestry town situated on the banks of the River Sabie. With its breathtaking scenery and beautiful waterfalls such as Lone Creek Falls and the Kruger Park only 64 km away, it is a popular tourist destination.

📷 TIP

This explosion of water is captured using a slow shutter speed, which causes the water to blur in movement. The slower the speed the more blur there is. A tripod is needed as the shutter is open for a long time.

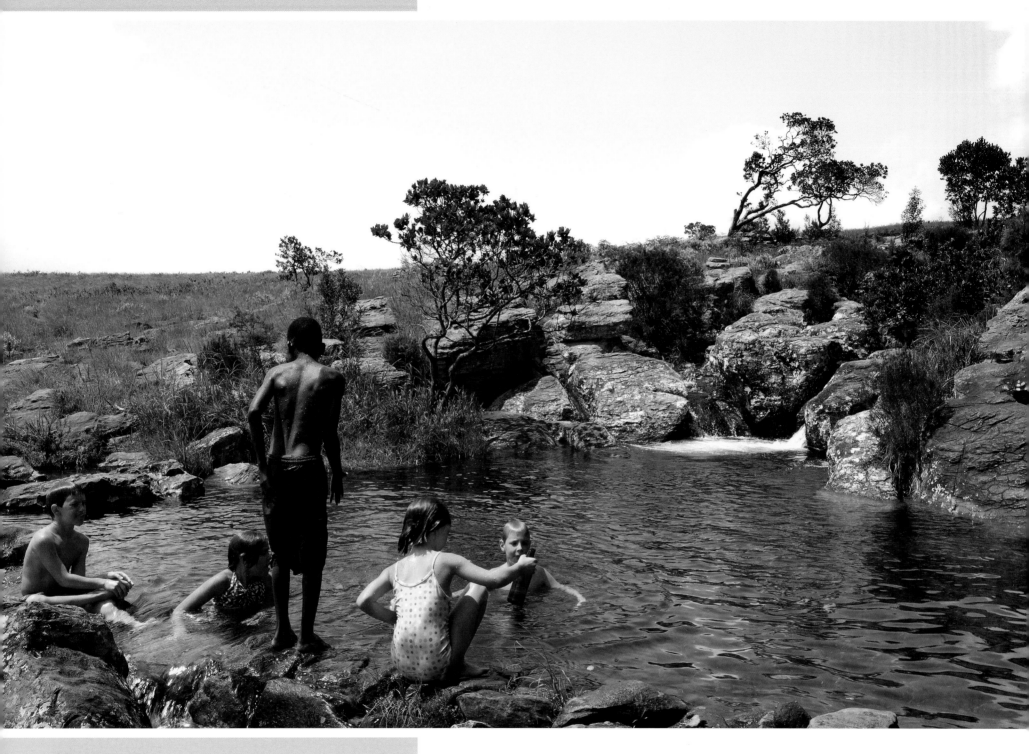

📷 **TIP**
Take care when photographing children – always obtain permission from an adult if you can.

Only 13 km away from Sabie is Mac Mac Pools, where you can splash around and swim in the refreshing crystal clear mountain stream pools. With excellent picnic and braai (BBQ) facilities it is very popular at the weekends with locals. An image that shows how South Africa has changed. Years ago you would not have seen this group of different coloured children playing together.

Mac Mac Falls was supposed to be one of the most photographed and beautiful falls in the area. They plummet down 65 metres and are named after the local village and the site of a gold rush in 1873. I was most disappointed as you can't get anywhere near the falls to take photographs or even see them. I am pleased I only paid a minimal fee to get to them.

TIP

Local industry – a chance to take images of people at work. A social history record.

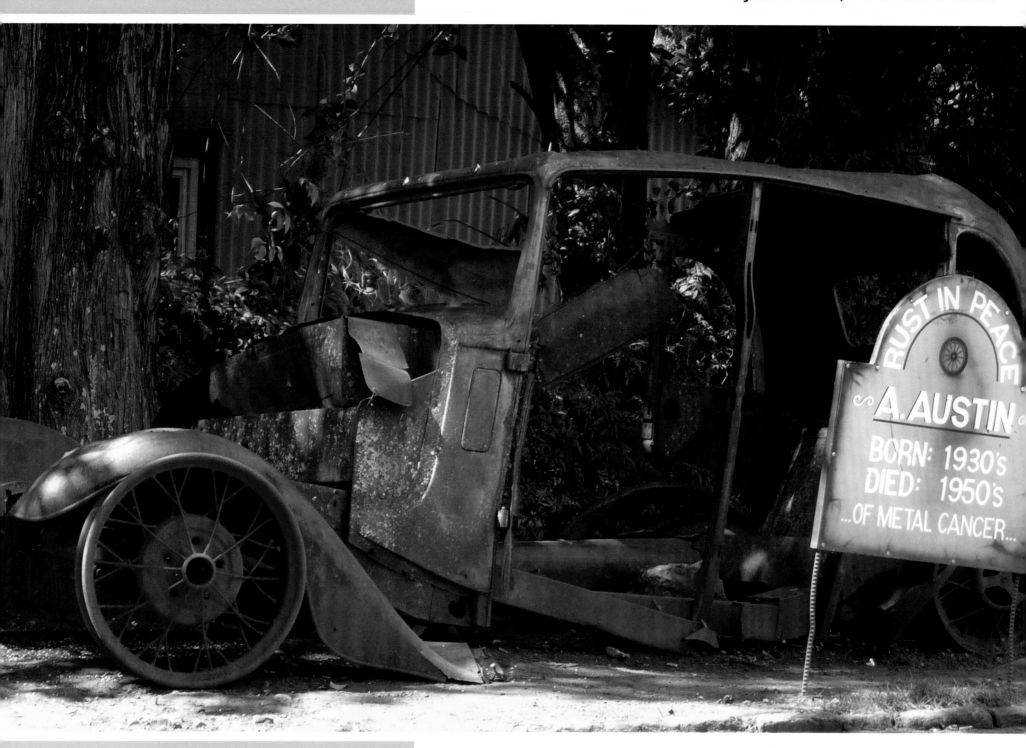

RUST IN PEACE

A. AUSTIN

BORN: 1930's
DIED: 1950's
...OF METAL CANCER...

📷 TIP
Derelict vehicle with humour.

In 1873 in a little stream now known as Pilgrim's Creek gold was found by Alex Patterson and William Trafford. Over the years a mining estate was established and Pilgrim's Rest grew into a small town with a church, school and its own newspaper. Mining operations ceased in 1971 and in 1972 the local government carefully restored this old gold diggers town into an open air museum.

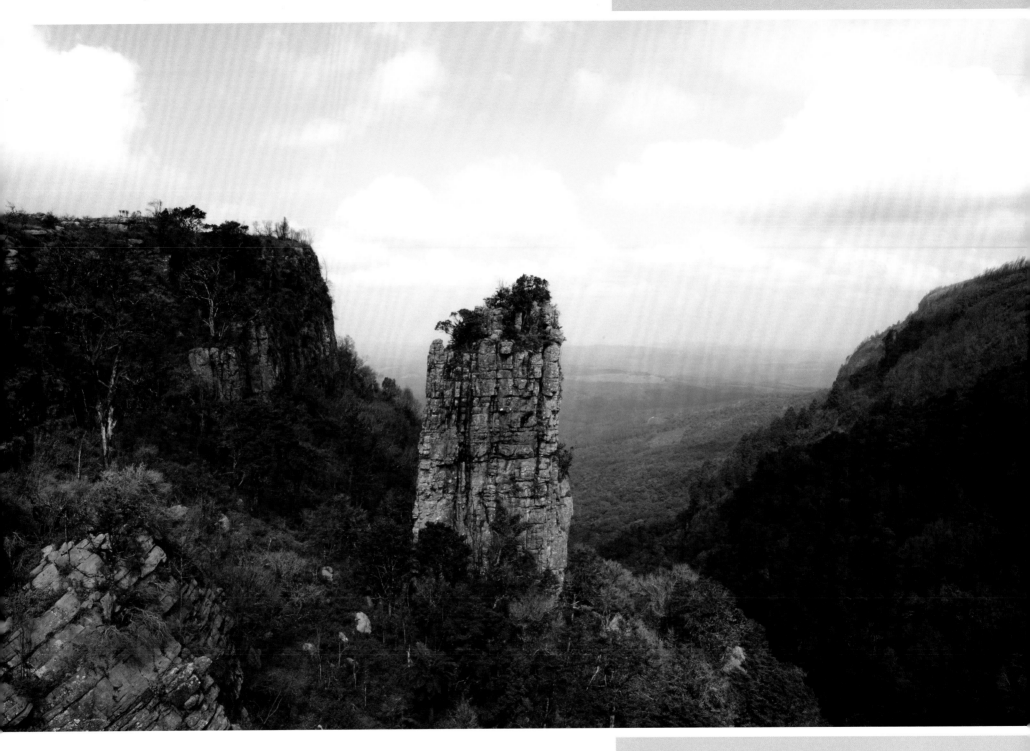

The Pinnacle is along the Drakensberg escarpment and is a 100 ft quartzite 'needle' that rises dramatically out of the surrounding fern-clad ravine. From the viewing platform you can see the plateau beneath the escarpment. I stayed in the town of Graskop before going on to God's Window.

📷 **TIP**
I always look for different angles and locations – the view from the top can be very different from the side view as this shows the escarpment.

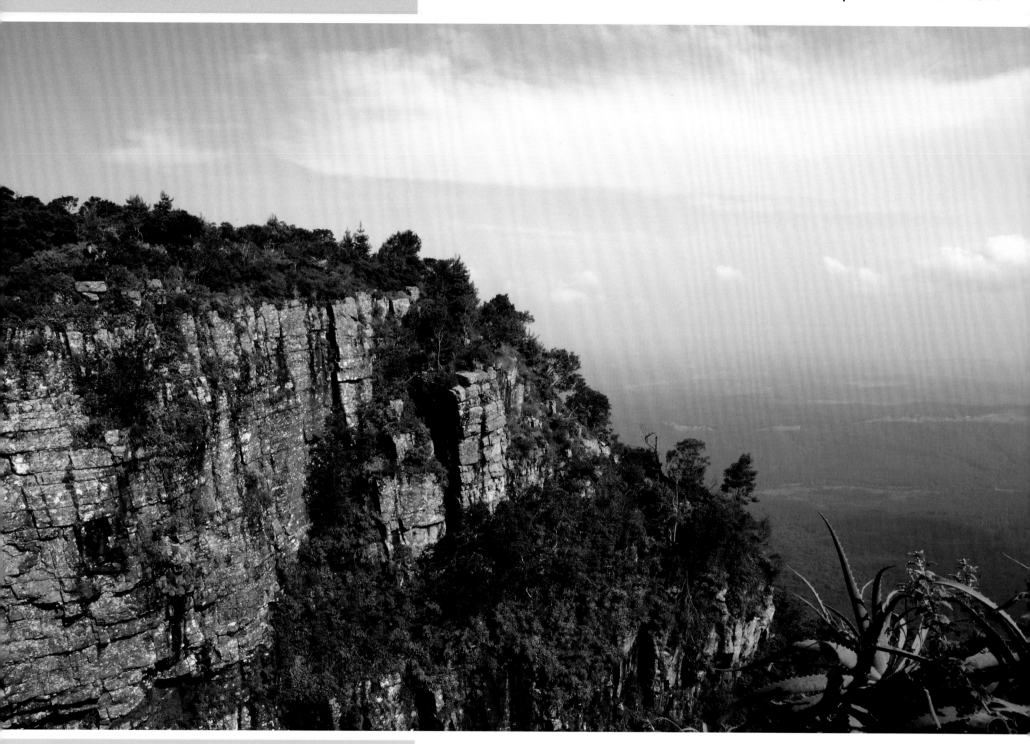

📷 TIP

By including the valley, perspective is given to the cliff face. Always include elements to add perspective to your images.

God's Window is the most famous of the Lowveld lookouts – it got its name because you peer through the rock 'window' gazing out into infinity. It is right at the top of a stiff climb. God's Window played an important role in the cult film *The Gods Must Be Crazy*. Near the end of the movie the bushman character travels to God's Window and due to low cloud cover believes it to be the end of the earth. This is where the bushman threw his coke bottle!

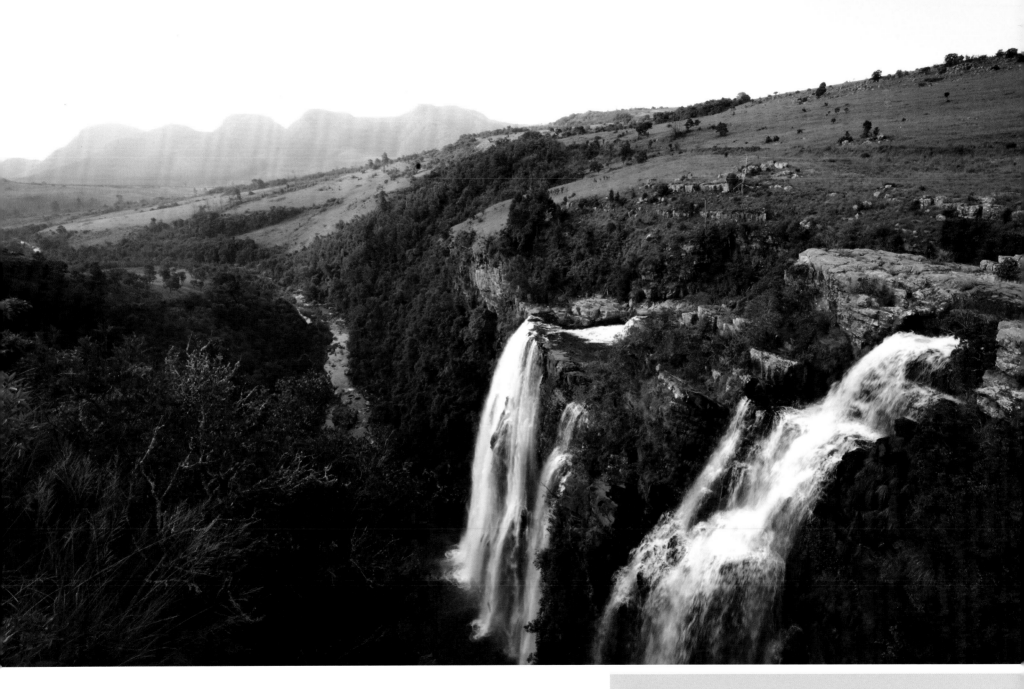

Lisbon Falls cascades 120 ft on to the rocks below, throwing up spray over a deep pool. The falls are the highest in the area and you can hike down a path from the car park to see this spectacular sight. However due to the state of the path I couldn't reach the bottom to see the pools that I wanted to get to. These falls are much more impressive than Mac Mac Falls.

 TIP
Slow shutter speeds on the waterfalls give them a 'milky' effect.

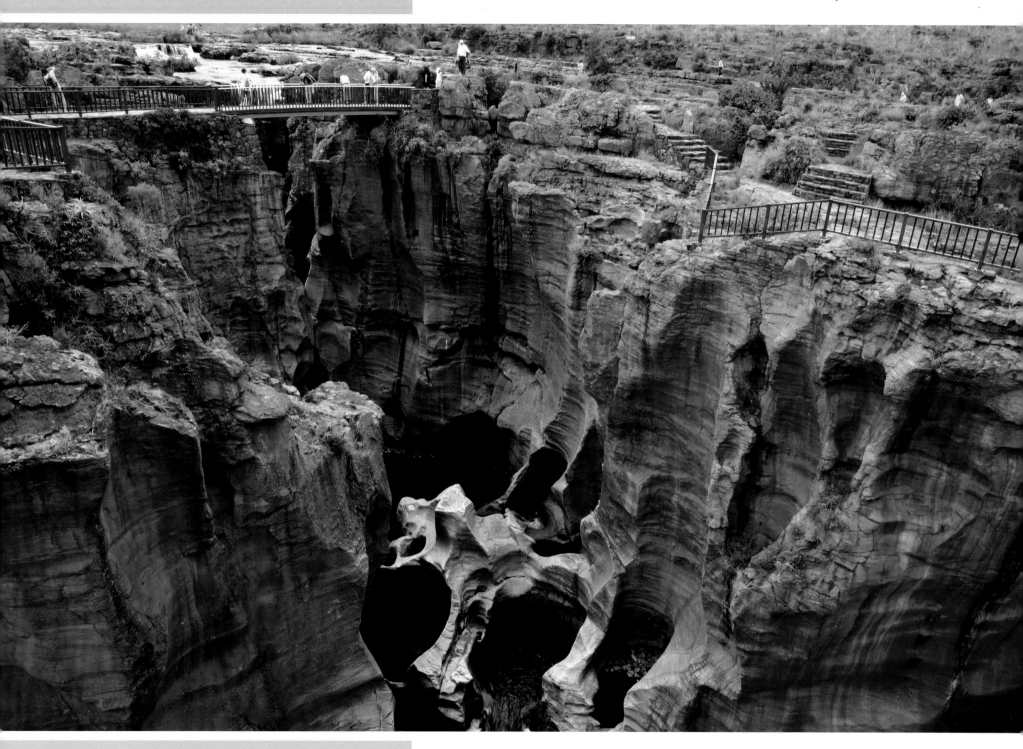

📷 TIP

People on the bridge give the perspective and show how large the canyon is. If only I had two images per day I could show the shapes of the potholes.

I moved up to Blyde River Canyon for the next couple of days and visited these potholes and nature reserve named after the gold prospector. The cylindrical, and rather alien looking, deep potholes filled with green water are carved into the rock by whirlpools where the Treur and Blyde rivers converge.

Nine miles from the potholes is the Three Rondawels, one of the most spectacular vistas in South Africa. You will find them in every travel brochure and now in my book! The rock formations have a vague similarity to the round thatched African dwellings of the same name. Local people named the rocks, 'the chief and his three wives' in honour of the mapulana chief Maripe Mashile.

📷 **TIP**
Weather can determine an image, e.g. low cloud.

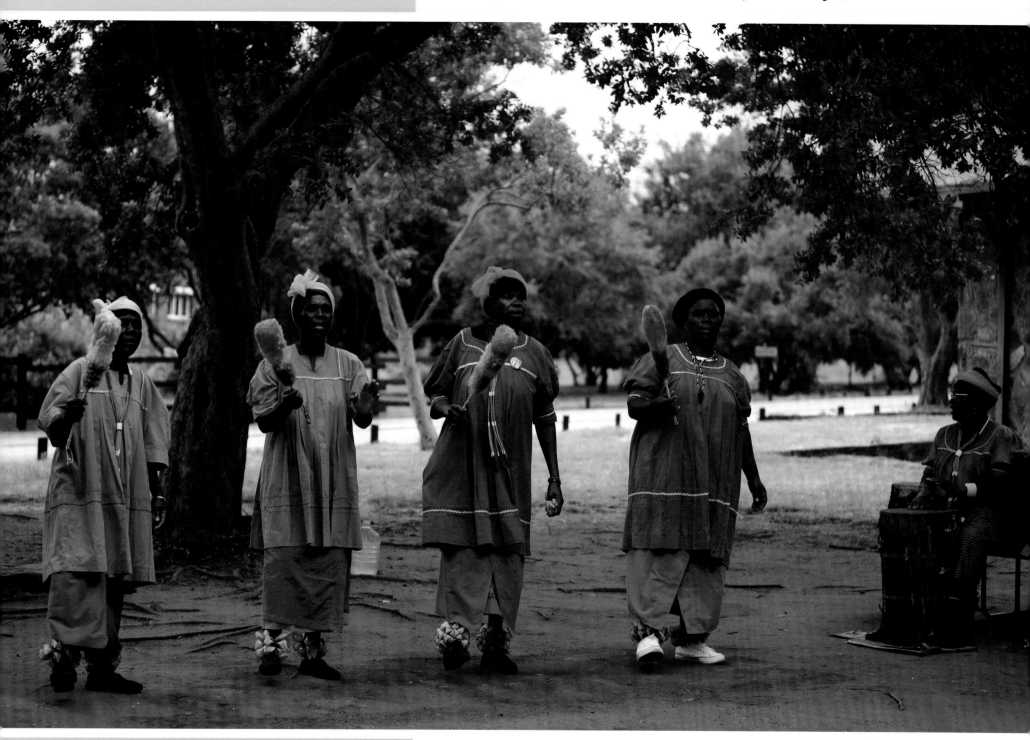

📷 TIP

Local customs are great images to capture while travelling, but it is the first time I have ever seen it done with feather dusters!

After following this panoramic route I start to make my way back, to go through Kruger Park using the Orpen Gate. I stop at a local park and restroom along the road to watch these dancers perform with feather dusters.

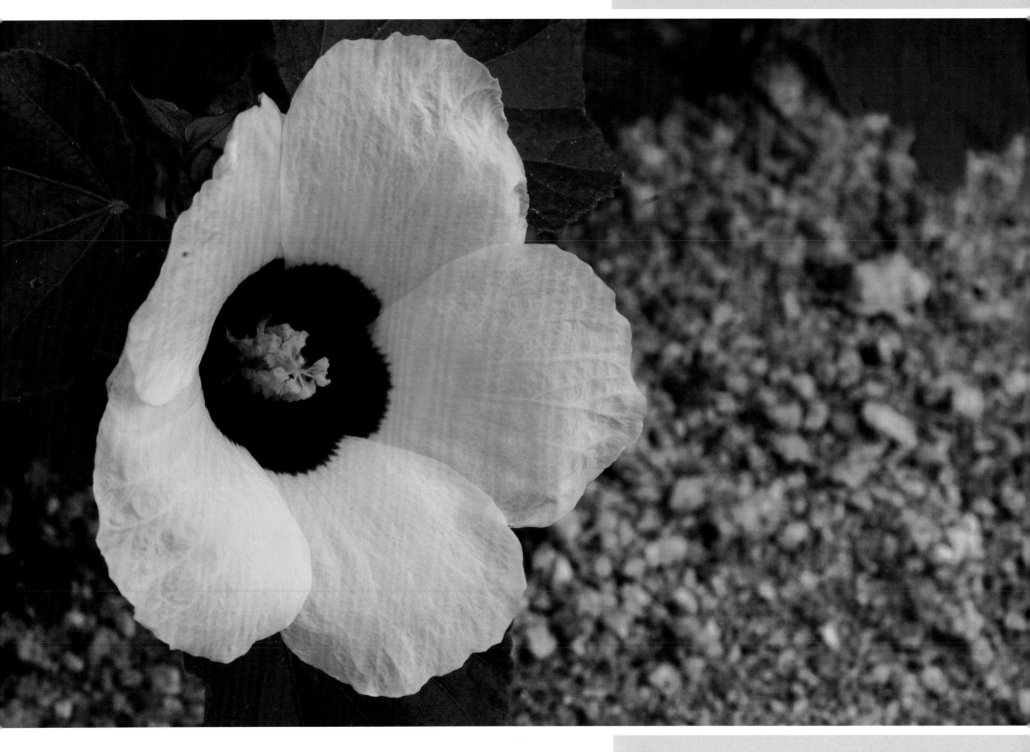

Wild hibiscus typified by five large petals and branch style.

📷 TIP

Taking good-quality images of flowers can seem intimidating – like any other photograph there are some simple techniques that help. Use a tripod – as you get closer to an object any motion of the camera is greatly magnified. A sturdy tripod is essential for sharp images. Don't use camera flash at close distances as it will burn out the detail in the flower. Use side lighting. Macro lenses allow you to get far closer to your subject.

📷 **TIP**

Adjust exposures when taking images of people according to the skin colour.

I try to embrace the wonders of photography wherever I go and it is great now with digital cameras as people can see the results instantly. I love the expression of delight on the child's face at seeing her own image on the camera; the other child is engrossed in learning.

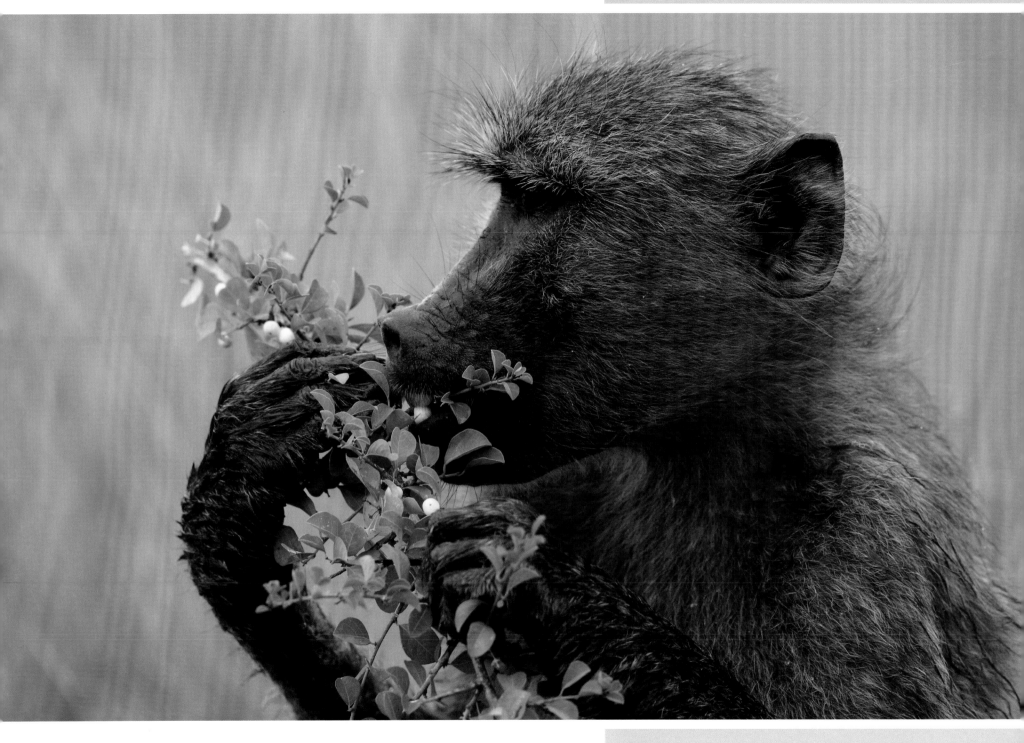

Baboons are often seen by the side of the road when driving into the Orpen Gate. Please do not feed the wildlife as this can lead to a death sentence. Feeding animals can make them become a pest and then they have to be shot. Baboons are old world monkeys and can live in troops up to 250 strong. Living up to 30 years in the wild their main predators are man and the leopard.

TIP

Look for human characteristics in wildlife photography.

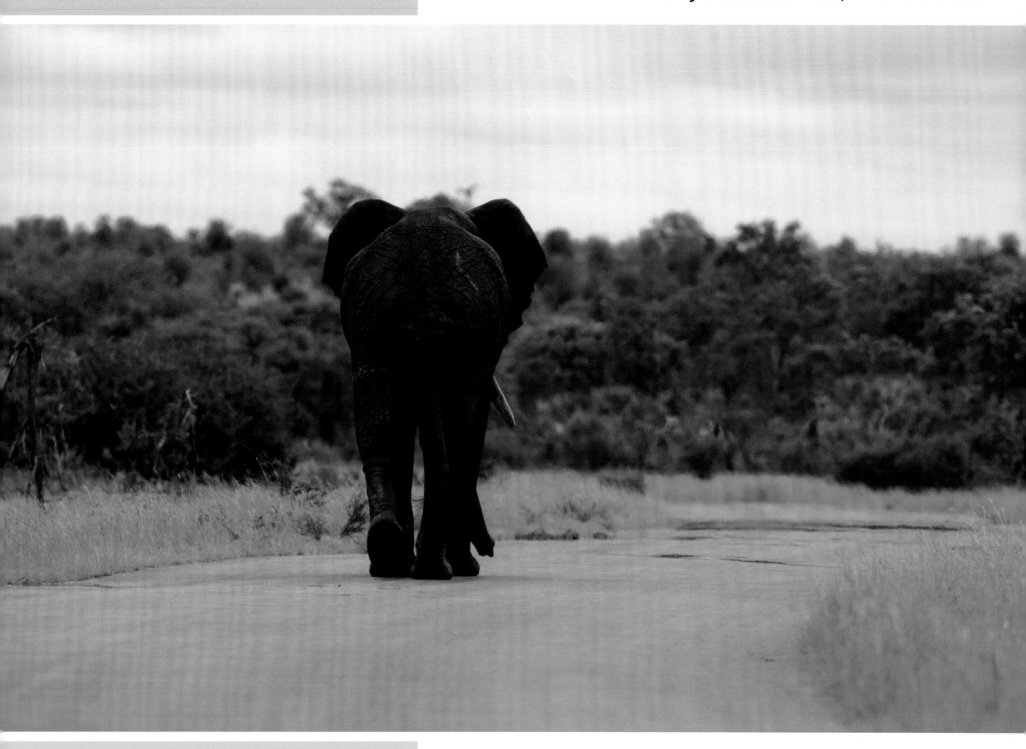

◻ TIP

With wildlife photography the most important thing is the welfare of the animal. Avoid causing stress as animals can become unpredictable and dangerous.

The park is eight times bigger than Pilanesberg National Park – or the size of Wales – and the park has eight main gates. In 1898 Paul Kruger created Sabie Game Reserve to control hunting. In 1926 other game reserves nearby combined to create Kruger National Park. The park has 21 rest camps. There are 517 species of birds and 147 species of mammals within the park.

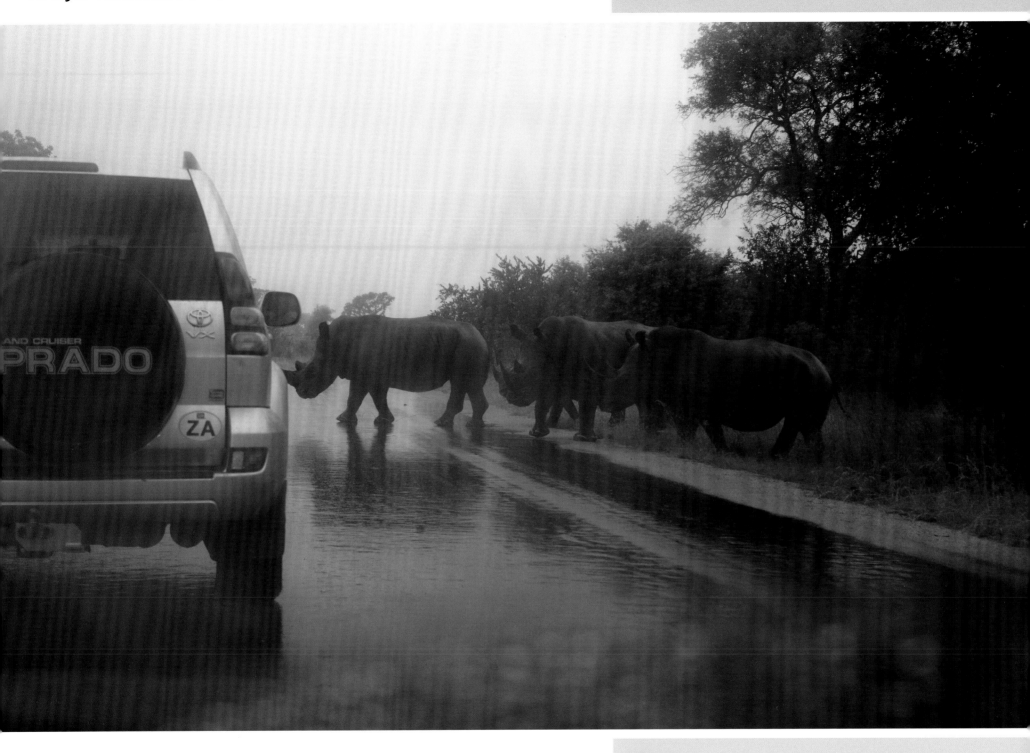

All the park roads are tarmaced and the speed limit is 40 kph. Still in the rainy season the heavens opened making visibility poor on the road, so I didn't travel far in the park. There are 4,500 white rhinos here and I came across a herd crossing the road.

TIP

The weather can create different images so go out with your camera in all conditions to see what you can find. Don't endanger yourself by going out in adverse weather, e.g. hurricanes.

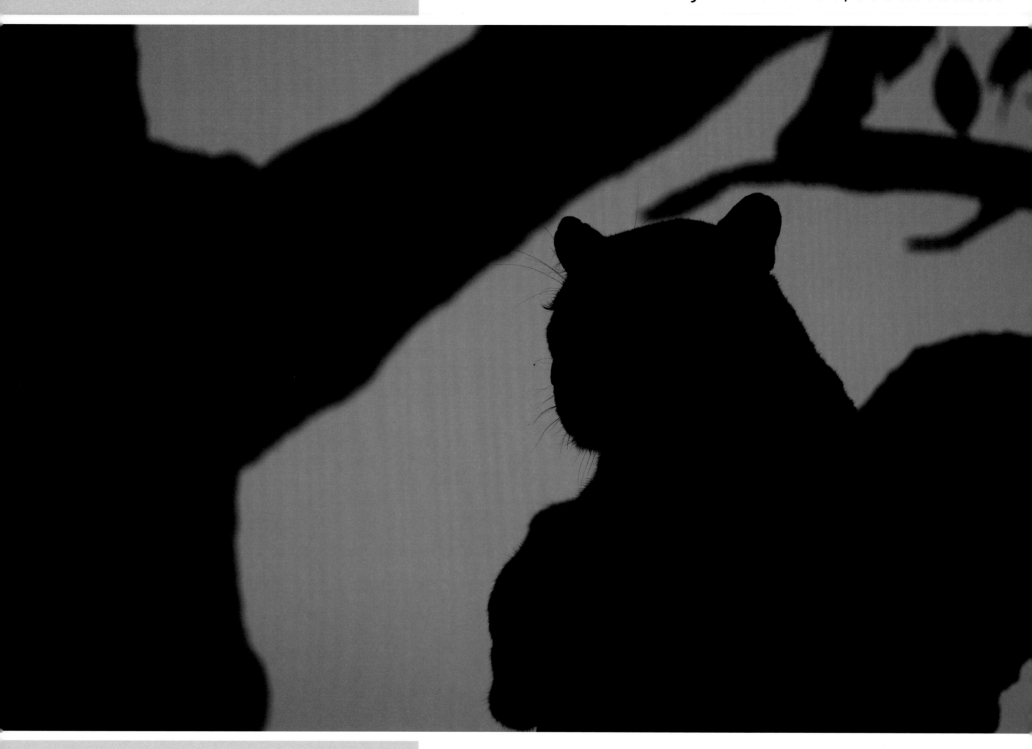

TIP

If you use backlighting only, you can create a silhouette.

I leave Skukuza rest camp to make my way to the Malelana Gate. I shall stay the night there before going back to Mufasa for Christmas and to pick someone very special up at the airport. A wildlife dream came true when I found this leopard up a tree in the early hours of the morning. I knew leopards liked trees by the road as impala can often be found by the roadside. The silhouette shows the true characteristics of the leopard.

From Kruger National Park to Johannesburg is about a 5-6 hour journey but the major roads are very straight in South Africa. I arrive in plenty of time to pick Hazel up from the airport as she has travelled from Texas to be with me for Christmas. We deliver the Christmas tree that Hazel has bought the orphanage and watch in delight as the children decorate it - she has made their Christmas as well as mine.

◉ TIP

Never be caught out by failing flash - carry at least one set of spare batteries for your flash gun.

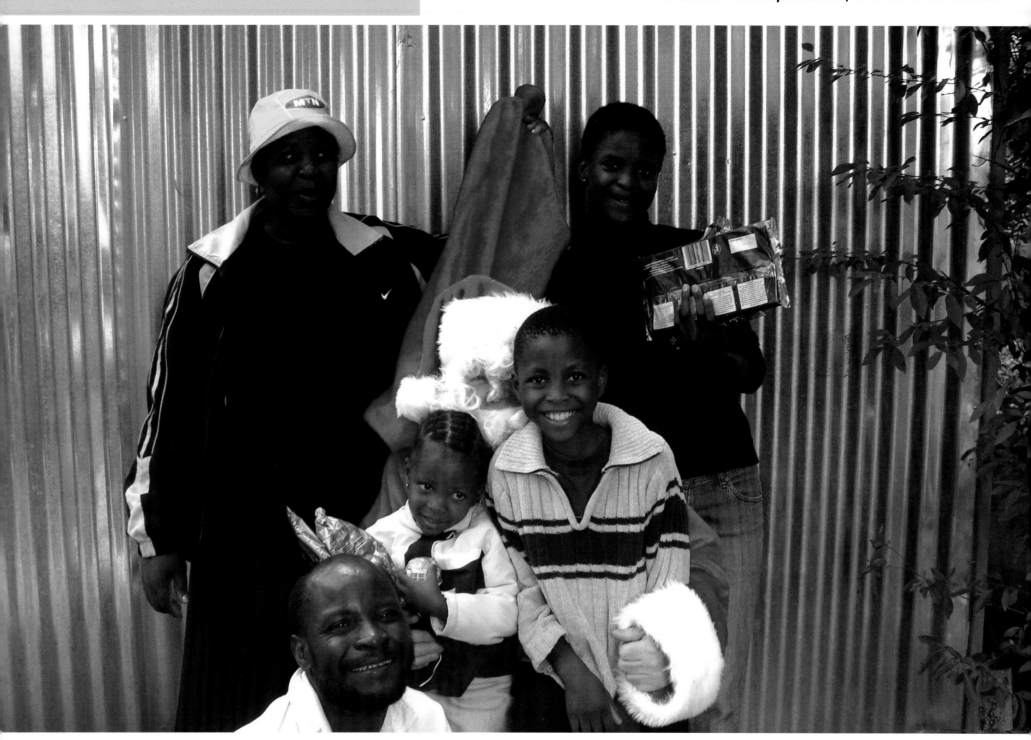

📷 **TIP**

Take care with eyes in group photography – ensure everyone is looking in the same direction.

Christmas Day was very special for obvious reasons. I also did a traditional English Christmas dinner for Juan and Toini, his family and friends, and also for Hendrick and his family, making 18 in total. I played the part of Father Christmas for Hendrick's children as they had never seen him before. The expression on his daughter's face will stay with me forever. Christmas is for children.

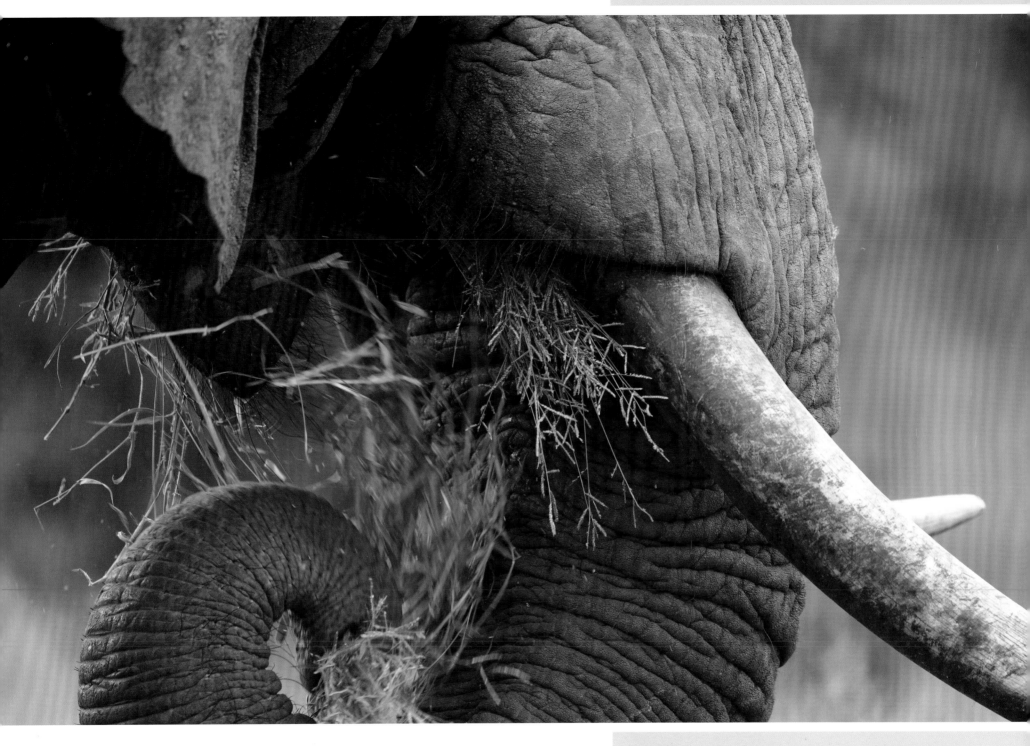

We leave for Kruger National Park for the final leg of my trip; we are staying at Hazy View. Hopefully with my wildlife skills I can give Hazel a safari of a lifetime and provide you with some stunning wildlife images for the end of this book. This of course depends on whether the light is good and the wildlife cooperative - nothing is guaranteed.

📷 TIP

Filling the frame with parts of a subject can be just as dramatic as the whole image.

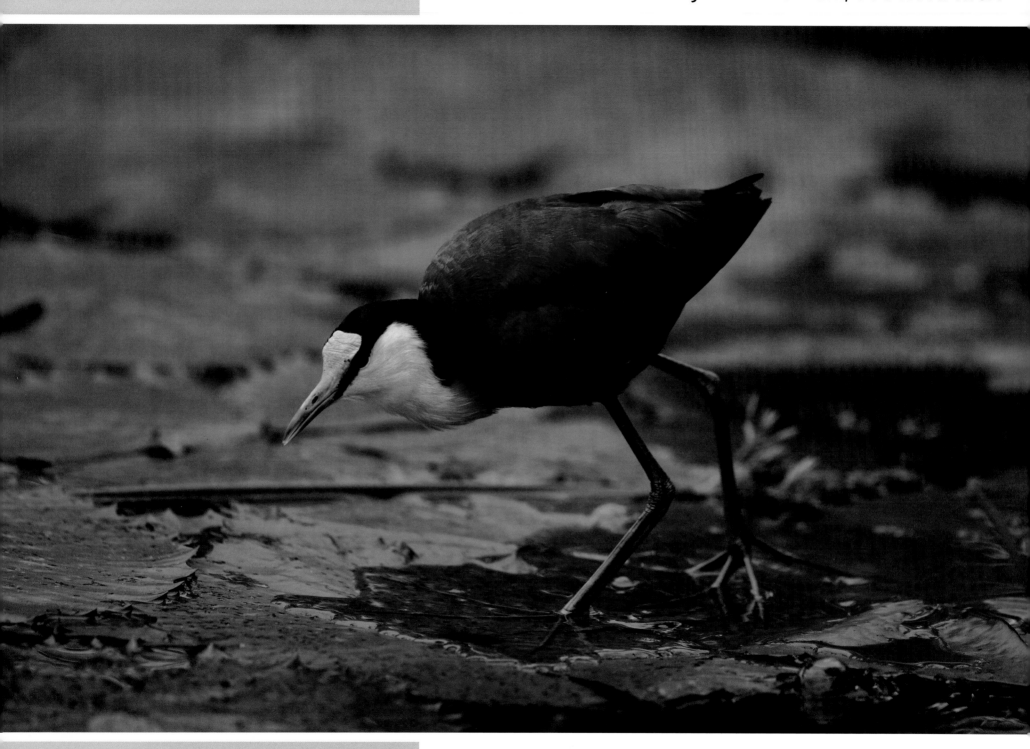

📷 TIP

Capturing natural behaviour can show what is special about different species i.e. jacanas walk across lily pads.

Kruger has not got many waterhole hides like Pilanesberg but near Skukuza has a very good bird hide on a lake. So this was a chance to photograph various species of waterbird. The image captured is of an African jacana - the male looks after the chick and if danger approaches the chick hides in its father's plumage for safety.

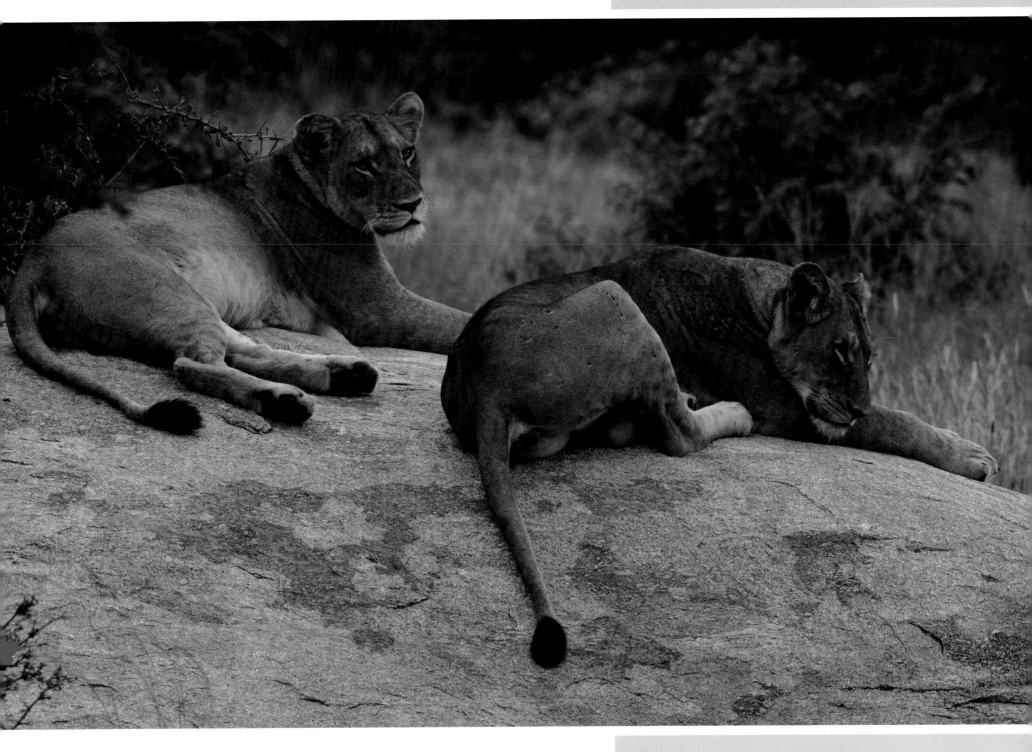

I heard about a pride of young lions that had been spotted on a group of rocks last night, so we headed out at 5.30 am to try and see them and capture them for the book. I found the lions, the only thing I couldn't find was the light! You can never plan the weather; most other things can be arranged.

📷 **TIP**

Natural lighting is so important, and a golden light would have changed this image dramatically. That's why wildlife photographers can take years to get that special image.

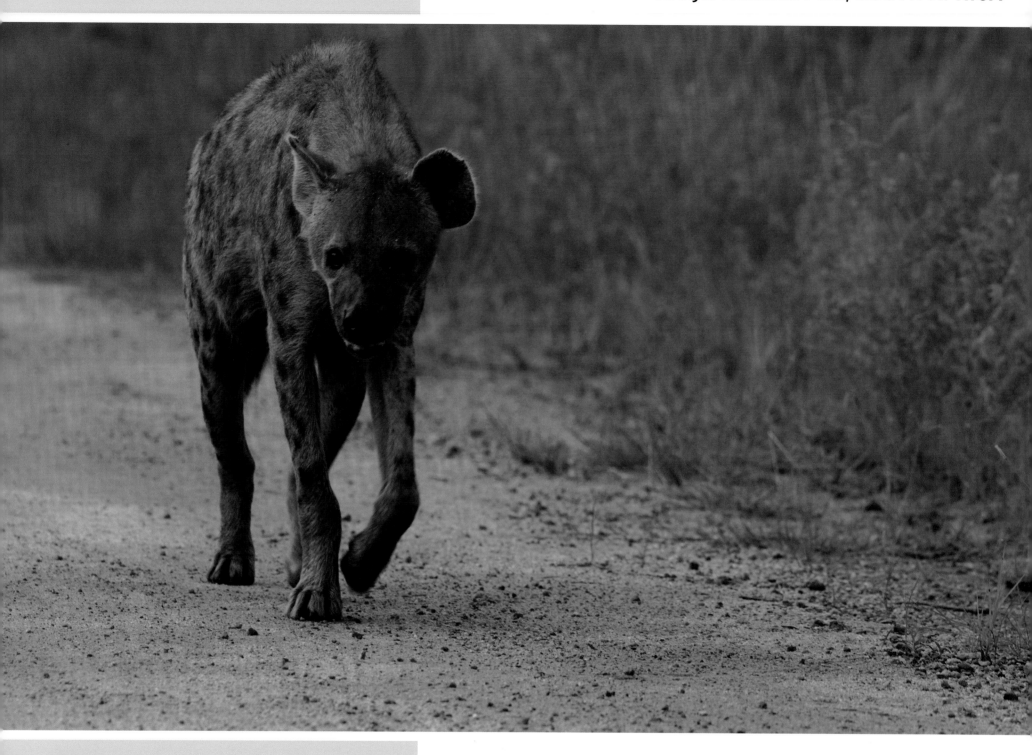

📷 TIP

If in doubt use f 8, a general all round f stop that will capture most images.

Spotted or laughing hyena and lions are eternal enemies as both are apex predators – meaning they feed on the same prey. Male lions are extremely aggressive towards hyenas and hyenas will kill lion cubs. The hyena is one of the most vocal animals and they live in a clan which is led by a single alpha female called the matriarch. The male hyena is the lowest rank in the clan.

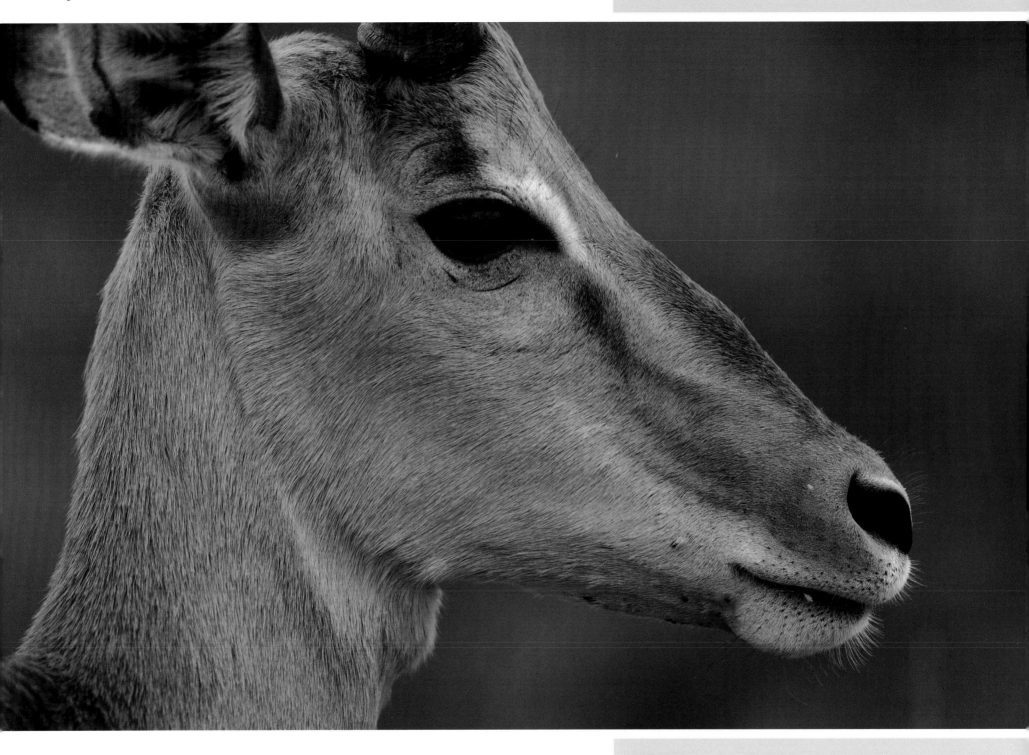

Head shot of an impala. Passion is my photography, photography is my passion. I'm pleased I am sharing my passion.

📷 **TIP**

The first problem is how close the lens will focus: lenses have a minimum focal distance which varies considerably from lens to lens. Choices have to be made between prime lenses (a single length lens) or telephoto lenses (lenses that have more than one focal length). Choose your lens purchases carefully. Some telephoto lenses have a 'macro' setting; others are purchased as macro lenses.

📷 TIP

Photography can report bad things as well as good.

Madness...I'm going to get on my soapbox. You are not supposed to block the road, only stop facing the way you are travelling and queue sensibly – but this doesn't happen especially if there is a lion kill beside the road. At Yellowstone you would get moved on. I have seen queues for miles at Yellowstone for a grizzly sighting but at least you can move around the park. I was behind these cars for 40 minutes!

A Happy New Year, and a new dawn. Rising early to see the dawn break over the park on New Year's Day is very special and romantic.

📷 **TIP**

It is amazing that I have seen fewer images of sunrises than sunsets. Maybe it is the early waking required to get to a point of beauty in time. Winter is probably the best time to start, because the nights are long and the days short. You need a tripod, patience and a certain amount of luck. Always dress for the conditions.

⬜ TIP
Hides would protect me from the heat of the sun so I could have maximum time taking images.

While I was at the pond with the hide, I had noticed the water lily flowers were beginning to emerge, so when I was close by I always popped in to see if they had opened. I would go back during the mid-morning when the animals start going to the bush for cover from the morning sun.

The woodland kingfisher is about 20 cm tall with a bright blue back and large red bill. You will often hear this bird before you see it – their flight is rapid and direct.

📷 **TIP**

By moving to the same level as the kingfisher I managed to keep the whole bird in front of the green background which I had blurred out with my depth of field. Due to the colouring of the bird and the lack of sun, if the kingfisher's head had been above the green it would have been washed out.

📷 TIP

Study your animal behaviour to understand your subject.

The white stork migrates to South Africa in winter – it is a huge bird at over a metre high and is completely white except for black wing flight feathers and its red bill and legs. Normally white storks hunt alone but after the rain they mass together and walk in formation like police looking for evidence at a crime scene. The storks are looking for frogs that have emerged after the rain.

A baboon stare - it is his eyes that are important. In this image you are drawn to his orange eyes and what they are looking at.

📷 TIP

Eyes are one of the most important features in an image; they are windows to the soul. Eyes need to be sharp and bright and should have a catchlight in them to make them 'sing'. If you start to look at eyes in images you will realise that when an eye 'sings' the image bursts into life.

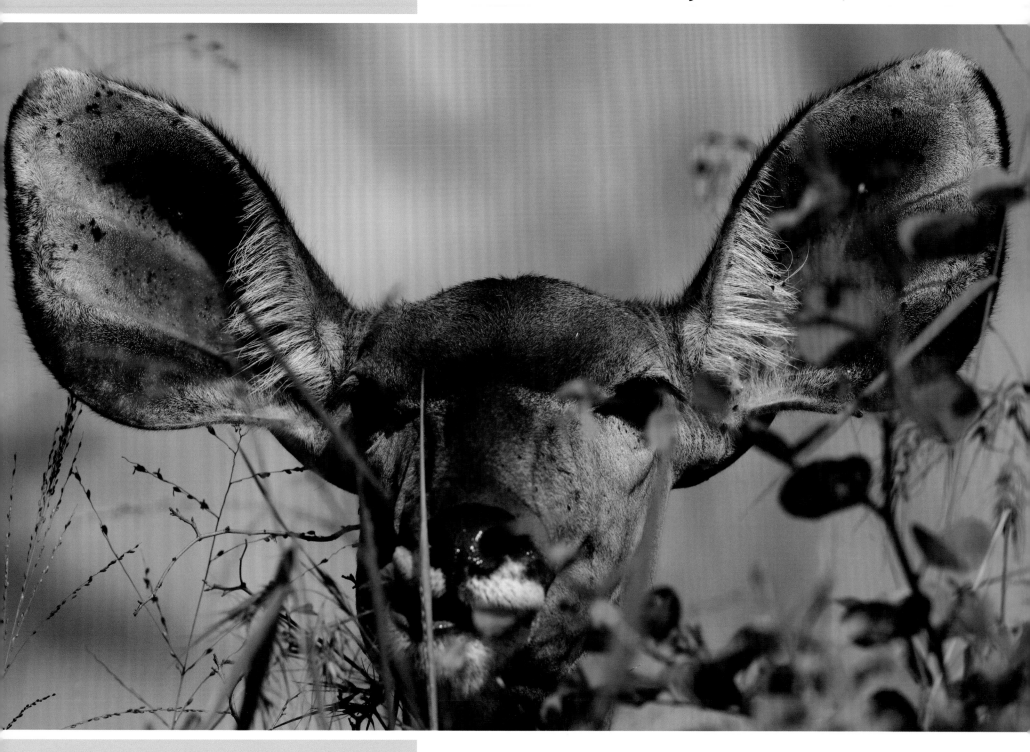

📷 **TIP**

Take something prominent in the image and emphasise it. If I had taken a full body portrait of this animal you wouldn't have noticed how big the ears are on a kudu. With her hiding behind the vegetation it also brings out the mystery and timidity of this beautiful antelope.

The eyes of this female greater kudu are not singing, but the key feature is her ears and how important they are to her. Deer and antelope ear markings are individual to each animal.

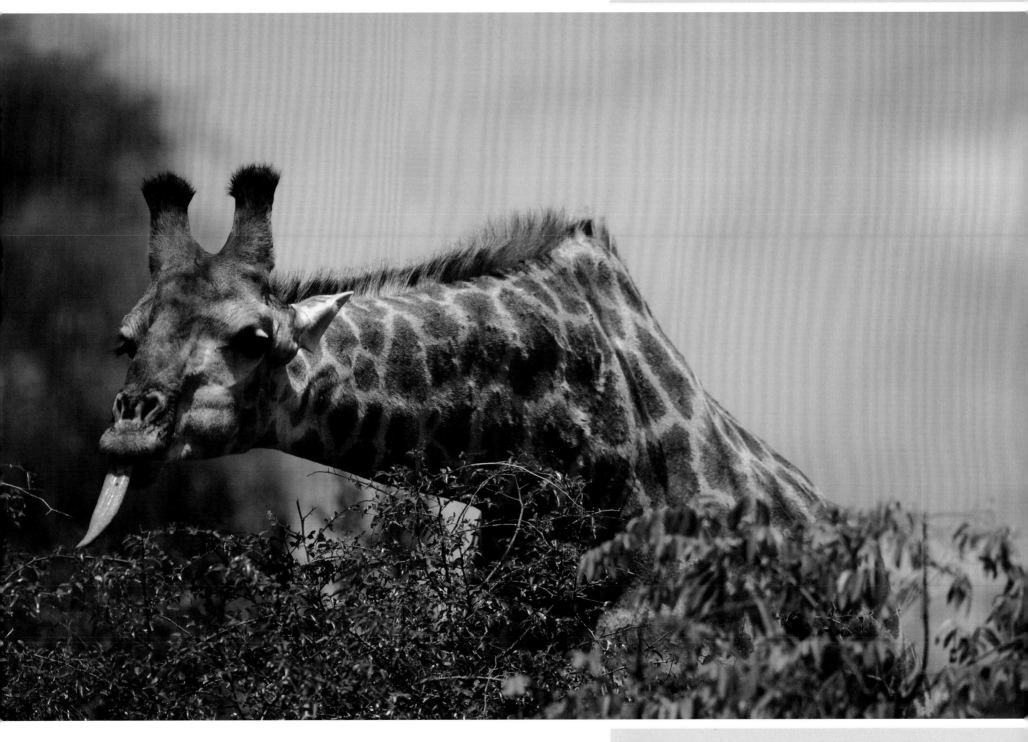

A giraffe feeding on the twigs of an acacia tree with its long tongue that measures up to 18 inches. The giraffe is the tallest of all land living animals, both sexes have horns but the males develop calcium deposits which form bumps on their skulls as they age. Giraffes only sleep for between ten minutes and two hours - the shortest sleep requirement of any animal.

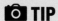 **TIP**
Capture individual habits of different species e.g. feeding.

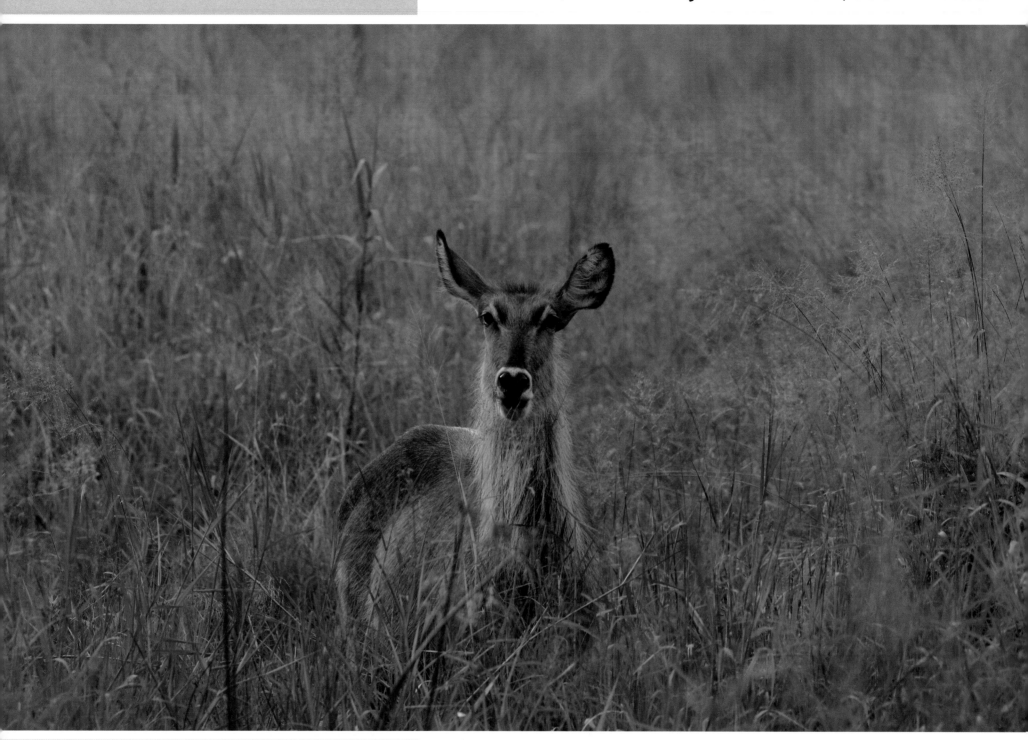

📷 **TIP**
By following the same tips you can capture similar species of wildlife. If you stand still, deer or antelope will come towards you – see Day 147.

Female waterbuck in lush grass. Waterbucks are found in scrub or savannah areas near water. They don't spend a great deal of time in water but will take refuge there to escape from predators. They have a white ring on the rump and males have long spiral stretched horns that sweep back and up.

My passion for elephants is shared by many people.

📷 TIP

Take different approaches to images. I hope to have inspired you to look at things differently, using they eyes and ears of an animal to capture its beauty. An elephant's tusks make it special, so I wanted to capture the large curving tusks of this bull elephant as it moved away, with just part of the elephant showing. The other trick to this image is getting behind the elephant.

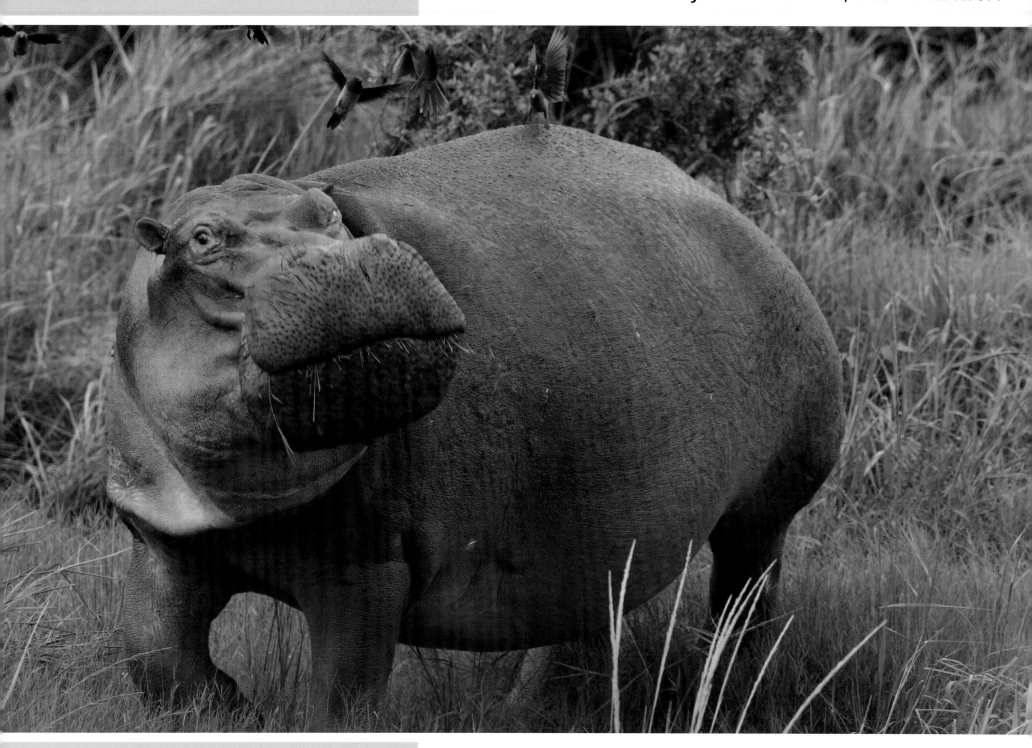

📷 **TIP**
Facial expressions will always catch a photographer's eye.

The hippopotamus doesn't tend to come out much during the day to avoid getting sunburnt, but due to the coolness of the day this hippo gave me a fantastic opportunity. Hippos have very violent tempers and should always be treated with caution. Even though this is the case the hippo has found a place in our hearts as their rotund frame which is often used to humorous effect.

Redheaded finches in flight remind me that I will have to fly home soon.

 TIP

The next three images are all about motion and action in photography.
There are situations when you have to decide how to capture a moving
subject. In my image of redheaded finches I have blurred the whole scene
to convey how fast everything is moving to the viewer. You should use a slow
shutter speed, anything below 1/100th second should do the trick and is best
for bright colours.

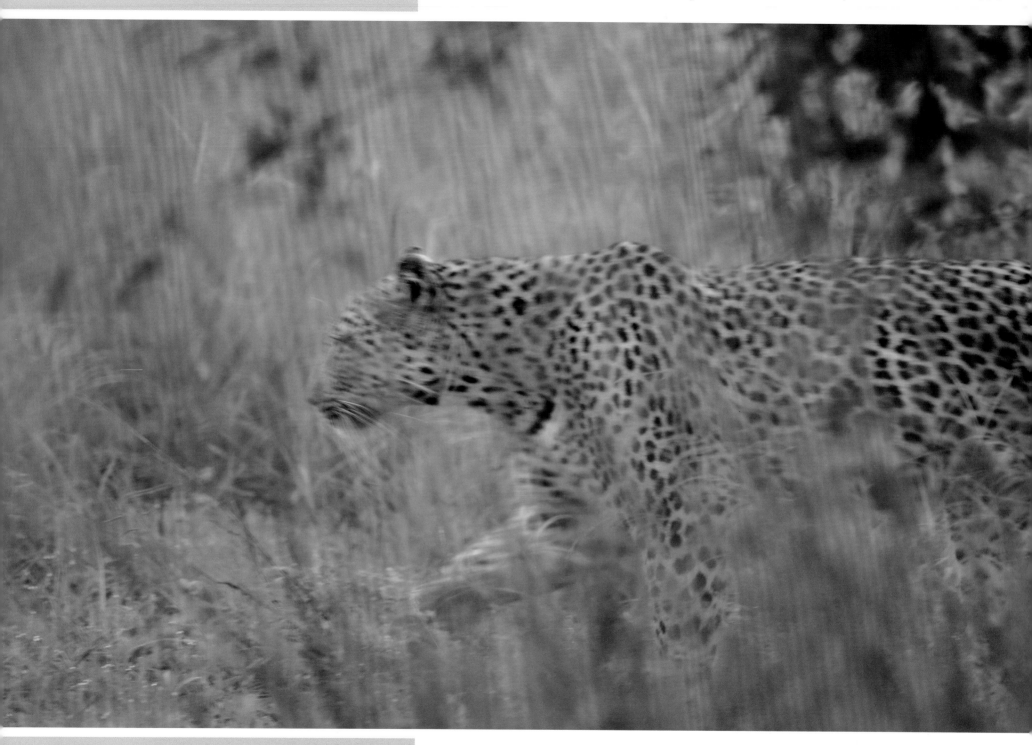

TIP

Motion can be caused by lack of light or camera shake, but also shooting through objects that are moving. I only had seconds to set the camera for this shot – that is why it is so important to know the workings of your camera. Without enough light it wasn't possible to freeze the motion so I turned the shutter dial to a slow speed and panned the camera from right to left.

Leopard moving through the grass. After all these years, I am still waiting for my perfect leopard shot. I will get it eventually, Bill.

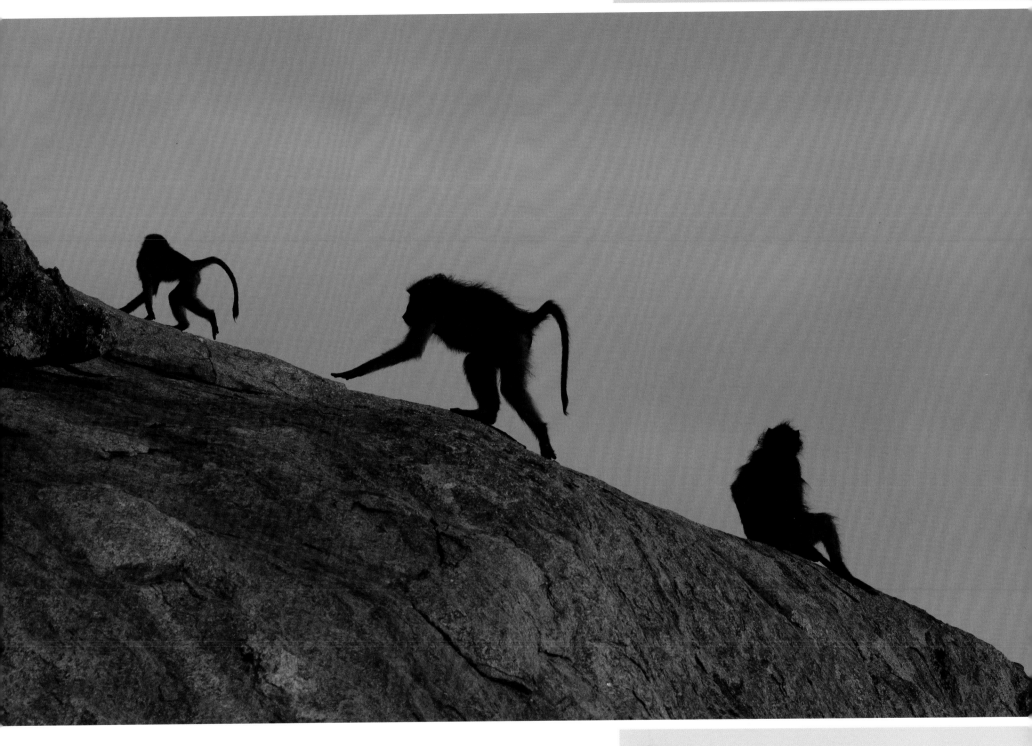

Baboons climbing on rocks.

📷 **TIP**

Freezing the motion of the image and the background behind. You should use a very high shutter speed of at least 1/300th second or higher – a lot of new cameras now have far higher shutter speeds which are good for motorsports. Freezing the motion of baboons is a perfect example of what I mean. Modern day lenses also have image stabilisers built in to help stop camera shake.

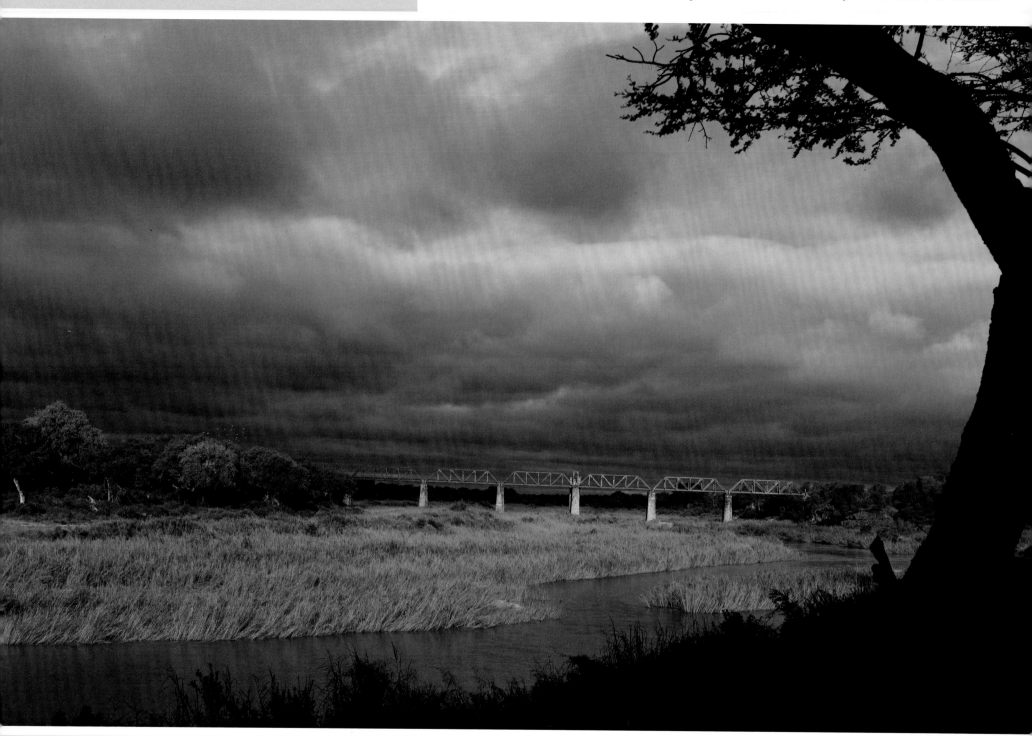

📷 **TIP**

Landscape photography and contrasting light. This image has been created by using the dark tree on the right to frame the image and the dark clouds behind the bridge leaving the golden light between them. A photographer's dream when this happens but the light often doesn't last long so you have to be ready for images like this.

Kruger railway bridge is near Skukuza, it can be seen from the riverbank of this camp. Skukuza is the largest rest camp in the park, the perfect bolt-hole.

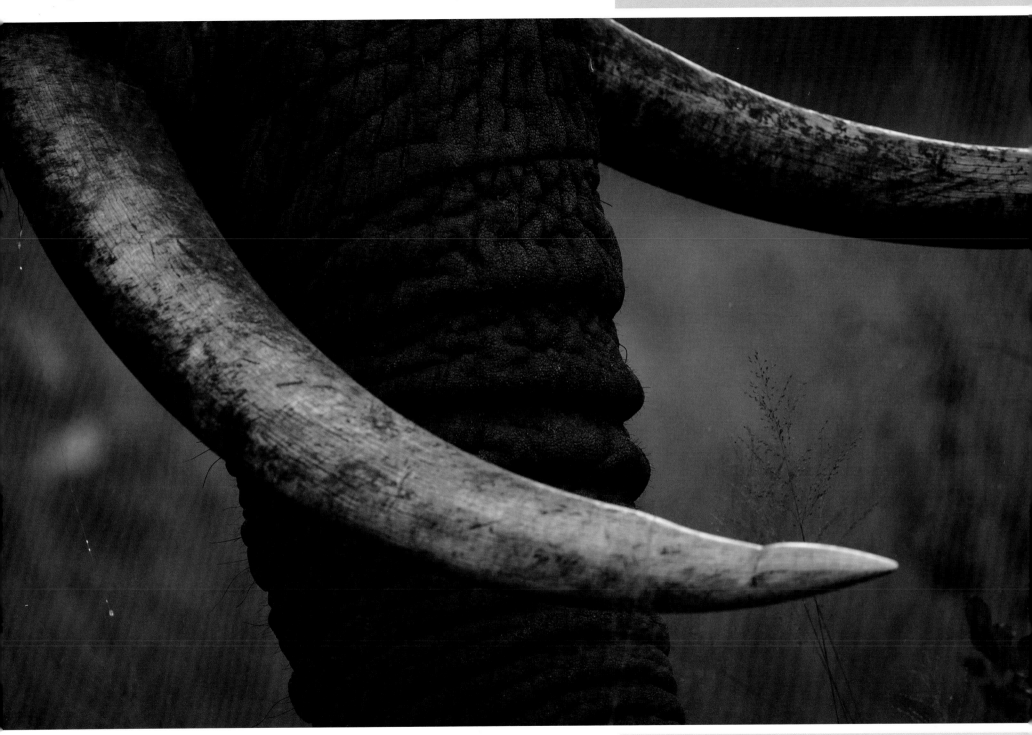

Elephants trunks and tusks. I am glad Hazel shares my passion for elephants.

TIP

Due to the weather being overcast, rainy and dull, I decided to shoot everything in black and white. On your camera's menu you have a function to change your colours from vibrant to less vibrant, colour to black and white. Altering it to black and white can give a more powerful image.

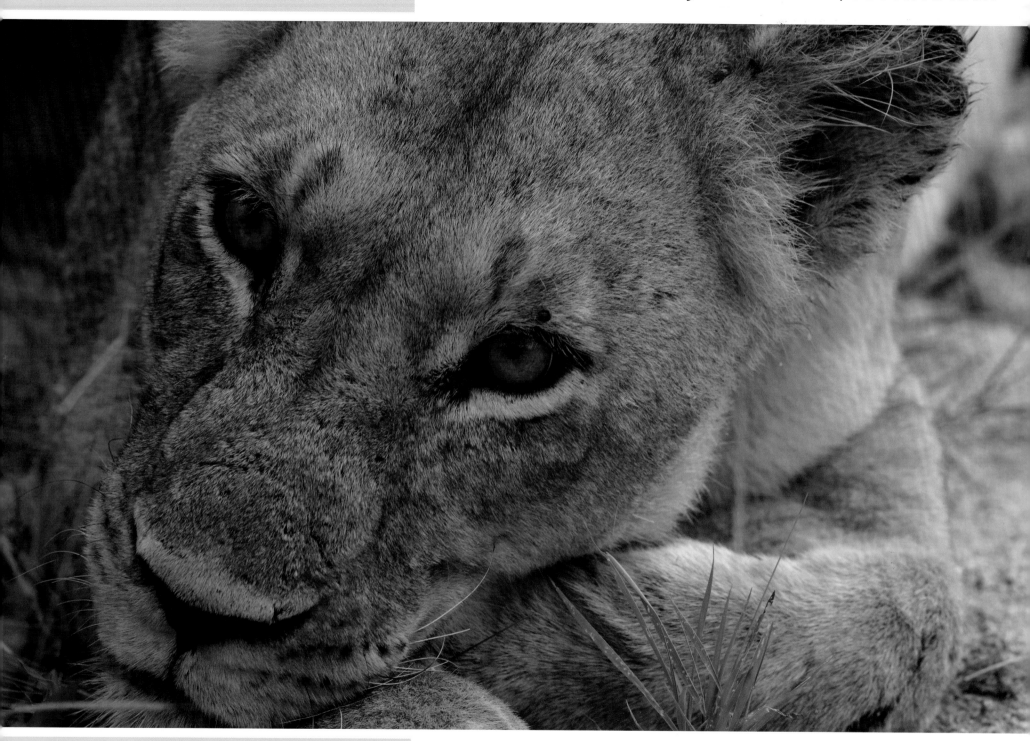

Lioness with her head on her paws looking sad – my thoughts inside me.

📷 TIP

Photography to me is all about passion. I hope my images, tips and the information I have given will help you with your own photography or in creating your own style. This full frame lioness's head is just one of the styles that I like to use but whatever the style, the main thing is always to enjoy your photography. It can be a life-changing as well as a rewarding hobby.

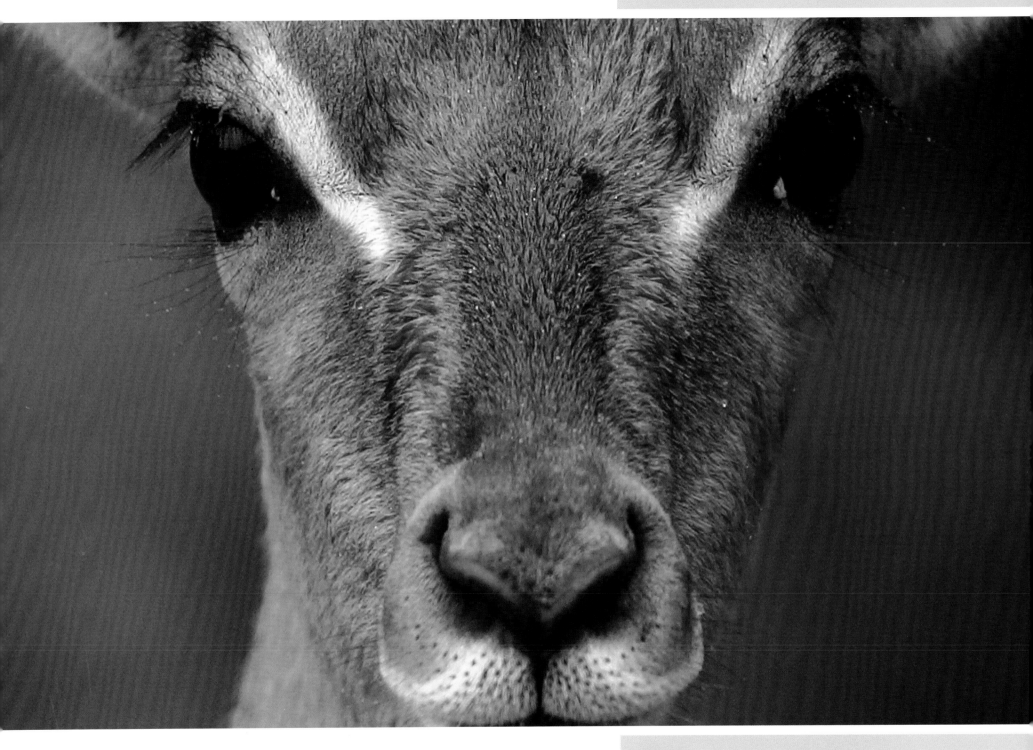

It's raining again. I am beginning to think I can't find an image for today, and failing my challenge with only two days to go. I can't even find a bedraggled-looking elephant or bird so I have to go back to basics.

📷 TIP

What are you going to photograph? And where? With over 90,000 impala in the park I suddenly have my answer. I spend the next hours taking images of impala and with eyes being so important this image is a winner.

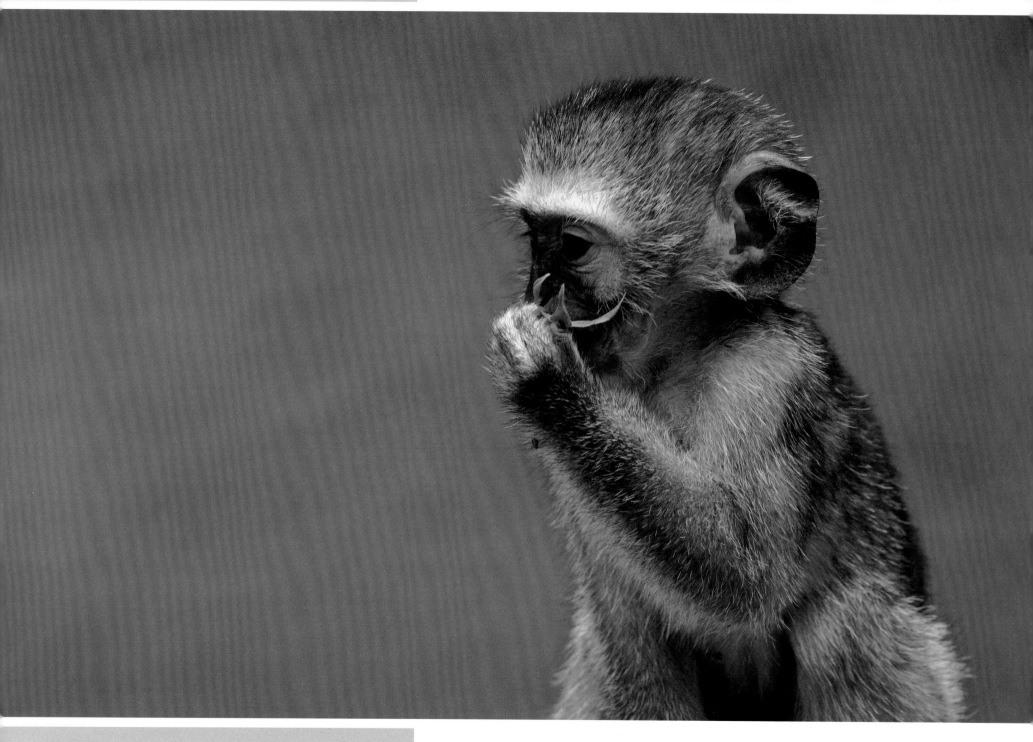

📷 TIP
This cute image and perfect background shows the monkey's colouring off to perfection.

After yesterday's difficulty, today's task of finding an image was as easy as pie. We are packing to go home and around our chalet baby vervet monkeys are playing, so it wasn't long before I had my image of the day – maybe it was the thought that someone else was packing while I was taking photographs that made my photographic eye 'snap into focus'.

USEFUL INFORMATION

Photographic Equipment

- Canon EOS 1D Mark III

- Canon EOS 5D (full frame)

- Canon 500 mm lens f4 L

- Canon 70-200 mm IS lens f2.8 L

- Canon 24-70 mm f2.8L

- Canon 17-40 mm f4

- Canon 10 x 30 IS binoculars

- Lowepro rucksack bag

- 12 inch laptop

- 7 Western digital portable hard drives

- Gitzo tripod and head (carbon fibre)

- Sandisk Extreme III 4 Gtbe CF Cards

Information

- Distance travelled: over 25,000 miles

- 11 countries visited

- Over 20,000 images taken for this publication

Canvas and Poster Prints

Phil Gould Photography and 365 photography days would like you to have a unique opportunity to buy a high-quality canvas and poster prints. They are produced by The Dot Foundry, a fine art/Giclee printing company, catering specifically for artists and photographers and winners of the 2010 Print Quality Award. They will produce the picture you want and post it directly to you.

Visit the Sales page at
www.365photographydays.com
for further details.

Websites

DAY	
19-73	www.dragoman.com
75-79	www.napowildlifecenter.com
82-365	www.hostelbookers.com
84-88	www.yosemitepark.com
110-115	www.grandcanyonhotel.com
111-115	www.grand.canyon.national-park.com
119-121	www.zion.national-park.com
123	www.bryce.canyon.national-park.com
124	www.antelopecanyon.com
125	www.navajonationparks.org
126	www.canyonlands.national-park.com
127	www.archers.national-park.com
128	www.grand.teton.national-park.com
129 & 135	www.yellowstonepark.com
132-134	www.animalsofmontana.com
142-153	www.glacier.national-park.com
142-153	www.nfhostel.com
159-160	www.crazyhorsememorial.org
254	www.whalecatch.co.nz
275-304	www.mufasabackpackers.com
304-365	www.sanparks.org

www.venturesport.co.uk
www.gearzone.co.uk
www.wildsounds.com
www.thedotfoundry.co.uk
www.wildlifewatchingsupplies.co.uk

www.365photographydays.com
www.philgouldphotography.com
facebook: 365photographydays

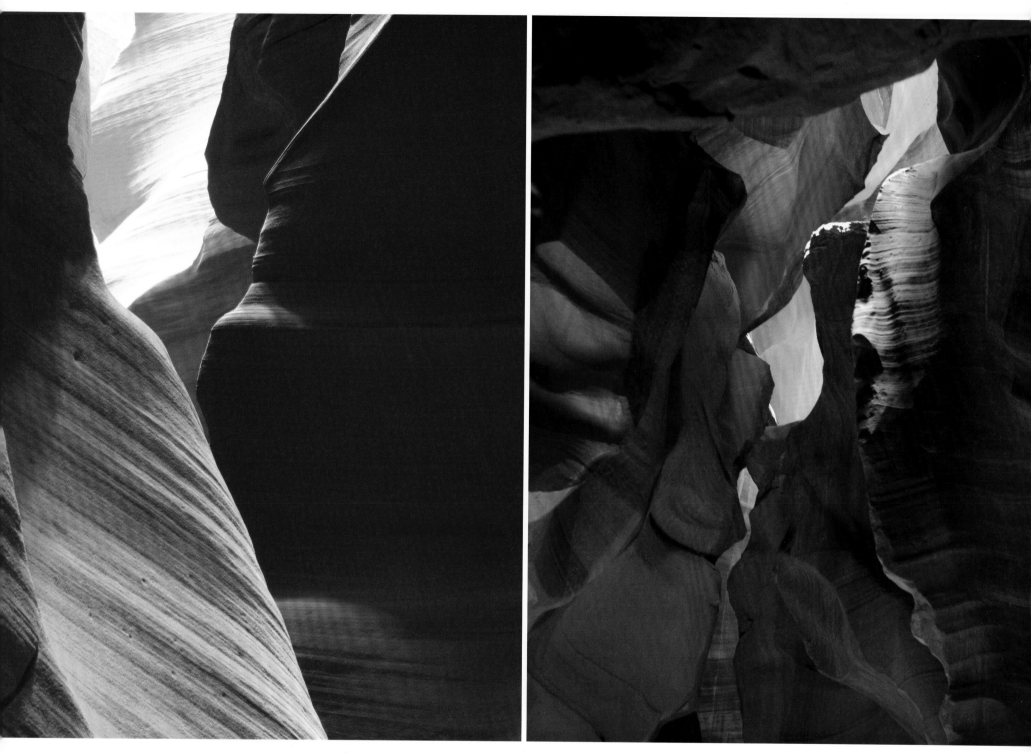

DEDICATION TO SARAH WESTON
For all the help that she has given to making this book possible. Antelope Canyon.

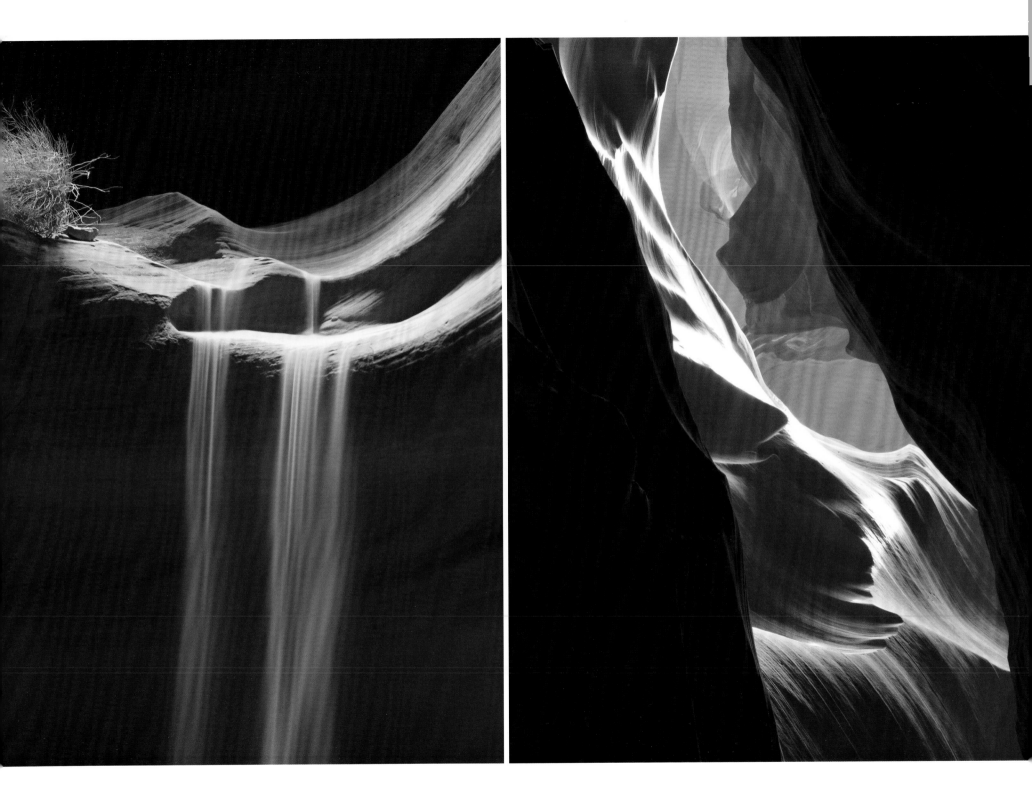

PHIL GOULD ON TOUR

Clockwise from the top.

1 Hazel and I in South Africa. 2 Father Christmas visits. 3 Party time on overland tour. 4 Phil in Desert. 5 In Sedona USA 6. Whale watching

Clockwise from the top.

1 Will go anywhere to get an image. 2 Staying in Bolivia. 3 Ancient city gates entrance, Cusco. 4. Animals of Montana.

5 Wildlife photography in Kruger National Park (using bean bag).

GLOSSARY

BALANCED COMPOSITION

Images need to have a balanced appearance. Your eye should be drawn to the subject in the image, and not wander around the image looking for interesting features. Some photographers place their subject in the centre of the frame but this gives a static image. The most interesting positions are off centre but away from the edge of the frame, i.e. rule of thirds position.

BEAN BAGS

A soft bag filled with dried lentils or grains and sealed. Used as a means of support for your camera and lens where space is limited, or a tripod is unavailable.

BLURRED IMAGES

Blurred images can be caused by a variety of problems i.e. camera shake or moving images taken at slow shutter speeds. Moving images require faster shutter speeds to freeze the action, alternatively select a shutter speed that gives a degree of blurring to accentuate the motion within the image. Camera shake, however, is usually caused by not supporting the camera sufficiently to prevent the camera moving slightly when taking images. If there is any doubt that your camera is not securely held when taking an image, use a tripod. Ensure that the tripod is set up properly with the legs spread evenly and press the shutter button down evenly and without sharp movement. Images will appear sharper than if you had tried to handhold the camera and lens. Images that have slow shutter speeds should always be used in conjunction with a tripod.

BRACKETTING EXPOSURE

Taking a series of three images both under and over the initial exposure i.e. -1/3 of an f stop, normal exposure, +1/3 of an f stop, ensures that one of your exposures will be correct for the image that you have taken. Sometimes it is difficult to gauge whether an image will contain all the detail that you expect from your exposure, therefore by taking a series of images at slightly different f stops, this gives you the opportunity to select which exposure suited your style of photography. When using digital photography software you can always draw more information out of an under exposed image, but you cannot add detail that was not taken as the exposure was over exposed.

CABLE RELEASE

A cable release is a metal cable or wire that is attached to a camera's shutter button on one end.

COMPOSITION IN NUMBERS

When composing your image in the viewfinder, you should note how many people, animals, objects etc. there are. Groupings in odd numbers work better than even numbers, with the popular compositions being one, three, or five in a grouping.

CONTINUOUS SHOOTING

Action photography or images that are constantly moving need to be taken with a fast shutter speed to freeze the image in the frame. By using continuous shooting you can take several images a second, and during that time you will capture the image with little or no blurring. In low light, support the camera with a tripod to avoid camera shake.

CONVERGING VERTICALS

When photographing architecture and other upright structures, converging verticals means that lines like the sides of buildings which are perpendicular to the ground look as though they are bending inwards in the picture. Depending on the type of lens used, the convergence can become exaggerated and look rather unusual or strange. Look for other angles in your photography to avoid this exaggeration. With digital photography some computer software programmes can correct converging verticals. Alternatively a tilt and shift lens allows you to alter perspective when taking architectural images.

DEPTH OF FIELD

Depth of field is the term used to set how much of your image you wish to be in focus. By selecting a higher numbered f stop, you can ensure that the greater part of your image is in focus, i.e. f16 is suitable for landscapes ensuring that all of the image will be sharp. If you select a lower f stop you will notice that areas of the image that are not covered by the selected focal point tend to be out of focus or unsharp. You can control the degree of sharpness that you wish to achieve in your images by experimenting with different f stops. An f stop of f1.4, f1.8, f2.8, f4 or f5.6 will create blurring away from your selected focal point. An average f stop of f8 will ensure that the focal point area of the image is sharp and then the background is recognisable but unsharp. If in doubt, use f8.

EXPOSURE

Exposure is the control of light reaching the film or sensor and determined by the f stop used in your photography.

ISO SETTINGS

Use an ISO of 100 or 200 when taking images outside in sunny conditions. If the sky is overcast or it is evening time, then use an ISO within the range of 400-800. With night photography or very low light you may need to set the ISO higher. The higher the ISO, the more grainy the image will look, therefore use as low an ISO as is suitable for your photographic conditions. By using a low ISO i.e. ISO 100, your image will be of better quality than using an ISO of 800.

FILL IN FLASH

Flash used in conjunction with sunlight or another primary source of light. Fill in flash is used to fill in any shadows or highlight the subject detail.

FOCAL POINTS

Every camera has a focal point and the majority of cameras have many focal points to choose from. When looking through your viewfinder ensure that your main point of composition is covered by a focal point. If your camera has auto-focussing, this will ensure that your image is sharp in the area that it is intended to be. Parts of the image that are not covered by the focal point selected will tend to be less sharp. When taking portraiture, ensure that the focal point is placed on the eye of the subject.

LEADING LINES

When creating your proposed image in the viewfinder, use the rule of thirds, and place your important features accordingly - to create an even stronger image look for aspects that will draw the viewer's eye into the image i.e. roads, trees, lines etc. that start in the foreground and recede into the background drawing you in. With the single main feature placed on the third, ensure there is nothing else in the image to distract the viewer. A good image is a clear and concise image that has nothing to distract you.

LENSES

Lenses are available in many different focal lengths. There are two distinct types of lenses, those that are prime lenses and are of a fixed length, and others that are telephoto/zoom lenses which allow the photographer to change the focal length of the lens without actually changing the lens on the camera. There are no rules for what lens to use, just your creative ability. Generally lenses come in these various focal lengths, wide angle 16-35mm, standard lens 28-80mm, telephoto lenses 70-300mm, with specialist longer lenses for wildlife i.e. 500mm, 800mm. Typically wide-angle lenses are used for landscapes, standard lenses for portraiture, and telephoto lenses for wildlife and sport. However, experiment outside these boundaries, your photography is all about creative challenges.

MONOPODS

A monopod is a single staff or pole used to help support cameras - basically a tripod with one leg. Where it is impractical to use a tripod through lack of space etc., the use of a monopod helps support and steady your camera and lens, allowing for sharper images in low light areas.

RULE OF THIRDS

Imagine that your viewfinder is divided into thirds horizontally and vertically - nine squares - an invisible grid in the viewfinder. By placing the important features of your proposed image as close to the intersecting lines as is practical, you will create an image that is based on 'the rule of thirds', and therefore the composition will appear stronger than a centrally placed feature.

PERSPECTIVE

When composing your image in the viewfinder remember the thirds rule and set horizons either low or high in the image and not straight through the middle. If you set the horizon at the middle point of the image you sometimes create two images, one above and one below the horizon. By creating a higher or lower horizon in the image you achieve a far better photograph.

POLARIZING FILTERS

By adding a polarizing filter to your lens, colours become more saturated, glare is reduced in reflective surfaces and haze in landscapes is reduced. Circularising polarizing filters are also available giving you the opportunity to twist the filter on the lens to reduce or enhance any of the polarizing features.

RIGHT-ANGLED EYE PIECES

A most useful attachment for waist-level or low-angle photography when mounted in place on the eyepiece frame.

ACKNOWLEDGMENTS WITH SPECIAL THANKS TO...

Brian MacFarlane

Chris Packham

Chris and Pauline Wallace

Hazel Stroud

Ian and Renee Gould

Juan and Toini

Ken and Julie Archer

Mum and Dad

Ruth Ziolkowski

Sarah Weston

All the family and friends that have given me support over the years